WRITING AND ART
SCOTT McCLOUD

LETTERING
BOB LAPPAN

EDITORIAL ADVICE AND
SELECTIVE EGO-TRIMMING
STEVE BISSETTE
KURT BUSIEK
NEIL GAIMAN
BOB LAPPAN
JENNIFER LEE
LARRY MARDER
IVY RATAFIA

EXTRA SPECIAL THANKS
WILL EISNER

EDITOR
MARK MARTIN

HarperCollins books may be purchased for educational, business, or sales promotional use. For information please write: Special Markets Department, HarperCollins Publishers, Inc., 10 East 53rd Street, New York, NY 10022.

First HarperPerennial edition published 1994.

ISBN 0-06-097625-X (pbk.)

14 15 RRD 47

ACKNOWLEDGEMENTS:

The book you're about to read took 15 months to produce and many of the ideas it contains had been on the back-burner for over nine years, so acknowledging all of those who have helped in its development may be next to impossible. Furthermore, since its initial publication in the comics industry, I've received tremendous support from hundreds of fellow travelers in all corners of the publishing world. My apologies to anyone who is not listed below and should have been.

My deepest gratitude to Steve Bissette, Kurt Busiek, Neil Gaiman, Larry Marder and Ivy Ratafia who all reviewed my original draft in detail and offered many valuable critiques. Their contribution to the project cannot be overstated. I was also fortunate to receive detailed analysis from the talented Jennifer Lee and beyond-the-call-of-duty proofreading and good advice from Bob Lappan. Special thanks are also due to the magnificent (and magnanimous) Will Eisner who offered many words of encouragement and excellent advice in the project's later stages. Will Eisner's work has been an inspiration to me, and to thousands of artists, for many years. Eisner's COMICS AND SEQUENTIAL ART was the first book to examine the art-form of comics. Here's the second. I couldn't have done it without you, Will. Thanks.

I'm deeply indebted to all of the friends and family who offered their thoughts on the manuscript as it was being prepared. Among this long list are Holly Ratafia, Alice Harrigan, Carol Ratafia, Barry Deutsch, Kip Manley, Amy Sacks, Caroline Woolf, Clarence Cummins, Karl Zimmerman, Catherine Bell, Adam Philips and the legendary Dewan Brothers, Ted and Brian.

In the comics world, special thanks go to Richard Howell, Mike Luce, Dave McKean, Rick Veitch, Don Simpson, Mike Bannon (technical support), Jim Woodring, and all of the wonderful clan at San Diego '92. Thanks also to the numerous professionals who have lent their support and endorsements to the project. I'm particularly indebted to Jim Valentino, Dave Sim and Keith Giffen who used their own books as a forum on my behalf. In the retail sector, my thanks to the generous members of the Direct Line Group, to the many stores which played host during our first tour and especially to the Mighty Moondog himself, Gary Colobuono. Thanks, as always, to Larry Marder, Nexus of All Comic Book Realities, for his tireless efforts on my behalf.

Thank you to the legion of journalists in print, radio and television who have been able to talk about this book without quoting sound effects from the old Batman TV show; especially Calvin Reid and the whole gang at PW.

Early influences on the ideas in this book are harder to trace, but no less important. Kurt Busiek introduced me to comics long ago and was my best guide for many years. Eclipse Editor-in-Chief cat yronwode helped shape my critical faculties over seven years on ZOT! and is one of the very few people in comics who really understood where I was coming from. Art Spiegelman, like Eisner, offered me a role-model for serious inquiry into comics as an art-form and, in his short comics-essay "Cracking Jokes," clarified comics' potential for non-fiction and made this book a possibility. Other important early influences include Syracuse professor Larry Bakke, Richard Howell and Carol Kalish.

My thanks to all the fine people at Tundra Publishing, Kitchen Sink Press and HarperCollins.

Without Kevin Eastman this book might have never seen the light of day. Thank you, Kevin.

Without Ian Ballantine, you wouldn't be holding it in your hands today. Thank you, Ian.

And without you, Ivy, it wouldn't have been much fun. I love you madly. Let's take tomorrow off.

Scott McCloud

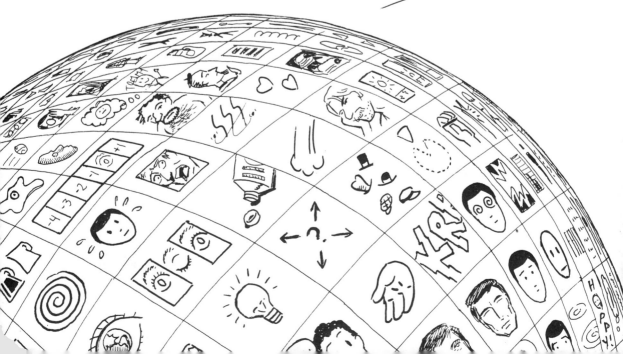

CONTENTS

 ## INTRODUCTION

INTRODUCTION

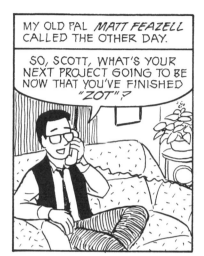

MY OLD PAL *MATT FEAZELL* CALLED THE OTHER DAY.

SO, SCOTT, WHAT'S YOUR NEXT PROJECT GOING TO BE NOW THAT YOU'VE FINISHED *"ZOT"?*

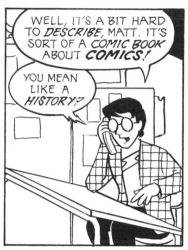

WELL, IT'S A BIT HARD TO *DESCRIBE,* MATT. IT'S SORT OF A *COMIC BOOK* ABOUT *COMICS!*

YOU MEAN LIKE A *HISTORY?*

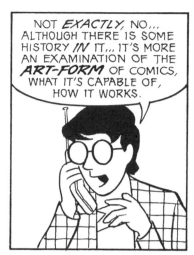

NOT *EXACTLY,* NO... ALTHOUGH THERE IS SOME HISTORY *IN* IT... IT'S MORE AN EXAMINATION OF THE *ART-FORM* OF COMICS, WHAT IT'S CAPABLE OF, HOW IT WORKS.

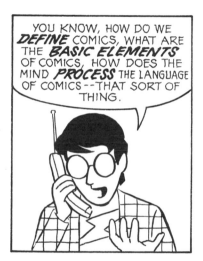

YOU KNOW, HOW DO WE *DEFINE* COMICS, WHAT ARE THE *BASIC ELEMENTS* OF COMICS, HOW DOES THE MIND *PROCESS* THE LANGUAGE OF COMICS--THAT SORT OF THING.

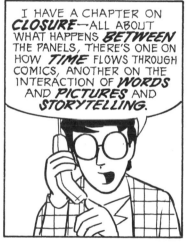

I HAVE A CHAPTER ON *CLOSURE*--ALL ABOUT WHAT HAPPENS *BETWEEN* THE PANELS, THERE'S ONE ON HOW *TIME* FLOWS THROUGH COMICS, ANOTHER ON THE INTERACTION OF *WORDS* AND *PICTURES* AND *STORYTELLING.*

I EVEN PUT TOGETHER A NEW *COMPREHENSIVE THEORY* OF THE *CREATIVE PROCESS* AND ITS IMPLICATIONS FOR COMICS AND FOR *ART IN GENERAL!!*

OH.

AREN'T YOU KIND OF *YOUNG* TO BE DOING THAT SORT OF THING?

UNDERSTANDING COMICS

CHAPTER ONE

SETTING THE RECORD STRAIGHT.

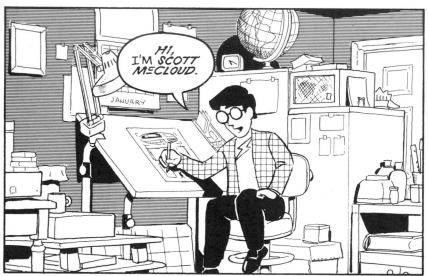

HI, I'M *SCOTT McCLOUD.*

JANUARY

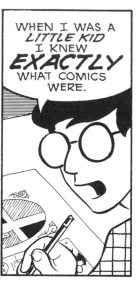

WHEN I WAS A *LITTLE KID* I KNEW *EXACTLY* WHAT COMICS WERE.

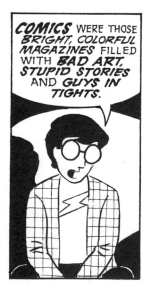

COMICS WERE THOSE *BRIGHT, COLORFUL MAGAZINES* FILLED WITH *BAD ART, STUPID STORIES* AND *GUYS IN TIGHTS.*

I READ *REAL* BOOKS, NATURALLY. I WAS MUCH TOO *OLD* FOR COMICS!

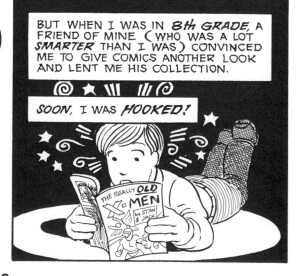

BUT WHEN I WAS IN *8th GRADE,* A FRIEND OF MINE (WHO WAS A LOT *SMARTER* THAN I WAS) CONVINCED ME TO GIVE COMICS ANOTHER LOOK AND LENT ME HIS COLLECTION.

SOON, I WAS HOOKED!

THE REALLY *OLD* X-MEN BY STAN & JACK

IN LESS THAN A *YEAR*, I BECAME *TOTALLY OBSESSED* WITH COMICS! I DECIDED TO BECOME A *COMICS ARTIST* IN *10th GRADE* AND BEGAN TO *PRACTICE, PRACTICE, PRACTICE!*

I FELT THAT THERE WAS SOMETHING *LURKING* IN COMICS... SOMETHING THAT HAD *NEVER BEEN DONE.*

SOME KIND OF *HIDDEN POWER!*

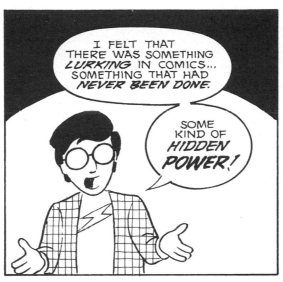

BUT WHENEVER I TRIED TO *EXPLAIN* MY FEELING, I FAILED *MISERABLY.*

COMIC BOOKS?! HA! HA! HA!

BUT IT-- BUT IT'S-- BUH...

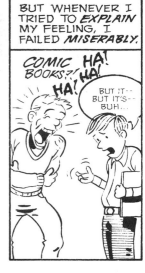

SURE, I REALIZED THAT COMIC BOOKS WERE USUALLY *CRUDE, POORLY-DRAWN, SEMILITERATE, CHEAP, DISPOSABLE KIDDIE FARE--*

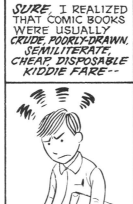

--*BUT*--

THEY DON'T *HAVE* TO BE!

THE *PROBLEM* WAS THAT FOR *MOST PEOPLE,* THAT WAS WHAT *"COMIC BOOK" MEANT!*

DON'T GIMME THAT *COMIC BOOK* TALK, BARNEY!

IF PEOPLE FAILED TO *UNDERSTAND* COMICS, IT WAS BECAUSE THEY DEFINED WHAT COMICS COULD BE *TOO NARROWLY!*

A *PROPER DEFINITION,* IF WE COULD *FIND* ONE, MIGHT GIVE *LIE* TO THE STEREOTYPES--

--AND SHOW THAT THE *POTENTIAL* OF COMICS IS *LIMITLESS* AND *EXCITING!*

THIS IS WHERE OUR JOURNEY *BEGINS.*

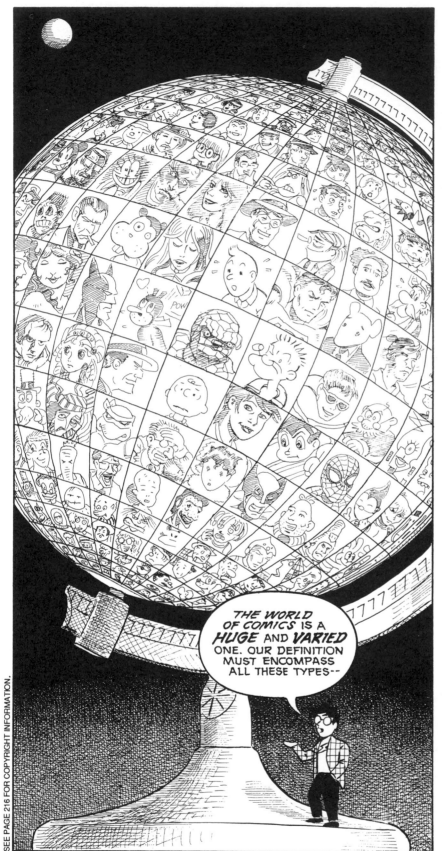

THE *WORLD* OF COMICS IS A *HUGE* AND *VARIED* ONE. OUR DEFINITION MUST ENCOMPASS ALL THESE TYPES--

--WHILE NOT BEING *SO* BROAD AS TO INCLUDE ANYTHING WHICH IS CLEARLY *NOT* COMICS.

"COMICS" IS THE WORD WORTH DEFINING, AS IT REFERS TO THE MEDIUM *ITSELF,* NOT A SPECIFIC *OBJECT* AS *"COMIC BOOK"* OR *"COMIC STRIP"* DO.

WE CAN ALL VISUALIZE *A* COMIC.

GENERIC GUY ™

BUT WHAT--

--IS--

--COMICS?

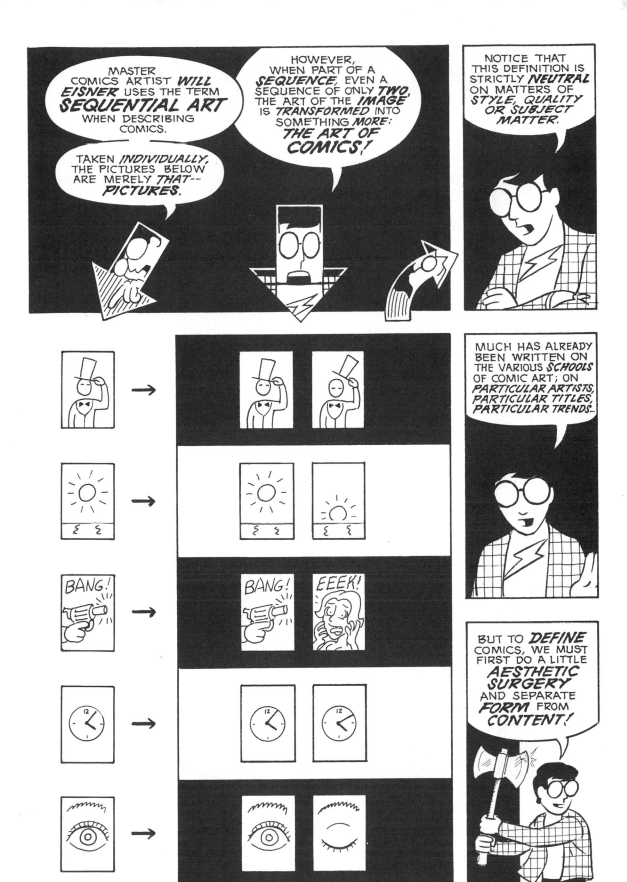

THE ARTFORM--THE *MEDIUM*--KNOWN AS COMICS IS A *VESSEL* WHICH CAN HOLD ANY *NUMBER* OF *IDEAS* AND *IMAGES*.

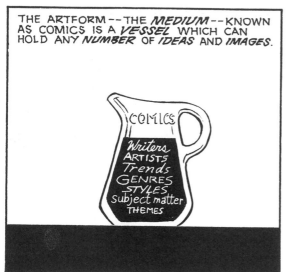

COMICS

Writers
ARTISTS
Trends
GENRES
STYLES
subject matter
THEMES

THE *"CONTENT"* OF THOSE IMAGES AND IDEAS IS, OF COURSE, UP TO *CREATORS,* AND WE ALL HAVE DIFFERENT *TASTES.*

=GLUG=

=GLUG=

PTUI!!!

=GAAK=

=WHEEEEZ=

=KAF! KAF!=

GLUGH·GGH...

=ahem=

THE *TRICK* IS TO NEVER MISTAKE THE *MESSAGE*--

--FOR THE *MESSENGER.*

COMICS

AT ONE TIME OR ANOTHER VIRTUALLY *ALL* THE GREAT MEDIA HAVE RECEIVED *CRITICAL EXAMINATION,* IN AND OF *THEMSELVES.*

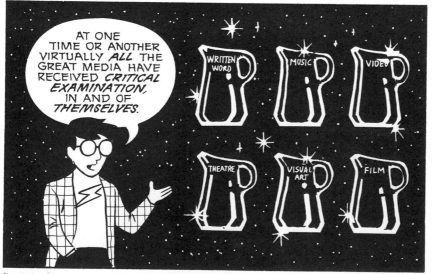

WRITTEN WORD

MUSIC

VIDEO

THEATRE

VISUAL ART

FILM

BUT FOR *COMICS,* THIS ATTENTION HAS BEEN *RARE.* *

LET'S SEE IF WE CAN HELP *RECTIFY* THE SITUATION.

*EISNER'S OWN *COMICS AND SEQUENTIAL ART* BEING A HAPPY EXCEPTION.

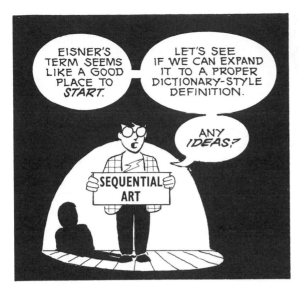

EISNER'S TERM SEEMS LIKE A GOOD PLACE TO *START.*

LET'S SEE IF WE CAN EXPAND IT TO A PROPER DICTIONARY-STYLE DEFINITION.

ANY *IDEAS?*

SEQUENTIAL ART

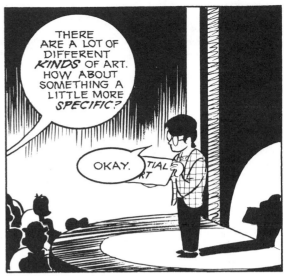

THERE ARE A LOT OF DIFFERENT *KINDS* OF ART. HOW ABOUT SOMETHING A LITTLE MORE *SPECIFIC?*

OKAY.

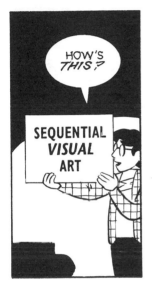

HOW'S *THIS?*

SEQUENTIAL VISUAL ART

HEY, WHAT ABOUT *ANIMATION?!*

BEG PARDON?

SEQUENTIAL VISUAL ART

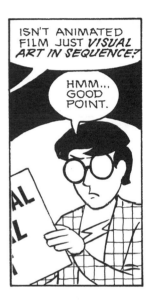

ISN'T ANIMATED FILM JUST *VISUAL ART IN SEQUENCE?*

HMM.., GOOD POINT.

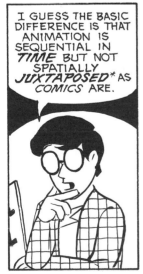

I GUESS THE BASIC DIFFERENCE IS THAT ANIMATION IS SEQUENTIAL IN *TIME* BUT NOT SPATIALLY *JUXTAPOSED** AS COMICS ARE.

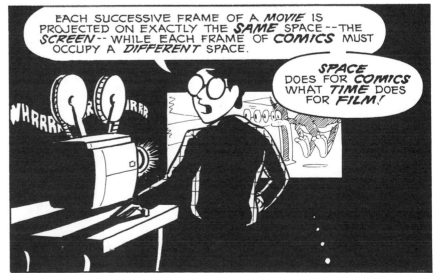

EACH SUCCESSIVE FRAME OF A *MOVIE* IS PROJECTED ON EXACTLY THE *SAME* SPACE -- THE *SCREEN* -- WHILE EACH FRAME OF *COMICS* MUST OCCUPY A *DIFFERENT* SPACE.

SPACE DOES FOR *COMICS* WHAT *TIME* DOES FOR *FILM!*

WHRRRRRRRRRRRRR

*JUXTAPOSED = ADJACENT, SIDE-BY-SIDE. GREAT ART SCHOOL WORD.

7

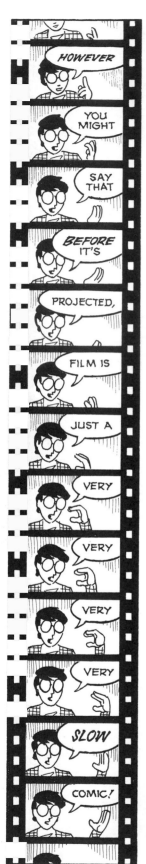
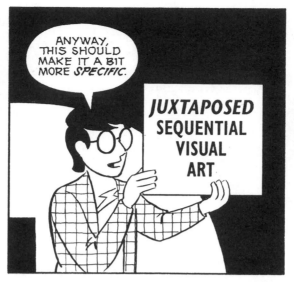
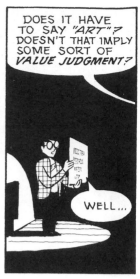
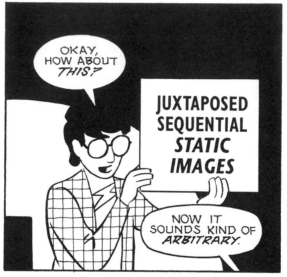
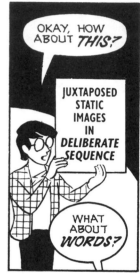
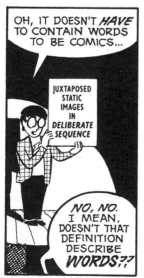
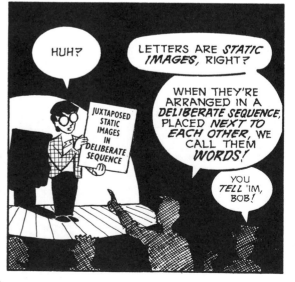

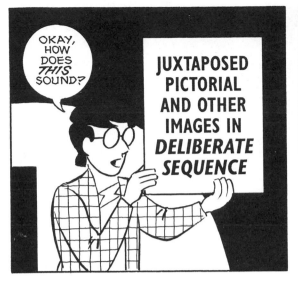

OKAY, HOW DOES *THIS* SOUND?

JUXTAPOSED PICTORIAL AND OTHER IMAGES IN *DELIBERATE SEQUENCE*

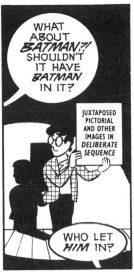

WHAT ABOUT *BATMAN?!* SHOULDN'T IT HAVE *BATMAN* IN IT?

JUXTAPOSED PICTORIAL AND OTHER IMAGES IN *DELIBERATE SEQUENCE*

WHO LET *HIM* IN?

NO, I *MEAN* IT! AND WHAT ABOUT THE *X-MEN* AND-- *OW!*--HEY! *HEY!* LET *GO* OF ME! *HEY!*

WELL, ANYWAY, THIS SHOULD DO FOR *NOW.*

WE'LL JUST *TYPE IT UP,* ADD A LITTLE BIT ON THE *USES* OF COMICS, AND--

tap tap tap tap tap

THERE!

adv.

com·ics (kom'iks)**n.** plural in form, used with a singular verb. **1.** Juxtaposed pictorial and other images in deliberate sequence, intended to convey information and/or to produce an aesthetic response in the viewer. **2.** Superheroes in bright colorful costumes, fighting dastardly villains who want to conquer the world, in violent sensational pulse-pounding action sequences! **3.** Cute, cuddly bunnies, mice and rolypoly bears, dancing to and fro, Hippity Hop, Hippity Hop. **4.** Corruptor of our Nation's Youth.

com·ing (kum'ing) **adj**

I ADMIT, THIS ISN'T THE SORT OF THING THAT COMES UP A LOT IN *CASUAL CONVERSATION--*

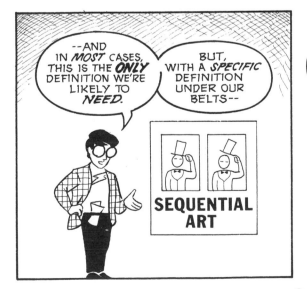

--AND IN *MOST* CASES, THIS IS THE *ONLY* DEFINITION WE'RE LIKELY TO *NEED.*

BUT, WITH A *SPECIFIC* DEFINITION UNDER OUR BELTS--

SEQUENTIAL ART

--PERHAPS WE CAN SHED SOME *NEW LIGHT* ON THE *HISTORY OF COMICS.*

MOST BOOKS *ABOUT* COMICS BEGIN SHORTLY BEFORE THE TURN OF THE CENTURY, BUT I THINK WE CAN VENTURE A BIT FARTHER THAN *THAT.*

1880 1890 1900 1910

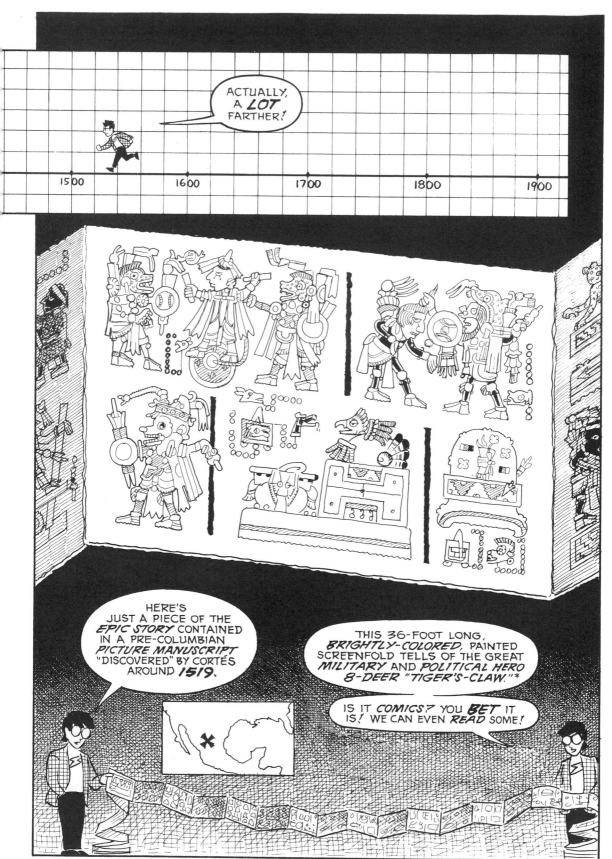

* OR "OCELOT'S CLAW" DEPENDING ON WHOSE BOOK YOU READ.
THIS SEQUENCE IS BASED ON A READING BY MEXICAN HISTORIAN
AND ARCHAEOLOGIST ALFONSO CASO.

FIRST, WE SEPARATE WORDS FROM *PICTURES*.

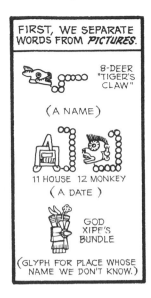

8-DEER "TIGER'S CLAW"

(A NAME)

11 HOUSE 12 MONKEY

(A DATE)

GOD XIPE'S BUNDLE

(GLYPH FOR PLACE WHOSE NAME WE DON'T KNOW.)

THEN *REVERSE* IT AND STRAIGHTEN IT OUT (THE ORIGINAL READ RIGHT-TO-LEFT AND *ZIGZAGGED*.) AND *BEGIN:*

THE YEAR: *1049 AD*
THE DATE: *MAY 3* *
THE PLACE: *HERE!*

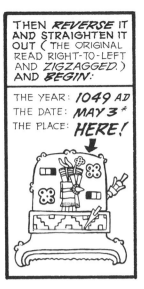

OUR HERO, *8-DEER "TIGER'S CLAW,"* CONQUERS THE PLACE AND CAPTURES THE *9-YEAR-OLD PRINCE, 4-WIND "SERPENT OF FIRE."*

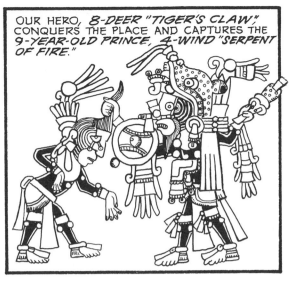

8-DEER ALSO CAPTURES THE PRINCE'S OLDER BROTHERS, *10-DOG "EAGLE COPAL BURNING"* AND *6-HOUSE "ROW OF FLINT KNIVES"* AND PUTS 'EM ON ICE.

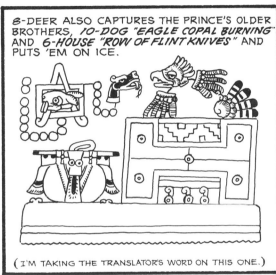

(I'M TAKING THE TRANSLATOR'S WORD ON THIS ONE.)

THE FOLLOWING YEAR, *8-DEER* AND (PROBABLY) HIS BROTHER, DISGUISED AS *TIGERS*, ENGAGE IN *SACRIFICIAL GLADIATORIAL COMBAT* WITH THE PRINCE, *10-DOG*, AND ANOTHER WARRIOR DISGUISED AS *DEATH*.

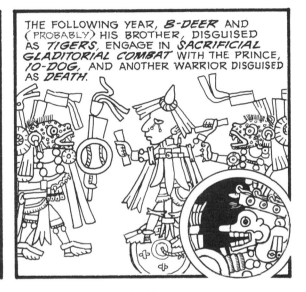

8-DEER KILLS THE OTHER PRINCE, *6-HOUSE "ROW OF FLINT KNIVES"* EIGHT DAYS LATER.

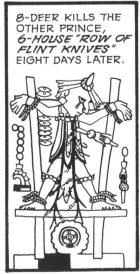

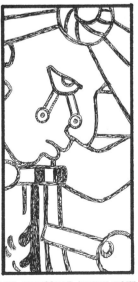

* WE KNOW THE YEAR; I'M JUST *GUESSING* AT THE DATE REPRESENTED BY "12 MONKEY"

11

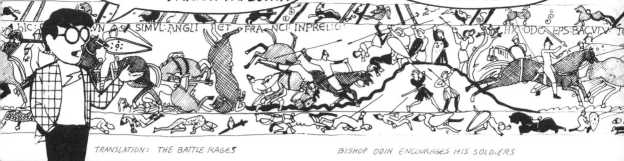

HUNDREDS OF YEARS BEFORE CORTÉS BEGAN COLLECTING COMICS, FRANCE PRODUCED THE *STRIKINGLY SIMILAR* WORK WE CALL THE *BAYEUX TAPESTRY.*

THIS 230 FOOT LONG TAPESTRY DETAILS THE *NORMAN CONQUEST* OF ENGLAND, BEGINNING IN *1066.*

TRANSLATION: THE BATTLE RAGES

BISHOP ODIN ENCOURAGES HIS SOLDIERS

FAR FROM *DISQUALIFYING* THESE AS COMICS, I THINK *MODERN* COMIC BOOK ARTISTS SHOULD *TAKE NOTE* OF THE *POSSIBILITIES* OF SUCH *WHOLE PAGE COMPOSITIONS* AND HOW *FEW* ARTISTS HAVE MADE GOOD USE OF THEM *SINCE!*

WHICH ONE IS THE *PRINCE?*

PERENNIAL EXCEPTION *WILL EISNER.*

LET'S CALL THE POLICE!

NO!

GIVE ME!

WHAT DO YOU WANT TO DO HERE, EH?

DO YOU THINK IF I REPORT THEM IT WILL BE THE END OF IT?

NO!! IT IS JUST THE BEGINNING!! ONLY A SOCIALIST REVOLUTION CAN STOP IT NOW!

WHAT, *NO HORSES?*

FINDING COMICS BEYOND OUR OWN *MILLENNIUM* IS A BIT *TRICKIER.*

0:00 11:00 12:00

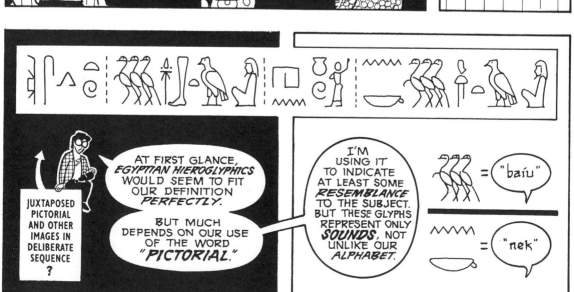

JUXTAPOSED PICTORIAL AND OTHER IMAGES IN DELIBERATE SEQUENCE ?

AT FIRST GLANCE, *EGYPTIAN HIEROGLYPHICS* WOULD SEEM TO FIT OUR DEFINITION *PERFECTLY.*

BUT MUCH DEPENDS ON OUR USE OF THE WORD "*PICTORIAL.*"

I'M USING IT TO INDICATE AT LEAST SOME *RESEMBLANCE* TO THE SUBJECT. BUT THESE GLYPHS REPRESENT ONLY *SOUNDS,* NOT UNLIKE OUR *ALPHABET.*

= "baíu"

= "nek"

12

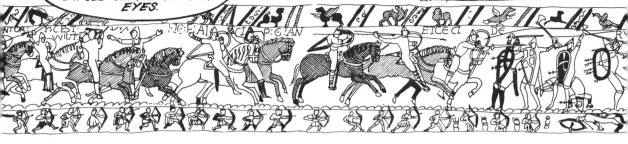

READING *LEFT TO RIGHT* WE SEE THE *EVENTS* OF THE CONQUEST, IN *DELIBERATE CHRONOLOGICAL ORDER* UNFOLD BEFORE OUR VERY *EYES.*

AS WITH THE *MEXICAN CODEX,* THERE ARE NO *PANEL BORDERS* PER SE, BUT THERE ARE CLEAR DIVISIONS OF SCENE BY *SUBJECT MATTER.*

DUKE WILLIAM REMOVES HIS HELMET TO RALLY HIS SOLDIERS

HAROLD'S ARMY IS CUT TO PIECES

THUS, THEIR *REAL* DESCENDENT IS *THE WRITTEN WORD* AND NOT COMICS.

"ses tu baíu abta, hennu-nek baíu amenta"

"FOLLOW THEE, THE SOULS OF THE EAST. PRAISE THEE, THE SOULS OF THE WEST."

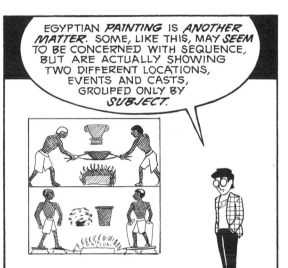

EGYPTIAN *PAINTING* IS *ANOTHER MATTER.* SOME, LIKE THIS, MAY *SEEM* TO BE CONCERNED WITH SEQUENCE, BUT ARE ACTUALLY SHOWING TWO DIFFERENT LOCATIONS, EVENTS AND CASTS, GROUPED ONLY BY *SUBJECT.*

I HAD BEEN TRYING TO FIND *SEQUENCE* IN EGYPTIAN PAINTINGS FOR *YEARS* WHEN I BEGAN THIS BOOK AND WAS READY TO CALL IT QUITS--

--UNTIL I DISCOVERED THAT THE BOOKS I HAD BEEN USING AS REFERENCE--

--HAD ONLY BEEN SHOWING ME *PART* OF THE PICTURE!

13

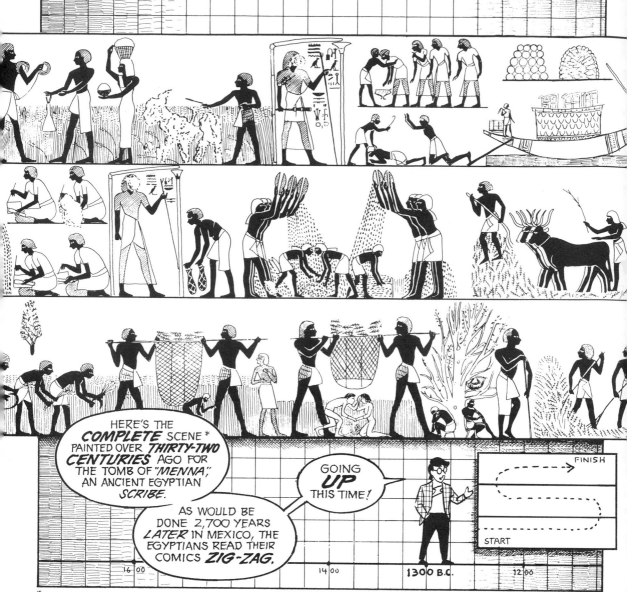

HERE'S THE *COMPLETE* SCENE * PAINTED OVER *THIRTY-TWO CENTURIES* AGO FOR THE TOMB OF *"MENNA,"* AN ANCIENT EGYPTIAN *SCRIBE.*

AS WOULD BE DONE 2,700 YEARS *LATER* IN MEXICO, THE EGYPTIANS READ THEIR COMICS *ZIG-ZAG.*

GOING *UP* THIS TIME!

FINISH

START

16|00 14|00 13|00 B.C. 12|00

* MORE *NEARLY* COMPLETE, ANYWAY.

STARTING AT THE *LOWER LEFT,* WE SEE THREE WORKERS REAPING WHEAT WITH THEIR SICKLES--

PAINTING TRACED FOR BLACK AND WHITE REPRODUCTION.

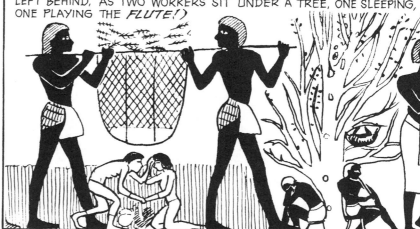

-- THEN CARRYING IT IN *BASKETS* TO A *THRESHING* LOCATION. (IN THE BACKGROUND TWO GIRLS FIGHT OVER BITS OF WHEAT LEFT BEHIND, AS TWO WORKERS SIT UNDER A TREE, ONE SLEEPING, ONE PLAYING THE *FLUTE!*)

14

THE SHEAVES ARE THEN *RAKED OUT* INTO A *THICK CARPET OF WHEAT.*

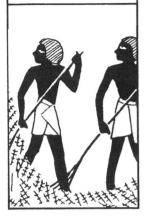

THEN OXEN TREAD *KERNELS* OUT OF THE HUSKS.

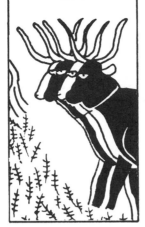

NEXT, PEASANTS SEPARATE THE WHEAT FROM THE CHAFF.

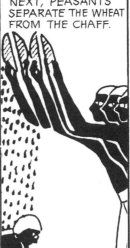

OLD MENNA HIMSELF LOOKS ON -- *

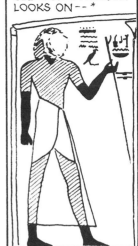

-- AS LOYAL SCRIBES RECORD THE YIELD ON THEIR TABLETS.

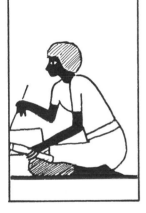

NOW AN OFFICIAL USES A MEASURING ROPE TO *SURVEY THE LAND* AND DECIDE HOW MUCH WHEAT IS OWED IN *TAXES.*

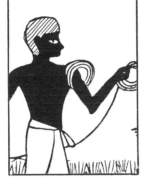

AND AS MENNA WATCHES, FARMERS *LATE* IN PAYING THEIR TAXES ARE *BEATEN.*

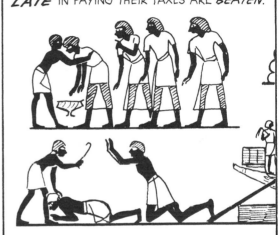

I'LL *GLADLY ADMIT* THAT I HAVE *NO IDEA* WHERE OR *WHEN* COMICS ORIGINATED. LET *OTHERS* WRESTLE WITH *THAT* ONE.

? B.C. ? A.D.

I'VE ONLY SCRATCHED THE *SURFACE* IN THIS CHAPTER... *TRAJAN'S COLUMN, GREEK PAINTING, JAPANESE SCROLLS*... ALL THESE HAVE BEEN SUGGESTED AND ALL SHOULD BE EXPLORED.

BUT THERE IS *ONE* EVENT WHICH LOOMS AS LARGE IN *COMICS* HISTORY AS IT DOES IN THE HISTORY OF THE *WRITTEN WORD.*

THE INVENTION OF PRINTING.

* FACE GOUGED OUT BY FUTURE GENERATIONS OF LEADERS

15

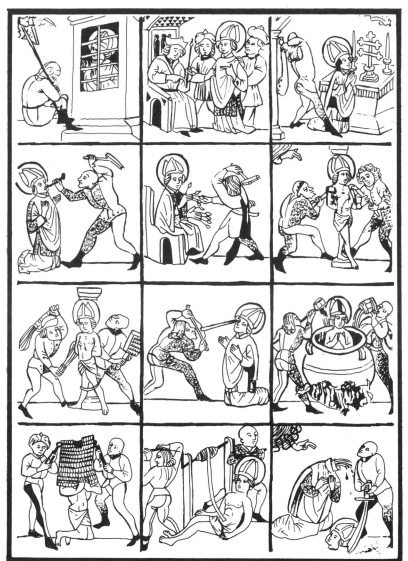

ART RESTORED FOR CLARITY -- OTHERWISE UNCHANGED.

WITH THE INVENTION OF PRINTING* THE ART-FORM WHICH HAD BEEN A DIVERSION OF THE *RICH* AND *POWERFUL* NOW COULD BE ENJOYED BY *EVERYONE!*

POPULAR TASTES HAVEN'T *CHANGED* MUCH IN *FIVE CENTURIES.* CHECK OUT *"THE TORTURES OF SAINT ERASMUS,"* CIRCA 1460. WORD HAS IT THIS GUY WAS A *VERY* POPULAR CHARACTER.

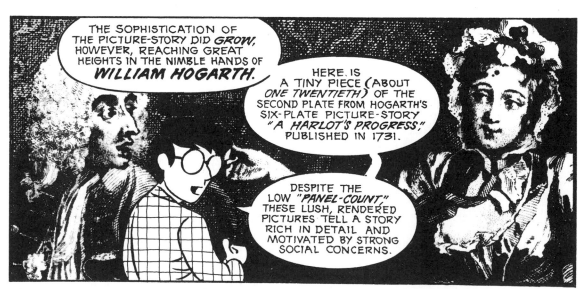

THE SOPHISTICATION OF THE PICTURE-STORY DID *GROW,* HOWEVER, REACHING GREAT HEIGHTS IN THE NIMBLE HANDS OF *WILLIAM HOGARTH.*

HERE IS A TINY PIECE (ABOUT *ONE TWENTIETH*) OF THE SECOND PLATE FROM HOGARTH'S SIX-PLATE PICTURE-STORY *"A HARLOT'S PROGRESS,"* PUBLISHED IN 1731.

DESPITE THE LOW *"PANEL-COUNT,"* THESE LUSH, RENDERED PICTURES TELL A STORY RICH IN DETAIL AND MOTIVATED BY STRONG SOCIAL CONCERNS.

16

* MAYBE I SHOULDN'T SAY "INVENT": EUROPEANS WERE A BIT LATE IN DISCOVERING PRINTING.

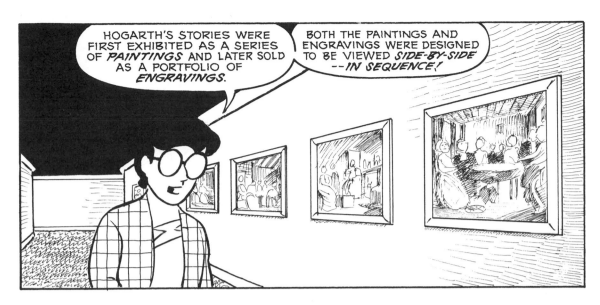

HOGARTH'S STORIES WERE FIRST EXHIBITED AS A SERIES OF *PAINTINGS* AND LATER SOLD AS A PORTFOLIO OF *ENGRAVINGS.*

BOTH THE PAINTINGS AND ENGRAVINGS WERE DESIGNED TO BE VIEWED *SIDE-BY-SIDE --IN SEQUENCE!*

"A HARLOT'S PROGRESS" AND ITS SEQUEL *"A RAKE'S PROGRESS"* PROVED SO POPULAR, NEW *COPYRIGHT LAWS* WERE CREATED TO PROTECT THIS NEW FORM.

GRRR!!

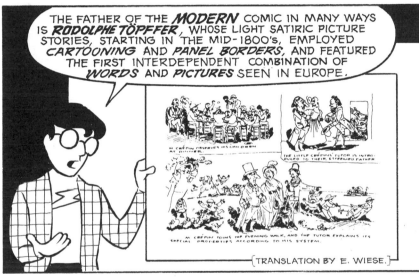

THE FATHER OF THE *MODERN* COMIC IN MANY WAYS IS *RODOLPHE TÖPFFER,* WHOSE LIGHT SATIRIC PICTURE STORIES, STARTING IN THE MID-1800'S, EMPLOYED *CARTOONING* AND *PANEL BORDERS,* AND FEATURED THE FIRST INTERDEPENDENT COMBINATION OF *WORDS* AND *PICTURES* SEEN IN EUROPE.

[TRANSLATION BY E. WIESE.]

UNFORTUNATELY, TÖPFFER HIMSELF FAILED TO GRASP AT FIRST THE FULL POTENTIAL OF HIS INVENTION, SEEING IT AS A MERE *DIVERSION,* A SIMPLE *HOBBY...*

"IF FOR THE FUTURE, HE [TÖPFFER] WOULD CHOOSE A LESS FRIVOLOUS SUBJECT AND RESTRICT HIMSELF A LITTLE, HE WOULD PRODUCE THINGS BEYOND ALL CONCEPTION."
-Goethe

EVEN SO, TÖPFFER'S CONTRIBUTION TO THE *UNDERSTANDING* OF COMICS IS CONSIDERABLE, IF ONLY FOR HIS REALIZATION THAT HE WHO WAS NEITHER ARTIST NOR WRITER--

-- HAD CREATED AND MASTERED A FORM WHICH WAS AT ONCE *BOTH* AND *NEITHER.*

A LANGUAGE ALL ITS OWN.

17

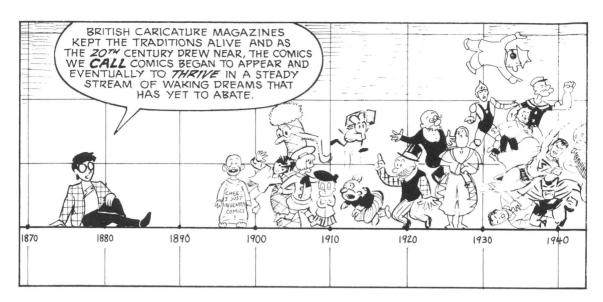

BRITISH CARICATURE MAGAZINES KEPT THE TRADITIONS ALIVE AND AS THE *20TH* CENTURY DREW NEAR, THE COMICS WE **CALL** COMICS BEGAN TO APPEAR AND EVENTUALLY TO *THRIVE* IN A STEADY STREAM OF WAKING DREAMS THAT HAS YET TO ABATE.

1870　1880　1890　1900　1910　1920　1930　1940

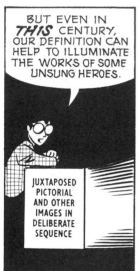

BUT EVEN IN **THIS** CENTURY, OUR DEFINITION CAN HELP TO ILLUMINATE THE WORKS OF SOME UNSUNG HEROES.

JUXTAPOSED PICTORIAL AND OTHER IMAGES IN DELIBERATE SEQUENCE

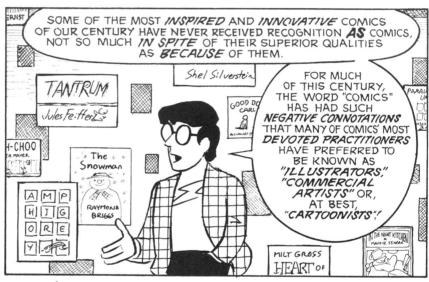

SOME OF THE MOST *INSPIRED* AND *INNOVATIVE* COMICS OF OUR CENTURY HAVE NEVER RECEIVED RECOGNITION **AS** COMICS, NOT SO MUCH *IN SPITE* OF THEIR SUPERIOR QUALITIES AS **BECAUSE** OF THEM.

FOR MUCH OF THIS CENTURY, THE WORD "COMICS" HAS HAD SUCH *NEGATIVE CONNOTATIONS* THAT MANY OF COMICS' MOST *DEVOTED PRACTITIONERS* HAVE PREFERRED TO BE KNOWN AS *"ILLUSTRATORS,"* *"COMMERCIAL ARTISTS"* OR, AT BEST, *"CARTOONISTS"!*

AND SO, COMICS' LOW SELF-ESTEEM IS *SELF-PERPETUATING!* THE HISTORICAL PERSPECTIVE NECESSARY TO *COUNTERACT* COMICS' NEGATIVE IMAGE IS OBSCURED **BY** THAT NEGATIVITY.

WOODCUT ARTIST *LYND WARD* IS ONE SUCH *MISSING LINK.* WARD'S SILENT *"WOODCUT NOVELS"* ARE POWERFUL MODERN FABLES, NOW *PRAISED* BY COMICS ARTISTS, BUT SELDOM RECOGNIZED **AS** COMICS.

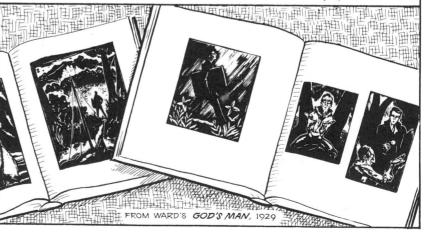

FROM WARD'S *GOD'S MAN,* 1929

18

ARTISTS LIKE WARD AND BELGIAN *FRANS MASEREEL* SAID MUCH THROUGH THEIR WOODCUTS ABOUT THE POTENTIAL OF COMICS, BUT FEW IN THE COMICS COMMUNITY OF THE DAY COULD *GET THE MESSAGE.*

THEIR *DEFINITION* OF COMICS, *THEN AS NOW,* WAS SIMPLY TOO *NARROW* TO INCLUDE SUCH WORK.

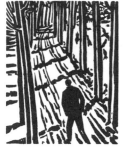

FROM FRANK MASEREEL'S *PASSIONATE JOURNEY,* 1919.

QUITE A *DIFFERENT* CASE IS MAX ERNST'S SURREAL *"COLLAGE NOVEL," A WEEK OF KINDNESS.*

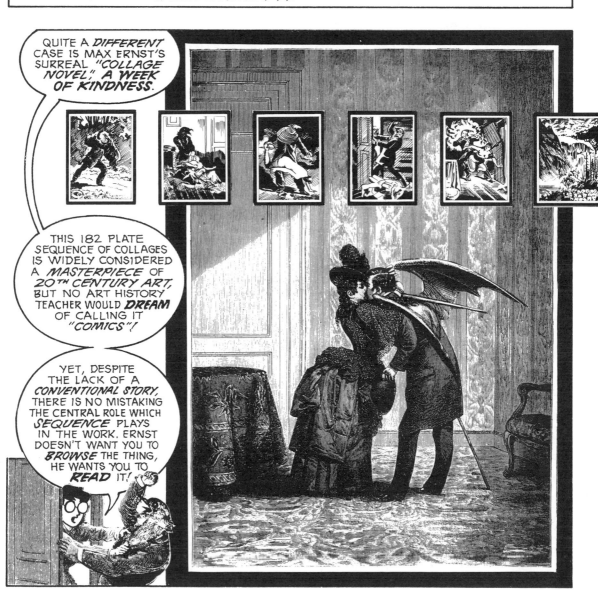

THIS 182 PLATE SEQUENCE OF COLLAGES IS WIDELY CONSIDERED A *MASTERPIECE* OF *20TH CENTURY ART,* BUT NO ART HISTORY TEACHER WOULD *DREAM* OF CALLING IT *"COMICS"!*

YET, DESPITE THE LACK OF A *CONVENTIONAL STORY,* THERE IS NO MISTAKING THE CENTRAL ROLE WHICH *SEQUENCE* PLAYS IN THE WORK. ERNST DOESN'T WANT YOU TO *BROWSE* THE THING, HE WANTS YOU TO *READ* IT!

19

IF WE DON'T EXCLUDE *PHOTOGRAPHY* FROM OUR DEFINITION, THEN HALF OF *AMERICA* HAS BEEN IN COMICS AT ONE TIME OR ANOTHER.

IN *SOME* COUNTRIES, PHOTO-COMICS ARE, IN FACT, QUITE *POPULAR.*

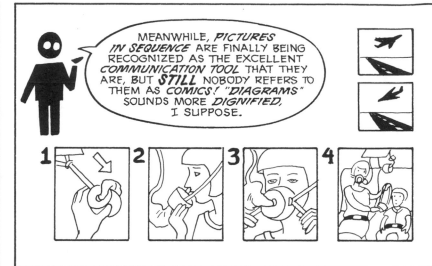

MEANWHILE, *PICTURES IN SEQUENCE* ARE FINALLY BEING RECOGNIZED AS THE EXCELLENT *COMMUNICATION TOOL* THAT THEY ARE, BUT *STILL* NOBODY REFERS TO THEM AS *COMICS!* *"DIAGRAMS"* SOUNDS MORE *DIGNIFIED,* I SUPPOSE.

1 **2** **3** **4**

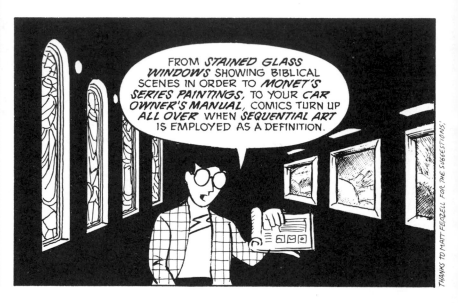

FROM *STAINED GLASS WINDOWS* SHOWING BIBLICAL SCENES IN ORDER TO *MONET'S SERIES PAINTINGS,* TO YOUR *CAR OWNER'S MANUAL,* COMICS TURN UP *ALL OVER* WHEN *SEQUENTIAL ART* IS EMPLOYED AS A DEFINITION.

THANKS TO MATT FEAZELL FOR THE SUGGESTIONS.

com·ics (kom'iks)**n.** plural in form, used with a singular verb. **1.** Juxtaposed pictorial and other images in deliberate sequence, intended to convey information and/or to produce an aesthetic response in the viewer.

FOR ALL THE DOORS THAT OUR DEFINITION *OPENS,* THERE IS ONE WHICH IT *CLOSES.*

SINGLE PANELS LIKE *THIS* ONE ARE OFTEN *LUMPED IN* WITH COMICS, YET THERE'S NO SUCH THING AS A SEQUENCE OF *ONE!*

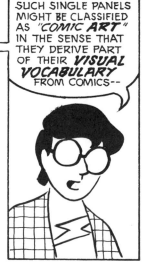

"Mommy, why ain't I Juxtaposed?"

SUCH SINGLE PANELS MIGHT BE CLASSIFIED AS *"COMIC ART"* IN THE SENSE THAT THEY DERIVE PART OF THEIR *VISUAL VOCABULARY* FROM COMICS--

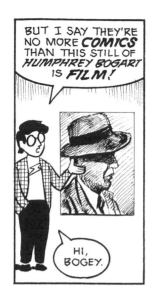

BUT I SAY THEY'RE NO MORE *COMICS* THAN THIS STILL OF *HUMPHREY BOGART* IS *FILM!*

HI, BOGEY.

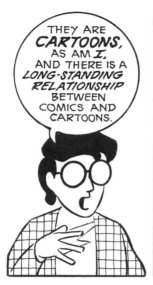

THEY ARE *CARTOONS,* AS AM *I,* AND THERE IS A *LONG-STANDING RELATIONSHIP* BETWEEN COMICS AND CARTOONS.

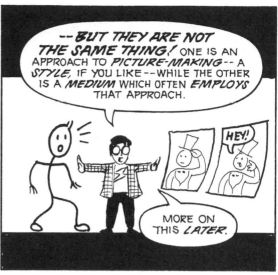

--BUT THEY ARE NOT *THE SAME THING!* ONE IS AN APPROACH TO *PICTURE-MAKING* -- A *STYLE,* IF YOU LIKE --WHILE THE OTHER IS A *MEDIUM* WHICH OFTEN *EMPLOYS* THAT APPROACH.

HEY!

MORE ON THIS *LATER.*

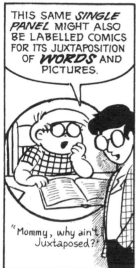

THIS SAME *SINGLE PANEL* MIGHT ALSO BE LABELLED COMICS FOR ITS JUXTAPOSITION OF *WORDS* AND PICTURES.

"Mommy, why ain't Juxtaposed?"

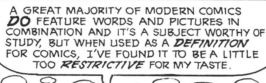

A GREAT MAJORITY OF MODERN COMICS *DO* FEATURE WORDS AND PICTURES IN COMBINATION AND IT'S A SUBJECT WORTHY OF STUDY, BUT WHEN USED AS A *DEFINITION* FOR COMICS, I'VE FOUND IT TO BE A LITTLE TOO *RESTRICTIVE* FOR MY TASTE.

OF COURSE, IF ANYONE WANTS TO WRITE A BOOK TAKING THE *OPPOSITE* VIEW, YOU CAN BET I'LL BE THE FIRST IN LINE TO *BUY* A COPY!

IF COMICS' SPECTACULARLY VARIED *PAST* IS ANY INDICATION, COMICS' *FUTURE* WILL BE VIRTUALLY *IMPOSSIBLE* TO PREDICT USING THE STANDARDS OF THE *PRESENT.*

BUT OUR DEFINITION CAN OFFER US SOME *CLUES.*

1980 1990 2000 2010 2020 2030 2040

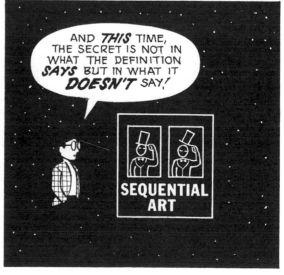

AND *THIS* TIME, THE SECRET IS NOT IN WHAT THE DEFINITION *SAYS* BUT IN WHAT IT *DOESN'T* SAY!

SEQUENTIAL ART

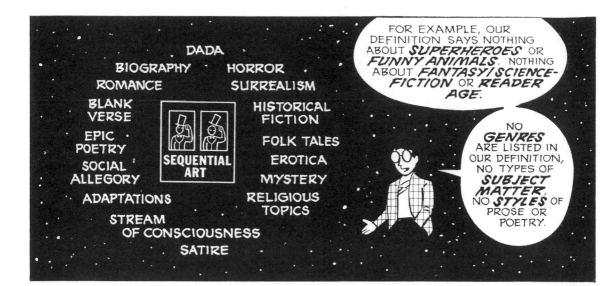

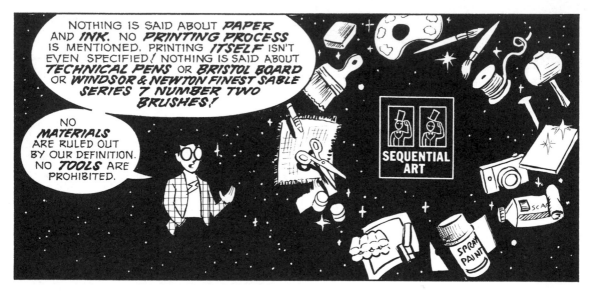

THOSE OF YOU WHO *MAKE* COMICS FOR A LIVING -- OR WOULD *LIKE* TO, SOMEDAY -- PROBABLY KNOW THAT KEEPING UP WITH ALL THE *ADVANCES* IN TODAY'S COMICS IS A *FULL-TIME JOB.*

THERE ARE SO MANY COMICS IN PRINT TODAY THAT IT WOULD TAKE AN *ARMY* OF READERS TO STUDY THEM ALL.

HOWEVER MUCH WE MAY TRY TO *UNDERSTAND* THE WORLD OF COMICS AROUND US, A *PART* OF THAT WORLD WILL ALWAYS LIE IN SHADOW -- A *MYSTERY.*

I'LL DO MY *BEST* IN THE FOLLOWING CHAPTERS TO *SHED LIGHT* ON THAT UNSEEN SIDE, BUT AS WE FOCUS ON THE WORLD OF COMICS *AS IT IS,* IT SHOULD BE KEPT IN MIND AT *ALL* TIMES THAT THIS WORLD IS ONLY *ONE* --

-- OF MANY *POSSIBLE* WORLDS!

OUR ATTEMPTS TO *DEFINE* COMICS ARE AN *ON-GOING PROCESS* WHICH WON'T END ANYTIME SOON.

A *NEW* GENERATION WILL NO DOUBT *REJECT* WHATEVER THIS ONE FINALLY DECIDES TO ACCEPT AND TRY ONCE MORE TO *RE-INVENT* COMICS.

AND SO THEY SHOULD.

HERE'S TO THE *GREAT DEBATE!*

CHAPTER TWO

THE VOCABULARY OF COMICS.

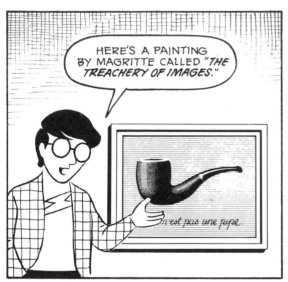

HERE'S A PAINTING BY MAGRITTE CALLED *"THE TREACHERY OF IMAGES."*

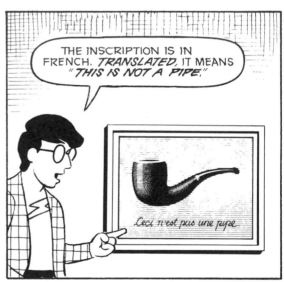

THE INSCRIPTION IS IN FRENCH. *TRANSLATED,* IT MEANS *"THIS IS NOT A PIPE."*

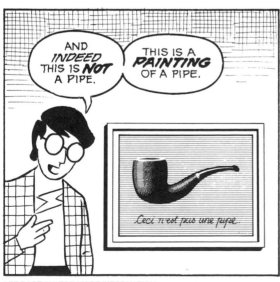

AND *INDEED* THIS IS *NOT* A PIPE.

THIS IS A *PAINTING* OF A PIPE.

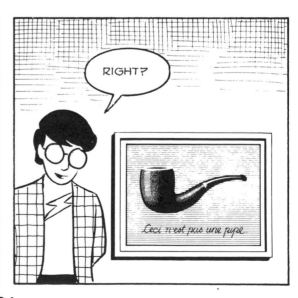

RIGHT?

SEE PAGE 216 FOR MORE INFORMATION.

24

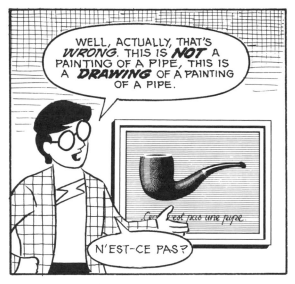

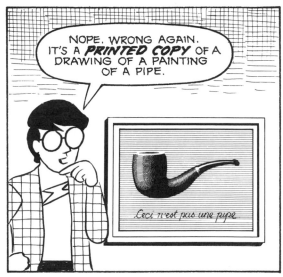

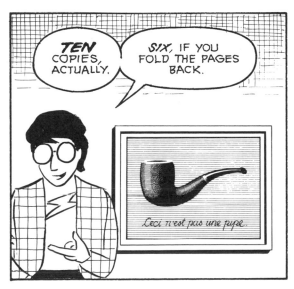

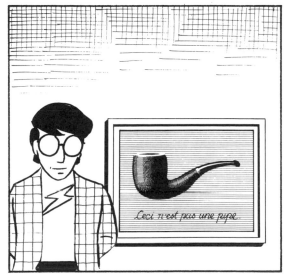

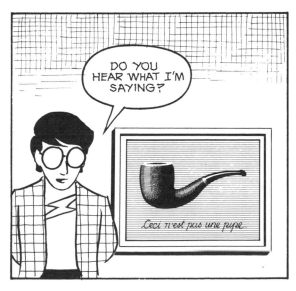

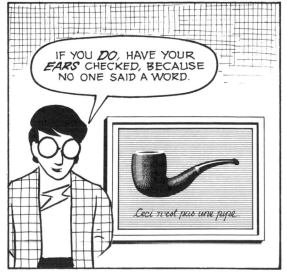

25

THIS IS NOT A MAN.

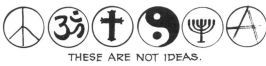

THESE ARE NOT IDEAS.

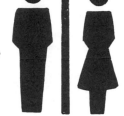

THESE ARE NOT PEOPLE

THIS IS NOT A COUNTRY.

THIS IS NOT
A LEAF

THIS IS NOT MUSIC.

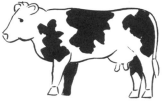

THIS IS NOT A COW.

WELCOME TO THE *STRANGE* AND *WONDERFUL* *WORLD* OF THE *ICON!*

THIS IS NOT MY VOICE.

THIS IS NOT SOUND.

THESE ARE NOT FLOWERS.

THIS IS NOT ME.

THIS IS NOT LAW.

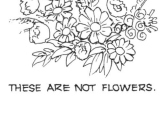

THIS IS NOT A PLANET.

THIS IS NOT FOOD.

THIS IS NOT A CAR.

THIS IS NOT A
COMPANY.

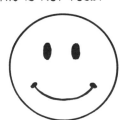

THIS IS NOT A
FACE.

THESE ARE NOT SEPARATE
MOMENTS.

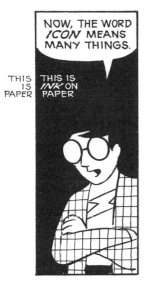

NOW, THE WORD *ICON* MEANS MANY THINGS.

THIS IS PAPER

THIS IS *INK* ON PAPER

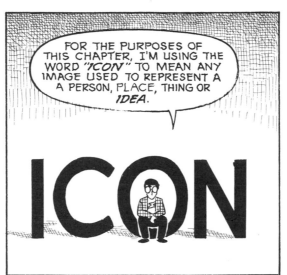

FOR THE PURPOSES OF THIS CHAPTER, I'M USING THE WORD *"ICON"* TO MEAN ANY IMAGE USED TO REPRESENT A A PERSON, PLACE, THING OR *IDEA*.

ICON

THAT'S A BIT BROADER THAN THE DEFINITION IN MY DICTIONARY, BUT IT'S THE CLOSEST THING TO WHAT I NEED HERE.

"SYMBOL" IS A BIT TOO *LOADED* FOR ME.

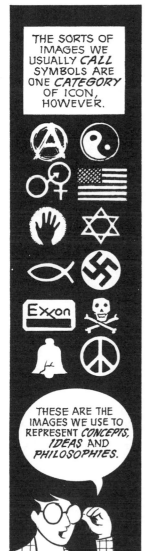

THE SORTS OF IMAGES WE USUALLY CALL SYMBOLS ARE ONE *CATEGORY* OF ICON, HOWEVER.

THESE ARE THE IMAGES WE USE TO REPRESENT *CONCEPTS, IDEAS* AND *PHILOSOPHIES*.

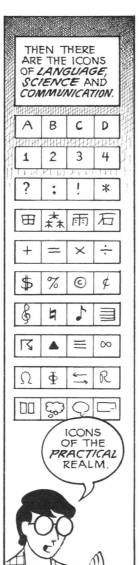

THEN THERE ARE THE ICONS OF *LANGUAGE, SCIENCE* AND *COMMUNICATION*.

A	B	C	D
1	2	3	4
?	:	!	*
田	森	雨	石
+	=	×	÷
$	%	©	¢

ICONS OF THE *PRACTICAL* REALM.

AND FINALLY, THE ICONS WE CALL *PICTURES:* IMAGES DESIGNED TO ACTUALLY *RESEMBLE* THEIR SUBJECTS.

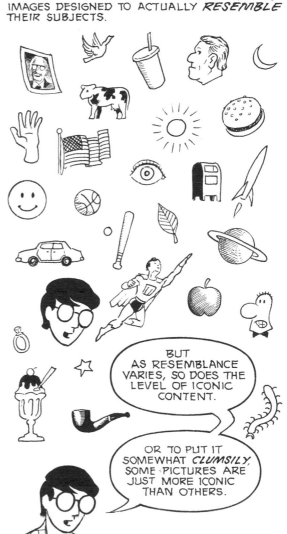

BUT AS RESEMBLANCE VARIES, SO DOES THE LEVEL OF ICONIC CONTENT.

OR TO PUT IT SOMEWHAT *CLUMSILY,* SOME PICTURES ARE JUST MORE ICONIC THAN OTHERS.

IN THE *NON-PICTORIAL* ICONS, MEANING IS *FIXED* AND *ABSOLUTE*. THEIR APPEARANCE DOESN'T AFFECT THEIR MEANING BECAUSE THEY REPRESENT *INVISIBLE IDEAS*.

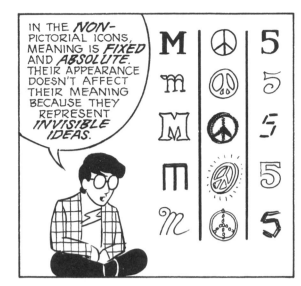

IN *PICTURES*, HOWEVER, MEANING IS *FLUID* AND *VARIABLE* ACCORDING TO APPEARANCE. THEY DIFFER FROM *"REAL-LIFE"* APPEARANCE TO VARYING *DEGREES*.

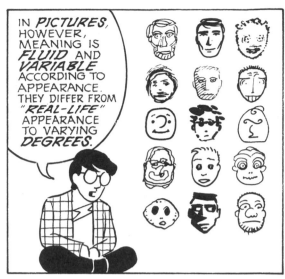

WORDS ARE TOTALLY *ABSTRACT* ICONS. THAT IS, THEY BEAR NO RESEMBLANCE AT ALL TO THE *REAL McCOY*.

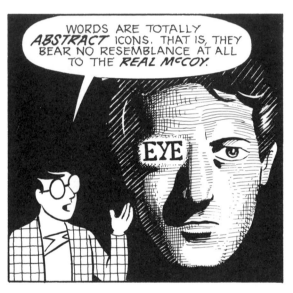

EYE

BUT IN PICTURES THE *LEVEL* OF ABSTRACTION *VARIES*. SOME, LIKE THE FACE IN THE *PREVIOUS* PANEL, SO CLOSELY RESEMBLE THEIR *REAL-LIFE COUNTERPARTS* AS TO ALMOST *TRICK THE EYE!*

OTHERS, LIKE YOURS TRULY, ARE QUITE A BIT *MORE* ABSTRACT AND, IN FACT, ARE VERY MUCH *UNLIKE* ANY HUMAN FACE YOU'VE EVER SEEN!

LET'S SEE IF WE CAN PUT THESE *PICTORIAL ICONS* IN SOME SORT OF ORDER.

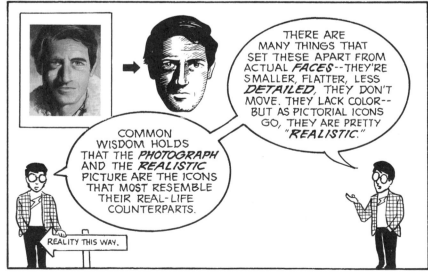

THERE ARE MANY THINGS THAT SET THESE APART FROM ACTUAL *FACES*--THEY'RE SMALLER, FLATTER, LESS *DETAILED*, THEY DON'T MOVE. THEY LACK COLOR--BUT AS PICTORIAL ICONS GO, THEY ARE PRETTY *"REALISTIC."*

COMMON WISDOM HOLDS THAT THE *PHOTOGRAPH* AND THE *REALISTIC* PICTURE ARE THE ICONS THAT MOST RESEMBLE THEIR REAL-LIFE COUNTERPARTS.

REALITY THIS WAY.

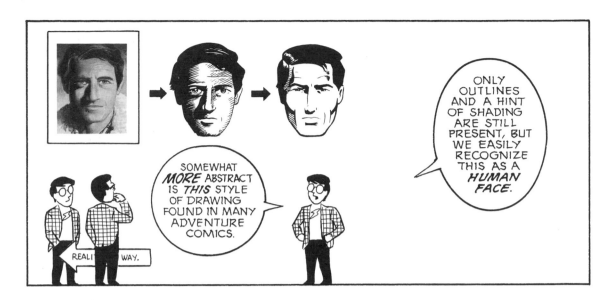

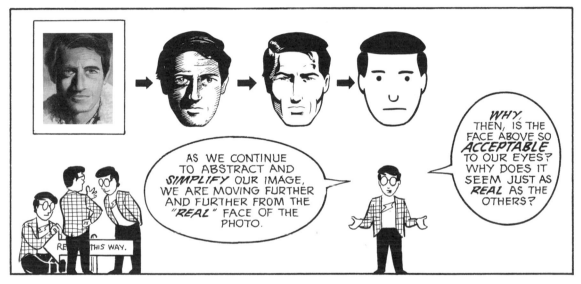

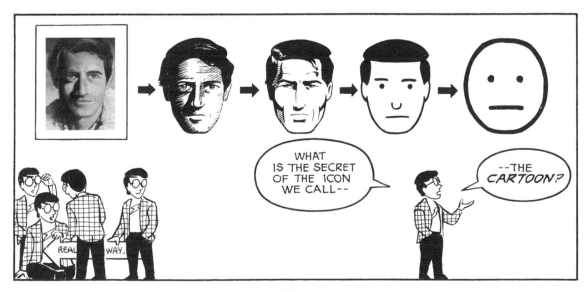

29

WHY-- --ARE-- --WE-- --SO-- --INVOLVED?

WHY WOULD *ANYONE*, YOUNG OR OLD, RESPOND TO A CARTOON AS MUCH OR MORE THAN A *REALISTIC IMAGE?*

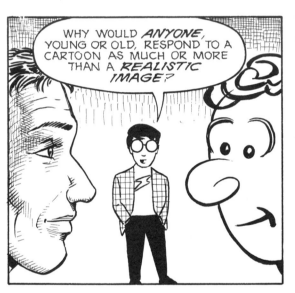

WHY IS OUR CULTURE *SO IN THRALL* TO THE *SIMPLIFIED REALITY* OF THE *CARTOON?*

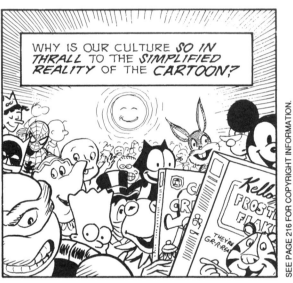

THEY'RE GR-R-R-REAT!

DEFINING THE CARTOON WOULD TAKE UP AS MUCH SPACE AS DEFINING *COMICS*, BUT FOR *NOW*, I'M GOING TO EXAMINE CARTOONING AS A FORM OF *AMPLIFICATION THROUGH SIMPLIFICATION.*

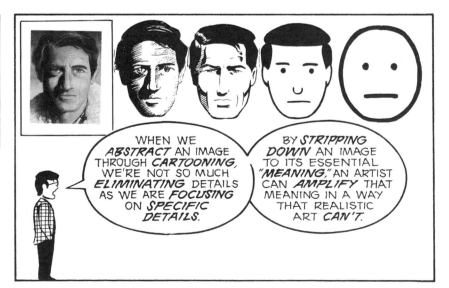

WHEN WE *ABSTRACT* AN IMAGE THROUGH *CARTOONING*, WE'RE NOT SO MUCH *ELIMINATING* DETAILS AS WE ARE *FOCUSING* ON *SPECIFIC DETAILS.*

BY *STRIPPING DOWN* AN IMAGE TO ITS ESSENTIAL *"MEANING,"* AN ARTIST CAN *AMPLIFY* THAT MEANING IN A WAY THAT REALISTIC ART *CAN'T.*

FILM CRITICS WILL SOMETIMES DESCRIBE A *LIVE-ACTION* FILM AS A "CARTOON" TO ACKNOWLEDGE THE STRIPPED-DOWN *INTENSITY* OF A SIMPLE STORY OR VISUAL STYLE.

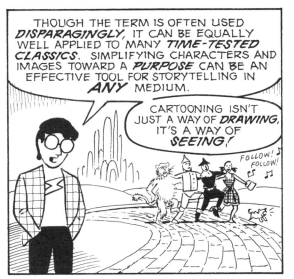

THOUGH THE TERM IS OFTEN USED *DISPARAGINGLY*, IT CAN BE EQUALLY WELL APPLIED TO MANY *TIME-TESTED CLASSICS*. SIMPLIFYING CHARACTERS AND IMAGES TOWARD A *PURPOSE* CAN BE AN EFFECTIVE TOOL FOR STORYTELLING IN *ANY* MEDIUM.

CARTOONING ISN'T JUST A WAY OF *DRAWING*, IT'S A WAY OF *SEEING!*

FOLLOW! FOLLOW!

THE ABILITY OF CARTOONS TO *FOCUS* OUR ATTENTION ON AN IDEA IS, I THINK, AN IMPORTANT PART OF THEIR SPECIAL POWER, BOTH IN COMICS AND IN DRAWING GENERALLY.

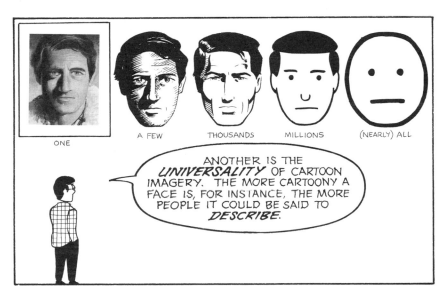

ONE A FEW THOUSANDS MILLIONS (NEARLY) ALL

ANOTHER IS THE *UNIVERSALITY* OF CARTOON IMAGERY. THE MORE CARTOONY A FACE IS, FOR INSTANCE, THE MORE PEOPLE IT COULD BE SAID TO *DESCRIBE*.

BUT I BELIEVE THERE'S SOMETHING *MORE* AT WORK IN OUR MINDS WHEN WE VIEW A CARTOON--ESPECIALLY OF A HUMAN FACE-- WHICH WARRANTS FURTHER INVESTIGATION.

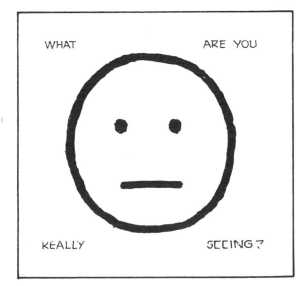

WHAT ARE YOU

REALLY SEEING?

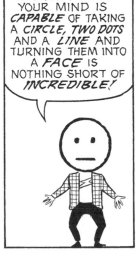

THE FACT THAT YOUR MIND IS *CAPABLE* OF TAKING A *CIRCLE, TWO DOTS* AND A *LINE* AND TURNING THEM INTO A *FACE* IS NOTHING SHORT OF *INCREDIBLE!*

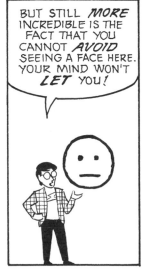

BUT STILL *MORE* INCREDIBLE IS THE FACT THAT YOU CANNOT *AVOID* SEEING A FACE HERE. YOUR MIND WON'T *LET* YOU!

ASK A FRIEND TO DRAW YOU SOME SHAPES ON A PIECE OF PAPER. THEY SHOULD BE *CLOSED CURVES*, BUT OTHER- WISE CAN BE AS *WEIRD* AND *IRREGULAR* AS HE OR SHE *WANTS*.

LET'S SAY THE RESULTS LOOK SOMETHING LIKE *THIS*.

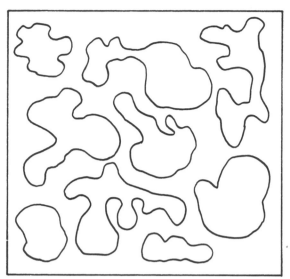

NOW-- YOU'LL FIND THAT NO MATTER WHAT THEY *LOOK* LIKE, EVERY SINGLE *ONE* OF THOSE SHAPES *CAN* BE MADE INTO A FACE WITH ONE SIMPLE ADDITION.

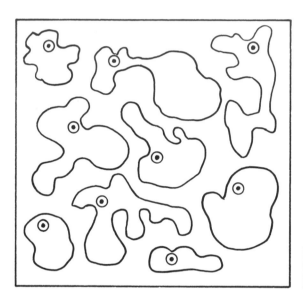

YOUR MIND HAS NO TROUBLE AT ALL CONVERTING SUCH SHAPES INTO FACES, YET WOULD IT EVER MISTAKE *THIS*--

--FOR *THIS?*

WE HUMANS ARE A SELF-CENTERED RACE.

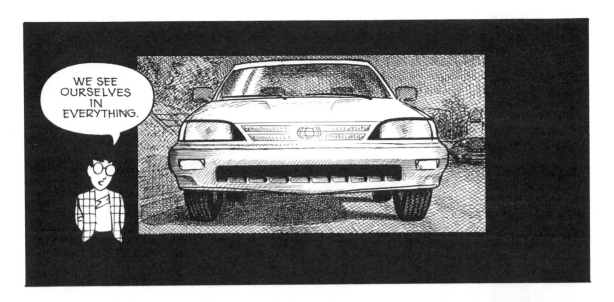

WE SEE OURSELVES IN EVERYTHING.

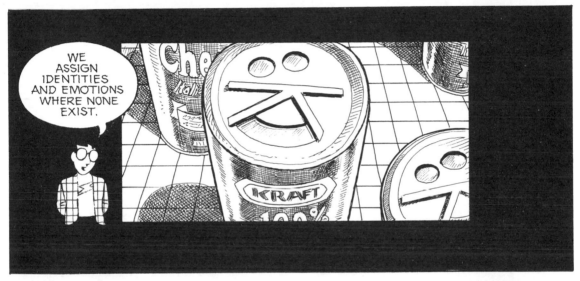

WE ASSIGN IDENTITIES AND EMOTIONS WHERE NONE EXIST.

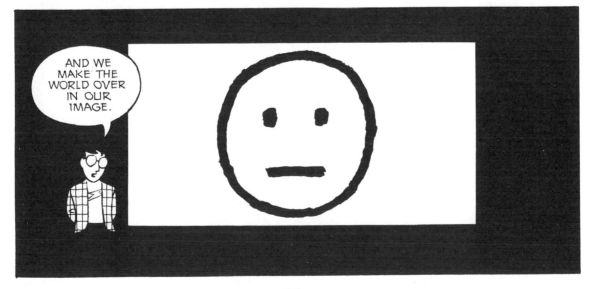

AND WE MAKE THE WORLD OVER IN OUR IMAGE.

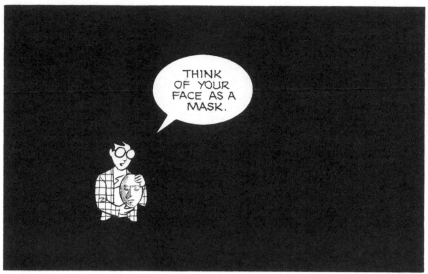

THINK OF YOUR FACE AS A MASK.

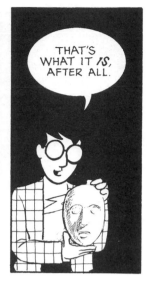

THAT'S WHAT IT *IS*, AFTER ALL.

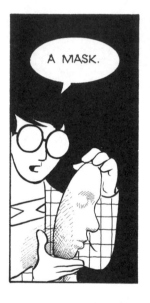

A MASK.

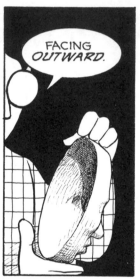

FACING *OUTWARD*.

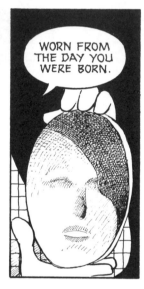

WORN FROM THE DAY YOU WERE BORN.

SLAVE TO YOUR EVERY MENTAL COMMAND.

SEEN BY EVERYONE YOU MEET.

BUT NEVER BY *YOU.*

OPEN ITS EYES NOW.

JUST *THINK* IT. THE MASK WILL OBEY.

34

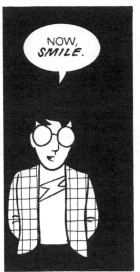

ALL SET? GOOD.

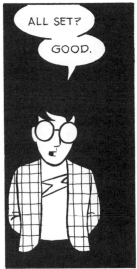

NOW, *SMILE.*

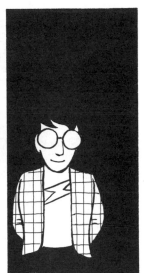

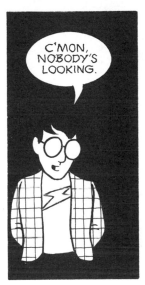

C'MON, NOBODY'S LOOKING.

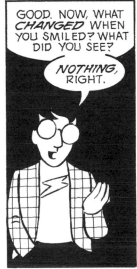

GOOD. NOW, WHAT *CHANGED* WHEN YOU SMILED? WHAT DID YOU SEE?

NOTHING, RIGHT.

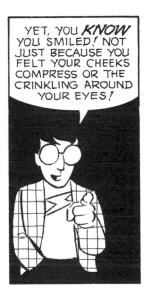

YET, YOU *KNOW* YOU SMILED! NOT JUST BECAUSE YOU FELT YOUR CHEEKS COMPRESS OR THE CRINKLING AROUND YOUR EYES!

YOU *KNOW* YOU SMILED BECAUSE YOU TRUSTED THIS MASK CALLED YOUR FACE TO *RESPOND!*

BUT THE FACE YOU SEE IN YOUR *MIND* IS NOT THE SAME AS *OTHERS'* SEE!

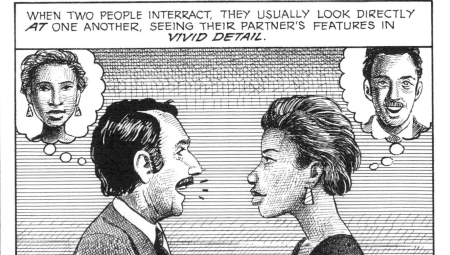

WHEN TWO PEOPLE INTERACT, THEY USUALLY LOOK DIRECTLY *AT* ONE ANOTHER, SEEING THEIR PARTNER'S FEATURES IN *VIVID DETAIL.*

35

EACH ONE *ALSO* SUSTAINS A CONSTANT AWARENESS OF HIS OR HER *OWN* FACE, BUT *THIS* MIND-PICTURE IS NOT NEARLY SO VIVID; JUST A SKETCHY ARRANGEMENT... A SENSE OF SHAPE... A SENSE OF *GENERAL PLACEMENT.*

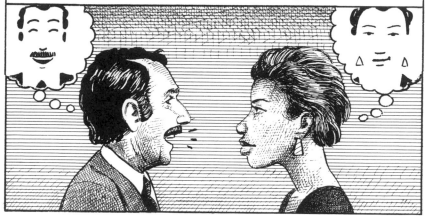

SOMETHING AS *SIMPLE* AND AS *BASIC* --

--AS A *CARTOON.*

THUS, WHEN YOU LOOK AT A PHOTO OR REALISTIC DRAWING OF A FACE--

--YOU SEE IT AS THE FACE OF *ANOTHER.*

BUT WHEN YOU ENTER THE WORLD OF THE *CARTOON*--

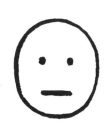

-- YOU SEE *YOURSELF.*

I BELIEVE THIS IS THE *PRIMARY CAUSE* OF OUR CHILDHOOD FASCINATION WITH *CARTOONS,* THOUGH OTHER FACTORS SUCH AS *UNIVERSAL IDENTIFICATION, SIMPLICITY* AND THE *CHILDLIKE FEATURES* OF MANY CARTOON CHARACTERS ALSO PLAY A PART.

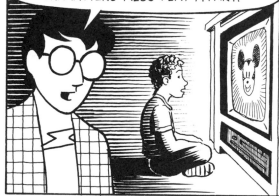

THE CARTOON IS A *VACUUM* INTO WHICH OUR *IDENTITY* AND *AWARENESS* ARE *PULLED...*

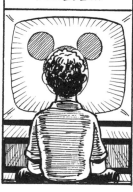

...AN *EMPTY SHELL* THAT WE INHABIT WHICH *ENABLES* US TO TRAVEL IN *ANOTHER REALM.*

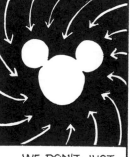

WE DON'T JUST *OBSERVE* THE CARTOON, WE *BECOME* IT!

THAT'S WHY I DECIDED TO *DRAW* MYSELF IN SUCH A SIMPLE *STYLE.*

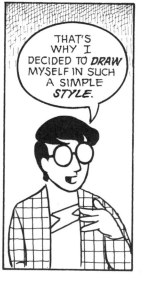

WOULD YOU HAVE *LISTENED* TO ME IF I LOOKED LIKE *THIS*??

I **DOUBT** IT! YOU WOULD HAVE BEEN FAR TOO AWARE OF THE **MESSENGER** TO FULLY RECEIVE THE **MESSAGE!**

APART FROM WHAT LITTLE I TOLD YOU ABOUT MYSELF IN **CHAPTER ONE**, I'M PRACTICALLY A **BLANK SLATE!**

IT WOULD NEVER EVEN **OCCUR** TO YOU TO WONDER WHAT MY **POLITICS** ARE, OR WHAT I HAD FOR **LUNCH** OR WHERE I GOT THIS **SILLY OUTFIT!**

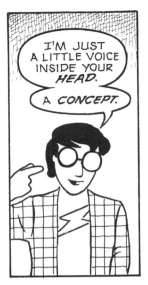

I'M JUST A LITTLE VOICE INSIDE YOUR **HEAD.**

A **CONCEPT.**

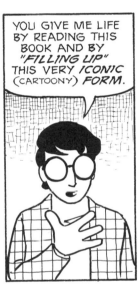

YOU GIVE ME LIFE BY READING THIS BOOK AND BY **"FILLING UP"** THIS VERY **ICONIC** (CARTOONY) **FORM.**

WHO I AM IS IRRELEVANT. I'M JUST A LITTLE PIECE OF **YOU.**

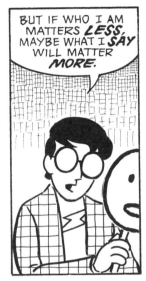

BUT IF WHO I AM MATTERS **LESS,** MAYBE WHAT I **SAY** WILL MATTER **MORE.**

THAT'S THE **THEORY,** ANYWAY.

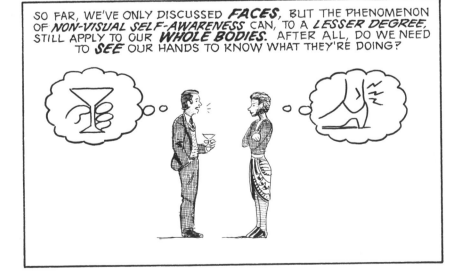

SO FAR, WE'VE ONLY DISCUSSED **FACES,** BUT THE PHENOMENON OF **NON-VISUAL SELF-AWARENESS** CAN, TO A **LESSER DEGREE,** STILL APPLY TO OUR **WHOLE BODIES.** AFTER ALL, DO WE NEED TO **SEE** OUR HANDS TO KNOW WHAT THEY'RE DOING?

THERE'S **MORE,** TOO!

THE LATE GREAT *MARSHALL McLUHAN* OBSERVED A *SIMILAR* FORM OF *NON-VISUAL AWARENESS* WHEN PEOPLE INTERACT WITH *INANIMATE OBJECTS.*

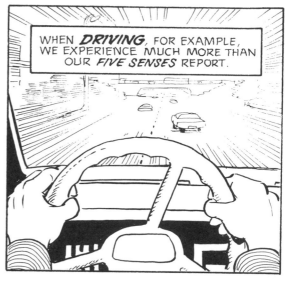

WHEN *DRIVING*, FOR EXAMPLE, WE EXPERIENCE MUCH MORE THAN OUR *FIVE SENSES* REPORT.

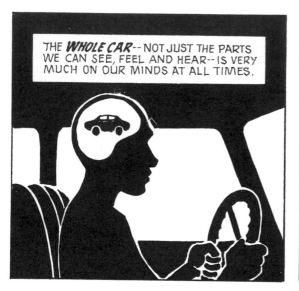

THE *WHOLE CAR*-- NOT JUST THE PARTS WE CAN SEE, FEEL AND HEAR-- IS VERY MUCH ON OUR MINDS AT ALL TIMES.

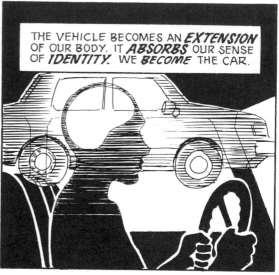

THE VEHICLE BECOMES AN *EXTENSION* OF OUR BODY. IT *ABSORBS* OUR SENSE OF *IDENTITY.* WE *BECOME* THE CAR.

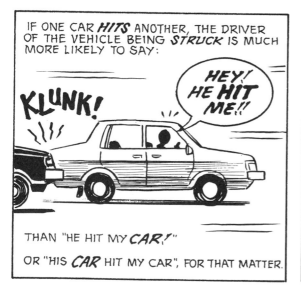

IF ONE CAR *HITS* ANOTHER, THE DRIVER OF THE VEHICLE BEING *STRUCK* IS MUCH MORE LIKELY TO SAY:

KLUNK!

HEY! HE *HIT* ME!!

THAN "HE HIT MY *CAR!*"

OR "HIS *CAR* HIT MY CAR", FOR THAT MATTER.

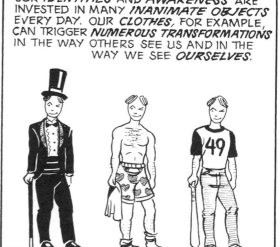

OUR *IDENTITIES* AND *AWARENESS* ARE INVESTED IN MANY *INANIMATE OBJECTS* EVERY DAY. OUR *CLOTHES*, FOR EXAMPLE, CAN TRIGGER *NUMEROUS TRANSFORMATIONS* IN THE WAY OTHERS SEE US AND IN THE WAY WE SEE *OURSELVES.*

OUR ABILITY TO *EXTEND* OUR IDENTITIES INTO INANIMATE OBJECTS CAN CAUSE PIECES OF WOOD TO BECOME *LEGS*...

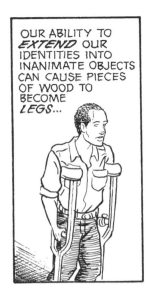

PIECES OF METAL TO BECOME *HANDS*...

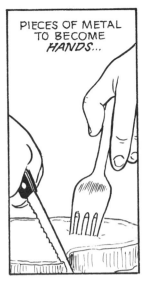

PIECES OF PLASTIC TO BECOME *EARS*...

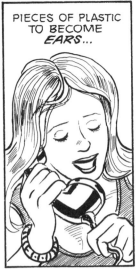

PIECES OF GLASS TO BECOME *EYES*.

AND IN *EVERY CASE*, OUR CONSTANT AWARENESS OF *SELF*--

--FLOWS *OUTWARD* TO INCLUDE THE OBJECT OF OUR *EXTENDED IDENTITY*.

AND JUST AS OUR AWARENESS OF OUR *BIOLOGICAL* SELVES ARE *SIMPLIFIED CONCEPTUALIZED IMAGES*--

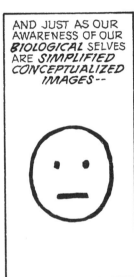

--SO TOO IS OUR AWARENESS OF *THESE* EXTENSIONS GREATLY *SIMPLIFIED*.

ALL THE THINGS WE *EXPERIENCE* IN LIFE CAN BE SEPARATED INTO *TWO REALMS, THE REALM OF THE CONCEPT*--

--AND THE REALM OF THE *SENSES*.

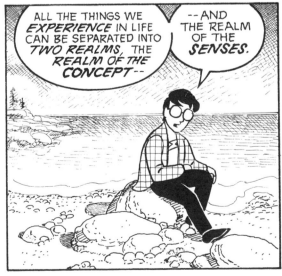

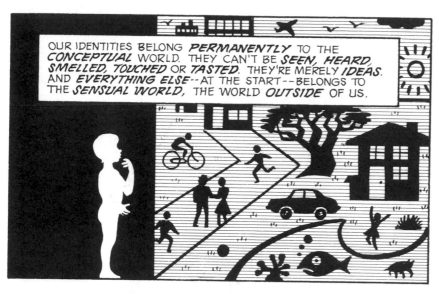

OUR IDENTITIES BELONG *PERMANENTLY* TO THE *CONCEPTUAL* WORLD. THEY CAN'T BE *SEEN, HEARD, SMELLED, TOUCHED* OR *TASTED*. THEY'RE MERELY *IDEAS*. AND *EVERYTHING ELSE*--AT THE START--BELONGS TO THE *SENSUAL WORLD*, THE WORLD *OUTSIDE* OF US.

GRADUALLY WE REACH *BEYOND* OURSELVES.

WE ENCOUNTER THE *SIGHT, SMELL, TOUCH, TASTE* AND *SOUND* OF OUR OWN BODIES.

AND OF THE WORLD *AROUND* US.

STOP

AND SOON WE DISCOVER THAT OBJECTS OF THE *PHYSICAL WORLD* CAN *ALSO* CROSS OVER--

--AND POSSESS IDENTITIES OF THEIR OWN.

OR, AS OUR *EXTENSIONS*--

--BEGIN TO GLOW--

--WITH THE LIFE--

--WE *LEND* TO THEM.

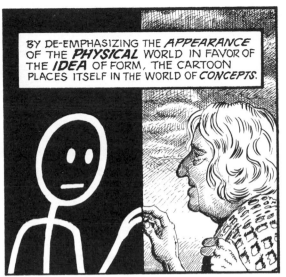

BY DE-EMPHASIZING THE *APPEARANCE* OF THE *PHYSICAL* WORLD IN FAVOR OF THE *IDEA* OF FORM, THE CARTOON PLACES ITSELF IN THE WORLD OF *CONCEPTS.*

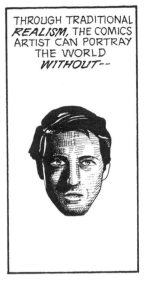

THROUGH TRADITIONAL *REALISM,* THE COMICS ARTIST CAN PORTRAY THE WORLD *WITHOUT--*

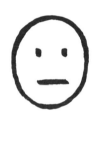

--AND THROUGH THE *CARTOON,* THE WORLD *WITHIN.*

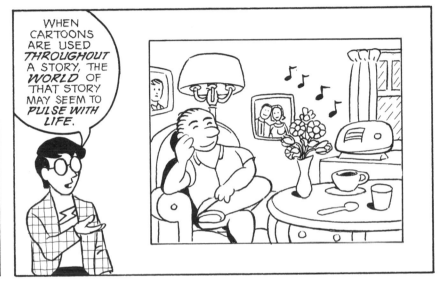

WHEN CARTOONS ARE USED *THROUGHOUT* A STORY, THE *WORLD* OF THAT STORY MAY SEEM TO *PULSE WITH LIFE.*

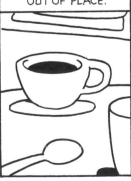

INANIMATE OBJECTS MAY SEEM TO POSSESS *SEPARATE IDENTITIES* SO THAT IF ONE *JUMPED UP* AND STARTED *SINGING* IT WOULDN'T FEEL OUT OF PLACE.

BUT IN EMPHASIZING THE *CONCEPTS* OF OBJECTS OVER THEIR *PHYSICAL APPEARANCE,* MUCH HAS TO BE *OMITTED.*

IF AN ARTIST WANTS TO PORTRAY THE BEAUTY AND COMPLEXITY OF THE *PHYSICAL WORLD--*

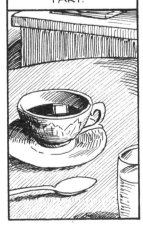

--REALISM OF *SOME* SORT IS GOING TO PLAY A PART.

41

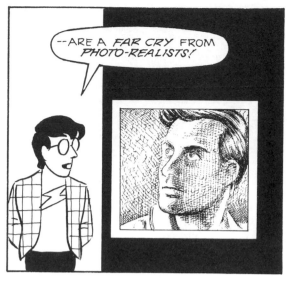

WHEN DRAWING THE FACE AND FIGURE, NEARLY *ALL* COMICS ARTISTS APPLY AT LEAST *SOME* SMALL MEASURE OF CARTOONING. EVEN THE MORE REALISTIC *ADVENTURE* ARTISTS--

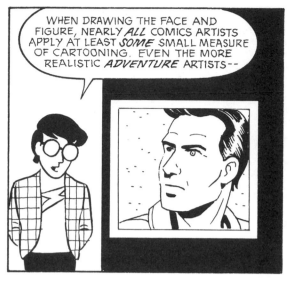

--ARE A *FAR CRY* FROM *PHOTO-REALISTS!*

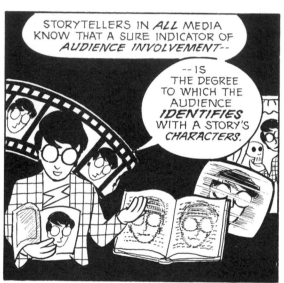

STORYTELLERS IN *ALL* MEDIA KNOW THAT A SURE INDICATOR OF *AUDIENCE INVOLVEMENT--*

--IS THE DEGREE TO WHICH THE AUDIENCE *IDENTIFIES* WITH A STORY'S *CHARACTERS.*

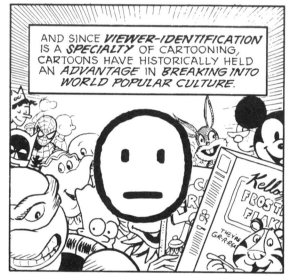

AND SINCE *VIEWER-IDENTIFICATION* IS A *SPECIALTY* OF CARTOONING, CARTOONS HAVE HISTORICALLY HELD AN *ADVANTAGE* IN *BREAKING INTO WORLD POPULAR CULTURE.*

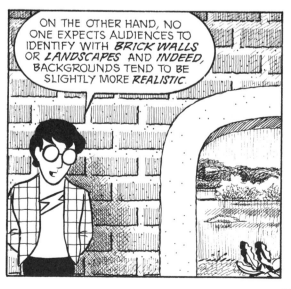

ON THE OTHER HAND, NO ONE EXPECTS AUDIENCES TO IDENTIFY WITH *BRICK WALLS* OR *LANDSCAPES* AND INDEED, BACKGROUNDS TEND TO BE SLIGHTLY MORE *REALISTIC.*

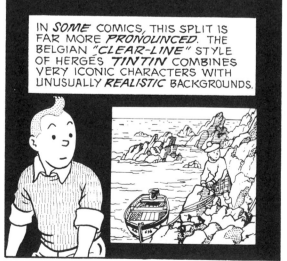

IN *SOME* COMICS, THIS SPLIT IS FAR MORE *PRONOUNCED.* THE BELGIAN *"CLEAR-LINE"* STYLE OF HERGÉ'S *TINTIN* COMBINES VERY ICONIC CHARACTERS WITH UNUSUALLY *REALISTIC* BACKGROUNDS.

42

TINTIN © EDITIONS CASTERMAN.

THIS COMBINATION ALLOWS READERS TO **MASK** THEMSELVES IN A CHARACTER AND SAFELY ENTER A SENSUALLY STIMULATING WORLD.

ONE SET OF LINES TO **SEE**. ANOTHER SET OF LINES TO **BE**.

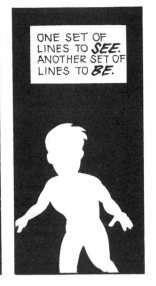

IN THE WORLD OF **ANIMATION**, WHERE THE EFFECT HAPPENS TO BE A PRACTICAL **NECESSITY**, DISNEY HAS USED IT WITH IMPRESSIVE RESULTS FOR OVER **50 YEARS!**

IN **EUROPE** IT CAN BE FOUND IN MANY POPULAR COMICS, FROM **ASTERIX** TO **TINTIN** TO WORKS OF **JACQUES TARDI.**

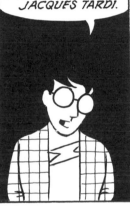

IN **AMERICAN** COMICS, THE EFFECT IS USED FAR LESS **OFTEN**, ALTHOUGH IT HAS CREPT UP IN THE WORKS OF ARTISTS AS DIVERSE AS **CARL BARKS, JAIME HERNANDEZ** AND IN THE TEAM OF **DAVE SIM** AND **GERHARD.**

CEREBUS © DAVE SIM.

IN **JAPAN,** ON THE OTHER HAND, THE MASKING EFFECT WAS, FOR A TIME, VIRTUALLY A **NATIONAL STYLE!**

THANKS TO THE **SEMINAL INFLUENCE** OF COMICS CREATOR **OSAMU TEZUKA,** JAPANESE COMICS HAVE A LONG, RICH HISTORY OF ICONIC CHARACTERS.

BUT, IN RECENT DECADES JAPANESE FANS ALSO DEVELOPED A TASTE FOR **FLASHY, PHOTO-REALISTIC ART.**

CLIK!

ART © HAYASI AND OSIMA.

43

THE RESULTANT HYBRID STYLES HAD TREMENDOUS ICONIC *RANGE,* FROM EXTREMELY CARTOONY CHARACTERS TO *NEAR-PHOTOGRAPHIC BACKGROUNDS.*

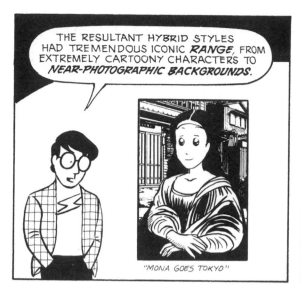

"MONA GOES TOKYO"

BUT JAPANESE COMICS ARTISTS TOOK THE IDEA A STEP FURTHER.

SOON, SOME OF THEM REALIZED THAT THE *OBJECTIFYING POWER* OF REALISTIC ARTS COULD BE PUT TO *OTHER* USES.

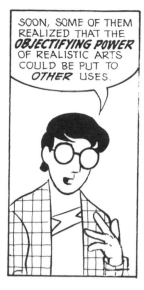

FOR EXAMPLE, WHILE *MOST* CHARACTERS WERE DESIGNED *SIMPLY,* TO ASSIST IN *READER-IDENTIFICATION*--

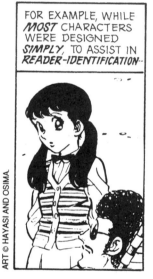

ART © HAYASI AND OSIMA.

--*OTHER* CHARACTERS WERE DRAWN MORE *REALISTICALLY* IN ORDER TO *OBJECTIFY* THEM, EMPHASIZING THEIR *"OTHERNESS"* FROM THE READER.

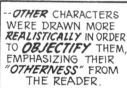

A PROP LIKE THIS *SWORD* MIGHT BE VERY *CARTOONY* IN *ONE* SEQUENCE--

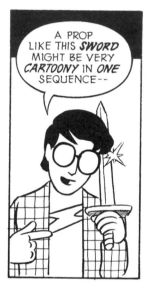

--DUE TO THE *"LIFE"* IT POSSESSES AS AN EXTENSION OF MY CARTOON IDENTITY!

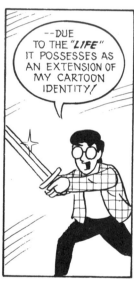

BUT SUPPOSE I NOTICE SOME *MYSTERIOUS WRITING* CARVED ON THE SWORD'S *HILT.*

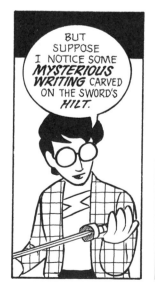

IN JAPANESE COMICS, THE SWORD MIGHT *NOW* BECOME VERY *REALISTIC,* NOT ONLY TO SHOW US THE DETAILS, BUT TO MAKE US AWARE OF THE SWORD AS AN *OBJECT,* SOMETHING WITH *WEIGHT, TEXTURE* AND *PHYSICAL COMPLEXITY.*

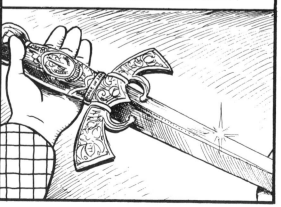

IN THIS AND IN *OTHER WAYS,* COMICS IN JAPAN HAVE EVOLVED VERY *DIFFERENTLY* FROM THOSE IN THE WEST.

WE'LL RETURN TO THESE DIFFERENCES SEVERAL TIMES DURING THIS BOOK.

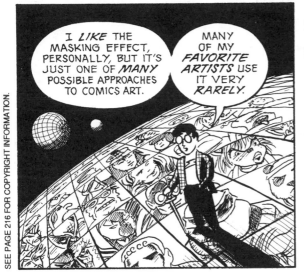

I *LIKE* THE MASKING EFFECT, PERSONALLY, BUT IT'S JUST ONE OF *MANY* POSSIBLE APPROACHES TO COMICS ART.

MANY OF MY *FAVORITE ARTISTS* USE IT VERY *RARELY.*

STILL, I HOPE THE JAPANESE PERSPECTIVE ON CARTOONING HELPS DEMONSTRATE THAT ONE'S CHOICE OF STYLES CAN HAVE CONSEQUENCES FAR BEYOND THE MERE *"LOOK"* OF A STORY.

AS I WRITE THIS, IN 1992, AMERICAN AUDIENCES ARE JUST BEGINNING TO REALIZE THAT A SIMPLE *STYLE* DOESN'T NECESSITATE SIMPLE *STORY.*

THE PLATONIC IDEAL OF THE CARTOON MAY SEEM TO OMIT MUCH OF THE *AMBIGUITY* AND *COMPLEX CHARACTERIZATION* WHICH ARE THE HALLMARKS OF *MODERN LITERATURE,* LEAVING THEM SUITABLE ONLY FOR *CHILDREN.*

BUT SIMPLE ELEMENTS CAN COMBINE IN COMPLEX WAYS, AS ATOMS BECOME MOLECULES AND MOLECULES BECOME LIFE.

AND *LIKE* THE ATOM, GREAT POWER IS LOCKED IN THESE FEW SIMPLE LINES.

RELEASEABLE ONLY BY THE READER'S MIND.

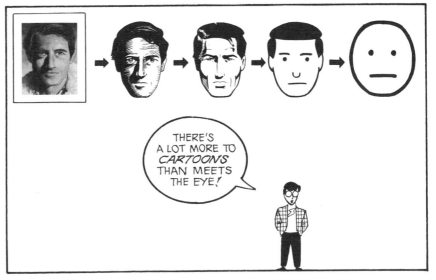

THERE'S A LOT MORE TO *CARTOONS* THAN MEETS THE EYE!

45

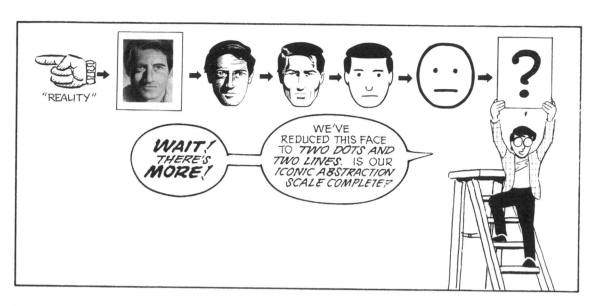

"REALITY"

WAIT! THERE'S MORE!

WE'VE REDUCED THIS FACE TO *TWO DOTS AND TWO LINES.* IS OUR *ICONIC ABSTRACTION SCALE* COMPLETE?

THE SCALE SHOWS SEVERAL SLIGHTLY *DIFFERENT* PROGRESSIONS. LET'S CONCENTRATE ON *ONE* AND SEE IF WE CAN TAKE IT ANY *FURTHER.*

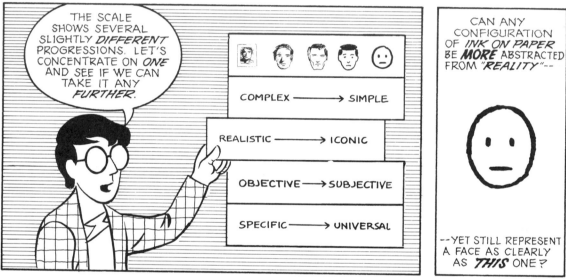

COMPLEX ⟶ SIMPLE

REALISTIC ⟶ ICONIC

OBJECTIVE ⟶ SUBJECTIVE

SPECIFIC ⟶ UNIVERSAL

CAN ANY CONFIGURATION OF *INK ON PAPER* BE *MORE* ABSTRACTED FROM *"REALITY"*--

--YET STILL REPRESENT A FACE AS CLEARLY AS *THIS* ONE?

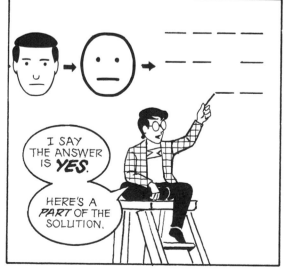

I SAY THE ANSWER IS *YES.*

HERE'S A *PART* OF THE SOLUTION.

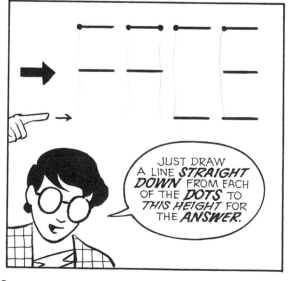

JUST DRAW A LINE *STRAIGHT DOWN* FROM EACH OF THE *DOTS* TO *THIS HEIGHT* FOR THE *ANSWER.*

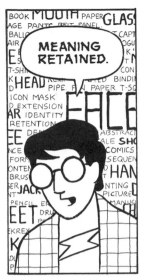

MEANING RETAINED.

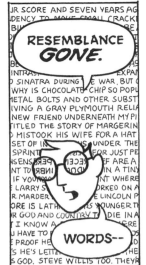

RESEMBLANCE *GONE.*

WORDS--

--ARE THE ULTIMATE ABSTRACTION.

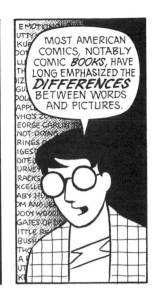

MOST AMERICAN COMICS, NOTABLY COMIC *BOOKS,* HAVE LONG EMPHASIZED THE *DIFFERENCES* BETWEEN WORDS AND PICTURES.

WRITING AND DRAWING ARE SEEN AS *SEPARATE DISCIPLINES,* WRITERS AND ARTISTS AS *SEPARATE BREEDS--*

-- AND "GOOD" COMICS AS THOSE IN WHICH THE *COMBINATION* OF THESE VERY *DIFFERENT* FORMS OF EXPRESSION IS THOUGHT TO BE *HARMONIOUS.*

BUT JUST HOW "DIFFERENT" *ARE* THEY?

WORDS, PICTURES AND OTHER ICONS ARE THE *VOCABULARY* OF THE LANGUAGE CALLED **COMICS.**

A SINGLE UNIFIED *LANGUAGE* DESERVES A SINGLE, UNIFIED *VOCABULARY.*

WITHOUT IT, COMICS WILL CONTINUE TO *LIMP ALONG* AS THE *"BASTARD CHILD"* OF WORDS AND PICTURES.

SEVERAL FACTORS HAVE CONSPIRED *AGAINST* COMICS RECEIVING THE *UNIFIED IDENTITY* IT *NEEDS.*

AND AMONG THEM LIE SOME OF OUR VERY *BEST INSTINCTS.*

BOTH ARTIST AND WRITER BEGIN, HANDS JOINED ACROSS THE GAP, WITH A COMMON PURPOSE: TO MAKE COMICS OF *"QUALITY"*

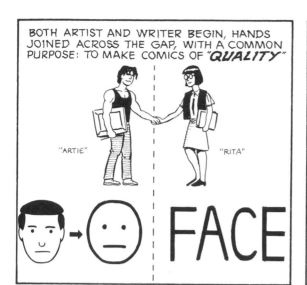

"ARTIE" "RITA"

THE ARTIST KNOWS THAT THIS MEANS MORE THAN JUST *STICK-FIGURES* AND *CRUDE CARTOONS*. HE SETS OFF IN SEARCH OF A *HIGHER* ART.

THE WRITER KNOWS THAT THIS MEANS MORE THAN JUST *OOF! POW! BLAM!* AND *ONE-A-DAY GAGS*. SHE SETS OFF IN SEARCH OF SOMETHING *DEEPER*.

IN MUSEUMS AND IN LIBRARIES, THE ARTIST FINDS WHAT HE'S LOOKING FOR. HE STUDIES THE TECHNIQUES OF THE *GREAT MASTERS* OF *WESTERN ART*, HE PRACTICES *NIGHT AND DAY*.

SHE *TOO* FINDS WHAT SHE'S LOOKING FOR, IN THE GREAT MASTERS OF *WESTERN LITERATURE*. SHE READS AND WRITES *CONSTANTLY*. SHE SEARCHES FOR A VOICE *UNIQUELY HERS*.

FINALLY, THEY'RE READY. BOTH HAVE *MASTERED THEIR ARTS*. HIS BRUSHSTROKE IS NEARLY *INVISIBLE* IN ITS SUBTLETY, THE FIGURES PURE *MICHAELANGELO*. HER DESCRIPTIONS ARE *DAZZLING*. THE WORDS FLOW TOGETHER LIKE A *SHAKESPEAREAN SONNET*.

THEY'RE READY TO *JOIN HANDS* ONCE MORE AND CREATE A *COMICS MASTERPIECE*.

 → → → → · **FACE** → TWO EYES, ONE NOSE, ONE MOUTH. → *Thy youth's proud livery so gaz'd on now...*

48

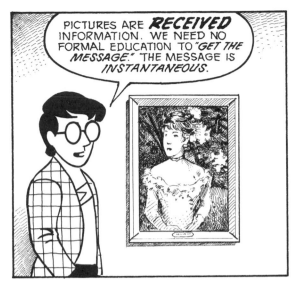

PICTURES ARE **RECEIVED** INFORMATION. WE NEED NO FORMAL EDUCATION TO *"GET THE MESSAGE."* THE MESSAGE IS *INSTANTANEOUS.*

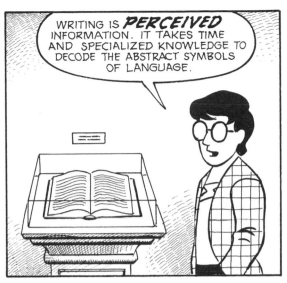

WRITING IS **PERCEIVED** INFORMATION. IT TAKES TIME AND SPECIALIZED KNOWLEDGE TO DECODE THE ABSTRACT SYMBOLS OF LANGUAGE.

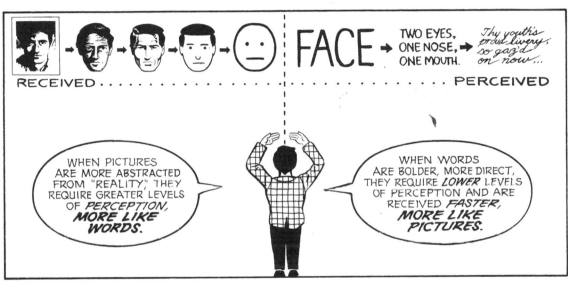

RECEIVED . PERCEIVED

FACE → TWO EYES, ONE NOSE, ONE MOUTH. → *Thy youth's proud livery, so gaz'd on now...*

WHEN PICTURES ARE MORE ABSTRACTED FROM "REALITY," THEY REQUIRE GREATER LEVELS OF *PERCEPTION,* **MORE LIKE WORDS.**

WHEN WORDS ARE BOLDER, MORE DIRECT, THEY REQUIRE *LOWER* LEVELS OF PERCEPTION AND ARE RECEIVED *FASTER,* **MORE LIKE PICTURES.**

OUR NEED FOR A UNIFIED **LANGUAGE** OF COMICS SENDS US TOWARD THE CENTER WHERE WORDS AND PICTURES ARE LIKE TWO SIDES OF *ONE COIN!*

BUT OUR NEED FOR **SOPHISTICATION** IN COMICS SEEMS TO LEAD US *OUTWARD,* WHERE WORDS AND PICTURES ARE MOST *SEPARATE.*

BOTH ARE *WORTHY ASPIRATIONS.* BOTH STEM FROM A LOVE OF COMICS AND A DEVOTION TO ITS FUTURE.

CAN THEY BE **RECONCILED?**

I SAY THE ANSWER IS **YES,** BUT SINCE THE REASONS BELONG IN A *DIFFERENT CHAPTER,* WE'LL HAVE TO COME BACK TO THIS *LATER.*

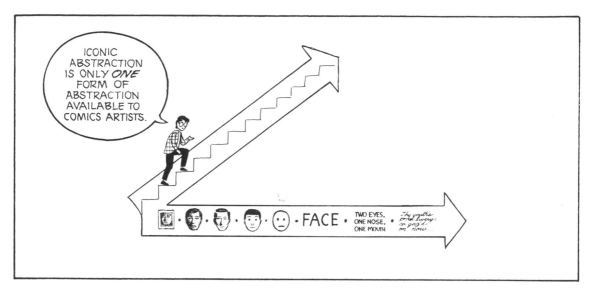

ICONIC ABSTRACTION IS ONLY *ONE* FORM OF ABSTRACTION AVAILABLE TO COMICS ARTISTS.

FACE · TWO EYES, ONE NOSE, ONE MOUTH ·

USUALLY THE WORD "ABSTRACTION" REFERS TO THE *NON-ICONIC* VARIETY, WHERE NO ATTEMPT IS MADE TO CLING TO RESEMBLANCE *OR* MEANING.

THE TYPE OF ART WHICH OFTEN PROMPTS THE QUESTION: *"WHAT DOES IT MEAN?"*

EARNING THE REPLY "IT *'MEANS'* WHAT IT *IS!*"

IN THIS CASE--

--INK ON PAPER.

50

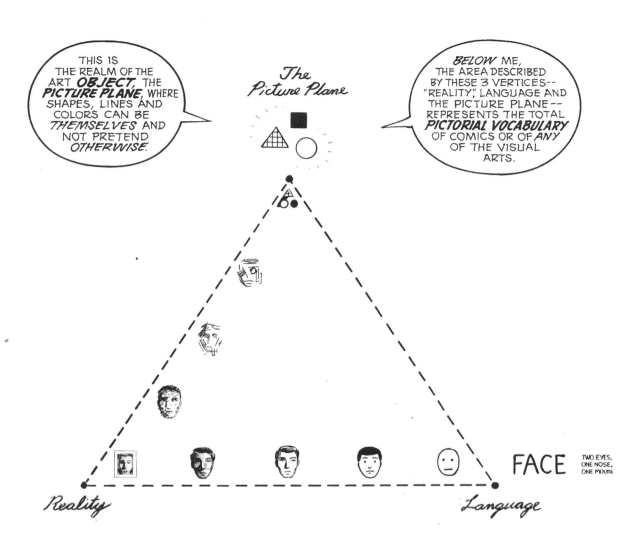

THIS IS THE REALM OF THE ART *OBJECT*, THE *PICTURE PLANE*, WHERE SHAPES, LINES AND COLORS CAN BE *THEMSELVES* AND NOT PRETEND *OTHERWISE*.

The Picture Plane

BELOW ME, THE AREA DESCRIBED BY THESE 3 VERTICES-- "REALITY," LANGUAGE AND THE PICTURE PLANE-- REPRESENTS THE TOTAL *PICTORIAL VOCABULARY* OF COMICS OR OF *ANY* OF THE VISUAL ARTS.

FACE

TWO EYES, ONE NOSE, ONE MOUTH

Reality

Language

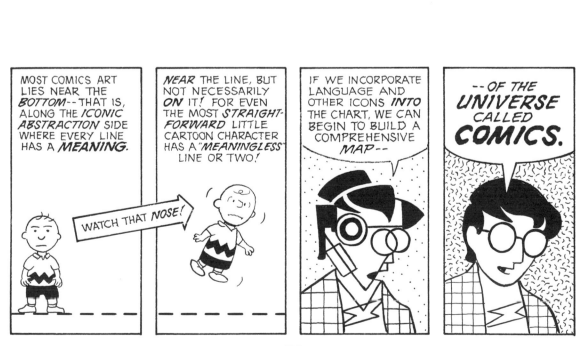

MOST COMICS ART LIES NEAR THE *BOTTOM*--THAT IS, ALONG THE *ICONIC ABSTRACTION* SIDE WHERE EVERY LINE HAS A *MEANING*.

NEAR THE LINE, BUT NOT NECESSARILY *ON* IT! FOR EVEN THE MOST *STRAIGHT-FORWARD* LITTLE CARTOON CHARACTER HAS A "*MEANINGLESS*" LINE OR TWO!

WATCH THAT *NOSE!*

IF WE INCORPORATE LANGUAGE AND OTHER ICONS *INTO* THE CHART, WE CAN BEGIN TO BUILD A COMPREHENSIVE *MAP*--

--OF THE *UNIVERSE* CALLED *COMICS.*

1. **MARY FLEENER** at her most abstract. 2. **MARISCAL**'s Piker. 3. **DAVE McKEAN** employing one of the many styles found in his series CAGES. 4. **MARC HEMPEL**'s GREGORY. 5. **MARK BEYER.** 6. **LARRY MARDER**'s Beanish from TALES OF THE BEANWORLD. "Resembling" nothing ever seen (hence all the way to the right), Marder's beans walk the line from design to meaning. 7. **SAUL STIENBERG.** 8. **PENNY MORAN VAN-HORN** from THE LIBRARIAN. 9. **LORENZO MATTOTI** in FIRES (© Editions Albin Michel S.A.) combines deeply impressionistic lighting with iconic forms and strong, design-oriented compositions. In other words, he's a hard one to place. 10. **ALINE KOMINSKY-CRUMB.** 11. **PETER BAGGE**'s Chuckie-Boy from NEAT STUFF. Compare to 39. 12. **KRISTINE KRYTTRE.** 13. **REA IRVIN.** THE SMYTHES © Field Newspaper Syndicate. 14. **STEVE WILLIS**'s Morty. 15. **PHIL YEH**'s FRANK THE UNICORN. 16. **JERRY MORIARTY**'s "Jack Survives". Based closely on real world light and shadow, but decomposed into rough shapes. Similar effects are found in no.s 8,18,19,20 and 34. 17. **JEFF WONG**'s art for Scott Russo's JIZZ. 18. **ROLF STARK**'s expressionistic RAIN. 19. **SPAIN**'s TRASHMAN. 20. **FRANK MILLER**'s THE DARK KNIGHT RETURNS. Batman © D.C. Comics. Batman created by Bob Kane. 21. **WILLIAM MESSNER-LOEBS**'s Wolverine MacAlistair from JOURNEY. 22. **DON SIMPSON**'s MEGATON MAN. Beginning from a

realistic anatomical base, Simpson distorts and exaggerates M.M.'s features to the brink of abstraction. 23. **MICHAEL CHERKAS** from SILENT INVASION, © Cherkas and Hancock. 24. **RICK GEARY.** 25. **PETER KUPER.** 26. **GARRY TRUDEAU**'s DOONESBURY. 27. **LYNDA BARRY.** 28. **SAMPEI SHIRATO.** 29. **CHARLES BURNS**'s BIG BABY. 29 1/2. (Whoops) **CLIFF STERRETT.** The character pictured here (from POLLY AND HER PALS) might belong a bit lower, but Sterrett's art, like Fleener's often heads upward toward the wildly abstract. P.A.H.P. is © Newspaper Features Syndicate, Inc. 30. **SERGIO ARAGONES**'s GROO THE WANDERER. Simple, straightforward, but with a strong gestural quality that always reminds us of the hand that holds the pen (also true of 14,28,31,41). 31. **ROBERTA GREGORY**'s Bitchy Bitch from NAUGHTY BITS. 32. **DAVID MAZZUCCHELLI** from BATMAN: YEAR ONE. Commissioner Gordon © D.C. Comics. 33. **JOSE MUNOZ** from "Mister Conrad, Mister Wilcox". © Munoz and Sampayo. 34. **CAROL**

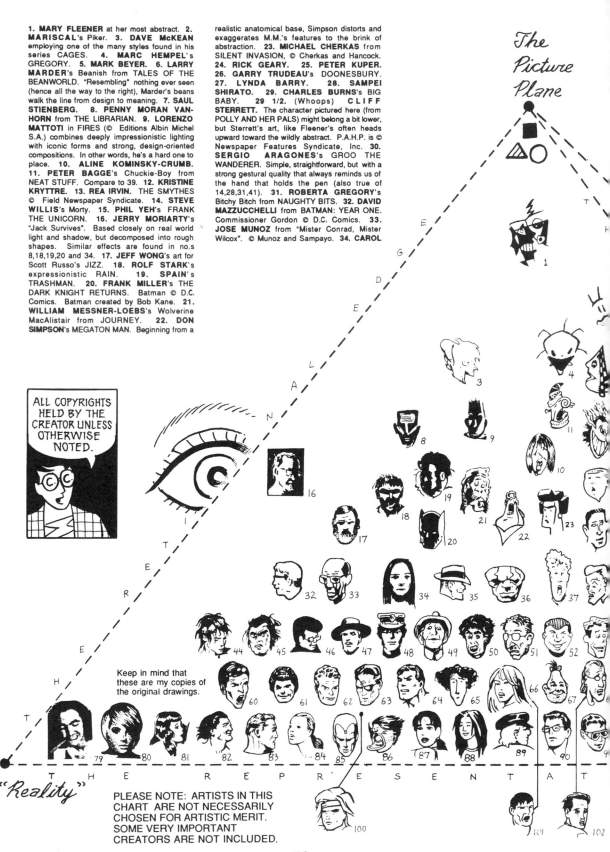

The Picture Plane

ALL COPYRIGHTS HELD BY THE CREATOR UNLESS OTHERWISE NOTED.

Keep in mind that these are my copies of the original drawings.

"Reality"

PLEASE NOTE: ARTISTS IN THIS CHART ARE NOT NECESSARILY CHOSEN FOR ARTISTIC MERIT. SOME VERY IMPORTANT CREATORS ARE NOT INCLUDED.

52

SWAIN. 35. CHESTER GOULD's DICK TRACY © Chicago Tribune-New York Syndicate, Inc. 36. JACK KIRBY's Darkseid, © D.C. Comics. 37. BOB BURDEN. 38. DANIEL TORRES's Rocco Vargas from TRITON. 39. PETER BAGGE's Buddy Bradley from HATE. Compare to 11. 40. SETH. 41. MARK MARTIN. 42. JULIE DOUCET. 43. EDWARD GOREY. 44. CRAIG RUSSELL's Mowgli from Kipling's THE JUNGLE BOOKS. Russell's characters are as finely observed and realistically based as Hal Foster's or Dave Stevens' but with an unparalleled sense of design that draws them toward the upper vertex. Lately, Russell has been moving a bit higher and toward the right in some cases. 45. GOSEKI KOJIMA from KOZURE OKAMI

("Wolf and Cub") © Koike and Kojima. 46. EDDIE CAMPBELL's ALEC. Realistic in tone, but also gestural and spontaneous. The *process* of drawing isn't hidden from view. 47. ALEX TOTH. Zorro © ZorroProductions, Inc. Art © Walt Disney Productions. (Zorro created by Johnston McCulley). 48. HUGO PRATT's CORTO MALTESE © Casterman, Paris-Tourmai. 49. WILL EISNER from TO THE HEART OF THE STORM. 50. DORI SEDA. 51. R. CRUMB swings between realistic and cartoony characters, usually staying about this high but occasionally venturing upward. 52. STEVE DITKO. 53. NORMAN DOG. 54. VALENTINO's NORMALMAN sits a bit to the right and up from his current SHADOWHAWK (whose iconic mask made him a bit harder to place). 55. ROZ CHAST. 56. JOOST SWARTE's Anton Makassar. 57. ELZIE SEGAR's POPEYE © King features Syndicate, Inc. 58. GEORGE HERRIMAN's "Offissa Pupp" from KRAZY KAT. © International feature Service, Inc. 59. JIM WOODRING's FRANK. 60. NEAL ADAMS. from X-MEN © Marvel Entertainment Group, Inc. (X-Men created by Lee and Kirby). 61. GIL KANE from ACTION COMICS © D.C. Comics, Inc. 62. MILTON CANIFF's STEVE CANYON. 63. JIM LEE. Nick Fury appearing in X-MEN © Marvel Entertainment Group, Inc. 64. JOHN BYRNE. Superman © D.C. Comics, Inc. (Superman created by Jerry Siegel and Joe Schuster). 65. JACQUES TARDI from LE DEMON DES GLACES © Dargaud Editeur. 66. JEAN-CLAUDE MEZIERES. Laureline from the VALERIAN series. © Dargaud Editeur. 67. BILL GRIFFITH's ZIPPY THE PINHEAD. 68. JOE MATT. 69. KYLE BAKER from WHY I HATE SATURN. 70. TRINA ROBBINS's

MISTY. © Marvel Entertainment Group, Inc. 71. RIYOKO IKEDA's Oscar from THE ROSE OF VERSAILLES. 72. GEORGE McMANUS. BRINGING UP FATHER © International Feature Service, Inc. 73. CHARLES SCHULZ's Charlie Brown from PEANUTS © United Features Syndicate, Inc. 74. ART SPIEGELMAN from MAUS. 75. MATT FEAZELL's CYNICALMAN. 76. The company Logo. The picture as symbol. 77. Title Logo. The word as object. 78. Sound Effect. The word as sound. 79. TOM KING's SNOOKUMS, THAT LOVABLE TRANSVESTITE, a photo-comic. 80. DREW FRIEDMAN. 81. DAVE STEVENS. 82. HAL FOSTER. TARZAN created by Edgar Rice Burroughs. 83. ALEX RAYMOND. Flash Gordon © King Features Syndicate, Inc. 84. MILO MANARA. 85. JOHN BUSCEMA. The Vision © Marvel Entertainment Group. 86. CAROL LAY's Irene Van de Kamp from GOOD GIRLS. A bizarre character, but drawn in a very straightforward style. 87. GILBERT HERNANDEZ. 88. JAIME HERNANDEZ. 89. COLIN UPTON. 90. KURT SCHAFFENBERGER. Superboy © D.C. Comics. 91. JACK COLE's PLASTIC MAN, © D.C. Comics. 92. REED WALLER's OMAHA THE CAT DANCER © Waller and Worley. 93. WENDY PINI's Skywise from ELFQUEST. © WaRP Graphics. 94. DAN DE CARLO. Veronica © Archie Comics. 95. HAROLD GRAY's LITTLE ORPHAN ANNIE. © Chicago Tribune- New York News Syndicate. 96. HERGE's TINTIN © Editions Casterman. 97. FLOYD GOTTFREDSON. Mickey Mouse © Walt Disney Productions. 98. JEFF SMITH's BONE. 99. Smile Dammit. 100. COLLEEN DORAN's A DISTANT SOIL. 101. ROY CRANE's CAPTAIN EASY © NEA Service, Inc. 102. DAN CLOWES. 103. WAYNO. 104. V.T. HAMLIN's ALLEY OOP © NEA Service, Inc. 105. CHESTER BROWN. 106. STAN SAKAI's USAGI YOJIMBO. 107. DAVE SIM's CEREBUS THE AARDVARK. 108. WALT KELLY's POGO © Selby Kelly. 109. RUDOLPH DIRKS's HANS AND FRITZ © King Features Syndicate, Inc. 110. H.C. "BUD" FISHER's Jeff from MUTT AND JEFF © McNaught Syndicate, Inc. 111. MORT WALKER's HI AND LOIS © King Features Syndicate, Inc. 112. OSAMU TEZUKA's ASTROBOY. 113. CARL BARKS. Scrooge McDuck © Walt Disney Productions. 114. CROCKETT JOHNSON's Mister O'Malley from BARNABY © Field Newspaper Syndicate, Inc. 115. PAT SULLIVAN's FELIX THE CAT © Newspaper Feature Service. 116. UDERZO. ASTERIX by Goscinny and Uderzo © Dargaud Editeur.

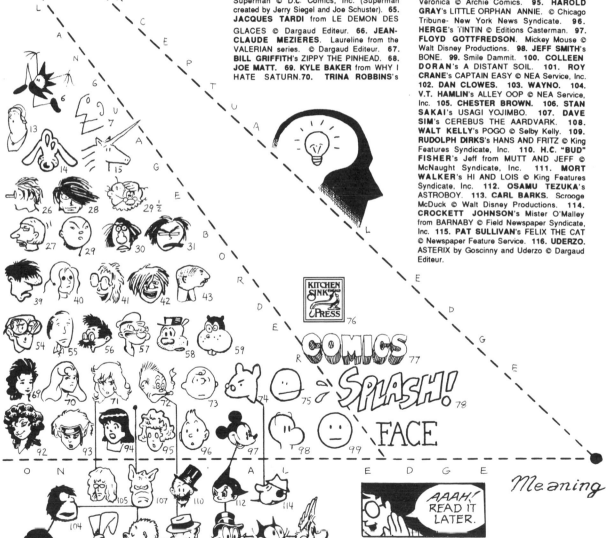

MOST OF THE PRECEDING EXAMPLES WERE PLACED ON OUR CHART BASED ON THE DRAWING STYLES USED ON *SPECIFIC CHARACTERS.*

EACH CREATOR EMPLOYS A *RANGE* OF STYLES, THOUGH, AND MANY OCCUPY *SEVERAL* PLACES ON THE CHART DURING A GIVEN PROJECT.

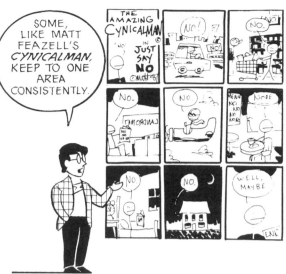

SOME, LIKE MATT FEAZELL'S *CYNICALMAN,* KEEP TO ONE AREA CONSISTENTLY.

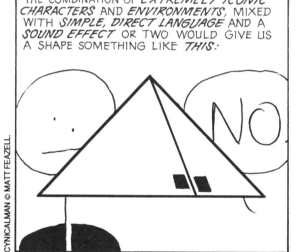

THE COMBINATION OF *EXTREMELY ICONIC CHARACTERS* AND *ENVIRONMENTS,* MIXED WITH *SIMPLE, DIRECT LANGUAGE* AND A *SOUND EFFECT* OR TWO WOULD GIVE US A SHAPE SOMETHING LIKE *THIS:*

CYNICALMAN © MATT FEAZELL.

BUT OTHERS *RANGE CONSIDERABLY* FROM ONE END OF THE CHART TO THE OTHER.

WE'VE ALREADY DISCUSSED THE RANGE OF HERGÉ AND OTHERS WHO CONTRAST *ICONIC CHARACTERS* WITH *REALISTIC BACKGROUNDS.*

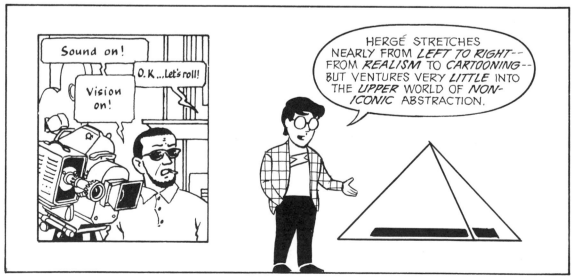

Sound on!

Vision on!

O.K...Let's roll!

HERGÉ STRETCHES NEARLY FROM *LEFT TO RIGHT*-- FROM *REALISM* TO *CARTOONING*-- BUT VENTURES VERY *LITTLE* INTO THE *UPPER* WORLD OF *NON-ICONIC* ABSTRACTION.

ART © EDITIONS CASTERMAN.

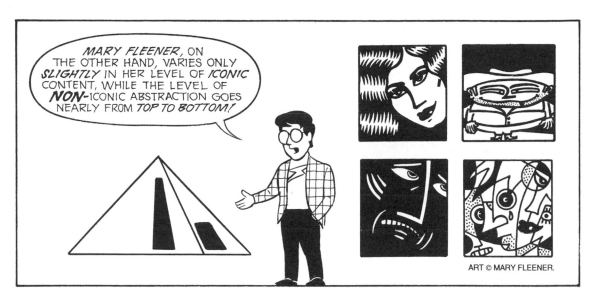

MARY FLEENER, ON THE OTHER HAND, VARIES ONLY *SLIGHTLY* IN HER LEVEL OF *ICONIC* CONTENT, WHILE THE LEVEL OF *NON*-ICONIC ABSTRACTION GOES NEARLY FROM *TOP TO BOTTOM!*

ART © MARY FLEENER.

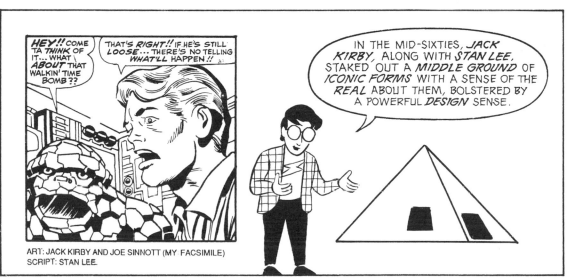

HEY!! COME TA *THINK* OF IT... WHAT *ABOUT* THAT WALKIN' TIME BOMB??

THAT'S *RIGHT!!* IF HE'S STILL *LOOSE*... THERE'S NO TELLING *WHAT'LL* HAPPEN!!

IN THE MID-SIXTIES, *JACK KIRBY*, ALONG WITH *STAN LEE*, STAKED OUT A *MIDDLE GROUND* OF *ICONIC FORMS* WITH A SENSE OF THE *REAL* ABOUT THEM, BOLSTERED BY A POWERFUL *DESIGN* SENSE.

ART: JACK KIRBY AND JOE SINNOTT (MY FACSIMILE)
SCRIPT: STAN LEE.

TODAY, MANY AMERICAN MAINSTREAM COMICS STILL FOLLOW KIRBY'S LEAD FOR STORYTELLING, BUT THE DESIRE FOR MORE *REALISTIC* ART AND MORE ELABORATE SCRIPTS HAS PUSHED ART AND STORY *FURTHER APART* IN MANY CASES.

A FIGHT STARTED ON HIS DOORSTEP, HE PUT A STOP TO IT. FAR AS ANYONE KNOWS, ALL THE SURVIVORS ARE PRETTY MUCH OKAY.

WAY YOU TALK, NICHOLAS, FOLKS EXPECT HIM TO START NUKIN' MAMA RUSSIA ANY MOMENT.

ART FROM COLOR PANELS TRACED FOR REPRODUCTION.
© MARVEL ENTERTAINMENT GROUP, INC.

ART: JIM LEE AND SCOTT WILLIAMS (FACSIMILE)
SCRIPT: CHRIS CLAREMONT.

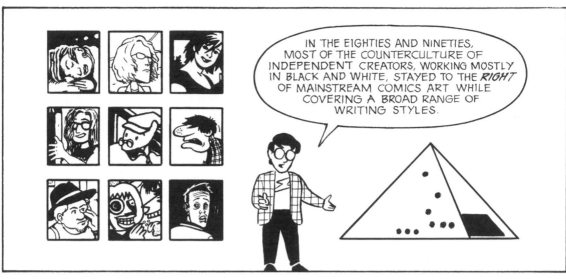

IN THE EIGHTIES AND NINETIES, MOST OF THE COUNTERCULTURE OF INDEPENDENT CREATORS, WORKING MOSTLY IN BLACK AND WHITE, STAYED TO THE *RIGHT* OF MAINSTREAM COMICS ART WHILE COVERING A BROAD RANGE OF WRITING STYLES.

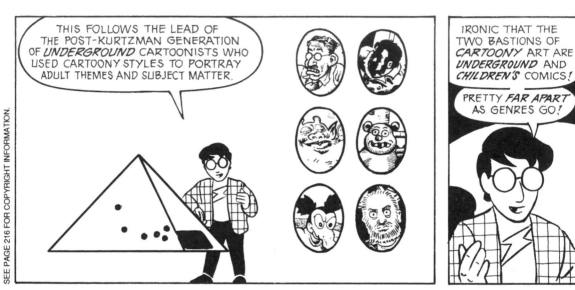

THIS FOLLOWS THE LEAD OF THE POST-KURTZMAN GENERATION OF *UNDERGROUND* CARTOONISTS WHO USED CARTOONY STYLES TO PORTRAY ADULT THEMES AND SUBJECT MATTER.

IRONIC THAT THE TWO BASTIONS OF *CARTOONY* ART ARE *UNDERGROUND* AND *CHILDREN'S* COMICS!

PRETTY *FAR APART* AS GENRES GO!

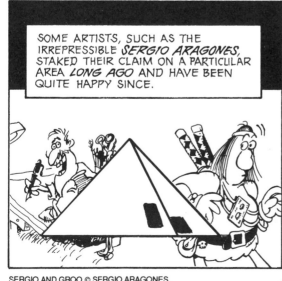

SOME ARTISTS, SUCH AS THE IRREPRESSIBLE *SERGIO ARAGONES*, STAKED THEIR CLAIM ON A PARTICULAR AREA *LONG AGO* AND HAVE BEEN QUITE HAPPY SINCE.

OTHERS, SUCH AS *DAVE McKEAN*, ARE FOREVER *ON THE MOVE, EXPERIMENTING, TAKING CHANCES, NEVER SATISFIED.*

56

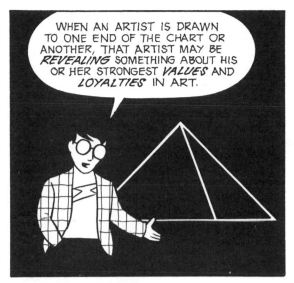 WHEN AN ARTIST IS DRAWN TO ONE END OF THE CHART OR ANOTHER, THAT ARTIST MAY BE *REVEALING* SOMETHING ABOUT HIS OR HER STRONGEST *VALUES* AND *LOYALTIES* IN ART.

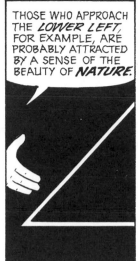 THOSE WHO APPROACH THE *LOWER LEFT,* FOR EXAMPLE, ARE PROBABLY ATTRACTED BY A SENSE OF THE BEAUTY OF *NATURE.*

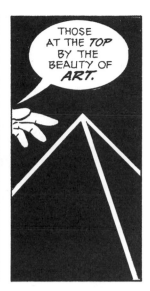 THOSE AT THE *TOP* BY THE BEAUTY OF *ART.*

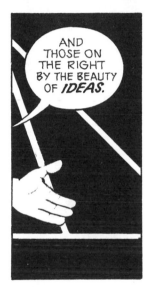 AND THOSE ON THE RIGHT BY THE BEAUTY OF *IDEAS.*

 FOR COMICS TO *MATURE* AS A *MEDIUM,* IT MUST BE CAPABLE OF EXPRESSING EACH ARTIST'S *INNERMOST NEEDS* AND *IDEAS.*

BUT EACH ARTIST HAS *DIFFERENT* INNER NEEDS, DIFFERENT POINTS OF VIEW, DIFFERENT *PASSIONS,* AND SO NEEDS TO FIND DIFFERENT *FORMS OF EXPRESSION.* *

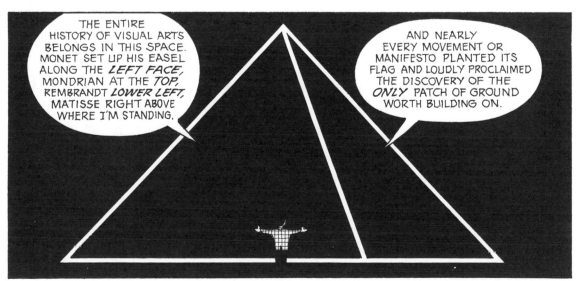 THE ENTIRE HISTORY OF VISUAL ARTS BELONGS IN THIS SPACE. MONET SET UP HIS EASEL ALONG THE *LEFT FACE,* MONDRIAN AT THE *TOP,* REMBRANDT *LOWER LEFT,* MATISSE RIGHT ABOVE WHERE I'M STANDING.

AND NEARLY EVERY MOVEMENT OR MANIFESTO PLANTED ITS FLAG AND LOUDLY PROCLAIMED THE DISCOVERY OF THE *ONLY* PATCH OF GROUND WORTH BUILDING ON.

* CHECK OUT WASSILY KANDINSKY'S TERRIFIC 1912 ESSAY, "ON THE PROBLEM OF FORM."

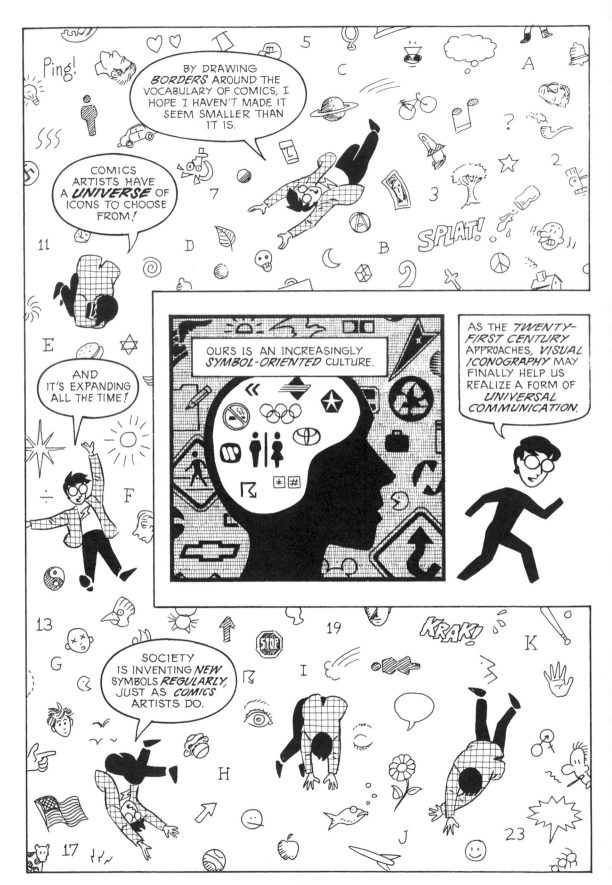

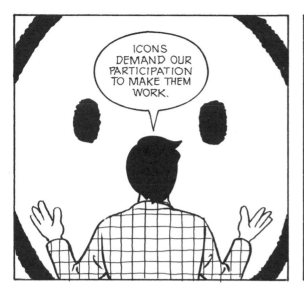

ICONS DEMAND OUR PARTICIPATION TO MAKE THEM WORK.

THERE IS NO LIFE HERE EXCEPT THAT WHICH YOU GIVE TO IT.

IT'S *YOUR* JOB TO CREATE AND *RECREATE* ME MOMENT BY MOMENT, NOT JUST THE CARTOONIST'S.

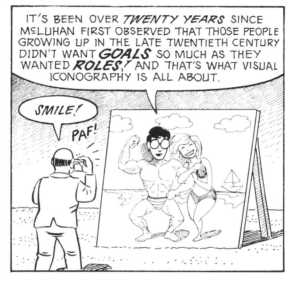

IT'S BEEN OVER *TWENTY YEARS* SINCE McLUHAN FIRST OBSERVED THAT THOSE PEOPLE GROWING UP IN THE LATE TWENTIETH CENTURY DIDN'T WANT *GOALS* SO MUCH AS THEY WANTED *ROLES!* AND THAT'S WHAT VISUAL ICONOGRAPHY IS ALL ABOUT.

SMILE!

PAF!

AS IT HAPPENS, ONLY *TWO* POPULAR MEDIA WERE IDENTIFIED BY McLUHAN AS "COOL" MEDIA-- THAT IS, MEDIA WHICH COMMAND AUDIENCE INVOLVEMENT THROUGH *ICONIC FORMS.*

ONE OF THEM, *TELEVISION,* HAS REACHED INTO THE LIVES OF EVERY HUMAN BEING ON EARTH--

--AND FOR BETTER OR WORSE, ALTERED THE COURSE OF HUMAN AFFAIRS FROM HERE 'TIL *DOOMSDAY.*

THE FATE OF THE *OTHER* ONE, *COMICS*--

SEQUENTIAL ART

-- IS ANYONE'S GUESS.

CHAPTER THREE

BLOOD IN THE GUTTER.

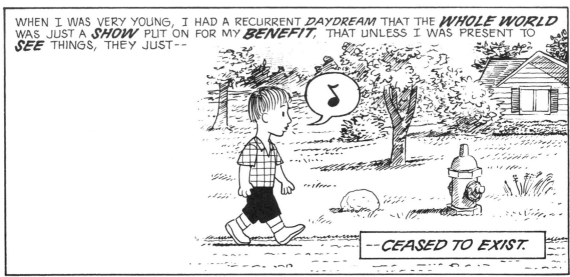

WHEN I WAS VERY YOUNG, I HAD A RECURRENT *DAYDREAM* THAT THE *WHOLE WORLD* WAS JUST A *SHOW* PUT ON FOR MY *BENEFIT*, THAT UNLESS I WAS PRESENT TO *SEE* THINGS, THEY JUST--

--CEASED TO EXIST.

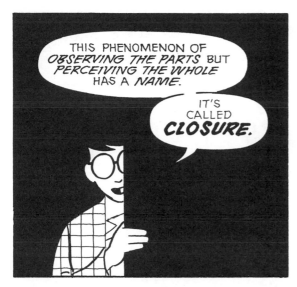

THIS PHENOMENON OF *OBSERVING THE PARTS* BUT *PERCEIVING THE WHOLE* HAS A *NAME.*

IT'S CALLED *CLOSURE.*

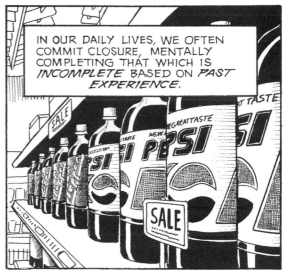

IN OUR DAILY LIVES, WE OFTEN COMMIT CLOSURE, MENTALLY COMPLETING THAT WHICH IS *INCOMPLETE* BASED ON *PAST EXPERIENCE.*

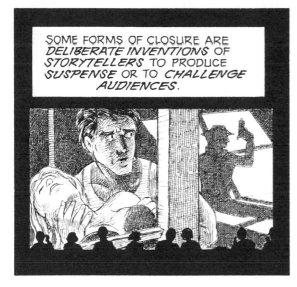

SOME FORMS OF CLOSURE ARE *DELIBERATE INVENTIONS* OF *STORYTELLERS* TO PRODUCE *SUSPENSE* OR TO *CHALLENGE AUDIENCES.*

OTHERS HAPPEN *AUTOMATICALLY,* WITHOUT MUCH *EFFORT...* PART OF *BUSINESS AS USUAL.*

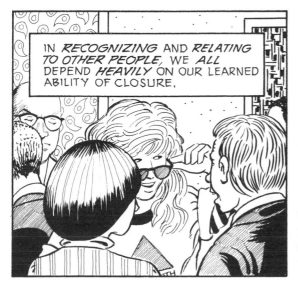

IN *RECOGNIZING* AND *RELATING TO OTHER PEOPLE,* WE *ALL* DEPEND *HEAVILY* ON OUR LEARNED ABILITY OF CLOSURE.

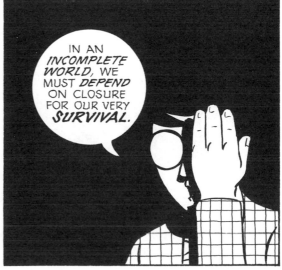

IN AN *INCOMPLETE WORLD,* WE MUST *DEPEND* ON CLOSURE FOR OUR VERY *SURVIVAL.*

CLOSURE CAN TAKE *MANY FORMS.* SOME *SIMPLE,* SOME *COMPLEX.*

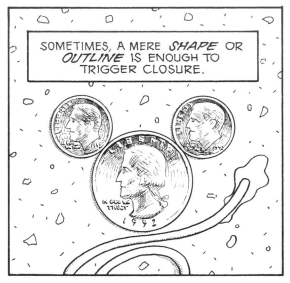

SOMETIMES, A MERE *SHAPE* OR *OUTLINE* IS ENOUGH TO TRIGGER CLOSURE.

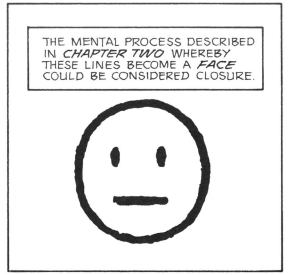

THE MENTAL PROCESS DESCRIBED IN *CHAPTER TWO* WHEREBY THESE LINES BECOME A *FACE* COULD BE CONSIDERED CLOSURE.

EVERY TIME WE SEE A *PHOTOGRAPH* REPRODUCED IN A *NEWSPAPER* OR *MAGAZINE,* WE COMMIT CLOSURE.

OUR *EYES* TAKE IN THE *FRAGMENTED, BLACK-AND-WHITE IMAGE* OF THE *"HALF-TONE"* PATTERNS--

--AND OUR MINDS TRANSFORM IT INTO THE *"REALITY"*--

--OF THE *PHOTOGRAPH!*

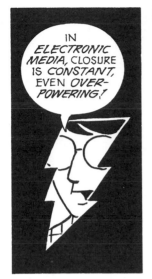

IN *ELECTRONIC MEDIA*, CLOSURE IS *CONSTANT*, EVEN *OVER-POWERING!*

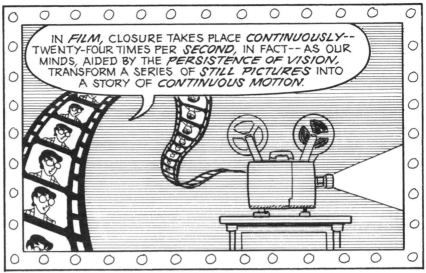

IN *FILM*, CLOSURE TAKES PLACE *CONTINUOUSLY*-- TWENTY-FOUR TIMES PER *SECOND*, IN FACT-- AS OUR MINDS, AIDED BY THE *PERSISTENCE OF VISION*, TRANSFORM A SERIES OF *STILL PICTURES* INTO A STORY OF *CONTINUOUS MOTION*.

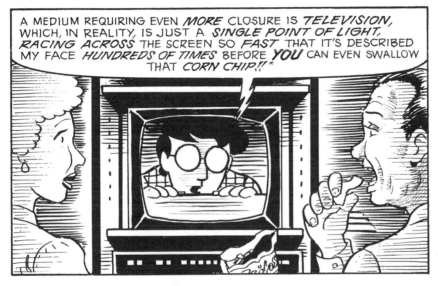

A MEDIUM REQUIRING EVEN *MORE* CLOSURE IS *TELEVISION*, WHICH, IN REALITY, IS JUST A *SINGLE POINT OF LIGHT*, *RACING ACROSS* THE SCREEN SO *FAST* THAT IT'S DESCRIBED MY FACE *HUNDREDS OF TIMES* BEFORE *YOU* CAN EVEN SWALLOW THAT *CORN CHIP!!* *

BETWEEN SUCH *AUTOMATIC ELECTRONIC* CLOSURE AND THE SIMPLER CLOSURE OF *EVERYDAY LIFE*--

--THERE LIES A MEDIUM OF COMMUNICATION AND EXPRESSION WHICH USES CLOSURE LIKE *NO OTHER*...

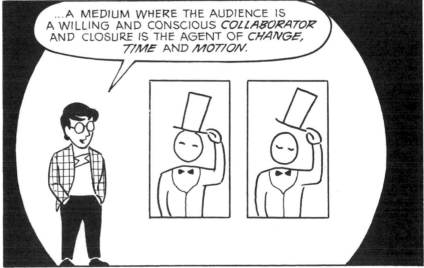

...A MEDIUM WHERE THE AUDIENCE IS A WILLING AND CONSCIOUS *COLLABORATOR* AND CLOSURE IS THE AGENT OF *CHANGE*, *TIME* AND *MOTION*.

* MEDIA GURU TONY SCHWARTZ DESCRIBES THIS AT LENGTH IN HIS BOOK *MEDIA, THE SECOND GOD*, ANCHOR BOOKS, 1983.

65

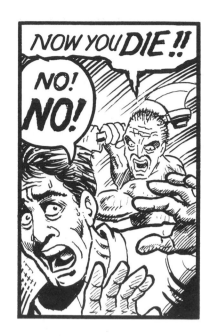

NOW YOU **DIE**!!

NO! **NO!**

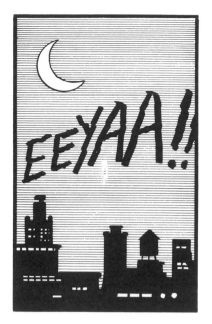

EEYAA!!

SEE THAT SPACE **BETWEEN** THE PANELS? THAT'S WHAT COMICS AFICIONADOS HAVE NAMED *"THE GUTTER."*

AND DESPITE ITS *UNCEREMONIOUS TITLE,* THE GUTTER PLAYS HOST TO MUCH OF THE *MAGIC* AND *MYSTERY* THAT ARE AT THE VERY *HEART OF COMICS!*

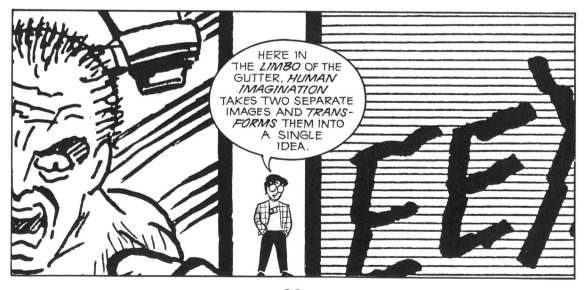

HERE IN THE *LIMBO* OF THE GUTTER, *HUMAN IMAGINATION* TAKES TWO SEPARATE IMAGES AND *TRANSFORMS* THEM INTO A SINGLE IDEA.

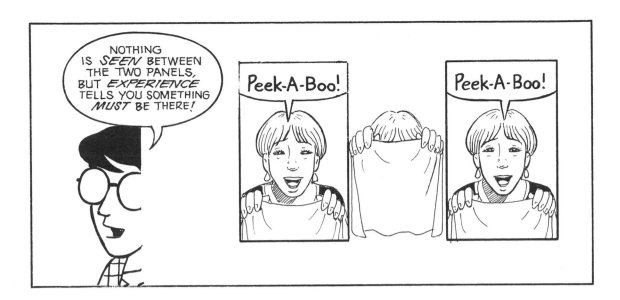

NOTHING IS *SEEN* BETWEEN THE TWO PANELS, BUT *EXPERIENCE* TELLS YOU SOMETHING *MUST* BE THERE!

Peek-A-Boo!

Peek-A-Boo!

COMICS PANELS *FRACTURE* BOTH *TIME* AND *SPACE*, OFFERING A *JAGGED, STACCATO RHYTHM* OF *UNCONNECTED MOMENTS.*

BUT CLOSURE ALLOWS US TO *CONNECT* THESE MOMENTS AND *MENTALLY CONSTRUCT* A *CONTINUOUS, UNIFIED REALITY.*

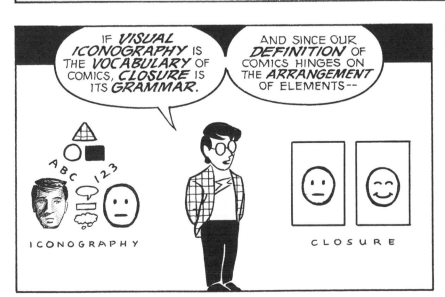

IF *VISUAL ICONOGRAPHY* IS THE *VOCABULARY* OF COMICS, *CLOSURE* IS ITS *GRAMMAR.*

AND SINCE OUR *DEFINITION* OF COMICS HINGES ON THE *ARRANGEMENT* OF ELEMENTS--

ICONOGRAPHY

CLOSURE

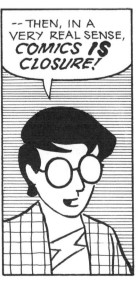

-- THEN, IN A VERY REAL SENSE, *COMICS IS CLOSURE!*

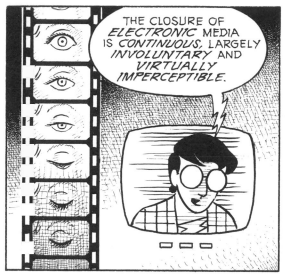

THE CLOSURE OF *ELECTRONIC* MEDIA IS *CONTINUOUS*, LARGELY *INVOLUNTARY* AND *VIRTUALLY IMPERCEPTIBLE*.

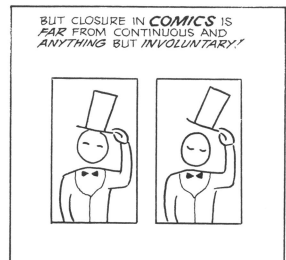

BUT CLOSURE IN *COMICS* IS *FAR* FROM CONTINUOUS AND *ANYTHING* BUT *INVOLUNTARY!*

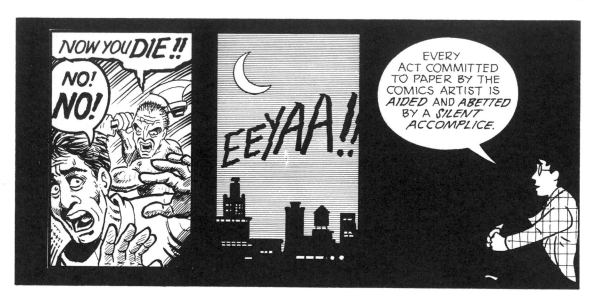

NOW YOU DIE!!

NO! NO!

EEYAA!!

EVERY ACT COMMITTED TO PAPER BY THE COMICS ARTIST IS *AIDED* AND *ABETTED* BY A *SILENT ACCOMPLICE.*

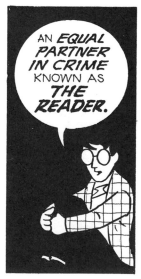

AN *EQUAL PARTNER IN CRIME* KNOWN AS *THE READER.*

I MAY HAVE DRAWN AN *AXE* BEING *RAISED* IN THIS EXAMPLE, BUT I'M NOT THE ONE WHO LET IT *DROP* OR DECIDED HOW *HARD* THE BLOW, OR *WHO* SCREAMED, OR *WHY.*

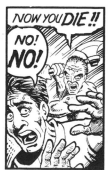

NOW YOU DIE!!

NO! NO!

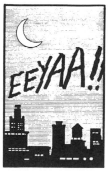

EEYAA!!

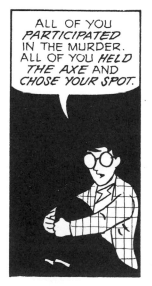

ALL OF YOU *PARTICIPATED* IN THE MURDER. ALL OF YOU *HELD THE AXE* AND *CHOSE YOUR SPOT.*

THAT, DEAR READER, WAS *YOUR SPECIAL CRIME*, EACH OF YOU COMMITTING IT IN YOUR OWN *STYLE.*

TO KILL A MAN BETWEEN PANELS IS TO CONDEMN HIM TO A THOUSAND DEATHS.

PARTICIPATION IS A *POWERFUL FORCE* IN *ANY* MEDIUM. FILMMAKERS *LONG AGO* REALIZED THE IMPORTANCE OF ALLOWING VIEWERS TO USE THEIR *IMAGINATIONS*.

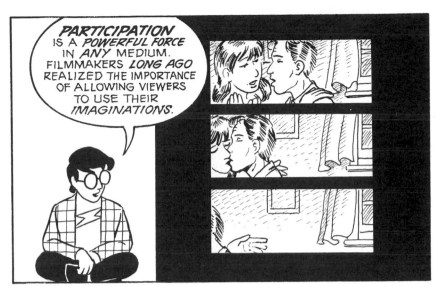

BUT WHILE *FILM* MAKES USE OF AUDIENCES' IMAGINATIONS FOR *OCCASIONAL EFFECTS*, *COMICS* MUST USE IT FAR MORE *OFTEN!*

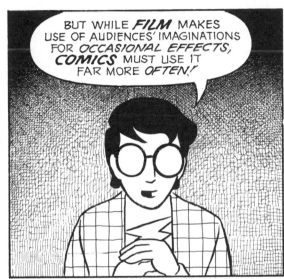

FROM THE *TOSSING* OF A *BASEBALL* TO THE *DEATH OF A PLANET*, THE READER'S *DELIBERATE, VOLUNTARY CLOSURE* IS COMICS' *PRIMARY* MEANS OF SIMULATING *TIME AND MOTION*.

CLOSURE IN COMICS FOSTERS AN INTIMACY SURPASSED ONLY BY THE *WRITTEN WORD*, A *SILENT, SECRET CONTRACT* BETWEEN *CREATOR* AND *AUDIENCE*.

HOW THE CREATOR *HONORS* THAT CONTRACT IS A MATTER OF BOTH *ART* AND *CRAFT*.

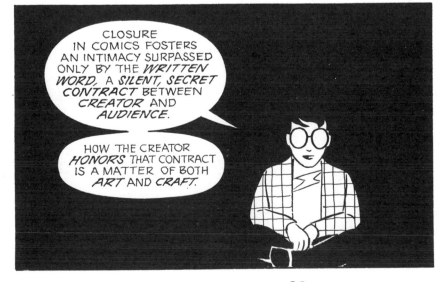

LET'S TAKE A LOOK AT THE *CRAFT*.

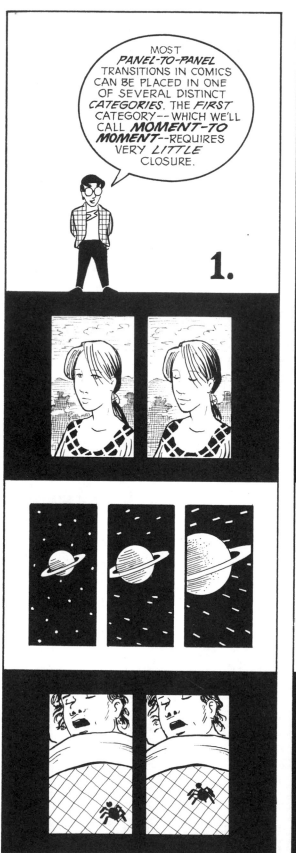

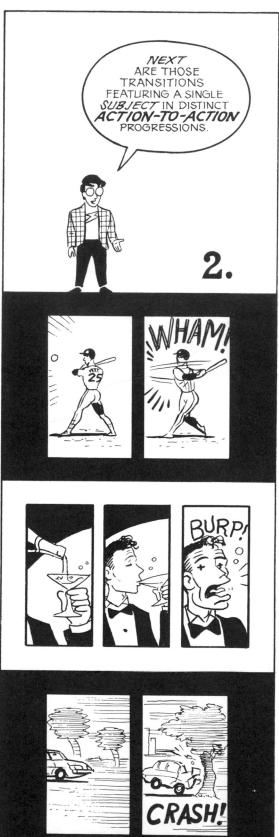

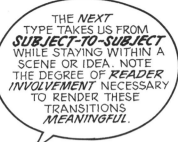
THE *NEXT* TYPE TAKES US FROM **SUBJECT-TO-SUBJECT** WHILE STAYING WITHIN A SCENE OR IDEA. NOTE THE DEGREE OF *READER INVOLVEMENT* NECESSARY TO RENDER THESE TRANSITIONS *MEANINGFUL.*

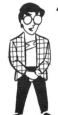

3.

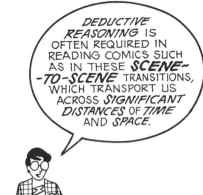
DEDUCTIVE REASONING IS OFTEN REQUIRED IN READING COMICS SUCH AS IN THESE **SCENE- -TO-SCENE** TRANSITIONS, WHICH TRANSPORT US ACROSS *SIGNIFICANT DISTANCES* OF *TIME* AND *SPACE.*

4.

NOW YOU DIE!!

NO!
NO!

EEYAA!!

HE CAN'T OUTRUN US *FOREVER!*

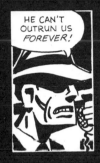
TEN YEARS LATER...
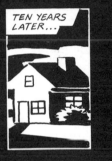

WHAT *MORE* COULD GO WRONG?!

WELL, AT LEAST *JERRY* NEVER CALLED!

RRIING.

BOMBAY!

PARIS!

NEW YORK!

FINI SH

CLIK!

NO ONE COULD HAVE SURVIVED THAT CRASH!

SNIFF! YOU'RE RIGHT.

MEANWHILE...

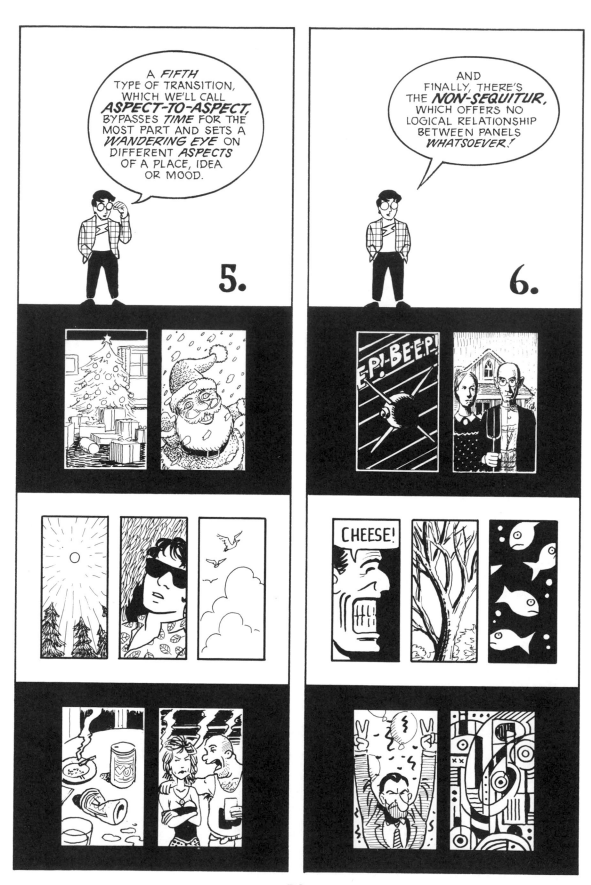

72

THIS *LAST* CATEGORY SUGGESTS AN INTERESTING *QUESTION.* IS IT POSSIBLE FOR *ANY* SEQUENCE OF PANELS TO BE *TOTALLY UNRELATED* TO EACH OTHER?

PERSONALLY, I DON'T *THINK* SO.

NO MATTER HOW *DISSIMILAR* ONE IMAGE MAY BE TO ANOTHER, THERE IS A KIND OF--

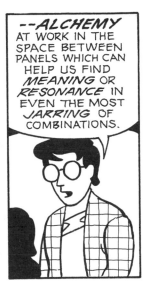

--*ALCHEMY* AT WORK IN THE SPACE BETWEEN PANELS WHICH CAN HELP US FIND *MEANING* OR *RESONANCE* IN EVEN THE MOST *JARRING* OF COMBINATIONS.

SUCH TRANSITIONS MAY NOT MAKE *"SENSE"* IN ANY TRADITIONAL WAY, BUT STILL A RELATIONSHIP OF *SOME* SORT WILL INEVITABLY *DEVELOP.*

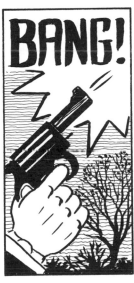

BANG!

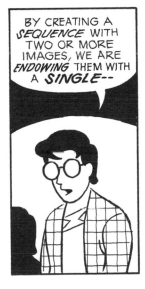

BY CREATING A *SEQUENCE* WITH TWO OR MORE IMAGES, WE ARE *ENDOWING* THEM WITH A *SINGLE*--

--*OVERRIDING IDENTITY,* AND *FORCING* THE VIEWER TO CONSIDER THEM AS A *WHOLE.*

HOWEVER *DIFFERENT* THEY HAD BEEN, THEY NOW BELONG TO A *SINGLE ORGANISM.*

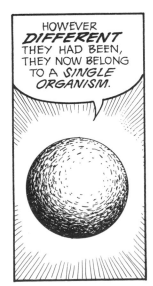

DANGER!!!!!

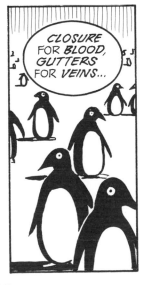

CLOSURE FOR *BLOOD,* GUTTERS FOR *VEINS...*

GE
BICYCL
PURC
CE

73

1. MOMENT-TO-MOMENT

2. ACTION-TO-ACTION

3. SUBJECT-TO-SUBJECT

4. SCENE-TO-SCENE

5. ASPECT-TO-ASPECT

6. NON-SEQUITUR

THIS SORT OF CATEGORIZATION IS AN *INEXACT SCIENCE* AT *BEST,* BUT BY USING OUR TRANSITION SCALE AS A *TOOL* --

-- WE CAN BEGIN TO UNRAVEL SOME OF THE MYSTERIES SURROUNDING THE *INVISIBLE ART* OF *COMICS* STORYTELLING!

MOST *MAINSTREAM COMICS* IN AMERICA EMPLOY STORYTELLING TECHNIQUES FIRST INTRODUCED BY *JACK KIRBY,* SO LET'S START BY EXAMINING THIS LEE-KIRBY COMIC FROM 1966.

ALTOGETHER, I COUNT *NINETY-FIVE* PANEL-TO-PANEL TRANSITIONS. LET'S SEE HOW THEY BREAK DOWN *PROPORTIONATELY.*

BY *FAR,* THE MOST COMMON TYPE OF TRANSITION IN KIRBY'S ART IS *ACTION-TO-ACTION.* I COUNT *SIXTY-TWO* OF THEM IN THIS STORY-- ABOUT *SIXTY-FIVE PERCENT* OF THE TOTAL NUMBER.

[TRACED AND SIMPLIFIED FOR CLARITY'S SAKE.]

SUBJECT-TO-SUBJECT TRANSITIONS ACCOUNT FOR AN ADDITIONAL *NINETEEN--* ABOUT *TWENTY PERCENT* OF THE TOTAL NUMBER.

74

AND SINCE **ALL** OF THE REMAINING TRANSITIONS ARE FROM **SCENE-TO-SCENE,** WE HAVE THE FOLLOWING **BREAKDOWN.**

1	—
2	65%
3	20%
4	15%
5	—
6	—

AS A **BAR GRAPH** IT WOULD LOOK SOMETHING LIKE **THIS.**

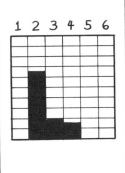

1 2 3 4 5 6

THIS EMPHASIS ON **ACTION-TO-ACTION** STORYTELLING SUITS MOST PEOPLE'S IDEAS ABOUT **KIRBY,** BUT IS HE **UNIQUE** IN THIS RESPECT?

APPARENTLY **NOT!** HERE'S A GRAPH OF PANEL TRANSITIONS IN HERGÉ'S **TINTIN** AND THE PROPORTION ARE VERY **SIMILAR** TO KIRBY'S

1 2 3 4 5 6

NOW, HERGÉ'S AND KIRBY'S STYLES ARE **NOT** SIMILAR! IN FACT, THEY'RE **RADICALLY DIFFERENT!!!**

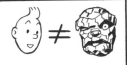

IS THERE SOME KIND OF **UNIVERSAL PROPORTION** AT WORK HERE, OR IS THERE ANOTHER **COMMON LINK?** MAYBE A SIMILARITY OF **GENRES?**

A RANDOM SAMPLING OF VARIOUS AMERICAN COMICS SHOWS THIS SAME PROPORTION PRETTY **CONSISTENTLY.**

X-MEN #1

CLAREMONT & LEE

"HEARTBREAK SOUP"

G. HERNANDEZ

BETTY & VERONICA

DOYLE & DECARLO

NAUGHTY BITS

GREGORY

FRANK IN THE RIVER

WOODRING

A CONTRACT WITH GOD

EISNER

MAUS

SPIEGELMAN

DONALD DUCK

BARKS

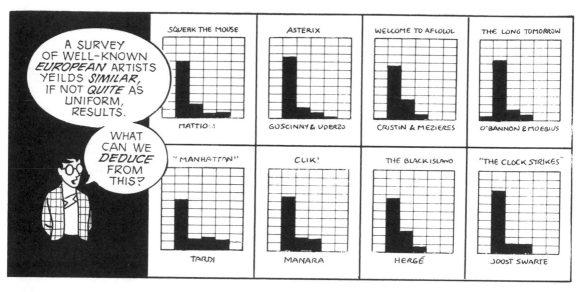

A SURVEY OF WELL-KNOWN *EUROPEAN* ARTISTS YEILDS *SIMILAR*, IF NOT *QUITE* AS UNIFORM, RESULTS.

WHAT CAN WE *DEDUCE* FROM THIS?

SQUEAK THE MOUSE — MATTIOLI

ASTERIX — GOSCINNY & UDERZO

WELCOME TO AFLOLOL — CRISTIN & MEZIERES

THE LONG TOMORROW — O'BANNON & MOEBIUS

"MANHATTAN" — TARDI

CLIK! — MANARA

THE BLACK ISLAND — HERGÉ

"THE CLOCK STRIKES" — JOOST SWARTE

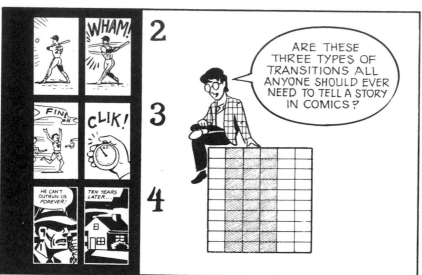

ARE THESE THREE TYPES OF TRANSITIONS ALL ANYONE SHOULD EVER NEED TO TELL A STORY IN COMICS?

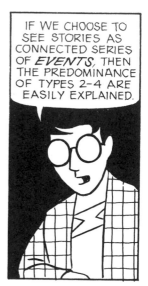

IF WE CHOOSE TO SEE STORIES AS CONNECTED SERIES OF *EVENTS*, THEN THE PREDOMINANCE OF TYPES 2–4 ARE EASILY EXPLAINED.

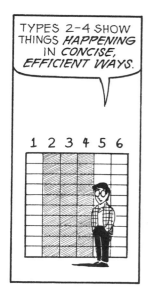

TYPES 2–4 SHOW THINGS *HAPPENING* IN *CONCISE*, *EFFICIENT WAYS*.

1 2 3 4 5 6

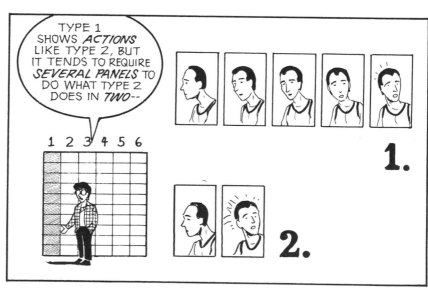

TYPE 1 SHOWS *ACTIONS* LIKE TYPE 2, BUT IT TENDS TO REQUIRE *SEVERAL PANELS* TO DO WHAT TYPE 2 DOES IN *TWO*--

1 2 3 4 5 6

1.

2.

--WHILE IN THE *FIFTH* TYPE, BY DEFINITION, NOTHING *"HAPPENS"* AT ALL!

1 2 3 4 5 6

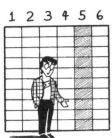

AND, OF COURSE, NON-SEQUITURS ARE UNCONCERNED WITH *EVENTS* OR ANY *NARRATIVE* PURPOSES OF ANY SORT.

1 2 3 4 5 6

SOME *EXPERIMENTAL COMICS,* LIKE THOSE OF *ART SPIEGELMAN'S* EARLY PERIOD, EXPLORE A *FULL RANGE* OF TRANSITIONS--

--THOUGH GENERALLY IN THE SERVICE OF EQUALLY RADICAL STORIES AND SUBJECTS.

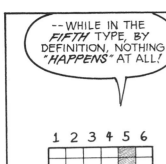

STORIES FROM SPIEGELMAN'S ANTHOLOGY *BREAKDOWNS:*

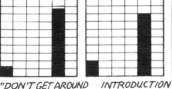

"DON'T GET AROUND MUCH ANYMORE" INTRODUCTION "MAUS" (ORIGINAL)

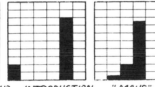

"SKINLESS PERKINS" "PRISONER ON THE HELL PLANET" "CRACKING JOKES"

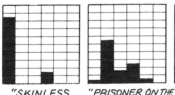

FRONT AND BACK COVERS "ACE-HOLE, MIDGET DETECTIVE" "REAL DREAM" 1975

BUT BEFORE WE CONCLUDE THAT TYPES 2-4 HAVE A MONOPOLY ON *STRAIGHTFORWARD* STORYTELLING, LET'S TAKE ANOTHER LOOK AT *OSAMU TEZUKA* FROM *JAPAN.*

TEZUKA IS A *FAR CRY* FROM THE EARLY SPIEGELMAN. HIS STORYTELLING IS CLEAR AND STRAIGHTFORWARD. *BUT LOOK AT HOW HE CHARTS!*

1 2 3 4 5 6

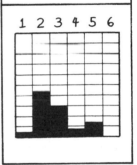

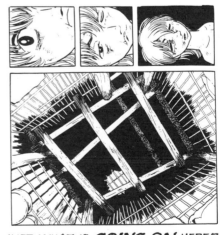

JUST WHAT IS *GOING ON* HERE?

77

ACTION-TO-ACTION TRANSITIONS STILL DOMINATE IN TEZUKA'S WORK, BUT TO A *LESSER DEGREE*.

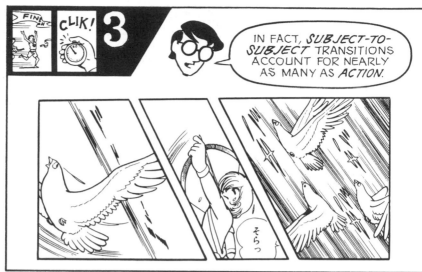

IN FACT, *SUBJECT-TO-SUBJECT* TRANSITIONS ACCOUNT FOR NEARLY AS MANY AS *ACTION*.

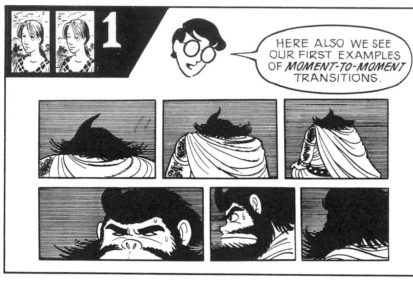

HERE ALSO WE SEE OUR FIRST EXAMPLES OF *MOMENT-TO-MOMENT* TRANSITIONS.

THOUGH THE LATTER TYPE ONLY ACCOUNTS FOR *FOUR PERCENT* OF THE TOTAL, SUCH SEQUENCES CONTRAST STRIKINGLY WITH THE WESTERN TRADITIONS EXEMPLIFIED BY KIRBY AND HERGÉ.

\TFEL OT THGIR DAER OT REBMEMER

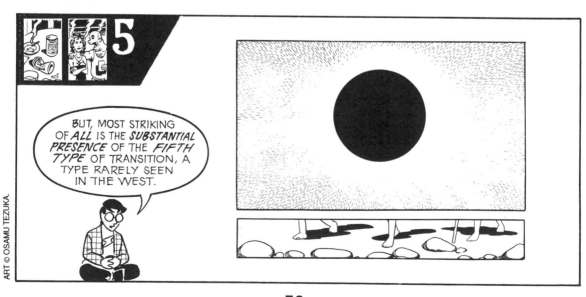

BUT, MOST STRIKING OF *ALL* IS THE *SUBSTANTIAL PRESENCE* OF THE *FIFTH TYPE* OF TRANSITION, A TYPE RARELY SEEN IN THE WEST.

水木は夜の古寺にいってみることにした

ASPECT-TO-ASPECT TRANSITIONS HAVE BEEN AN INTEGRAL PART OF *JAPANESE MAINSTREAM COMICS* ALMOST FROM THE VERY *BEGINNING.*

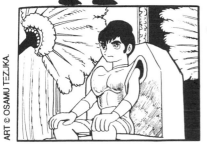

MOST OFTEN USED TO ESTABLISH A *MOOD* OR A *SENSE OF PLACE*, TIME SEEMS TO *STAND STILL* IN THESE QUIET, CONTEMPLATIVE COMBINATIONS.

EVEN *SEQUENCE*, WHILE STILL AN ISSUE, SEEMS FAR LESS IMPORTANT HERE THAN IN OTHER TRANSITIONS.

RATHER THAN ACTING AS A BRIDGE BETWEEN *SEPARATE* MOMENTS, THE READER *HERE* MUST ASSEMBLE A *SINGLE* MOMENT USING *SCATTERED FRAGMENTS.*

79

IN EXAMINING *SEVERAL* JAPANESE ARTISTS, WE FIND SIMILAR PROPORTIONS TO TEZUKA'S, INCLUDING A HIGH INCIDENCE OF THE *FIFTH TYPE.*

WHY?

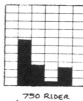

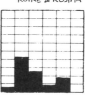

750 RIDER
(右井いさみ?)

FATHER & SON
HAYASI & OSIMA

WOLF & CUB
KOIKE & KOJIMA

AKIRA
KATSUHIRO OTOMO

CYBORG 009
SHOTARU ISHIMORI

PHOENIX
OSAMU TEZUKA

LENGTH MAY BE ONE OF THE FACTORS AT WORK HERE. MOST JAPANESE COMICS FIRST APPEAR IN ENORMOUS *ANTHOLOGY* TITLES WHERE THE PRESSURE ISN'T AS GREAT ON ANY ONE INSTALLMENT TO SHOW A LOT *"HAPPENING."*

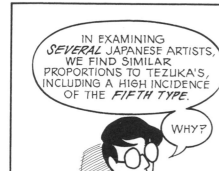

WHEN INDIVIDUAL FEATURES ARE *COLLECTED,* THEY MAY RUN FOR *THOUSANDS* OF PAGES.

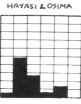

AS SUCH, *DOZENS* OF PANELS CAN BE DEVOTED TO PORTRAYING *SLOW CINEMATIC MOVEMENT* OR TO *SETTING A MOOD.*

BUT I DON'T THINK *LONGER STORIES* ARE THE *ONLY* FACTOR, OR EVEN THE MOST *IMPORTANT* ONE.

I BELIEVE THERE'S SOMETHING A BIT MORE *FUNDAMENTAL* TO THIS PARTICULAR EAST/WEST SPLIT.

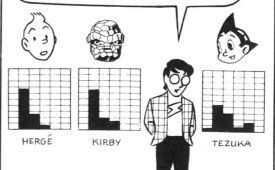

HERGÉ

KIRBY

TEZUKA

80

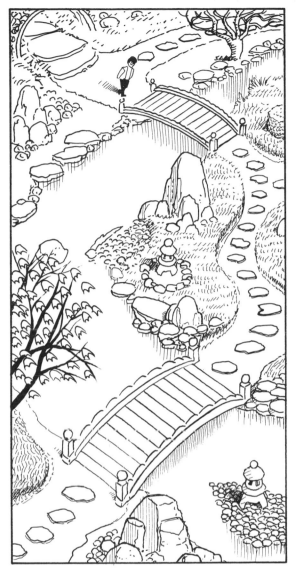

MMM... WHERE *WAS* I ?

OH, YES...

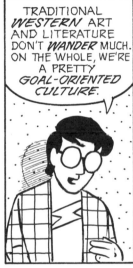

TRADITIONAL *WESTERN* ART AND LITERATURE DON'T *WANDER* MUCH. ON THE WHOLE, WE'RE A PRETTY *GOAL-ORIENTED* CULTURE.

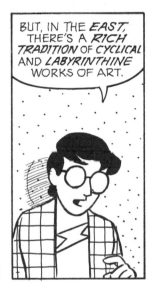

BUT, IN THE *EAST,* THERE'S A *RICH TRADITION* OF *CYCLICAL* AND *LABYRINTHINE* WORKS OF ART.

JAPANESE COMICS MAY BE *HEIRS* TO THIS TRADITION, IN THE WAY THEY SO OFTEN EMPHASIZE *BEING THERE* OVER *GETTING THERE.*

THROUGH THESE AND OTHER STORYTELLING TECHNIQUES, THE JAPANESE OFFER A VISION OF COMICS VERY *DIFFERENT* FROM OUR OWN.

FOR IN *JAPAN* MORE THAN *ANYWHERE ELSE,* COMICS IS AN ART--

81

--OF *INTERVALS*.

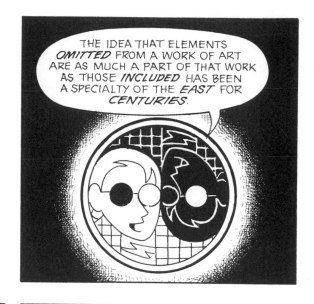

THE IDEA THAT ELEMENTS *OMITTED* FROM A WORK OF ART ARE AS MUCH A PART OF THAT WORK AS THOSE *INCLUDED* HAS BEEN A SPECIALTY OF THE *EAST* FOR *CENTURIES*.

IN THE GRAPHIC ARTS THIS HAS MEANT A GREATER FOCUS ON *FIGURE/GROUND* RELATIONSHIPS AND *"NEGATIVE SPACE."*

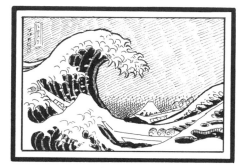

"THE GREAT WAVE OFF KANAG'AWA" BY HOKUSAI (c.1829) (TURN THIS PICTURE UPSIDE DOWN TO SEE THE *OTHER* WAVE OF NEGATIVE SPACE...NATURE'S *YIN AND YANG*.)

IN MUSIC TOO, WHILE THE WESTERN CLASSICAL TRADITION WAS EMPHASIZING THE *CONTINUOUS, CONNECTED* WORLDS OF MELODY AND HARMONY, EASTERN CLASSICAL MUSIC WAS EQUALLY CONCERNED WITH THE ROLE OF *SILENCE!*

WEST

EAST

IN THE LAST *CENTURY* OR TWO, AS *WESTERN* CULTURAL INFLUENCES SWEPT THE *EAST*, SO TOO HAVE *EASTERN* AND *AFRICAN* IDEAS OF *FRAGMENTATION* AND *RHYTHM* SWEPT THE *WEST*.

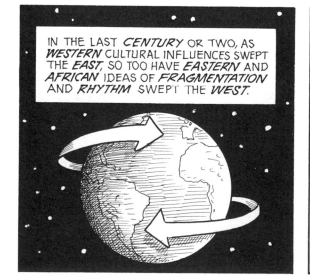

FROM *DEBUSSY* TO *STRAVINSKY* TO *COUNT BASIE*, WESTERN MUSIC HAS GRADUALLY INCORPORATED A STRONG AWARENESS OF THE POWER OF *FRAGMENTATION* AND *INTERVALS*.

BASIE

BASIE'S BAND.

IN THE *VISUAL* ARTS, THE IMPACT OF EASTERN IDEAS WAS BOTH POWERFUL AND *LASTING.*

THE TRADITIONAL EMPHASIS IN WESTERN ART UPON THE PRIMACY OF *FOREGROUND* SUBJECTS AND *CONTINUOUSNESS* OF *TONES* GAVE WAY TO *FRAGMENTATION* AND A NEW AWARENESS OF THE *PICTURE PLANE.*

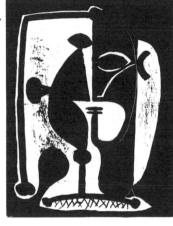

FACSIMILE OF "FIGURE" BY PABLO PICASSO 1948

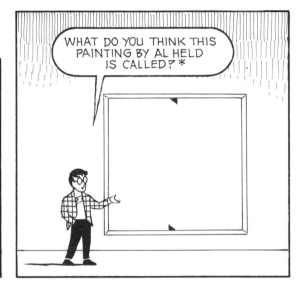

WHAT DO YOU THINK THIS PAINTING BY AL HELD IS CALLED? *

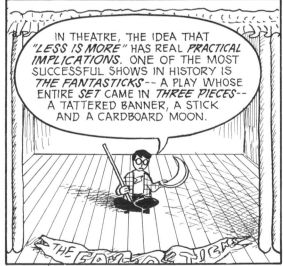

IN THEATRE, THE IDEA THAT *"LESS IS MORE"* HAS REAL *PRACTICAL IMPLICATIONS.* ONE OF THE MOST SUCCESSFUL SHOWS IN HISTORY IS *THE FANTASTICKS*-- A PLAY WHOSE ENTIRE *SET* CAME IN *THREE PIECES*-- A TATTERED BANNER, A STICK AND A CARDBOARD MOON.

THE MASTERY OF *ANY* MEDIUM USING MINIMAL ELEMENTS HAS LONG BEEN CONSIDERED A *NOBLE ASPIRATION.*

*ANSWER: "THE BIG 'N'"
[SEE PAGE 216]

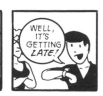
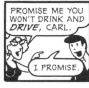
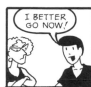

* "BRUM" APPEARS COURTESY OF M. FEAZELL

HERE'S A STORY.

PROMISE ME YOU WON'T DRINK AND *DRIVE*, CARL.

I PROMISE.

BRUM!

HERE I AM!

HERE'S A STORY.

PROMISE ME YOU WON'T DRINK AND *DRIVE*, CARL.

I PROMISE.

I'LL BUY SOME *BEERS*.

HI, CARL! HI, DAISY!

I'M SORRY, CARL, BUT I CAN'T GO OUT WITH YOU TONIGHT.

AWW!

WHAT'LL I DO *NOW*?

GLUG! GLUG! BUD

I'LL BUY SOME *BEERS*.

GLUG! GLUG! BUD

CRASH!

R.I.P. CARL

END

CRASH!

R.I.P. CARL

END

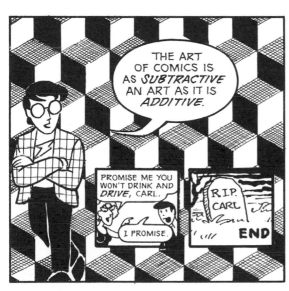
THE ART OF COMICS IS AS *SUBTRACTIVE* AN ART AS IT IS *ADDITIVE*.

PROMISE ME YOU WON'T DRINK AND *DRIVE*, CARL.

I PROMISE.

R.I.P. CARL

END

AND FINDING THE BALANCE BETWEEN *TOO MUCH* AND *TOO LITTLE* IS CRUCIAL TO COMICS CREATORS THE WORLD OVER.

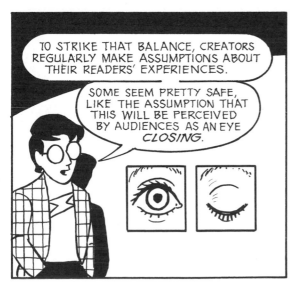
TO STRIKE THAT BALANCE, CREATORS REGULARLY MAKE ASSUMPTIONS ABOUT THEIR READERS' EXPERIENCES.

SOME SEEM PRETTY SAFE, LIKE THE ASSUMPTION THAT THIS WILL BE PERCEIVED BY AUDIENCES AS AN EYE *CLOSING*.

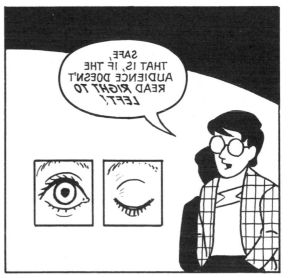
SAFE, THAT IS, IF THE AUDIENCE DOESN'T READ RIGHT TO LEFT!

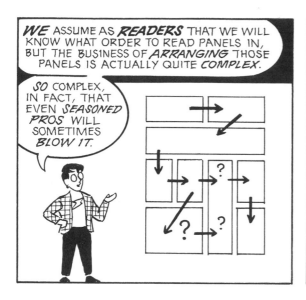

WE ASSUME AS *READERS* THAT WE WILL KNOW WHAT ORDER TO READ PANELS IN, BUT THE BUSINESS OF *ARRANGING* THOSE PANELS IS ACTUALLY QUITE *COMPLEX.*

SO COMPLEX, IN FACT, THAT EVEN *SEASONED PROS* WILL SOMETIMES *BLOW IT.*

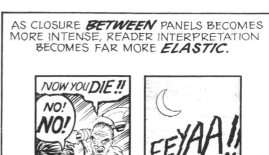

AS CLOSURE *BETWEEN* PANELS BECOMES MORE INTENSE, READER INTERPRETATION BECOMES FAR MORE *ELASTIC.*

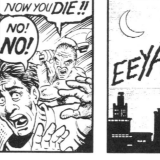

NOW YOU *DIE* !!

NO! NO!

EEYAA!!

AND *MANAGING* IT BECOMES MORE COMPLICATED FOR THE *CREATOR.*

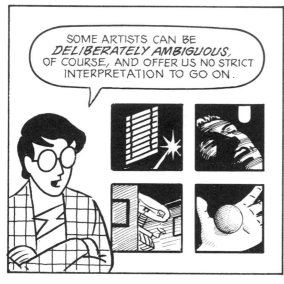

SOME ARTISTS CAN BE *DELIBERATELY AMBIGUOUS,* OF COURSE, AND OFFER US NO STRICT INTERPRETATION TO GO ON.

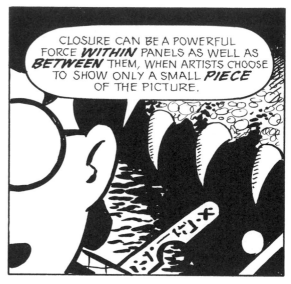

CLOSURE CAN BE A POWERFUL FORCE *WITHIN* PANELS AS WELL AS *BETWEEN* THEM, WHEN ARTISTS CHOOSE TO SHOW ONLY A SMALL *PIECE* OF THE PICTURE.

COMICS CAN BE *MADDENINGLY VAGUE* ABOUT WHAT IT SHOWS US.

BY SHOWING LITTLE OR NOTHING OF A GIVEN SCENE--

--AND OFFERING ONLY *CLUES* TO THE READER--

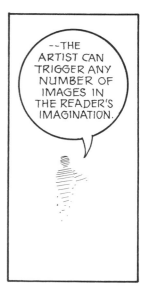

--THE ARTIST CAN TRIGGER ANY NUMBER OF IMAGES IN THE READER'S IMAGINATION.

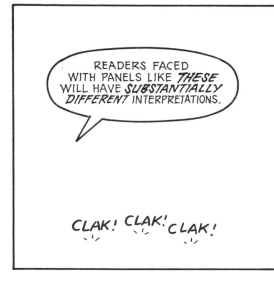

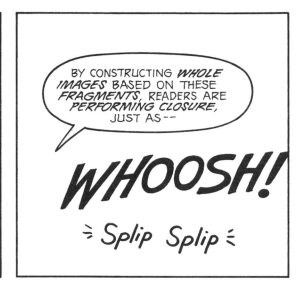

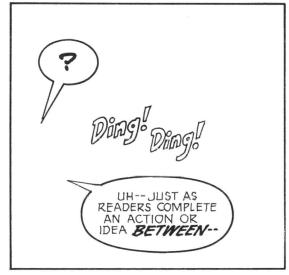

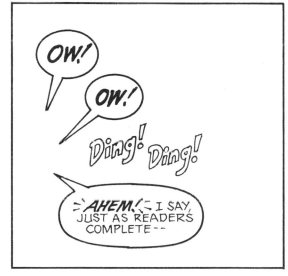

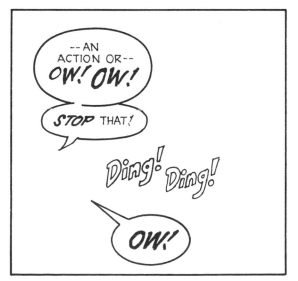

WHATEVER THE MYSTERIES *WITHIN* EACH PANEL, IT'S THE POWER OF CLOSURE *BETWEEN* PANELS THAT I FIND THE MOST *INTERESTING.*

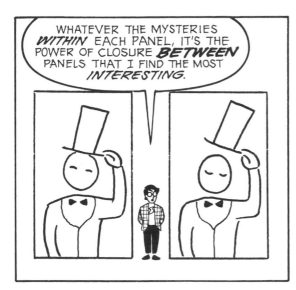

THERE'S SOMETHING *STRANGE* AND *WONDERFUL* THAT HAPPENS IN THIS *BLANK RIBBON OF PAPER.*

WE ALREADY KNOW THAT COMICS ASKS THE MIND TO WORK AS A SORT OF *IN-BETWEENER* -- FILLING IN THE GAPS BETWEEN PANELS AS AN *ANIMATOR* MIGHT-- BUT I BELIEVE THERE'S STILL MORE TO IT THAN THAT.

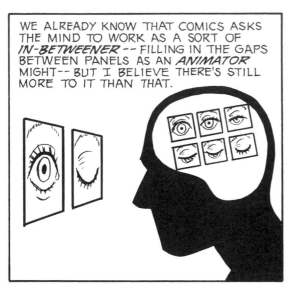

LET'S TAKE ANOTHER LOOK AT THE *FIFTH* TYPE OF TRANSITION, THE ONE SO POPULAR IN JAPAN.

HERE'S A FOUR-PANEL *ESTABLISHING* SHOT OF AN *OLD-FASHIONED* KITCHEN SCENE.

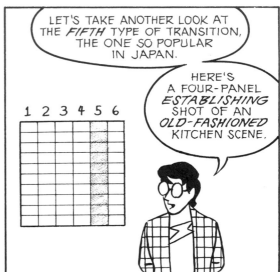

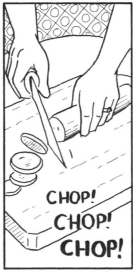

CHOP!
CHOP!
CHOP!

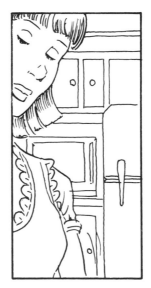

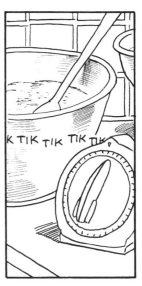

K TIK TIK TIK TIK

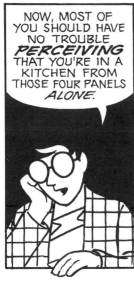

NOW, MOST OF YOU SHOULD HAVE NO TROUBLE *PERCEIVING* THAT YOU'RE IN A KITCHEN FROM THOSE FOUR PANELS *ALONE.*

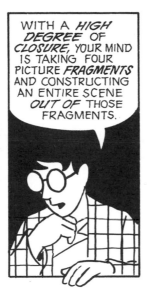

WITH A *HIGH DEGREE* OF *CLOSURE,* YOUR MIND IS TAKING FOUR PICTURE *FRAGMENTS* AND CONSTRUCTING AN ENTIRE SCENE *OUT OF* THOSE FRAGMENTS.

BUT THE SCENE YOUR MIND CONSTRUCTS FROM THOSE *FOUR* PANELS IS A VERY *DIFFERENT PLACE* FROM THE SCENE CONSTRUCTED FROM OUR TRADITIONAL *ONE-PANEL* ESTABLISHING SHOT!

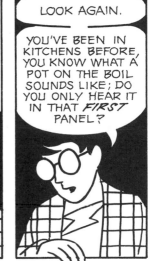

LOOK AGAIN.

YOU'VE BEEN IN KITCHENS BEFORE, YOU KNOW WHAT A POT ON THE BOIL SOUNDS LIKE; DO YOU ONLY HEAR IT IN THAT *FIRST* PANEL?

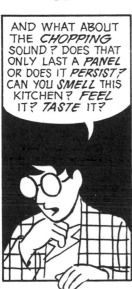

AND WHAT ABOUT THE *CHOPPING* SOUND? DOES THAT ONLY LAST A *PANEL* OR DOES IT *PERSIST?* CAN YOU *SMELL* THIS KITCHEN? *FEEL* IT? *TASTE* IT?

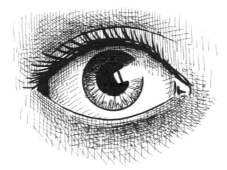

COMICS IS A *MONO-SENSORY* MEDIUM. IT RELIES ON ONLY *ONE* OF THE SENSES TO CONVEY A *WORLD* OF EXPERIENCE.

BUT WHAT OF THE OTHER *FOUR?*

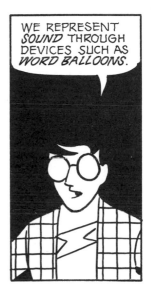

WE REPRESENT *SOUND* THROUGH DEVICES SUCH AS *WORD BALLOONS.*

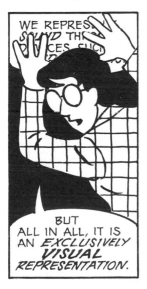

WE REPRES... *SOUND* TH... DEVICES SUC...

BUT ALL IN ALL, IT IS AN *EXCLUSIVELY VISUAL REPRESENTATION.*

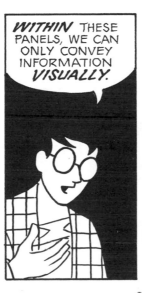

WITHIN THESE PANELS, WE CAN ONLY CONVEY INFORMATION *VISUALLY.*

BUT *BETWEEN* PANELS, NONE OF OUR SENSES ARE REQUIRED AT ALL.

WHICH IS WHY *ALL* OF OUR SENSES ARE ENGAGED!

SEVERAL TIMES ON EVERY PAGE THE READER IS *RELEASED*--LIKE A *TRAPEZE ARTIST*-- INTO THE OPEN AIR OF *IMAGINATION*...

...THEN *CAUGHT* BY THE OUTSTRETCHED ARMS OF THE *EVER-PRESENT NEXT PANEL!*

CAUGHT *QUICKLY* SO AS NOT TO LET THE READER *FALL* INTO *CONFUSION* OR *BOREDOM.*

BUT IS IT POSSIBLE THAT CLOSURE CAN BE SO MANAGED IN SOME CASES--

--THAT THE READER MIGHT LEARN TO *FLY?*

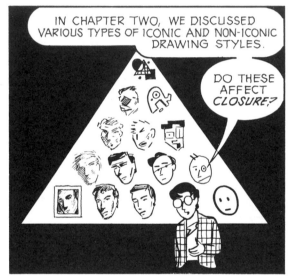

IN CHAPTER TWO, WE DISCUSSED VARIOUS TYPES OF ICONIC AND NON-ICONIC DRAWING STYLES.

DO THESE AFFECT *CLOSURE?*

I THINK THE ANSWER IS *YES.*

SINCE CARTOONS ALREADY EXIST AS CONCEPTS FOR THE READER, THEY TEND TO FLOW EASILY THROUGH THE CONCEPTUAL TERRITORY *BETWEEN* PANELS.

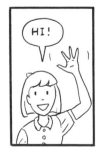

HI!

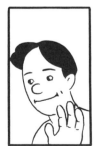

IDEAS FLOWING INTO ONE ANOTHER *SEAMLESSLY.*

BUT *REALISTIC* IMAGES HAVE A BUMPIER RIDE. THEIRS IS A PRIMARILY *VISUAL* EXISTENCE WHICH DOESN'T PASS EASILY INTO THE REALM OF IDEAS.

AND SO, WHAT SEEMED LIKE A CONTINUOUS SERIES OF MOMENTS IN THE LAST EXAMPLE, HERE LOOKS A LITTLE MORE LIKE A SERIES OF *STILL PICTURES*...

...TO *ME* ANYWAY. THESE THINGS ARE ALL *SUBJECTIVE!*

SIMILARLY, I THINK WHEN COMICS ART VEERS CLOSER TO CONCERNS OF THE *PICTURE PLANE*, CLOSURE CAN BE MORE DIFFICULT TO ACHIEVE, THOUGH FOR DIFFERENT REASONS.

NOW IT'S THE *UNIFYING PROPERTIES* OF *DESIGN* THAT MAKE US MORE AWARE OF THE PAGE AS A *WHOLE*, RATHER THAN ITS INDIVIDUAL COMPONENTS, THE *PANELS.*

A GOOD RULE OF THUMB IS THAT IF READERS ARE PARTICULARLY *AWARE* OF THE ART IN A GIVEN STORY--

--THEN CLOSURE IS PROBABLY NOT HAPPENING WITHOUT SOME *EFFORT.*

OF COURSE, MAKING THE READER *WORK* A LITTLE MAY BE JUST WHAT THE ARTIST IS *TRYING* TO DO. ONCE AGAIN, IT'S ALL A MATTER OF *PERSONAL TASTE.*

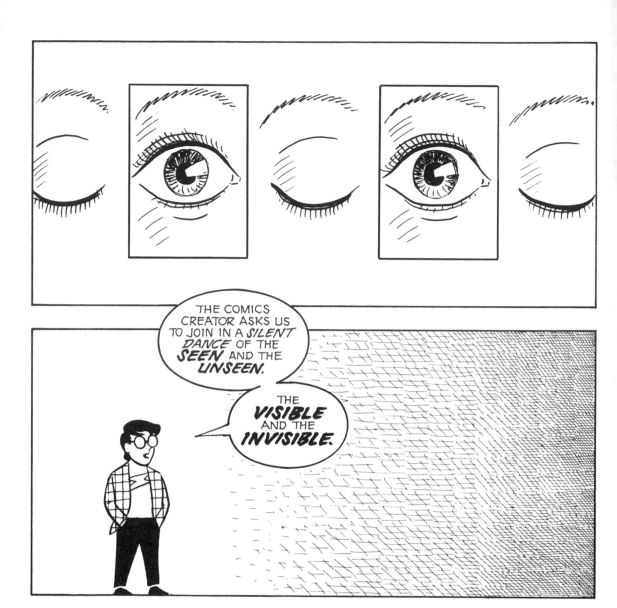

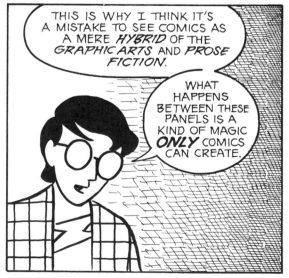

HERE IN THIS STUDIO, I'VE TRIED TO *CONTROL* THAT PROCESS AND USE IT TO MAKE MY CASE.

BUT I CAN ONLY *POINT THE WAY.* I CAN'T TAKE YOU *ANYWHERE* YOU DON'T WANT TO *GO.*

ALL I CAN DO IS MAKE *ASSUMPTIONS* ABOUT YOU AND HOPE THAT THEY'RE *CORRECT*--

--JUST AS WE *ALL* ASSUME, *EVERY DAY,* THAT THERE'S MORE TO LIFE THAN MEETS THE EYE.

ALL I ASK OF YOU IS A LITTLE *FAITH*--

--AND A *WORLD* OF *IMAGINATION.*

CHAPTER FOUR

TIME FRAMES.

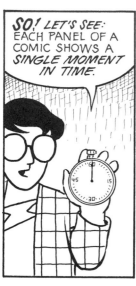

SO! LET'S SEE: EACH PANEL OF A COMIC SHOWS A *SINGLE MOMENT IN TIME.*

AND **BETWEEN** THOSE FROZEN MOMENTS -- BETWEEN THE PANELS -- OUR MINDS FILL IN THE *INTERVENING MOMENTS,* CREATING THE ILLUSION OF *TIME AND MOTION.*

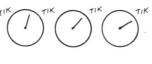

TIK TIK TIK TIK

LIKE A LINE DRAWN BETWEEN TWO POINTS.

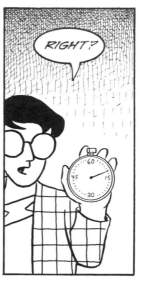

RIGHT?

CLIK

NAAH! OF *COURSE* NOT!

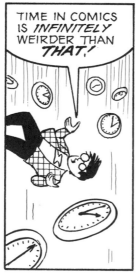

TIME IN COMICS IS *INFINITELY* WEIRDER THAN *THAT!*

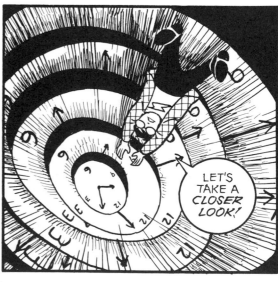

LET'S TAKE A *CLOSER* LOOK!

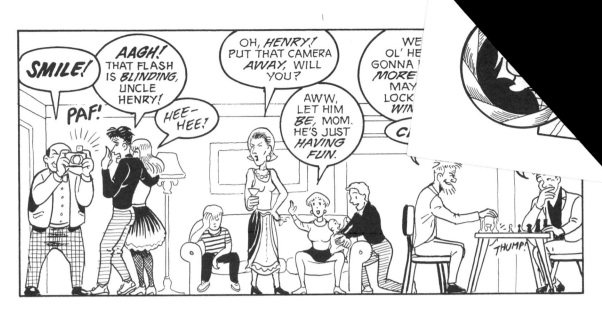

SMILE!

PAF!

AAGH! THAT FLASH IS *BLINDING*, UNCLE HENRY!

HEE-HEE!

OH, *HENRY!* PUT THAT CAMERA *AWAY*, WILL YOU?

AWW, LET HIM *BE*, MOM. HE'S JUST *HAVING FUN.*

WE OL' HE GONNA MORE MAY LOCK WIN

C

THUMP!

SINGLE MOMENT? *HARDLY!*

WHIRRRRRR

EVEN THE BRIEF SOUND OF A *FLASHBULB* HAS A CERTAIN *DURATION*, SHORT TO BE *SURE*, BUT NOT *INSTANTANEOUS!*

PAF!

FAR *SLOWER* IS THE DURATION OF THE AVERAGE *WORD.* UNCLE HENRY *ALONE* BURNS UP A GOOD *SECOND* IN THIS PANEL, ESPECIALLY SINCE *"SMILE!"* UNDOUBTEDLY *PRECEDED* THE FLASH.

SMILE!

PAF!

LIKEWISE, THE NEXT BALLOONS COULD HAVE ONLY *FOLLOWED* THE BURST OF THE FLASHBULB, THUS ADDING STILL *MORE* TIME.

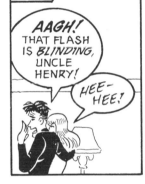

AAGH! THAT FLASH IS *BLINDING*, UNCLE HENRY!

HEE-HEE!

JUST AS PICTURES AND THE INTERVALS *BETWEEN* THEM CREATE THE ILLUSION OF TIME THROUGH *CLOSURE*, *WORDS* INTRODUCE TIME BY REPRESENTING THAT WHICH CAN ONLY EXIST *IN* TIME -- *SOUND.*

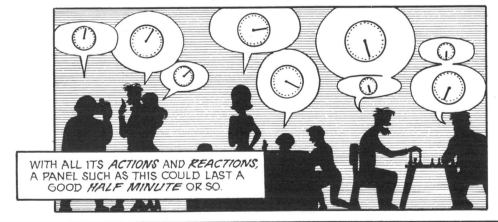

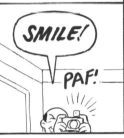

WITH ALL ITS *ACTIONS* AND *REACTIONS*, A PANEL SUCH AS THIS COULD LAST A GOOD *HALF MINUTE* OR SO.

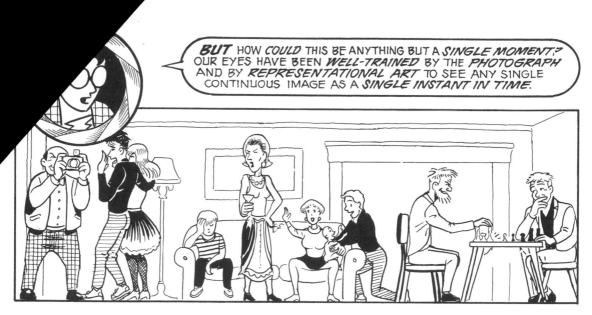

BUT HOW *COULD* THIS BE ANYTHING BUT A *SINGLE MOMENT?* OUR EYES HAVE BEEN *WELL-TRAINED* BY THE *PHOTOGRAPH* AND BY *REPRESENTATIONAL ART* TO SEE ANY SINGLE CONTINUOUS IMAGE AS A *SINGLE INSTANT IN TIME.*

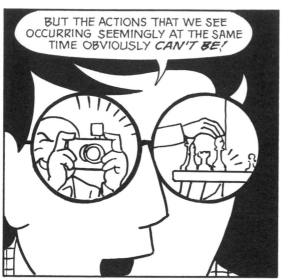

BUT THE ACTIONS THAT WE SEE OCCURRING SEEMINGLY AT THE SAME TIME OBVIOUSLY *CAN'T BE!*

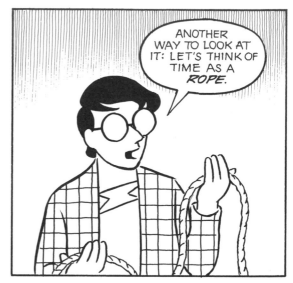

ANOTHER WAY TO LOOK AT IT: LET'S THINK OF TIME AS A *ROPE.*

EACH INCH REPRESENTS A *SECOND.*

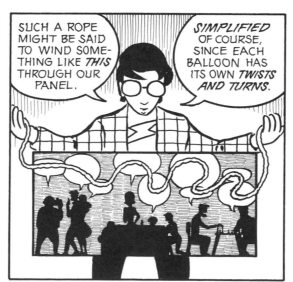

SUCH A ROPE MIGHT BE SAID TO WIND SOMETHING LIKE *THIS* THROUGH OUR PANEL.

SIMPLIFIED OF COURSE, SINCE EACH BALLOON HAS ITS OWN *TWISTS AND TURNS.*

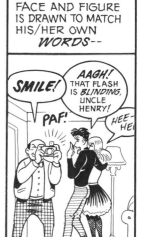

AND SINCE EACH FACE AND FIGURE IS DRAWN TO MATCH HIS/HER OWN *WORDS*--

SMILE!

PAF!

AAGH! THAT FLASH IS *BLINDING,* UNCLE HENRY!

HEE-HE

96

--THOSE FIGURES, FACES AND WORDS ARE MATCHED IN *TIME* AS WELL.

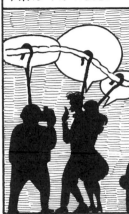

THE PROPERTIES OF THE SINGLE CONTINUOUS *IMAGE*, MEANWHILE, TEND TO MATCH EACH FIGURE WITH EVERY *OTHER* FIGURE.

SINGLE *IMAGE*.

SINGLE *MOMENT*.

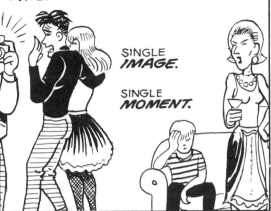

PORTRAYING TIME ON A LINE MOVING *LEFT TO RIGHT*, THIS PUTS ALL THE *IMAGES* ON THE SAME VERTICAL AXIS.

AND *TANGLES UP TIME* BEYOND *ALL RECOGNITION!*

SNAP!

SNAP!

CRASH!

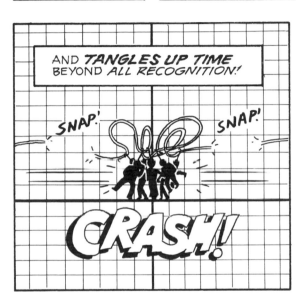

PERHAPS WE'VE BEEN TOO CONDITIONED BY PHOTOGRAPHY TO PERCEIVE SINGLE IMAGES AS *SINGLE MOMENTS*. AFTER ALL, IT DOES TAKE AN EYE *TIME* TO MOVE ACROSS SCENES IN *REAL LIFE!*

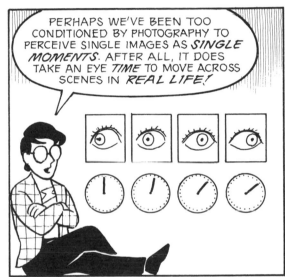

EACH FIGURE IS ARRANGED FROM *LEFT TO RIGHT* IN THE SEQUENCE WE WILL *"READ"* THEM, EACH OCCUPYING A DISTINCT *TIME SLOT*.

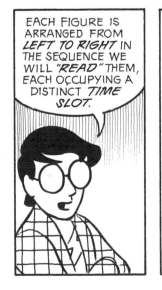

IN SOME RESPECTS THIS PANEL BY ITSELF ACTUALLY *FITS* OUR *DEFINITION* OF COMICS! ALL IT NEEDS IS A FEW *GUTTERS* THROWN IN TO *CLARIFY THE SEQUENCE*.

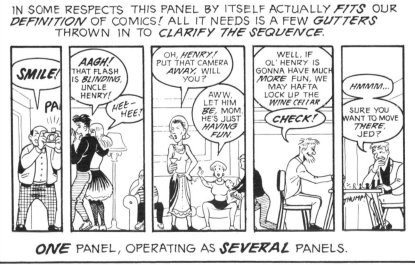

SMILE!

PA

AAGH! THAT FLASH IS *BLINDING*, UNCLE HENRY!

HEE-HEE!

OH, *HENRY!* PUT THAT CAMERA *AWAY*, WILL YOU?

AWW, LET HIM *BE*, MOM, HE'S JUST *HAVING FUN*.

WELL, IF OL' HENRY IS GONNA HAVE MUCH *MORE FUN*, WE MAY HAFTA LOCK UP THE *WINE CELLAR*

CHECK!

HMMM...

SURE YOU WANT TO MOVE *THERE*, JED?

THUMP!

ONE PANEL, OPERATING AS *SEVERAL* PANELS.

NOT *ALL* PANELS ARE LIKE THAT, OF COURSE.

A SILENT PANEL SUCH AS THIS COULD *INDEED* BE SAID TO DEPICT A *SINGLE MOMENT!*

HE'S GIVING IT HIS *ALL,* FOLKS!

IF *SOUND* IS INTRODUCED, THIS CEASES TO BE TRUE--

--BUT, IN AN OTHERWISE SILENT *CAPTIONED* PANEL, THE SINGLE MOMENT CAN ACTUALLY BE *HELD.*

HE WAS GIVING IT HIS *ALL,* WHEN--

THESE VARIOUS SHAPES WE CALL *PANELS* HOLD IN THEIR BORDERS ALL OF THE ICONS THAT ADD UP TO THE *VOCABULARY OF COMICS.*

ALL EXCEPT *ONE.*

FOR JUST AS THE BODY'S LARGEST ORGAN --OUR *SKIN*-- IS SELDOM *THOUGHT OF* AS AN ORGAN--

--SO TOO IS THE PANEL *ITSELF* OVERLOOKED AS COMICS' MOST IMPORTANT *ICON!*

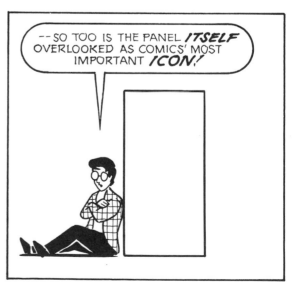

THESE ICONS WE CALL PANELS OR "FRAMES" HAVE NO *FIXED* OR *ABSOLUTE MEANING,* LIKE THE ICONS OF *LANGUAGE, SCIENCE* AND *COMMUNICATION.*

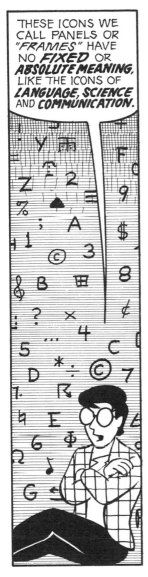

NOR IS THEIR MEANING AS *FLUID* AND *MALLEABLE* AS THE SORTS OF ICONS WE CALL *PICTURES.*

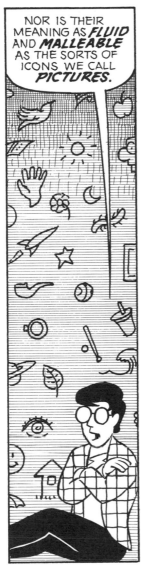

THE PANEL ACTS AS A SORT OF *GENERAL INDICATOR* THAT *TIME* OR *SPACE* IS BEING *DIVIDED.*

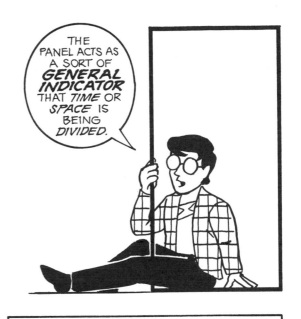

THE *DURATIONS* OF THAT *TIME* AND THE *DIMENSIONS* OF THAT *SPACE* ARE DEFINED MORE BY THE *CONTENTS* OF THE PANEL THAN BY THE PANEL *ITSELF.* *

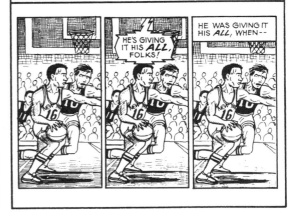

HE'S GIVING IT HIS *ALL,* FOLKS!

HE WAS GIVING IT HIS *ALL,* WHEN--

PANEL *SHAPES* VARY *CONSIDERABLY* THOUGH, AND WHILE DIFFERENCES OF SHAPE DON'T AFFECT THE SPECIFIC *"MEANINGS"* OF THOSE PANELS VIS-A-VIS TIME, THEY *CAN* AFFECT THE READING *EXPERIENCE.*

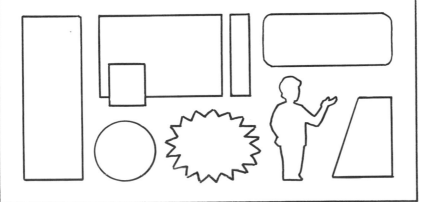

WHICH BRINGS US TO THE STRANGE RELATIONSHIP BETWEEN TIME AS *DEPICTED* IN COMICS AND TIME AS *PERCEIVED* BY THE READER.

* EISNER DISCUSSES THIS UNDER THE HEADING "FRAMING TIME" IN COMICS AND SEQUENTIAL ART.

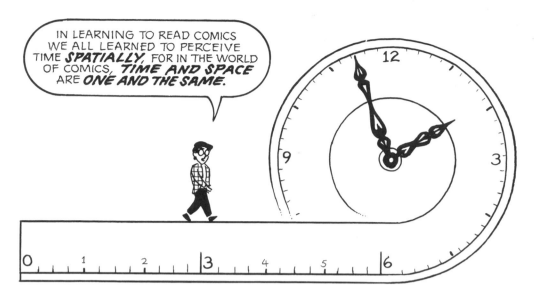

IN LEARNING TO READ COMICS WE ALL LEARNED TO PERCEIVE TIME *SPATIALLY,* FOR IN THE WORLD OF COMICS, *TIME AND SPACE* ARE *ONE AND THE SAME.*

THE PROBLEM IS *THERE'S NO CONVERSION CHART!*

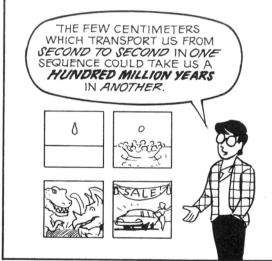

THE FEW CENTIMETERS WHICH TRANSPORT US FROM *SECOND TO SECOND* IN *ONE* SEQUENCE COULD TAKE US A *HUNDRED MILLION YEARS* IN *ANOTHER.*

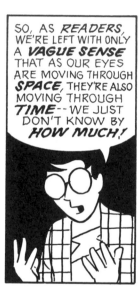

SO, AS *READERS,* WE'RE LEFT WITH ONLY A *VAGUE SENSE* THAT AS OUR EYES ARE MOVING THROUGH *SPACE,* THEY'RE ALSO MOVING THROUGH *TIME*-- WE JUST DON'T KNOW BY *HOW MUCH!*

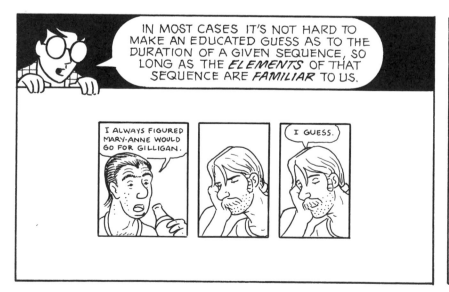

IN MOST CASES IT'S NOT HARD TO MAKE AN EDUCATED GUESS AS TO THE DURATION OF A GIVEN SEQUENCE, SO LONG AS THE *ELEMENTS* OF THAT SEQUENCE ARE *FAMILIAR* TO US.

I ALWAYS FIGURED MARY-ANNE WOULD GO FOR GILLIGAN.

I GUESS.

FROM A *LIFETIME OF CONVERSATIONS,* WE CAN BE SURE THAT A *"PAUSE"* PANEL LIKE THIS LASTS FOR NO MORE THAN SEVERAL *SECONDS.*

 BUT IF THE CREATOR OF THIS SCENE WANTED TO *LENGTHEN* THAT PAUSE, HOW COULD HE OR SHE DO SO? ONE OBVIOUS SOLUTION WOULD BE TO ADD MORE PANELS, BUT IS THAT THE ONLY WAY?

 D'YA THINK THE SOX COULD FINALLY DO IT THIS YEAR?

 I GUESS.

 IS THERE ANY WAY TO MAKE A SINGLE SILENT PANEL LIKE THIS ONE SEEM *LONGER?* HOW ABOUT WIDENING THE SPACE *BETWEEN PANELS?* ANY *DIFFERENCE?*

WE'VE SEEN HOW TIME CAN BE CONTROLLED THROUGH THE *CONTENT* OF PANELS, THE *NUMBER* OF PANELS AND CLOSURE *BETWEEN* PANELS, BUT THERE'S STILL *ONE MORE.*

 HEY, I DESERVE A BETTER JOB! I COULD BE A *BRAIN SURGEON!*

 I GUESS.

 AS UNLIKELY AS IT SOUNDS, THE PANEL *SHAPE* CAN ACTUALLY MAKE A *DIFFERENCE* IN OUR *PERCEPTION* OF TIME. EVEN THOUGH THIS LONG PANEL HAS THE SAME BASIC "MEANING" AS ITS SHORTER VERSIONS, STILL IT HAS THE *FEELING* OF GREATER LENGTH!

 THAT *MADONNA*, MAN, SHE'S ONE *HOT* BABE!

 I GUESS.

EVER NOTICED HOW THE WORDS *"SHORT"* OR *"LONG"* CAN REFER EITHER TO THE *FIRST* DIMENSION OR TO THE *FOURTH?*

IN A MEDIUM WHERE TIME AND SPACE *MERGE* SO *COMPLETELY,* THE DISTINCTION OFTEN *VANISHES!*

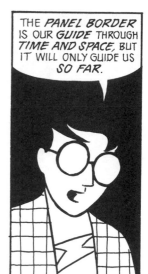

THE *PANEL BORDER* IS OUR *GUIDE* THROUGH *TIME AND SPACE,* BUT IT WILL ONLY GUIDE US *SO FAR.*

AS MENTIONED, PANELS COME IN MANY SHAPES AND SIZES, THOUGH THE *CLASSIC RECTANGLE* IS USED MOST *OFTEN.*

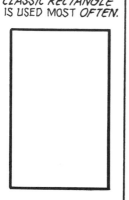

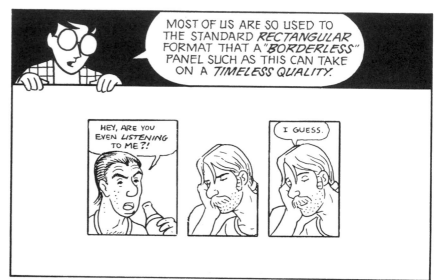

MOST OF US ARE SO USED TO THE STANDARD *RECTANGULAR* FORMAT THAT A *"BORDERLESS"* PANEL SUCH AS THIS CAN TAKE ON A *TIMELESS QUALITY.*

HEY, ARE YOU EVEN *LISTENING* TO ME?!

I GUESS.

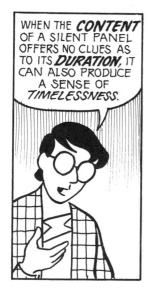

WHEN THE *CONTENT* OF A SILENT PANEL OFFERS NO CLUES AS TO ITS *DURATION,* IT CAN ALSO PRODUCE A SENSE OF *TIMELESSNESS.*

BECAUSE OF ITS *UNRESOLVED NATURE,* SUCH A PANEL MAY *LINGER* IN THE READER'S MIND.

AND ITS PRESENCE MAY BE FELT IN THE PANELS WHICH *FOLLOW* IT.

WHEN *"BLEEDS"* ARE USED -- I.E., WHEN A PANEL RUNS OFF THE EDGE OF THE *PAGE* -- THIS EFFECT IS *COMPOUNDED.*

TIME IS NO LONGER CONTAINED BY THE FAMILIAR ICON OF THE *CLOSED PANEL,* BUT INSTEAD *HEMORRHAGES* AND ESCAPES INTO *TIMELESS SPACE.*

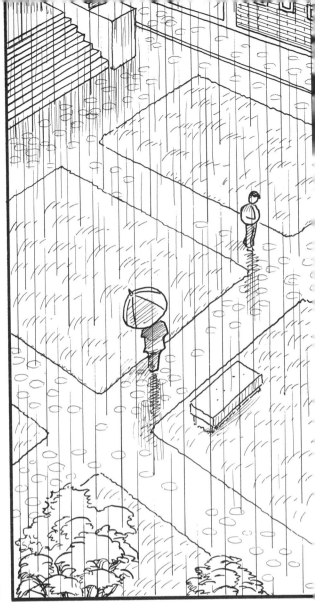

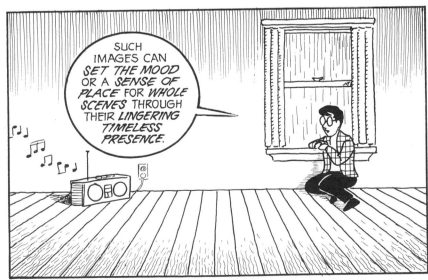

SUCH IMAGES CAN *SET THE MOOD* OR A *SENSE OF PLACE* FOR *WHOLE SCENES* THROUGH THEIR *LINGERING TIMELESS PRESENCE.*

ONCE AGAIN, THIS IS A TECHNIQUE USED MOST OFTEN IN JAPAN AND ONLY RECENTLY ADOPTED HERE IN THE WEST.

103

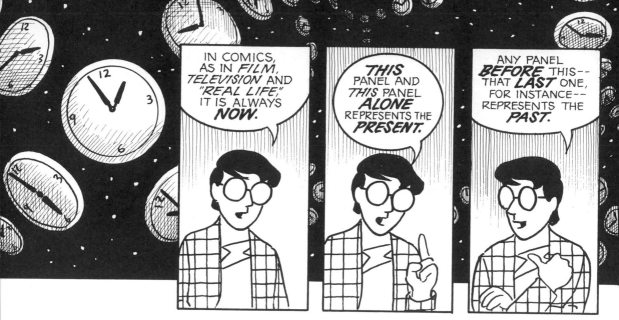
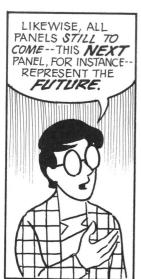
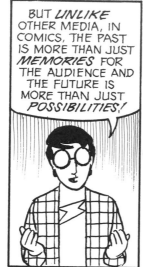

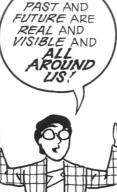

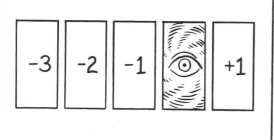
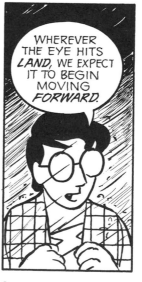
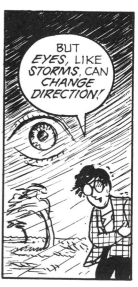

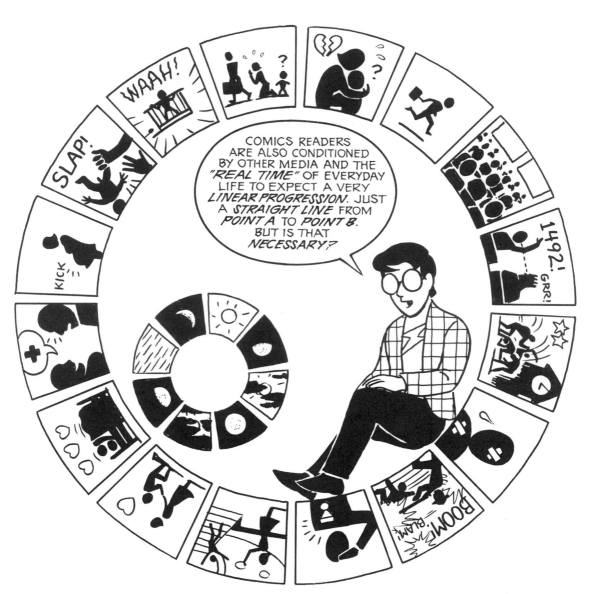

COMICS READERS ARE ALSO CONDITIONED BY OTHER MEDIA AND THE *"REAL TIME"* OF EVERYDAY LIFE TO EXPECT A VERY *LINEAR PROGRESSION*. JUST A *STRAIGHT LINE* FROM *POINT A* TO *POINT B*. BUT IS THAT *NECESSARY?*

FOR *NOW*, THESE QUESTIONS ARE THE TERRITORY OF *GAMES* AND *STRANGE LITTLE EXPERIMENTS*.

BUT *VIEWER PARTICIPATION* IS ON THE VERGE OF BECOMING AN *ENORMOUS ISSUE* IN *OTHER MEDIA*.

HOW COMICS *ADDRESSES* THIS ISSUE-- OR *FAILS* TO-- COULD PLAY A CRUCIAL PART IN *DEFINING* THE ROLE OF COMICS IN THE *NEW CENTURY*.

TIME WILL TELL.

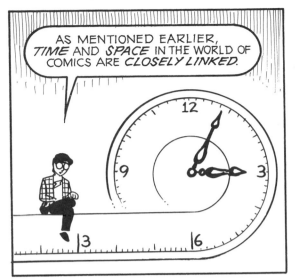

AS MENTIONED EARLIER, *TIME* AND *SPACE* IN THE WORLD OF COMICS ARE *CLOSELY LINKED.*

AS A RESULT, SO TOO ARE THE ISSUES OF *TIME* AND *MOTION.*

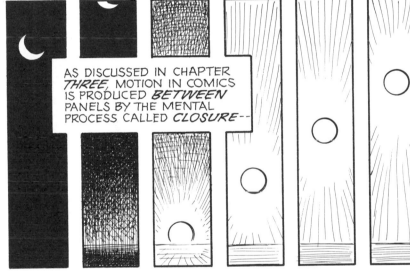

AS DISCUSSED IN CHAPTER *THREE,* MOTION IN COMICS IS PRODUCED *BETWEEN* PANELS BY THE MENTAL PROCESS CALLED *CLOSURE*--

--USUALLY BY TRANSITION TYPES *ONE* *TWO*...BUT LET'S NOT GET INTO *THAT* AGAIN!

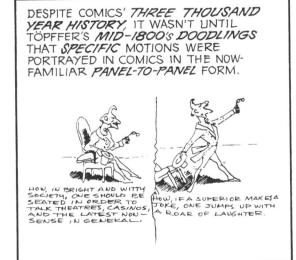

DESPITE COMICS' *THREE THOUSAND YEAR HISTORY,* IT WASN'T UNTIL TÖPFFER'S *MID-1800's DOODLINGS* THAT *SPECIFIC* MOTIONS WERE PORTRAYED IN COMICS IN THE NOW-FAMILIAR *PANEL-TO-PANEL* FORM.

HOW, IN BRIGHT AND WITTY SOCIETY, ONE SHOULD BE SEATED IN ORDER TO TALK THEATRES, CASINOS, AND THE LATEST NON-SENSE IN GENERAL.

HOW, IF A SUPERIOR MAKES A JOKE, ONE JUMPS UP WITH A ROAR OF LAUGHTER.

WITHIN A FEW YEARS, HOWEVER, MOTION WAS A *HOT TOPIC* INDEED!

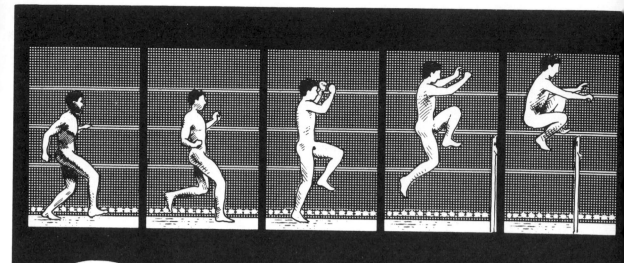

IN THE LAST QUARTER OF THE *NINETEENTH CENTURY* IT SEEMED LIKE *EVERYONE* WAS TRYING TO CAPTURE MOTION THROUGH *SCIENCE!*

BY *1880,* INVENTORS THE *WORLD OVER* KNEW THAT *"MOVING PICTURES"* WERE JUST AROUND THE CORNER. *EVERYONE* WANTED TO BE *FIRST!*

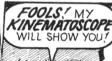

MY *STROBOSCOPE* IS *SUPERIOR IN EVERY WAY* TO THE OBSOLETE *ZOËTROPE!*

BAH! MY *PRAXINOSCOPE* IS BETTER!

FOOLS! MY *KINEMATOSCOPE* WILL SHOW YOU!

HA! CHILD'S PLAY! THEY ARE BUT *MERE TOYS* NEXT TO THE AWESOME *PHANTASMATROPE!*

FRAUDS *ALL!* MY *ZOÖPRAXINOSCOPE* WILL--!

EVENTUALLY *THOMAS EDISON,* THAT OLD SCALLYWAG, FILED THE FIRST *PATENT* ON A PROCESS USING STRIPS OF *CLEAR PLASTIC PHOTOS* AND *FILM* WAS *OFF AND RUNNING!*

AS THE *MOVING PICTURE* BEGAN ITS SPECTACULAR RISE, A FEW OF THE MORE RADICAL *PAINTERS* OF THE DAY EXPLORED THE IDEA THAT MOTION COULD BE DEPICTED BY A *SINGLE* IMAGE ON *CANVAS.*

THE FUTURISTS IN ITALY AND *MARCEL DUCHAMP* IN FRANCE BEGAN THE *SYSTEMATIC DECOMPOSITION OF MOVING IMAGES* IN A *STATIC MEDIUM.*

IT WASN'T A BAD IDEA!

Girl Running on a Balcony by Balla

Nude Descending a Staircase #2 by Duchamp

108

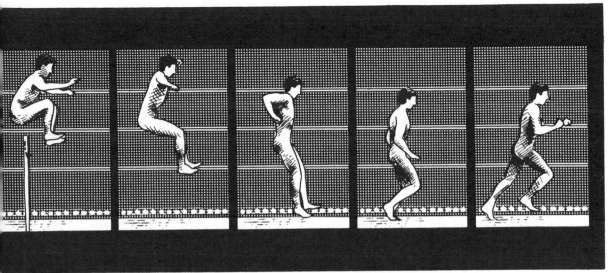

COPIED FROM PHOTOGRAPHS TAKEN BY EADWEARD MUYBRIDGE.

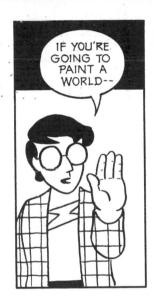

IF YOU'RE GOING TO PAINT A WORLD--

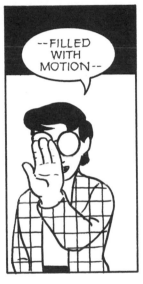

--FILLED WITH MOTION--

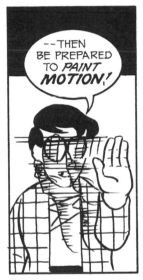

--THEN BE PREPARED TO *PAINT MOTION!*

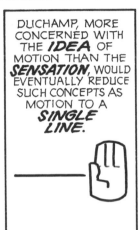

DUCHAMP, MORE CONCERNED WITH THE *IDEA* OF MOTION THAN THE *SENSATION*, WOULD EVENTUALLY REDUCE SUCH CONCEPTS AS MOTION TO A *SINGLE LINE.*

DUCHAMP SOON MOVED ON, THE FUTURISTS *DISBANDED* AND FINE ARTISTS GENERALLY *LOST INTEREST* IN THIS *OTHER* TYPE OF *"MOVING PICTURE."*

BUT THROUGHOUT THIS SAME PERIOD *ANOTHER* MEDIUM, LESS *CONSPICUOUSLY*, HAD BEEN INVESTIGATING THIS SAME AREA.

I'M SURE YOU CAN ALL GUESS WHICH MEDIUM I MEAN!

109

WAK!

FROM ITS *EARLIEST DAYS*, THE MODERN COMIC HAS GRAPPLED WITH THE PROBLEM OF SHOWING MOTION IN A *STATIC MEDIUM*.

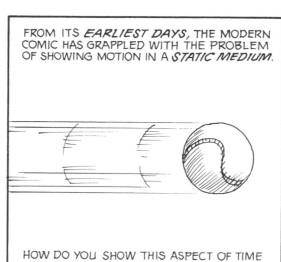

HOW DO YOU SHOW THIS ASPECT OF TIME IN AN ART WHERE *TIME STANDS STILL?*

AND IN COMICS, UNLIKE PAINTING, IT WAS MORE THAN JUST A *THEORETICAL QUESTION!*

SMASH!

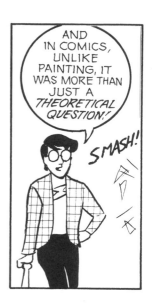

THOUGH SEQUENTIAL ART SURVIVED FOR MANY CENTURIES *WITHOUT* DEPICTING MOTION, ONCE THE GENIE WAS OUT OF THE BOTTLE IT WAS PERHAPS *INEVITABLE* THAT MORE AND MORE EFFICIENT MEANS WOULD BE SOUGHT. AT FIRST, THIS SEARCH CENTERED ON *MULTIPLE* IMAGES IN SEQUENCE.

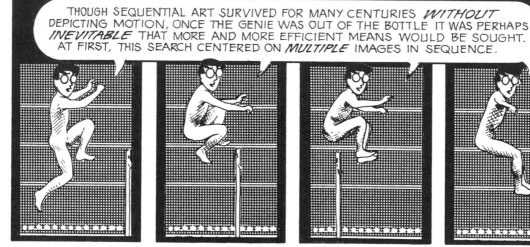

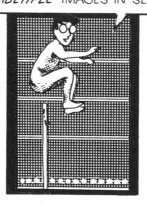
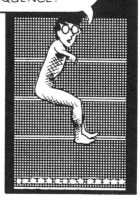

BUT JUST AS A SINGLE PANEL CAN REPRESENT A *SPAN* OF TIME THROUGH *SOUND*--

SMILE!

PAF!

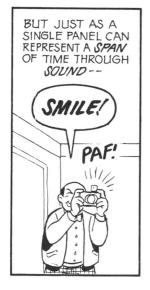

--SO TOO CAN A SINGLE PANEL REPRESENT A SPAN OF TIME THROUGH *PICTURES!*

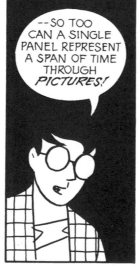

SOMEWHERE BETWEEN THE FUTURISTS' *DYNAMIC* MOVEMENT AND DUCHAMP'S DIAGRAMMATIC *CONCEPT* OF MOVEMENT LIES COMICS' *"MOTION LINE."*

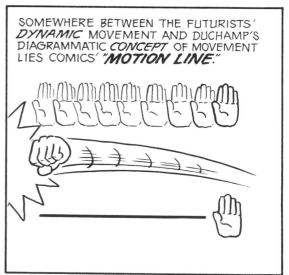

IN THE BEGINNING, MOTION LINES--OR "*ZIP-RIBBONS*" AS SOME CALL THEM-- WERE *WILD, MESSY,* ALMOST *DESPERATE* ATTEMPTS TO REPRESENT THE PATHS OF *MOVING OBJECTS* THROUGH *SPACE.*

OVER THE YEARS, THESE LINES BECAME MORE *REFINED* AND *STYLIZED,* EVEN *DIAGRAMMATIC.*

EVENTUALLY, IN THE HANDS OF *HEROIC FANTASY* ARTISTS LIKE *BILL EVERETT* AND *JACK KIRBY*--

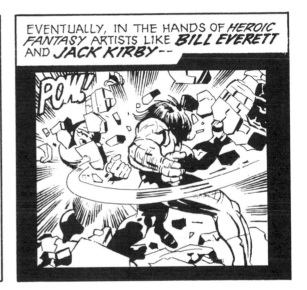

--THOSE SAME LINES BECAME *SO* STYLIZED AS TO ALMOST HAVE A *LIFE* AND *PHYSICAL PRESENCE* **ALL THEIR OWN!**

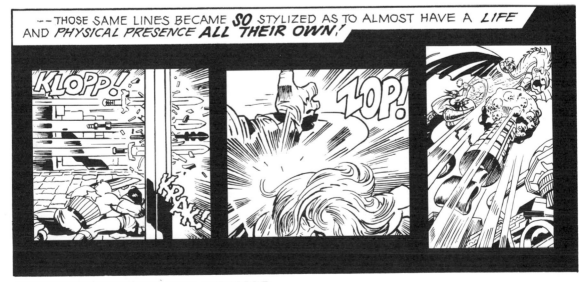

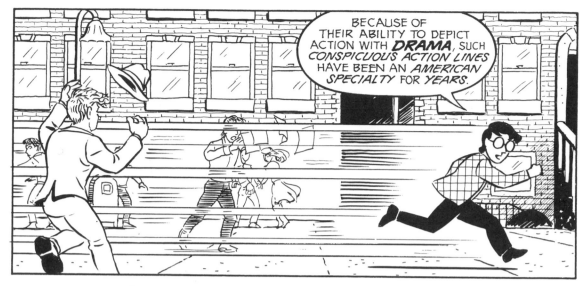

Because of their ability to depict action with DRAMA, such conspicuous action lines have been an AMERICAN SPECIALTY for years.

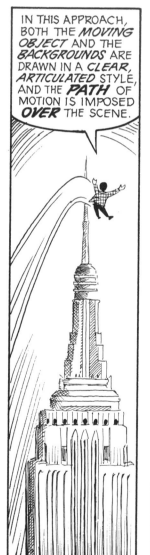

In this approach, both the MOVING OBJECT and the BACKGROUNDS are drawn in a CLEAR, ARTICULATED style, and the PATH of motion is imposed OVER the scene.

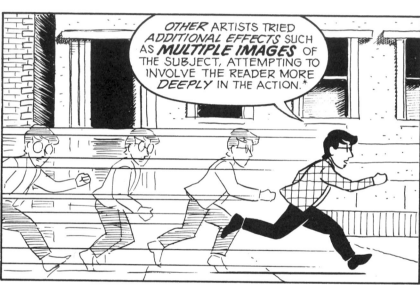

OTHER artists tried ADDITIONAL EFFECTS such as MULTIPLE IMAGES of the subject, attempting to involve the reader more DEEPLY in the action.*

Still OTHERS, such as Marvel's GENE COLAN, began incorporating photographic STREAKING effects with some intriguing results in the sixties and seventies.

* MULTIPLE IMAGES CAN BE FOUND IN THE WORK OF KRIGSTEIN, INFANTINO AND OTHERS.

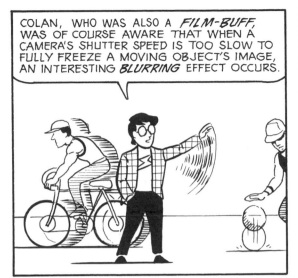

COLAN, WHO WAS ALSO A *FILM-BUFF*, WAS OF COURSE AWARE THAT WHEN A CAMERA'S SHUTTER SPEED IS TOO SLOW TO FULLY FREEZE A MOVING OBJECT'S IMAGE, AN INTERESTING *BLURRING* EFFECT OCCURS.

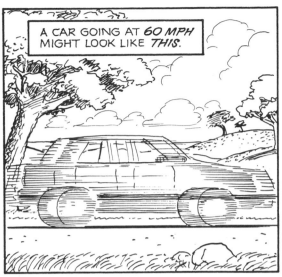

A CAR GOING AT *60 MPH* MIGHT LOOK LIKE *THIS*.

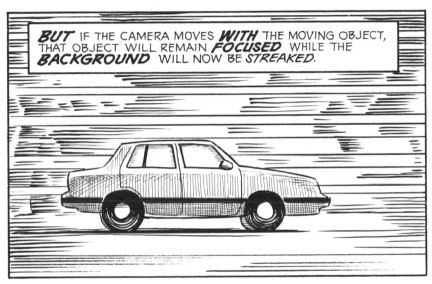

BUT IF THE CAMERA MOVES *WITH* THE MOVING OBJECT, THAT OBJECT WILL REMAIN *FOCUSED* WHILE THE *BACKGROUND* WILL NOW BE *STREAKED*.

AMERICAN COMICS ARTISTS TOOK LITTLE OR NO INTEREST IN THIS KIND OF *PHOTOGRAPHIC TRICKERY*.

AND IN *EUROPE* WHERE MOTION LINES WERE USED ONLY *SPARINGLY*, IT WAS LIKEWISE IGNORED.

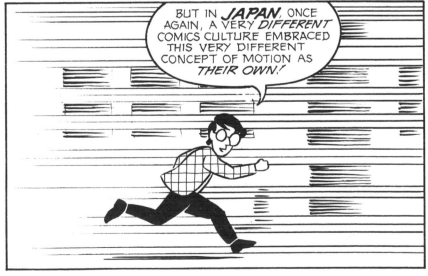

BUT IN *JAPAN*, ONCE AGAIN, A VERY *DIFFERENT* COMICS CULTURE EMBRACED THIS VERY DIFFERENT CONCEPT OF MOTION AS *THEIR OWN!*

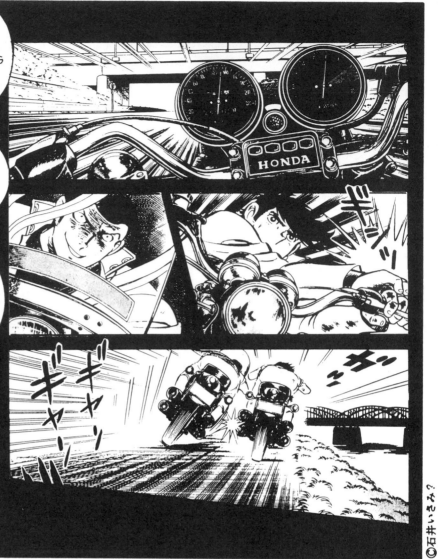

"*SUBJECTIVE MOTION*," AS I CALL IT, OPERATES ON THE ASSUMPTION THAT IF *OBSERVING* A MOVING OBJECT *CAN* BE INVOLVING, *BEING* THAT OBJECT SHOULD BE *MORE* SO.

JAPANESE ARTISTS, STARTING IN THE LATE *60's,* BEGAN PUTTING THEIR READERS *"IN THE DRIVER'S SEAT"* WITH PANELS LIKE *THESE.*

AND STARTING IN THE *MID-EIGHTIES,* A FEW *AMERICAN* ARTISTS BEGAN TO ADOPT THE EFFECT IN THEIR OWN WORK, UNTIL BY THE EARLY *NINETIES* IT HAS BECOME FAIRLY COMMON.

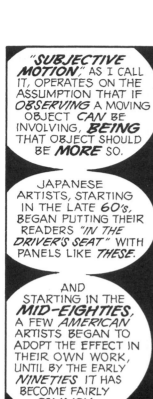

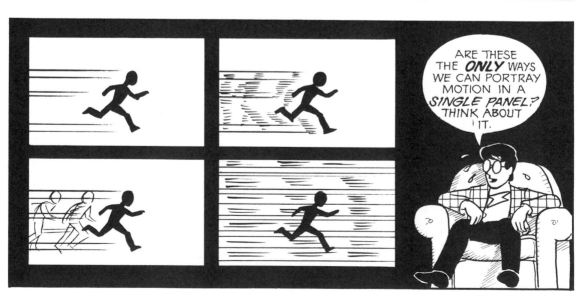

ARE THESE THE *ONLY* WAYS WE CAN PORTRAY MOTION IN A *SINGLE PANEL?* THINK ABOUT IT.

114

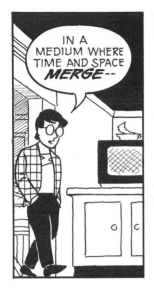

IN A MEDIUM WHERE TIME AND SPACE *MERGE*--

--THE STORYTELLER HAS SOME UNUSUAL TOOLS AT HIS/HER DISPOSAL--

--SUCH AS THE *POLYPTYCH*, WHERE A MOVING FIGURE OR FIGURES--

--IS IMPOSED OVER A *CONTINUOUS BACKGROUND*.

IN COMICS, *COMPOSITION* FOLLOWS A VERY DIFFERENT SET OF RULES THAN IN MOST *GRAPHIC ARTS*.

BY INTRODUCING *TIME* INTO THE EQUATION, COMICS ARTISTS ARE ARRANGING THE PAGE IN WAYS NOT ALWAYS CONDUCIVE TO TRADITIONAL PICTURE-MAKING.

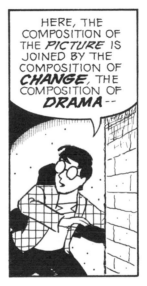

HERE, THE COMPOSITION OF THE *PICTURE* IS JOINED BY THE COMPOSITION OF *CHANGE*, THE COMPOSITION OF *DRAMA*--

-- AND THE COMPOSITION OF *MEMORY*.

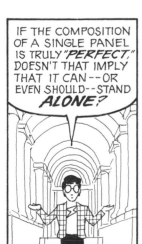

IF THE COMPOSITION OF A SINGLE PANEL IS TRULY *"PERFECT,"* DOESN'T THAT IMPLY THAT IT CAN--OR EVEN SHOULD--STAND *ALONE?*

THE *NATURAL* WORLD CREATES *GREAT BEAUTY* EVERY DAY, YET THE ONLY RULES OF COMPOSITION IT FOLLOWS ARE THOSE OF *FUNCTION* AND *CHANCE*.

COMICS, AT ITS BEST, SHOULD DO NO LESS.

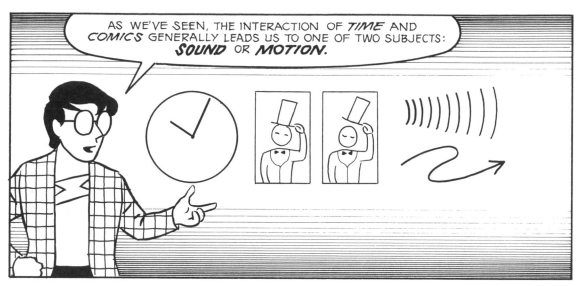

AS WE'VE SEEN, THE INTERACTION OF *TIME* AND *COMICS* GENERALLY LEADS US TO ONE OF TWO SUBJECTS: *SOUND* OR *MOTION.*

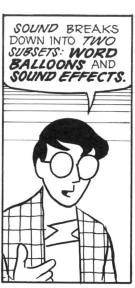

SOUND BREAKS DOWN INTO *TWO SUBSETS: WORD BALLOONS* AND *SOUND EFFECTS.*

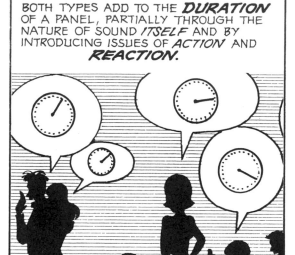

BOTH TYPES ADD TO THE *DURATION* OF A PANEL, PARTIALLY THROUGH THE NATURE OF SOUND *ITSELF* AND BY INTRODUCING ISSUES OF *ACTION* AND *REACTION.*

MOTION ALSO BREAKS DOWN INTO TWO SUBSETS. THE *FIRST* TYPE-- *PANEL-TO-PANEL CLOSURE*-- WAS IMPORTANT ENOUGH TO MERIT ITS OWN *CHAPTER.*

THE *OTHER* TYPE -- MOTION *WITHIN* PANELS--CAN BE *FURTHER* DIVIDED INTO SEVERAL DISTINCT *STYLES.* I'VE COVERED THE ONES *I* KNOW, BUT THERE MAY BE MANY *OTHERS.* TIME WILL TELL.

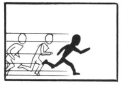
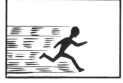
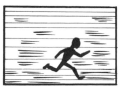

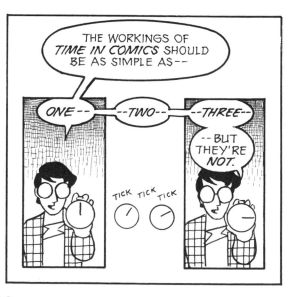

THE WORKINGS OF *TIME IN COMICS* SHOULD BE AS SIMPLE AS--

ONE-- --TWO-- --THREE--

--BUT THEY'RE *NOT.*

TICK TICK TICK

I'VE BEEN TRYING TO FIGURE OUT WHAT MAKES COMICS *"TICK"* FOR *YEARS* AND I'M STILL AMAZED BY THE *STRANGENESS* OF IT ALL.

SNAP!

SNAP!

CRASH!

BUT NO MATTER HOW *BIZARRE* THE WORKINGS OF TIME IN COMICS IS--

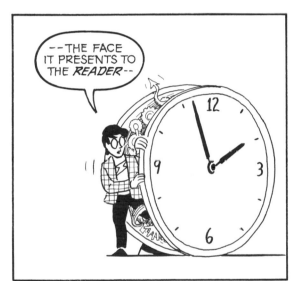

--THE FACE IT PRESENTS TO THE *READER*--

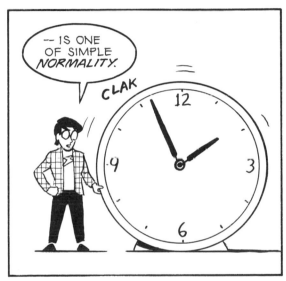

-- IS ONE OF SIMPLE *NORMALITY.*

CLAK

OR THE *ILLUSION* OF IT, ANYWAY.

ALL DEPENDS ON YOUR *FRAME OF MIND.*

CHAPTER FIVE

LIVING IN LINE.

CAN EMOTIONS BE MADE **VISIBLE?**

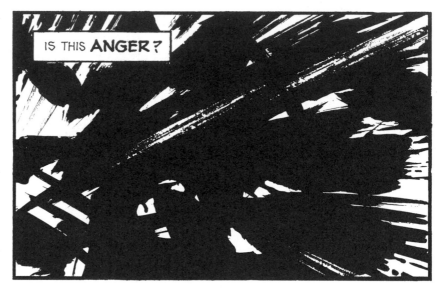

IS THIS **ANGER?**

JOY?

SERENITY?

TENSION?

INTIMACY?

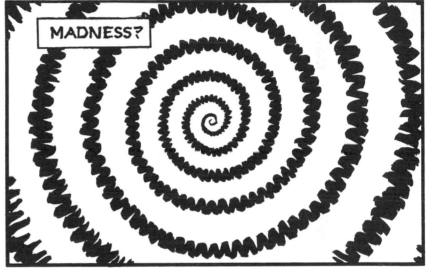

MADNESS?

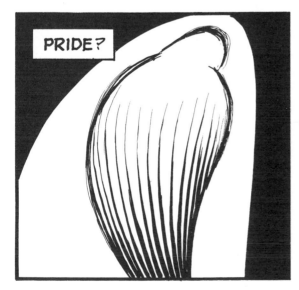

PRIDE?

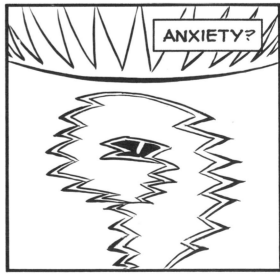

ANXIETY?

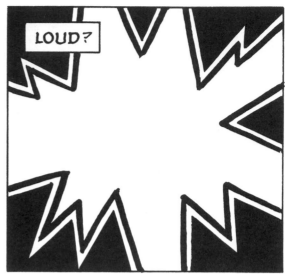

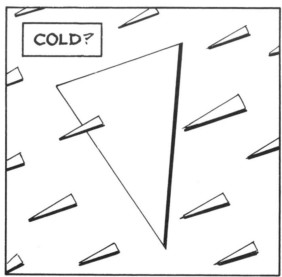

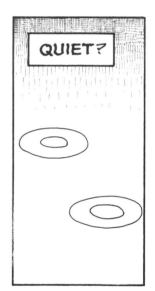

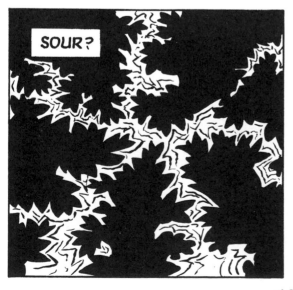

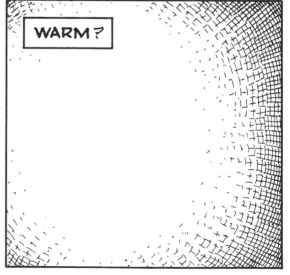

120

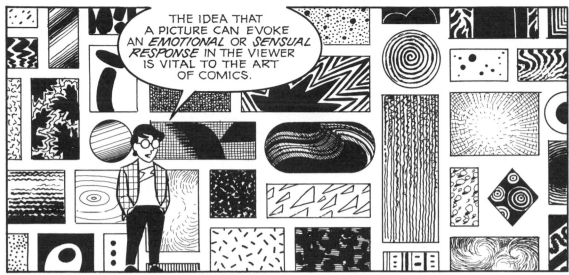

THE IDEA THAT A PICTURE CAN EVOKE AN *EMOTIONAL* OR *SENSUAL* *RESPONSE* IN THE VIEWER IS VITAL TO THE ART OF COMICS.

SOME IMAGES INSPIRED BY THE PAINTINGS OF ADAM PHILIPS.

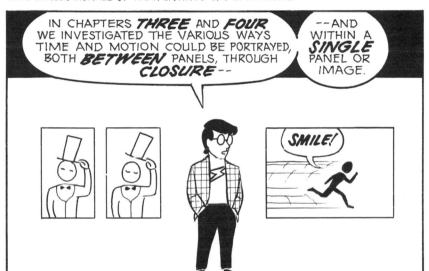

IN CHAPTERS *THREE* AND *FOUR* WE INVESTIGATED THE VARIOUS WAYS TIME AND MOTION COULD BE PORTRAYED, BOTH *BETWEEN* PANELS, THROUGH *CLOSURE*--

--AND WITHIN A *SINGLE* PANEL OR IMAGE.

SMILE!

THE INVISIBLE WORLD OF SENSES AND EMOTIONS CAN *ALSO* BE PORTRAYED EITHER *BETWEEN* OR *WITHIN* PANELS.

WE'VE TOUCHED UPON THE *FORMER* CATEGORY IN *CHAPTER THREE,* BUT WHAT ABOUT THE *LATTER?*

CHOP! CHOP! CHOP!

HOW CAN A *SINGLE IMAGE* REPRESENT THE *SENSES* AND *EMOTIONS* AND HOW DOES THIS IDEA APPLY TO *COMICS?*

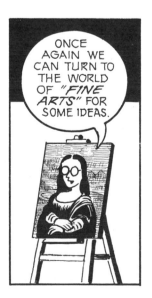

ONCE AGAIN WE CAN TURN TO THE WORLD OF *"FINE ARTS"* FOR SOME IDEAS.

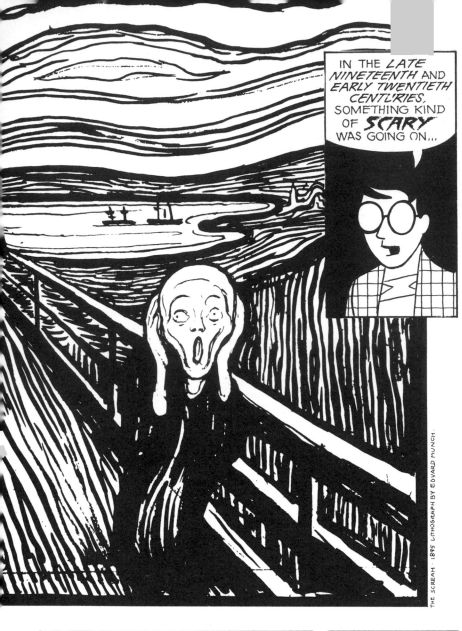

THE SCREAM · 1895 LITHOGRAPH BY EDVARD MUNCH.

IN THE *LATE NINETEENTH* AND *EARLY TWENTIETH CENTURIES*, SOMETHING KIND OF **SCARY** WAS GOING ON...

NO SOONER HAD THE *IMPRESSIONISTS* FINALLY CONVINCED THEIR PEERS THAT THE WORLD *THEY* SAW WAS THE WORLD AS IT IS *TRULY* SEEN--

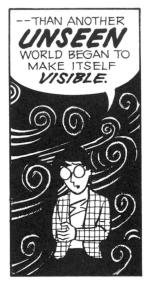

--THAN ANOTHER **UNSEEN** WORLD BEGAN TO MAKE ITSELF *VISIBLE*.

IN THE WORKS OF **EDVARD MUNCH** AND **VINCENT VAN GOGH**, THE OBJECTIVE STUDY OF LIGHT SO PRIZED BY THE *IMPRESSIONIST MAINSTREAM* WAS BEING *ABANDONED* IN FAVOR OF A NEW, FRIGHTENINGLY **SUBJECTIVE** APPROACH

EXPRESSIONISM, AS IT CAME TO BE CALLED, DIDN'T START AS A *SCIENTIFIC ART*, BUT RATHER AS AN HONEST *EXPRESSION* OF THE INTERNAL TURMOIL THESE ARTISTS JUST COULD NOT *REPRESS*.

THE *SCIENCE* OF IT WASN'T FAR *BEHIND* THOUGH!

122

AS THE *NEW CENTURY* GOT UNDER WAY, *COOLER HEADS* SUCH AS *WASSILY KANDINSKY* TOOK *GREAT INTEREST* IN THE POWER OF *LINE, SHAPE* AND *COLOR* TO SUGGEST THE INNER STATE OF THE ARTIST *AND* TO PROVOKE THE *FIVE SENSES.*

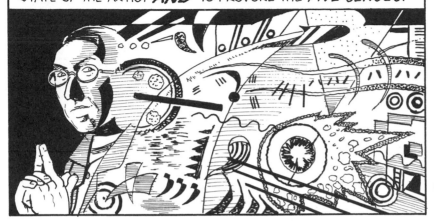

ANGRY *REDS...* PLACID *BLUES...* ANXIOUS *TEXTURES...* LOUD *SHAPES...* QUIET *LINES...* COLD *GREENS...*

THESE WERE *STRANGE IDEAS* IN 1912!

KANDINSKY AND HIS PEERS WERE SEARCHING FOR AN ART THAT MIGHT SOMEHOW *UNITE THE SENSES*--

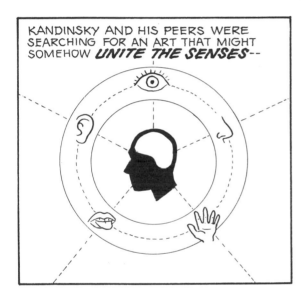

-- AND IN *DOING SO,* UNITE THE DIFFERENT ARTFORMS WHICH *APPEALED* TO THOSE DIFFERENT SENSES.

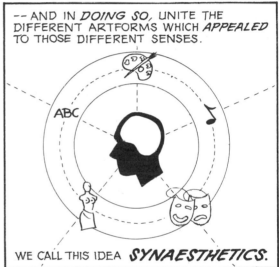

ABC

WE CALL THIS IDEA *SYNAESTHETICS.*

NOT *SURPRISING,* THEN, THAT SIMILAR IDEAS WERE EXPRESSED BY CREATORS IN *OTHER* FIELDS SUCH AS *RICHARD WAGNER* AND THE FRENCH POET *BAUDELAIRE.*

"Art does not reproduce the visible; rather, it *makes* visible."

—PAUL KLEE
PAINTER, TEACHER, CARTOONIST.

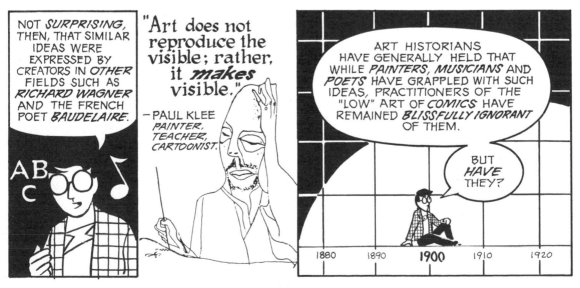

ART HISTORIANS HAVE GENERALLY HELD THAT WHILE *PAINTERS, MUSICIANS* AND *POETS* HAVE GRAPPLED WITH SUCH IDEAS, PRACTITIONERS OF THE "LOW" ART OF *COMICS* HAVE REMAINED *BLISSFULLY IGNORANT* OF THEM.

BUT *HAVE* THEY?

1880 1890 **1900** 1910 1920

123

IN SURVEYING A *CENTURY* OF COMICS, ONE FINDS CREATORS LIKE THE UNDERGROUND'S *RORY HAYES,* WHO ARE *BLATANTLY EXPRESSIONISTIC,* BUT SUCH ARTISTS ARE *FEW AND FAR BETWEEN.*

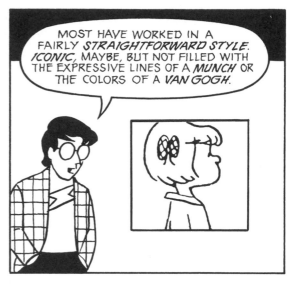

MOST HAVE WORKED IN A FAIRLY *STRAIGHTFORWARD STYLE.* *ICONIC,* MAYBE, BUT NOT FILLED WITH THE EXPRESSIVE LINES OF A *MUNCH* OR THE COLORS OF A *VAN GOGH.*

CAN WE SAY, THEREFORE, THAT ONE OF THESE TWO CREATORS IS EXPRESSING MOOD AND EMOTION AND THE OTHER IS *NOT?* OR DOES THE DIFFERENCE LIE IN *WHAT* IS BEING EXPRESSED?

HELP!

PEANUTS

CHARLES SCHULZ

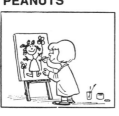

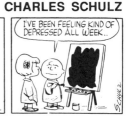

I'VE BEEN FEELING KIND OF DEPRESSED ALL WEEK...

IF *THESE* LINES ARE EXPRESSIVE OF *FEAR, ANXIETY* AND *MADNESS*--

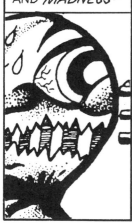

--THEN COULDN'T *THESE* LINES BE SAID TO PORTRAY *CALM, REASON* AND *INTROSPECTION?*

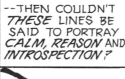
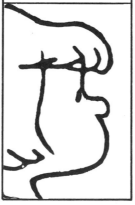

IN TRUTH, DON'T *ALL* LINES CARRY WITH THEM AN *EXPRESSIVE POTENTIAL?*

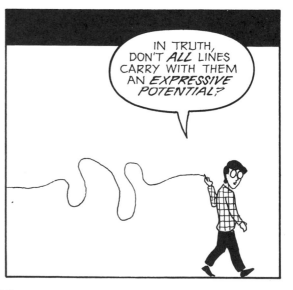

BY *DIRECTION ALONE*, A LINE MAY GO FROM *PASSIVE AND TIMELESS*--

--TO *PROUD AND STRONG*--

--TO *DYNAMIC AND CHANGING!*

BY ITS *SHAPE*, IT CAN BE *UNWELCOMING* AND *SEVERE*--

--OR *WARM* AND *GENTLE*--

--OR *RATIONAL* AND *CONSERVATIVE*.

BY ITS *CHARACTER* IT MAY SEEM *SAVAGE* AND *DEADLY*--

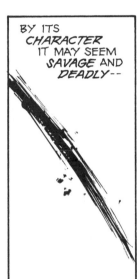

--OR *WEAK* AND *UNSTABLE*--

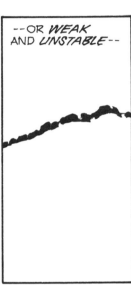

--OR *HONEST* AND *DIRECT*.

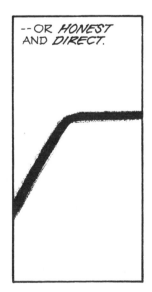

THE MOST BLAND *"EXPRESSIONLESS"* LINES ON *EARTH* CAN'T HELP BUT CHARACTERIZE THEIR SUBJECT IN SOME WAY.

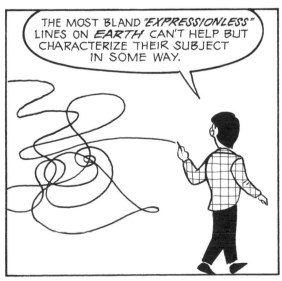

AND WHILE FEW COMIC ARTISTS MAY CONSIDER THEMSELVES *EXPRESSIONISTS*, THAT DOESN'T MEAN THAT THEY CAN'T TELL *ONE* LINE FROM *ANOTHER!*

IN *DICK TRACY*, FOR EXAMPLE, CHESTER GOULD USED *BOLD LINES, OBTUSE ANGLES* AND *HEAVY BLACKS* TO SUGGEST THE MOOD OF A *GRIM, DEADLY* WORLD OF *ADULTS*--

-- WHILE THE *GENTLE CURVES* AND *OPEN LINES* OF *CARL BARKS' UNCLE $CROOGE* CONVEY A FEELING OF *WHIMSY, YOUTH* AND *INNOCENCE*.

IN *R. CRUMB'S* WORLD, THE *CURVES* OF *INNOCENCE* ARE *BETRAYED* BY THE *NEUROTIC QUILL-LINES* OF *MODERN ADULTHOOD*, AND LEFT *PAINFULLY OUT OF PLACE*--

-- WHILE IN *KRYSTINE KRYTTRE'S* ART, THE CURVES OF CHILDHOOD AND THE MAD LINES OF A *MUNCH* CREATE A *CRAZY TODDLER LOOK*.

IN THE *MID-1960s* WHEN THE *AVERAGE MARVEL READER* WAS *PRE-ADOLESCENT*, POPULAR INKERS USED *DYNAMIC* BUT *FRIENDLY* LINES À LA *KIRBY/SINNOTT*.

BUT WHEN MARVEL'S READER BASE *GREW* INTO THE *ANXIETIES* OF *ADOLESCENCE*, THE *HOSTILE, JAGGED* LINES OF A *ROB LIEFELD* STRUCK A MORE *RESPONSIVE CHORD*.

FOR *DECADES* OF COLOR COMIC BOOKS, THE *SIGNATURE STYLES* OF INDIVIDUAL ARTISTS LIKE *NICK CARDY* HAVE INFUSED *PERSONAL EXPRESSION* INTO *EVERY STORY*--

-- WHILE *JULES FEIFFER'S UNEVEN LINES* DID *BATTLE* WITH THEMSELVES IN A *PANTOMIME* OF THE *INNER STRUGGLES* OF *MODERN LIFE*.

IN *JOSÉ MUNOZ'S* WORK, *DENSE PUDDLES OF INK* AND *FRAYING LINEWORK COMBINE* TO EVOKE A WORLD OF *DEPRAVITY* AND *MORBID DECAY*--

--WHILE *JOOST SWARTE'S CRISP ELEGANT* LINES AND *JAZZY DESIGNS* SPEAK OF *COOL SOPHISTICATION* AND *IRONY*.

IN SPIEGELMAN'S *"PRISONER ON THE HELL PLANET,"* DELIBERATELY *EXPRESSIONISTIC LINES* DEPICT A *TRUE-LIFE HORROR STORY*.

AND IN EISNER'S *MODERN* WORK A *FULL RANGE* OF LINE STYLES CAPTURE A FULL RANGE OF MOODS AND *EMOTIONS*.

SEE PAGE 216 FOR COPYRIGHT INFORMATION.

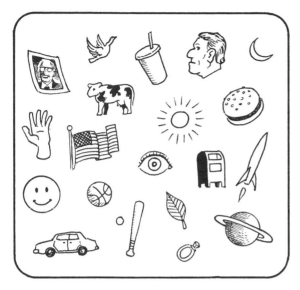

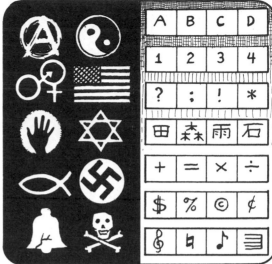

NOW, IF PICTURES CAN, THROUGH THEIR RENDERING, REPRESENT *INVISIBLE* CONCERNS SUCH AS *EMOTIONS* AND THE *OTHER SENSES*--

--THEN THE DISTINCTION BETWEEN PICTURES AND *OTHER* TYPES OF ICONS LIKE LANGUAGE WHICH *SPECIALIZE* IN THE INVISIBLE MAY SEEM A BIT *BLURRY.*

IN FACT, WHAT WE'RE SEEING IN THE *LIVING LINES* OF THESE PICTURES IS *THE PRIMORDIAL STUFF* FROM WHICH A *FORMALIZED LANGUAGE* CAN *EVOLVE!*

I'LL GIVE YOU AN *EXAMPLE.*

LET'S SAY I WANTED TO SMOKE THIS *PIPE*--

--ASSUMING IT *IS* A PIPE--

--AND I LIT IT WITH A MATCH LIKE *SO:*

127

COUGH!
COUGH!

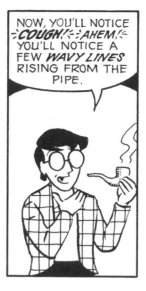

NOW, YOU'LL NOTICE -=COUGH!=- -=AHEM!=- YOU'LL NOTICE A FEW *WAVY LINES* RISING FROM THE PIPE.

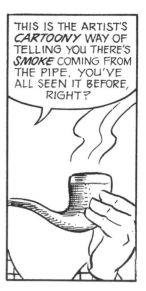

THIS IS THE ARTIST'S *CARTOONY* WAY OF TELLING YOU THERE'S *SMOKE* COMING FROM THE PIPE, YOU'VE ALL SEEN IT BEFORE, RIGHT?

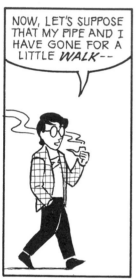

NOW, LET'S SUPPOSE THAT MY PIPE AND I HAVE GONE FOR A LITTLE *WALK*--

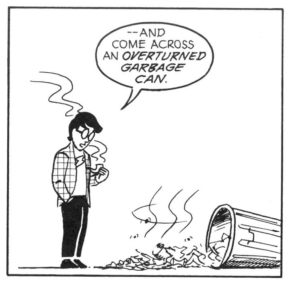

--AND COME ACROSS AN *OVERTURNED GARBAGE CAN.*

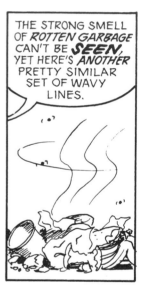

THE STRONG SMELL OF *ROTTEN GARBAGE* CAN'T BE *SEEN,* YET HERE'S *ANOTHER* PRETTY SIMILAR SET OF WAVY LINES.

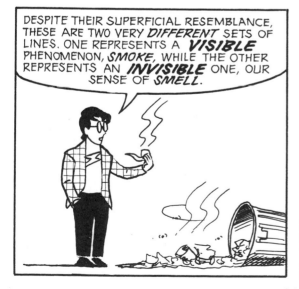

DESPITE THEIR SUPERFICIAL RESEMBLANCE, THESE ARE TWO VERY *DIFFERENT* SETS OF LINES. ONE REPRESENTS A *VISIBLE* PHENOMENON, *SMOKE,* WHILE THE OTHER REPRESENTS AN *INVISIBLE* ONE, OUR SENSE OF *SMELL.*

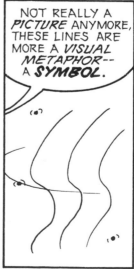

NOT REALLY A *PICTURE* ANYMORE, THESE LINES ARE MORE A *VISUAL METAPHOR--* A *SYMBOL.*

AND SYMBOLS ARE THE BASIS OF *LANGUAGE!*

TAKEN OUT OF THEIR *ORIGINAL CONTEXT*, THEY CAN NOW BE APPLIED *ANYWHERE* AND THE READER WILL INSTANTLY KNOW WHAT THEY MEAN.

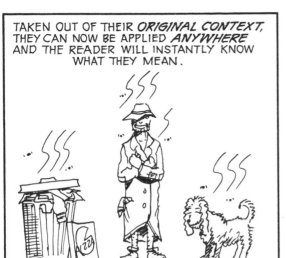

EVEN THE *FLIES* HAVE OVER THE YEARS BEEN APPROACHING THE *ABSTRACT STATUS* OF *LINGUISTIC SYMBOLS*.

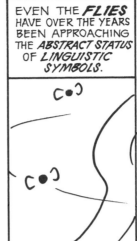

WHENEVER AN ARTIST INVENTS A NEW WAY TO *REPRESENT THE INVISIBLE*, THERE IS ALWAYS A CHANCE THAT IT WILL BE *PICKED UP* BY *OTHER* ARTISTS.

IF ENOUGH ARTISTS BEGIN *USING* THE SYMBOL, IT WILL ENTER THE LANGUAGE FOR *GOOD*--

--AS MANY *HAVE* THROUGH THE YEARS.

HIC

129

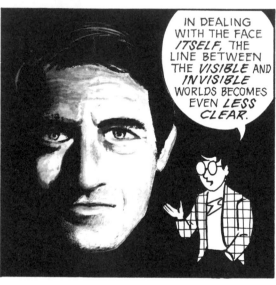

IN DEALING WITH THE FACE *ITSELF*, THE LINE BETWEEN THE *VISIBLE* AND *INVISIBLE* WORLDS BECOMES EVEN *LESS CLEAR*.

THE CARTOON FACE IS AN *ABSTRACT*, BUT IT IS BASED UPON *VISUAL DATA*.

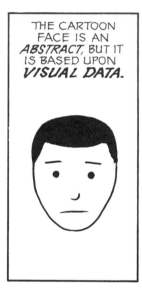

SOME INDICATORS OF EMOTION ARE *ALSO* VISUALLY BASED, SUCH AS THE FAMILIAR *SWEAT BEAD*.

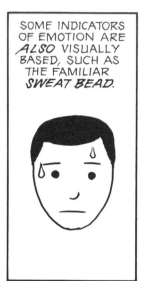

BUT WHEN SUCH IMAGES BEGIN TO DRIFT *OUT* OF THEIR *VISUAL CONTEXT*--

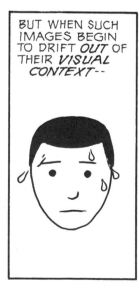

--THEY DRIFT *INTO* THE *INVISIBLE WORLD* OF THE *SYMBOL*.

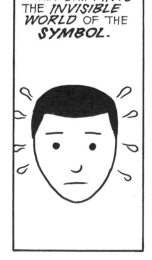

THIS DRIFT FROM *VISIBLE* TO *INVISIBLE* HAS BEEN THE BASIS OF ALL *WRITTEN LANGUAGES* SINCE CIVILIZATION *BEGAN*.

130

SUMERIANS IN ANCIENT MESOPOTAMIA GOT THINGS ROLLING OVER *5,000 YEARS AGO* WHEN A NEED WAS FOUND TO RECORD CERTAIN *COMMODITIES.*

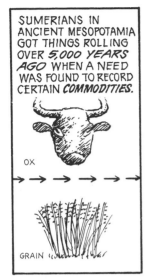

OX

GRAIN

THESE FIRST SYMBOLS -- *CARTOONS,* REALLY -- GRADUALLY EVOLVED AWAY FROM *ANY* RESEMBLANCE TO THEIR SUBJECT, TOWARD THE HIGHLY ABSTRACTED FORMS OF MODERN LANGUAGES...

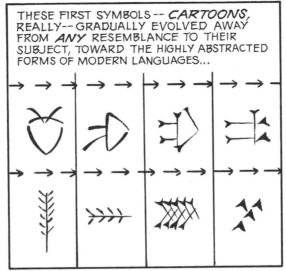

...AND *EVENTUALLY* TO OUR *TOTALLY* ABSTRACT *SOUND-BASED* SYSTEM.

THE LONGER ANY FORM OF ART OR COMMUNICATION EXISTS, THE MORE *SYMBOLS* IT ACCUMULATES.

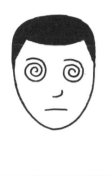

THE MODERN COMIC IS A YOUNG LANGUAGE, BUT IT ALREADY HAS AN *IMPRESSIVE ARRAY* OF *RECOGNIZABLE SYMBOLS.*

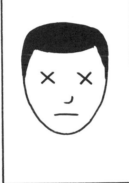

AND THIS *VISUAL VOCABULARY* HAS AN *UNLIMITED POTENTIAL* FOR *GROWTH.*

WITHIN A GIVEN CULTURE THESE SYMBOLS WILL QUICKLY SPREAD UNTIL EVERYBODY KNOWS THEM AT A GLANCE.

BUT WHAT HAPPENS WHEN A LANGUAGE EVOLVES IN MORE THAN ONE DISTINCT CULTURE AT A TIME?

THE ANSWER, OF COURSE, IS THAT MORE THAN ONE SET OF SYMBOLS WILL EVOLVE!

SO IT WAS, ONCE AGAIN, IN *JAPAN* WHERE COMICS DEVELOPED FOR *YEARS* IN RELATIVE *ISOLATION* FROM THEIR WESTERN COUSINS.

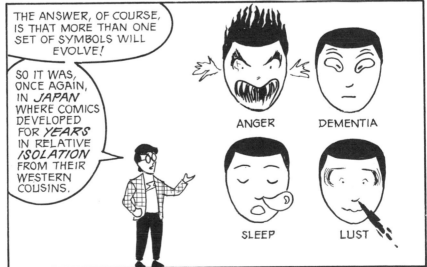

ANGER

DEMENTIA

SLEEP

LUST

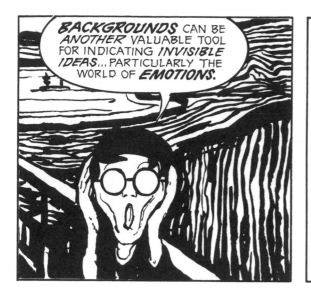

BACKGROUNDS CAN BE *ANOTHER* VALUABLE TOOL FOR INDICATING *INVISIBLE IDEAS*... PARTICULARLY THE WORLD OF *EMOTIONS.*

EVEN WHEN THERE IS LITTLE OR NO DISTORTION OF THE *CHARACTERS* IN A GIVEN SCENE, A DISTORTED OR EXPRESSIONISTIC *BACKGROUND* WILL USUALLY AFFECT OUR "READING" OF CHARACTERS' *INNER STATES.*

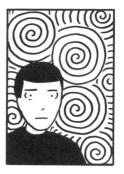

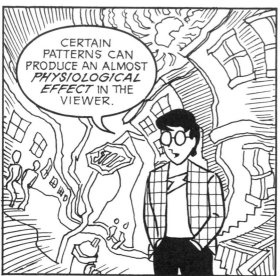

CERTAIN PATTERNS CAN PRODUCE AN ALMOST *PHYSIOLOGICAL EFFECT* IN THE VIEWER.

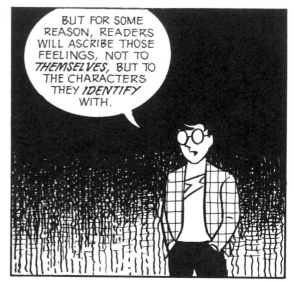

BUT FOR SOME REASON, READERS WILL ASCRIBE THOSE FEELINGS, NOT TO *THEMSELVES,* BUT TO THE CHARACTERS THEY *IDENTIFY* WITH.

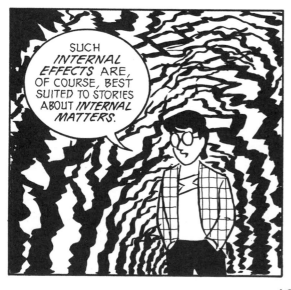

SUCH *INTERNAL EFFECTS* ARE, OF COURSE, BEST SUITED TO STORIES ABOUT *INTERNAL MATTERS.*

WHEN A STORY HINGES MORE ON *CHARACTERIZATION* THAN COLD *PLOT,* THERE MAY NOT BE A LOT TO SHOW *EXTERNALLY*--

--BUT THE *LANDSCAPE* OF THE CHARACTERS' *MINDS* CAN BE QUITE A *SIGHT!*

THIS PRINCIPLE IS EVIDENT IN MANY *EUROPEAN COLOR COMICS* AND IN *JAPANESE ROMANCE COMICS* WHERE EXPRESSIONISTIC EFFECTS HAVE BEEN DEVISED FOR ALMOST *ANY EMOTION IMAGINABLE!*

ねえ！
連れてって
くれるん
でしょ！？

ハハハ

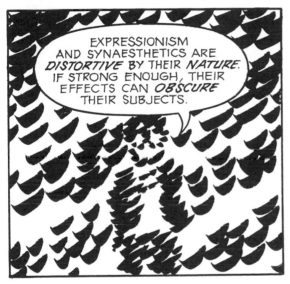

EXPRESSIONISM AND SYNAESTHETICS ARE *DISTORTIVE* BY THEIR *NATURE.* IF STRONG ENOUGH, THEIR EFFECTS CAN *OBSCURE* THEIR SUBJECTS.

BUT A LACK OF CLARITY CAN ALSO FOSTER GREATER *PARTICIPATION* BY THE READER AND A SENSE OF *INVOLVEMENT* WHICH MANY WRITERS AND ARTISTS *PREFER.*

CREATORS WHO USE THESE EFFECTS MAY NEED TO *CLARIFY* WHAT IS BEING SHOWN, HOWEVER.

EITHER THROUGH THE *CONTENT* OF *SURROUNDING SCENES* OR, OF COURSE, THROUGH *WORDS.*

133

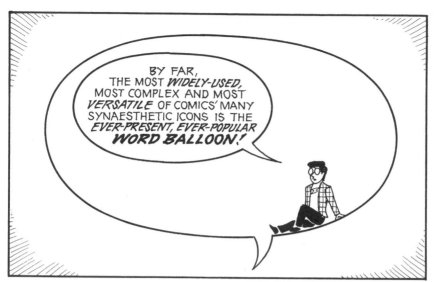

BY FAR, THE MOST *WIDELY-USED,* MOST COMPLEX AND MOST *VERSATILE* OF COMICS' MANY SYNAESTHETIC ICONS IS THE *EVER-PRESENT, EVER-POPULAR* **WORD BALLOON!**

OVER THE YEARS, COMICS CREATORS HAVE STRUGGLED WITH DOZENS OF VARIATIONS IN THEIR DESPERATE ATTEMPTS* TO DEPICT *SOUND* IN A STRICTLY *VISUAL MEDIUM.*

VARIATIONS IN BALLOON SHAPE ARE *MANY* AND NEW ONES ARE BEING INVENTED EVERY DAY.

I WILL BE--

AAARH!

HEE HEE HEE HEE HEE

IT'S SO *QUIET!*

OH, IT'S *YOU.*

ZACHA

TIMBER!!

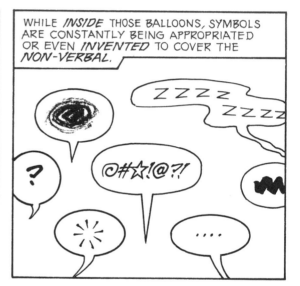

WHILE *INSIDE* THOSE BALLOONS, SYMBOLS ARE CONSTANTLY BEING APPROPRIATED OR EVEN *INVENTED* TO COVER THE *NON-VERBAL.*

ZZZZ ZZZZ

?

@#☆?!@?!

✦

....

EVEN THE VARIATIONS OF LETTERING *STYLES,* BOTH IN AND OUT OF BALLOONS, SPEAK OF AN *ONGOING STRUGGLE* TO CAPTURE THE VERY *ESSENCE* OF SOUND.

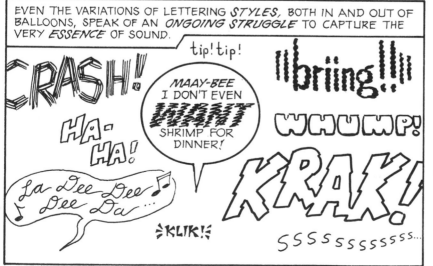

CRASH!

HA- HA!

La Dee Dee Dee Da...

tip! tip!

MAAY-BEE I DON'T EVEN WANT SHRIMP FOR DINNER!

!KLIK!

!!briing!!!

WHUMP!

KRAK!

SSSSSSSSSSS...

AND AS FOR THE ESSENCE OF *THOUGHT...*

134

* EISNER DESCRIBES THE WORD BALLOON AS A "DESPERATION DEVICE."

OF COURSE WORDS *THEMSELVES*, MORE THAN ALL THE OTHER VISUAL SYMBOLS, HAVE THE POWER TO *COMPLETELY DESCRIBE* THE *INVISIBLE REALM* OF *SENSES AND EMOTIONS.*

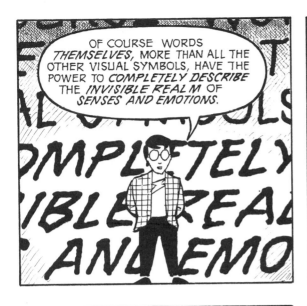

WORDS CAN TAKE EVEN SEEMINGLY *NEUTRAL* IMAGES AND INVEST THEM WITH A *WEALTH OF FEELINGS* AND *EXPERIENCES.*

I SAT BY THE OPEN WINDOW, HOPING TO CATCH A WHIFF OF THE OLD CHARCOAL GRILLS. FROM NEXT DOOR CAME THE OTHERWORLDLY HUM OF TELEVISION. THE OLD CLOCK STRUCK A LAZY EIGHT.

AS NOTED, PICTURES CAN INDUCE *STRONG FEELINGS* IN THE READER, BUT THEY CAN ALSO LACK THE *SPECIFICITY* OF WORDS.

WORDS, ON THE OTHER HAND, OFFER THAT SPECIFICITY, BUT CAN LACK THE IMMEDIATE EMOTIONAL CHARGE OF PICTURES, RELYING INSTEAD ON A GRADUAL *CUMULATIVE* EFFECT.

I JUST WANT YOU TO KNOW THAT I'M ON TO YOUR PLOT... I KNOW YOU PUT SOMETHING IN MY DOG'S FOOD THAT MADE HIM NOT LOVE ME ANYMORE AND...

TOGETHER, OF COURSE, WORDS AND PICTURES CAN WORK MIRACLES.

BUT WE'LL GET TO THAT IN THE *NEXT CHAPTER.*

135

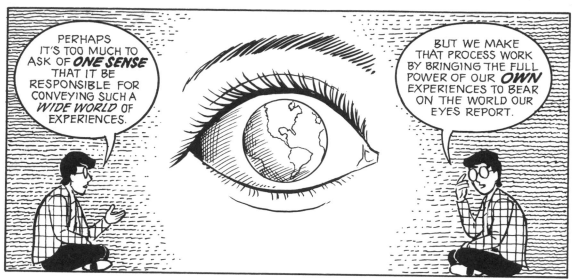

PERHAPS IT'S TOO MUCH TO ASK OF *ONE SENSE* THAT IT BE RESPONSIBLE FOR CONVEYING SUCH A *WIDE WORLD* OF EXPERIENCES.

BUT WE MAKE THAT PROCESS WORK BY BRINGING THE FULL POWER OF OUR *OWN* EXPERIENCES TO BEAR ON THE WORLD OUR EYES REPORT.

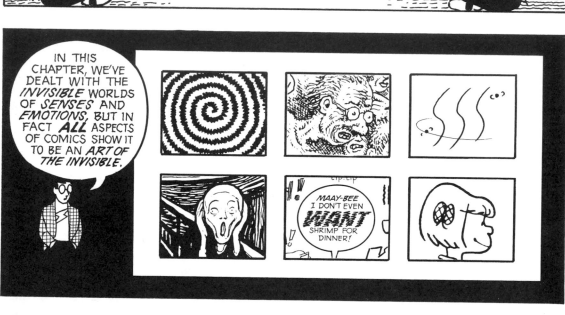

IN THIS CHAPTER, WE'VE DEALT WITH THE *INVISIBLE* WORLDS OF *SENSES* AND *EMOTIONS,* BUT IN FACT *ALL* ASPECTS OF COMICS SHOW IT TO BE AN *ART OF THE INVISIBLE.*

MAAY-BEE I DON'T EVEN *WANT* SHRIMP FOR DINNER!

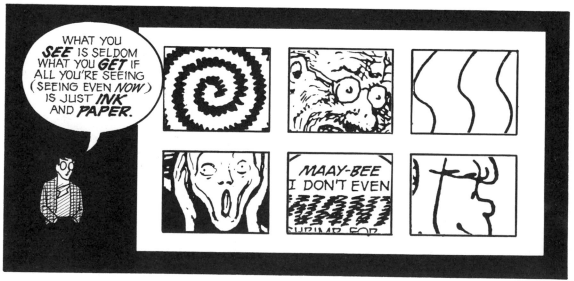

WHAT YOU *SEE* IS SELDOM WHAT YOU *GET* IF ALL YOU'RE SEEING (SEEING EVEN *NOW*) IS JUST *INK* AND *PAPER.*

MAAY-BEE I DON'T EVEN *WANT* SHRIMP FOR

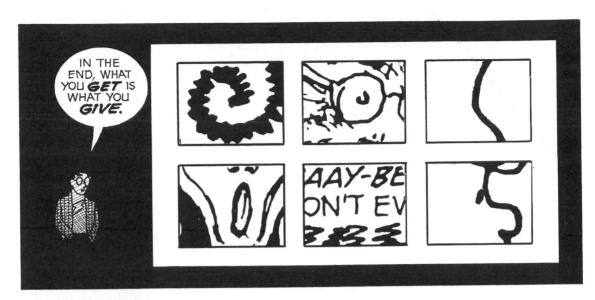

137

CHAPTER SIX

SHOW AND TELL.

THIS IS MY ROBOT.

WHAT CAN YOU **TELL** US ABOUT YOUR ROBOT, TOMMY?

WELL, UH... I LIKE IT 'CAUSE... 'CAUSE, UH...

IT'S GOT ONE OF **THESE** THINGS.

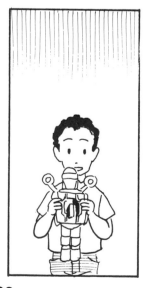

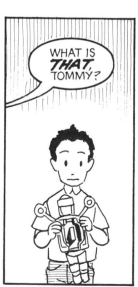

WHAT IS **THAT**, TOMMY?

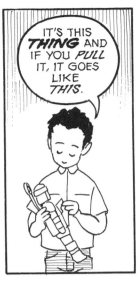

IT'S THIS *THING* AND IF YOU *PULL* IT, IT GOES LIKE *THIS*.

KUNK!

THE HEAD FLIPS BACK.

...?

YEAH.

AND... AND *THEN* YOU CAN DO *THIS* AND IT GOES *UP* AND YOU FLIP *THIS*.

I DID IT WRONG. WAIT.

LOOK, IT'S A *AIRPLANE* NOW!

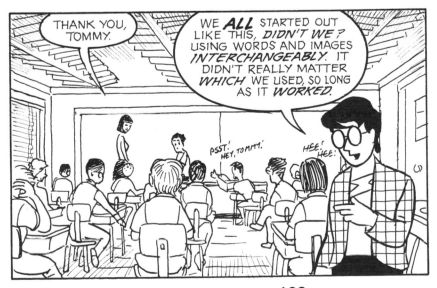

THANK YOU, TOMMY.

WE *ALL* STARTED OUT LIKE THIS, *DIDN'T WE?* USING WORDS AND IMAGES *INTERCHANGEABLY.* IT DIDN'T REALLY MATTER *WHICH* WE USED, SO LONG AS IT *WORKED.*

PSST! HEY, TOMMY!

HEE! HEE!

IT'S CONSIDERED *NORMAL* IN THIS SOCIETY FOR CHILDREN TO COMBINE WORDS AND PICTURES, SO LONG AS THEY *GROW OUT OF IT.*

139.

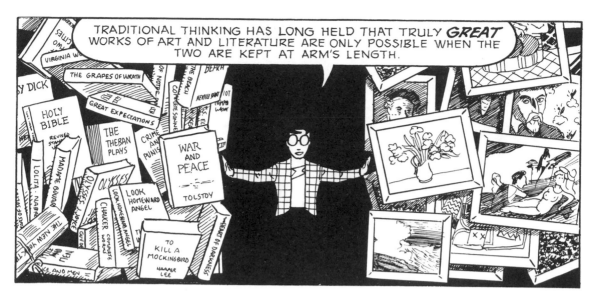

TRADITIONAL THINKING HAS LONG HELD THAT TRULY **GREAT** WORKS OF ART AND LITERATURE ARE ONLY POSSIBLE WHEN THE TWO ARE KEPT AT ARM'S LENGTH.

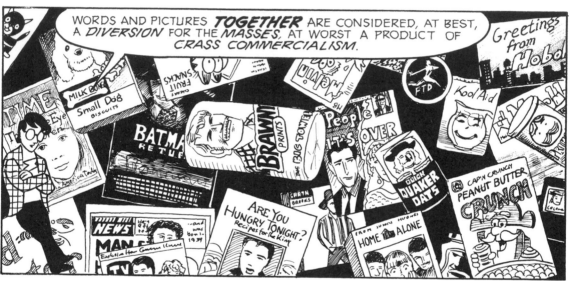

WORDS AND PICTURES **TOGETHER** ARE CONSIDERED, AT BEST, A *DIVERSION* FOR THE *MASSES*, AT WORST A PRODUCT OF *CRASS COMMERCIALISM.*

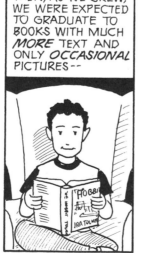

AS CHILDREN, OUR FIRST BOOKS HAD *PICTURES GALORE* AND VERY FEW *WORDS* BECAUSE THAT WAS "EASIER."

THEN, AS WE GREW, WE WERE EXPECTED TO GRADUATE TO BOOKS WITH MUCH *MORE* TEXT AND ONLY *OCCASIONAL* PICTURES--

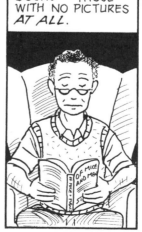

--AND FINALLY TO ARRIVE AT *"REAL"* BOOKS-- THOSE WITH NO PICTURES *AT ALL.*

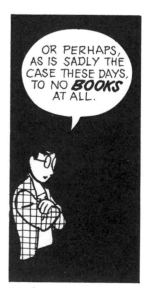

OR PERHAPS, AS IS SADLY THE CASE THESE DAYS, TO NO *BOOKS* AT ALL.

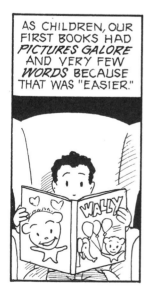

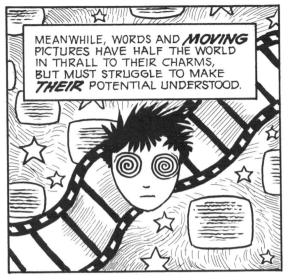

MEANWHILE, WORDS AND **MOVING** PICTURES HAVE HALF THE WORLD IN THRALL TO THEIR CHARMS, BUT MUST STRUGGLE TO MAKE **THEIR** POTENTIAL UNDERSTOOD.

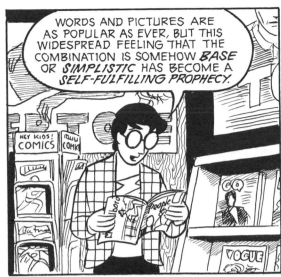

WORDS AND PICTURES ARE AS POPULAR AS EVER, BUT THIS WIDESPREAD FEELING THAT THE COMBINATION IS SOMEHOW **BASE** OR **SIMPLISTIC** HAS BECOME A **SELF-FULFILLING PROPHECY.**

THE ROOTS OF THIS ATTITUDE RUN PRETTY **DEEP.**

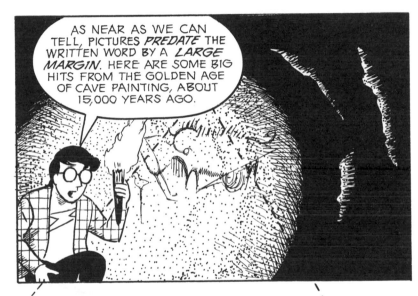

AS NEAR AS WE CAN TELL, PICTURES **PREDATE** THE WRITTEN WORD BY A **LARGE MARGIN.** HERE ARE SOME BIG HITS FROM THE GOLDEN AGE OF CAVE PAINTING, ABOUT 15,000 YEARS AGO.

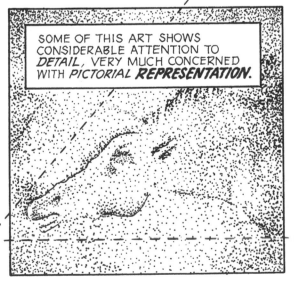

SOME OF THIS ART SHOWS CONSIDERABLE ATTENTION TO **DETAIL,** VERY MUCH CONCERNED WITH PICTORIAL **REPRESENTATION.**

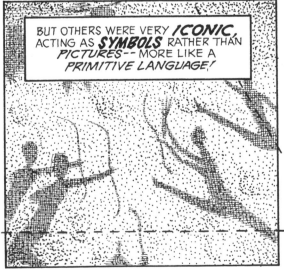

BUT OTHERS WERE VERY **ICONIC,** ACTING AS **SYMBOLS** RATHER THAN **PICTURES**-- MORE LIKE A **PRIMITIVE LANGUAGE!**

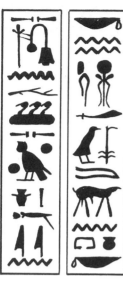

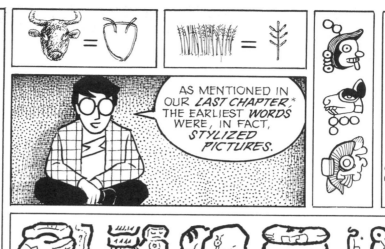

AS MENTIONED IN OUR *LAST CHAPTER,** THE EARLIEST *WORDS* WERE, IN FACT, *STYLIZED PICTURES.*

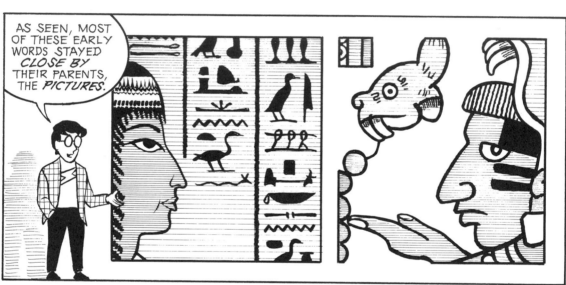

AS SEEN, MOST OF THESE EARLY WORDS STAYED *CLOSE BY* THEIR PARENTS, THE *PICTURES.*

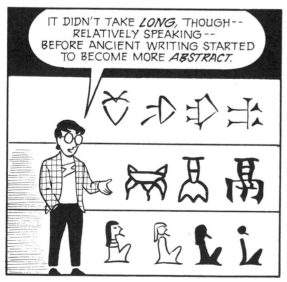

IT DIDN'T TAKE *LONG,* THOUGH -- RELATIVELY SPEAKING -- BEFORE ANCIENT WRITING STARTED TO BECOME MORE *ABSTRACT.*

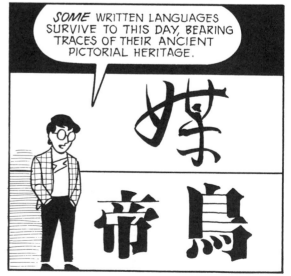

SOME WRITTEN LANGUAGES SURVIVE TO THIS DAY, BEARING TRACES OF THEIR ANCIENT PICTORIAL HERITAGE.

* SEE PAGE 129.

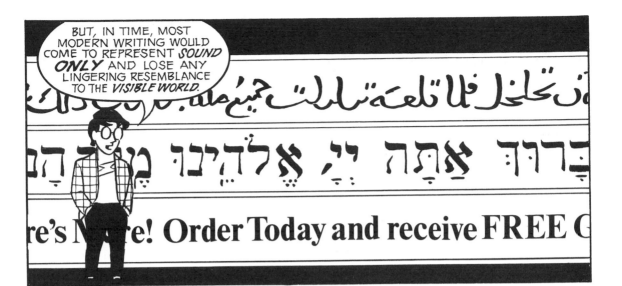

BUT, IN TIME, MOST MODERN WRITING WOULD COME TO REPRESENT *SOUND ONLY* AND LOSE ANY LINGERING RESEMBLANCE TO THE *VISIBLE WORLD.*

re's More! Order Today and receive FREE G

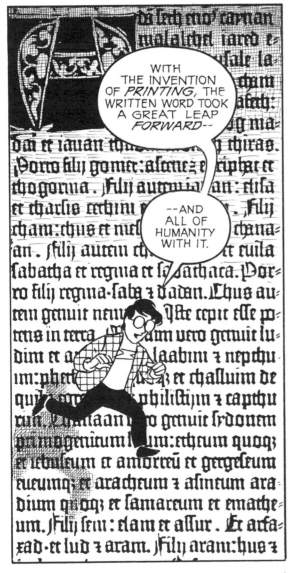

WITH THE INVENTION OF *PRINTING,* THE WRITTEN WORD TOOK A GREAT LEAP *FORWARD--*

--AND ALL OF HUMANITY WITH IT.

BUT WHERE HAD THE *PICTURES* ALL GONE?

WORDS AND PICTURES DID STILL *COEXIST* AT THIS STAGE IN WESTERN CIVILIZATION.*

BUT *THOSE* INSTANCES WERE BECOMING THE *EXCEPTION,* NOT THE *RULE.*

143

*IN ILLUMINATED MANUSCRIPTS, FOR EXAMPLE.

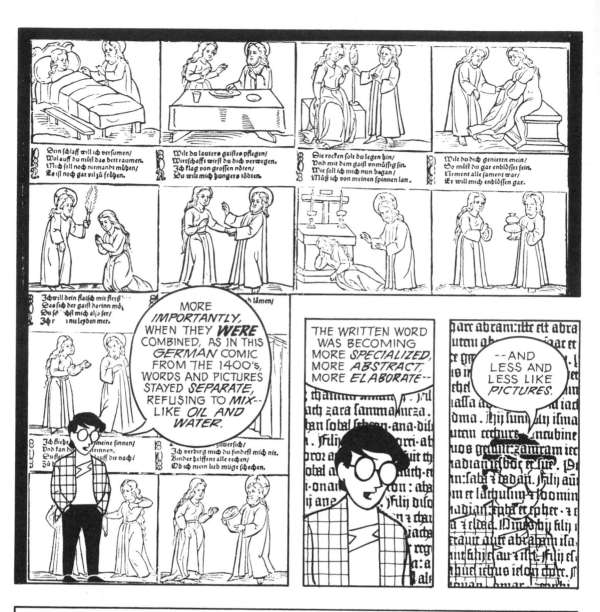

MORE *IMPORTANTLY*, WHEN THEY **WERE** COMBINED, AS IN THIS *GERMAN* COMIC FROM THE 1400's, WORDS AND PICTURES STAYED *SEPARATE*, REFUSING TO *MIX*-- LIKE *OIL AND WATER.*

THE WRITTEN WORD WAS BECOMING MORE *SPECIALIZED,* MORE *ABSTRACT,* MORE *ELABORATE*--

--AND *LESS* AND *LESS* LIKE *PICTURES.*

PICTURES, MEANWHILE, BEGAN TO GROW IN THE *OPPOSITE* DIRECTION: LESS *ABSTRACT* OR *SYMBOLIC,* MORE *REPRESENTATIONAL* AND *SPECIFIC.*

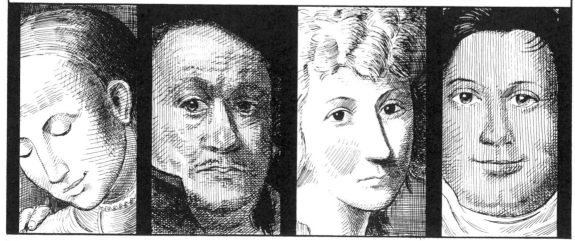

FACSIMILE DETAILS OF PORTRAITS BY DURER (1519) REMBRANDT (1660) DAVID (1788) AND INGRES (1810-15).

144

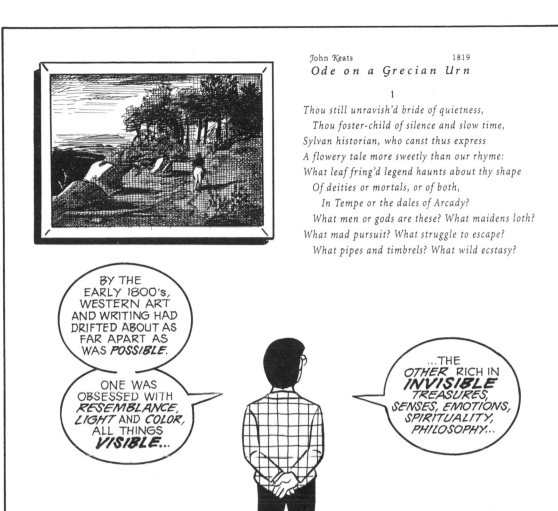

John Keats 1819
Ode on a Grecian Urn

1

Thou still unravish'd bride of quietness,
 Thou foster-child of silence and slow time,
Sylvan historian, who canst thus express
A flowery tale more sweetly than our rhyme:
What leaf fring'd legend haunts about thy shape
 Of deities or mortals, or of both,
 In Tempe or the dales of Arcady?
 What men or gods are these? What maidens loth?
What mad pursuit? What struggle to escape?
 What pipes and timbrels? What wild ecstasy?

BY THE EARLY 1800's, WESTERN ART AND WRITING HAD DRIFTED ABOUT AS FAR APART AS WAS *POSSIBLE*.

ONE WAS OBSESSED WITH *RESEMBLANCE, LIGHT* AND *COLOR,* ALL THINGS *VISIBLE...*

...THE *OTHER* RICH IN *INVISIBLE* TREASURES, SENSES, EMOTIONS, SPIRITUALITY, PHILOSOPHY...

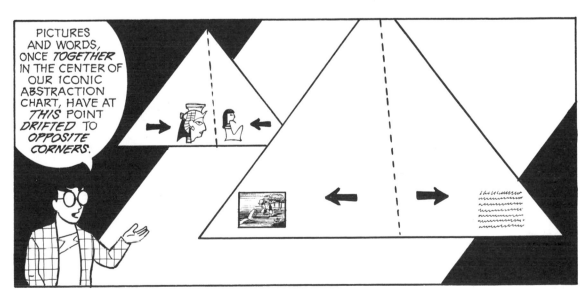

PICTURES AND WORDS, ONCE *TOGETHER* IN THE CENTER OF OUR ICONIC ABSTRACTION CHART, HAVE AT *THIS* POINT *DRIFTED* TO *OPPOSITE* CORNERS.

IN A WAY, PICTURES AND WORDS HAD REACHED THE END OF A *5,000 YEAR JOURNEY.* IF THEY WERE TO *CONTINUE* MOVING, WHERE COULD THEY GO?

PICTURE PLANE

P

W

RESEMBLANCE

MEANING

FOR *PICTURES,* THERE WAS ONLY *UP!*

IMPRESSIONISM SENT WESTERN ART TOWARD THE *ABSTRACT VERTEX,* BUT IN A WAY THAT *CLUNG* TO WHAT THE *EYE* SAW.

P

IMPRESSIONISM, WHILE IT COULD BE THOUGHT OF AS THE FIRST *MODERN* MOVEMENT, WAS MORE A *CULMINATION* OF THE *OLD,* THE *ULTIMATE STUDY* OF *LIGHT AND COLOR.*

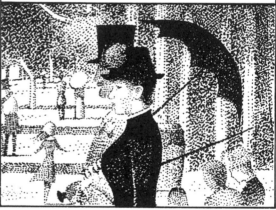

FACSIMILE DETAIL OF "A SUNDAY AFTERNOON ON THE ISLAND OF LA GRANDE JATTE" BY GEORGES SEURAT

SOON AFTER CAME THE ***EXPLOSION!*** EXPRESSIONISM, FUTURISM, DADA, SURREALISM, FAUVISM, CUBISM, ABSTRACT EXPRESSIONISM, NEO-PLASTICISM, CONSTRUCTIVISM.

EVERY WHICH WAY BUT *BACKWARDS!*

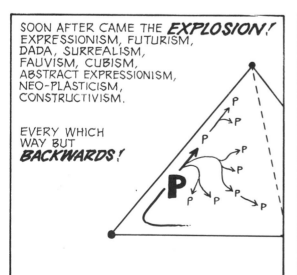

STRICT REPRESENTATIONAL STYLES WERE OF LITTLE IMPORTANCE TO THE NEW SCHOOLS. *ABSTRACTION,* BOTH ICONIC AND *NON-*ICONIC MADE A SPECTACULAR *COMEBACK!*

146

FACSIMILE DETAILS OF PORTRAITS BY PICASSO, LEGER AND KLEE.

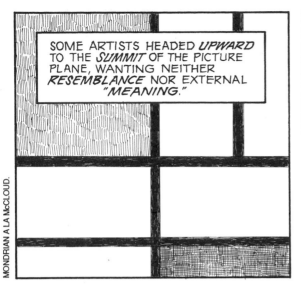

SOME ARTISTS HEADED *UPWARD* TO THE *SUMMIT* OF THE PICTURE PLANE, WANTING NEITHER *RESEMBLANCE* NOR EXTERNAL *"MEANING."*

MONDRIAN A LA McCLOUD.

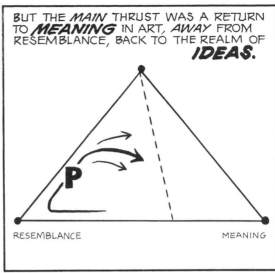

BUT THE *MAIN* THRUST WAS A RETURN TO *MEANING* IN ART, *AWAY* FROM RESEMBLANCE, BACK TO THE REALM OF *IDEAS.*

RESEMBLANCE MEANING

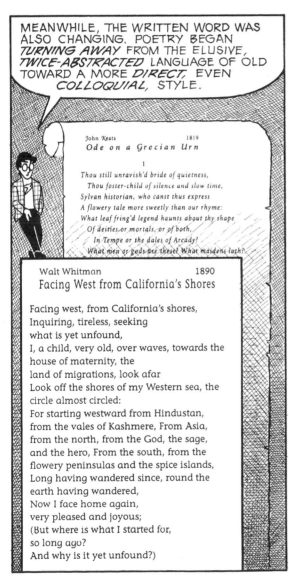

MEANWHILE, THE WRITTEN WORD WAS ALSO CHANGING. POETRY BEGAN *TURNING AWAY* FROM THE ELUSIVE, *TWICE-ABSTRACTED* LANGUAGE OF OLD TOWARD A MORE *DIRECT,* EVEN *COLLOQUIAL,* STYLE.

John Keats 1819
Ode on a Grecian Urn

1

Thou still unravish'd bride of quietness,
Thou foster-child of silence and slow time,
Sylvan historian, who canst thus express
A flowery tale more sweetly than our rhyme:
What leaf fring'd legend haunts about thy shape
Of deities or mortals, or of both,
In Tempe or the dales of Arcady?
What men or gods are these? What maidens loth?

Walt Whitman 1890
Facing West from California's Shores

Facing west, from California's shores,
Inquiring, tireless, seeking
what is yet unfound,
I, a child, very old, over waves, towards the
house of maternity, the
land of migrations, look afar
Look off the shores of my Western sea, the
circle almost circled:
For starting westward from Hindustan,
from the vales of Kashmere, From Asia,
from the north, from the God, the sage,
and the hero, From the south, from the
flowery peninsulas and the spice islands,
Long having wandered since, round the
earth having wandered,
Now I face home again,
very pleased and joyous;
(But where is what I started for,
so long ago?
And why is it yet unfound?)

IN PROSE, LANGUAGE WAS BECOMING EVEN MORE DIRECT, CONVEYING MEANING *SIMPLY* AND *QUICKLY,* MORE LIKE *PICTURES.*

"MEANING" WAS NOT *ABANDONED* BY *ANY MEANS,* BUT AUTHORS WERE DEFINITELY MOVING *LEFT--*

W

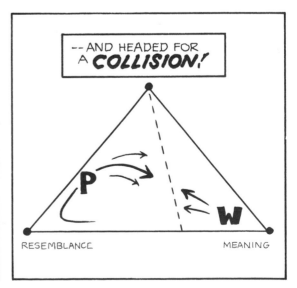

*--*AND HEADED FOR A *COLLISION!*

P W

RESEMBLANCE MEANING

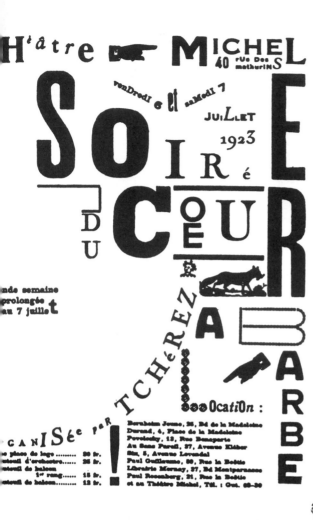

DADA POSTER FOR THE PLAY
"THE BEARDED HEART"

Portrait de TRISTAN TZARA
par
FRANCIS PICABIA

THE WORK OF *DADAISTS, FUTURISTS* AND VARIOUS *INDIVIDUAL* ARTISTS OF THE MODERN ERA BREACHED THE FRONTIER BETWEEN *APPEARANCE* AND *MEANING!*

PAINTINGS INCREASINGLY TOOK ON *SYMBOLIC,* EVEN *CALLIGRAPHIC,* MEANINGS...

WHILE SOME ARTISTS ADDRESSED THE IRONIES OF WORDS AND PICTURES *HEAD-ON!*

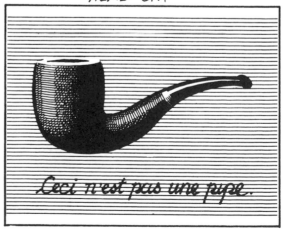

Ceci n'est pas une pipe.

AND IN *POPULAR* CULTURE THE TWO FORMS COLLIDED *AGAIN AND AGAIN* WITHOUT ANY PRETENSES OF *"HIGH"* ART.

NOWHERE IS THIS COLLISION MORE THOROUGHLY EXPLORED THAN THE MODERN COMIC. AND IT'S NOT A RECENT OBSESSION.

LET'S GO BACK TO THE EARLY 1800'S BEFORE ANY OF THIS HAPPENED, WHEN WORDS AND PICTURES HAD DRIFTED AS FAR APART AS *POSSIBLE.*

UP TO THAT POINT, *EUROPEAN BROADSHEETS* HAD OFFERED *REMINDERS* OF WHAT WORDS AND PICTURES COULD DO WHEN COMBINED.

BUT AGAIN IT WAS *RODOLPHE TÖPFFER* WHO FORESAW THEIR *INTERDEPENDENCY* AND BROUGHT THE FAMILY *BACK TOGETHER* AT LAST.

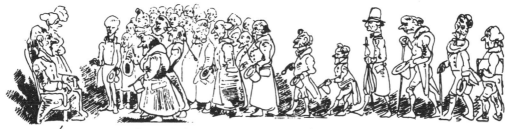

M. CRÉPIN ADVERTISES FOR A TUTOR, AND MANY APPLY FOR THE JOB.

I'M SURE THAT THESE IDEAS WERE THE *FURTHEST THING* FROM TÖPFFER'S MIND WHEN HE PUT *PEN TO PAPER*--

--BUT THE FACT THAT THE MODERN COMIC WAS BORN JUST AS ART AND WRITING WERE PREPARING TO CHANGE DIRECTION IS AT LEAST *INTRIGUING.*

AND PERHAPS THIS COMMON THREAD OF *UNIFICATION* DID GROW OUT OF A *SHARED INSTINCT* OF THE DAY...

...AN INSTINCT WHICH SAID THAT WE HAD REACHED THE END OF A *LONG JOURNEY* AND THAT IT WAS TIME AT LAST TO *HEAD FOR HOME.*

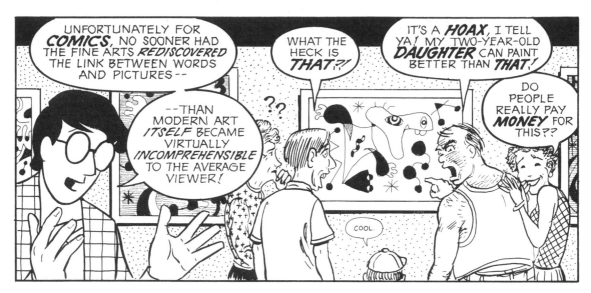

UNFORTUNATELY FOR *COMICS*, NO SOONER HAD THE FINE ARTS *REDISCOVERED* THE LINK BETWEEN WORDS AND PICTURES--

--THAN MODERN ART *ITSELF* BECAME VIRTUALLY *INCOMPREHENSIBLE* TO THE AVERAGE VIEWER!

WHAT THE HECK IS *THAT?!*

IT'S A *HOAX*, I TELL YA! MY TWO-YEAR-OLD *DAUGHTER* CAN PAINT BETTER THAN *THAT!*

DO PEOPLE REALLY PAY *MONEY* FOR THIS??

COOL.

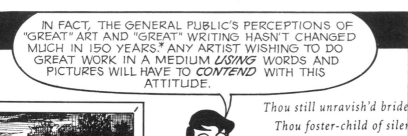

IN FACT, THE GENERAL PUBLIC'S PERCEPTIONS OF "GREAT" ART AND "GREAT" WRITING HASN'T CHANGED MUCH IN 150 YEARS.* ANY ARTIST WISHING TO DO GREAT WORK IN A MEDIUM *USING* WORDS AND PICTURES WILL HAVE TO *CONTEND* WITH THIS ATTITUDE.

IN OTHERS *AND* IN *THEMSELVES...*

Thou still unravish'd bride
Thou foster-child of siler
Sylvan historian, who cans
A flowery tale more sweetl
What leaf fring'd legend he
Of deities or mortals, or
In Tempe or the dales
What men or gods are th
What mad pursuit? What s
What pipes and timbrels

...BECAUSE, DEEP DOWN INSIDE, MANY COMICS CREATORS STILL MEASURE ART AND WRITING BY *DIFFERENT STANDARDS* AND ACT ON THE FAITH THAT *"GREAT"* ART AND *"GREAT"* WRITING WILL COMBINE HARMONIOUSLY BY VIRTUE OF *QUALITY ALONE*.

 → 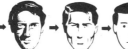 → → ⊙ ·FACE → TWO EYES, ONE NOSE, ONE MOUTH. →

Thy youth's proud livery, so gaz'd on now...

* NOT AS MUCH AS WE LIKE TO *THINK* IT HAS, ANYWAY.

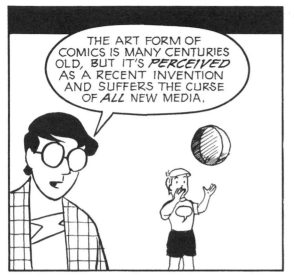

THE ART FORM OF COMICS IS MANY CENTURIES OLD, BUT IT'S *PERCEIVED* AS A RECENT INVENTION AND SUFFERS THE CURSE OF *ALL* NEW MEDIA,

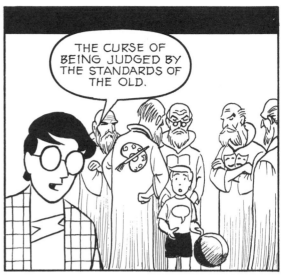

THE CURSE OF BEING JUDGED BY THE STANDARDS OF THE OLD.

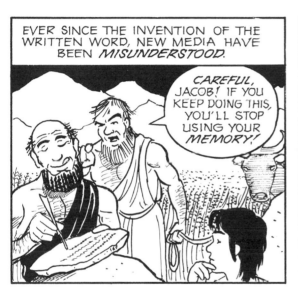

EVER SINCE THE INVENTION OF THE WRITTEN WORD, NEW MEDIA HAVE BEEN *MISUNDERSTOOD*.

CAREFUL, JACOB! IF YOU KEEP DOING THIS, YOU'LL STOP USING YOUR *MEMORY!*

EACH NEW MEDIUM BEGINS ITS LIFE BY IMITATING ITS *PREDECESSORS.* MANY EARLY MOVIES WERE LIKE FILMED *STAGE PLAYS,* MUCH EARLY *TELEVISION* WAS LIKE *RADIO WITH PICTURES* OR *REDUCED MOVIES:*

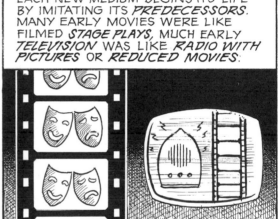

FAR TOO MANY COMICS CREATORS HAVE NO HIGHER GOAL THAN TO MATCH THE ACHIEVEMENTS OF OTHER MEDIA, AND VIEW ANY CHANCE TO *WORK* IN OTHER MEDIA AS A *STEP UP.*

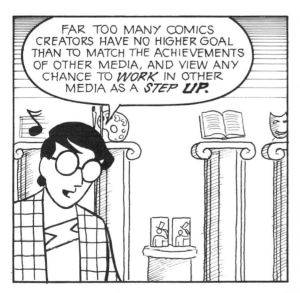

AND *AGAIN,* AS LONG AS WE VIEW COMICS AS A *GENRE* OF WRITING OR A *STYLE* OF GRAPHIC ART THIS ATTITUDE MAY *NEVER* DISAPPEAR.

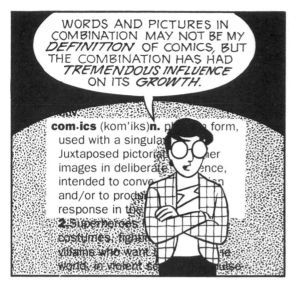

WORDS AND PICTURES IN COMBINATION MAY NOT BE MY *DEFINITION* OF COMICS, BUT THE COMBINATION HAS HAD *TREMENDOUS INFLUENCE* ON ITS *GROWTH.*

com·ics (kom'iks) n. pl... a form, used with a singular... Juxtaposed pictorial... other images in deliberate... ence, intended to conve... ion and/or to prod... response in the...

2: Superheroes... costumes, fighting... villains who want t... ... re world in violent s... ... duse...

A HUGE RANGE OF HUMAN EXPERIENCES CAN BE *PORTRAYED* IN COMICS THROUGH EITHER WORDS OR PICTURES.

AS A RESULT-- AND DESPITE ITS MANY *OTHER* POTENTIAL USES -- COMICS HAVE BECOME *FIRMLY IDENTIFIED* WITH THE ART OF *STORYTELLING.*

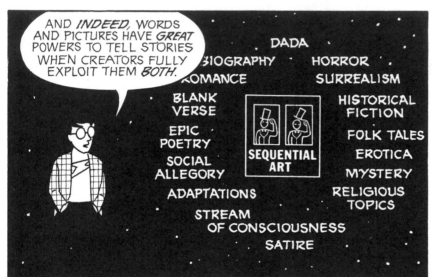

AND *INDEED*, WORDS AND PICTURES HAVE *GREAT* POWERS TO TELL STORIES WHEN CREATORS FULLY EXPLOIT THEM *BOTH.*

DADA
BIOGRAPHY HORROR
ROMANCE SURREALISM
BLANK VERSE HISTORICAL FICTION
EPIC POETRY FOLK TALES
SOCIAL ALLEGORY SEQUENTIAL ART EROTICA
MYSTERY
ADAPTATIONS RELIGIOUS TOPICS
STREAM OF CONSCIOUSNESS
SATIRE

AND SO FAR, WE'VE ONLY SEEN THE *TIP OF THE ICEBERG!*

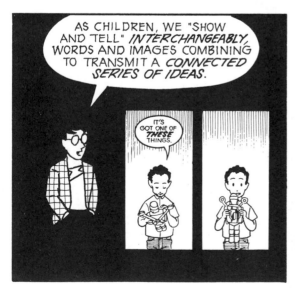

AS CHILDREN, WE "SHOW AND TELL" *INTERCHANGEABLY,* WORDS AND IMAGES COMBINING TO TRANSMIT A *CONNECTED SERIES OF IDEAS.*

IT'S GOT ONE OF *THESE* THINGS.

THE DIFFERENT WAYS IN WHICH WORDS AND PICTURES CAN *COMBINE* IN COMICS IS VIRTUALLY *UNLIMITED.*

BUT LET'S TRY TO BREAK IT DOWN INTO SOME DISTINCT *CATEGORIES.*

FIRST, WE HAVE THE **WORD SPECIFIC** COMBINATIONS, WHERE PICTURES *ILLUSTRATE,* BUT DON'T SIGNIFICANTLY *ADD* TO A LARGELY *COMPLETE* TEXT.

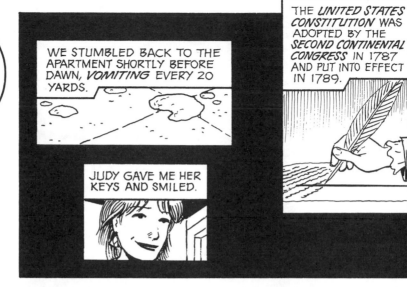

WE STUMBLED BACK TO THE APARTMENT SHORTLY BEFORE DAWN, *VOMITING* EVERY 20 YARDS.

JUDY GAVE ME HER KEYS AND SMILED.

THE *UNITED STATES CONSTITUTION* WAS ADOPTED BY THE *SECOND CONTINENTAL CONGRESS* IN 1787 AND PUT INTO EFFECT IN 1789.

THEN THERE ARE **PICTURE SPECIFIC** COMBINATIONS WHERE WORDS DO LITTLE MORE THAN ADD A *SOUNDTRACK* TO A VISUALLY TOLD SEQUENCE.

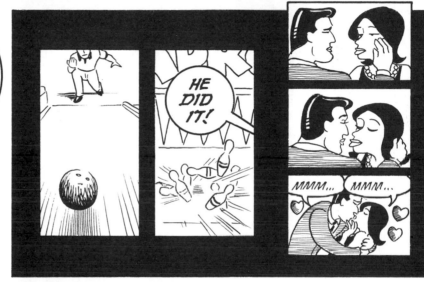

HE DID *IT!*

MMM... MMM...

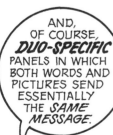

AND, OF COURSE, **DUO-SPECIFIC** PANELS IN WHICH BOTH WORDS AND PICTURES SEND ESSENTIALLY THE *SAME* MESSAGE.

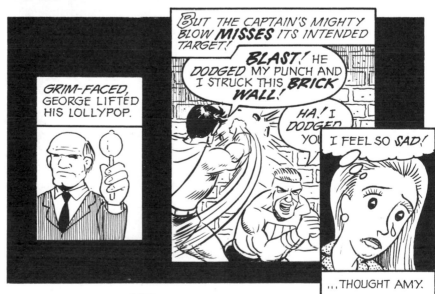

GRIM-FACED, GEORGE LIFTED HIS LOLLYPOP.

BUT THE CAPTAIN'S MIGHTY BLOW **MISSES** ITS INTENDED TARGET!

BLAST! HE *DODGED* MY PUNCH AND I STRUCK THIS *BRICK WALL!*

HA! I *DODGED* YOU

I FEEL SO *SAD!*

...THOUGHT AMY.

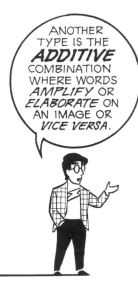

ANOTHER TYPE IS THE **ADDITIVE** COMBINATION WHERE WORDS *AMPLIFY* OR *ELABORATE* ON AN IMAGE OR *VICE VERSA*.

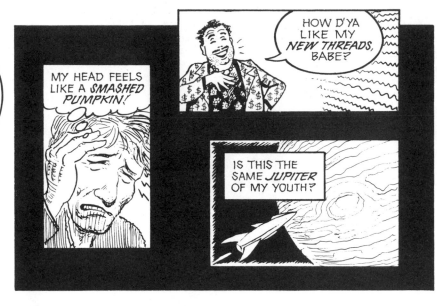

HOW D'YA LIKE MY *NEW THREADS*, BABE?

MY HEAD FEELS LIKE A *SMASHED PUMPKIN*!

IS THIS THE SAME *JUPITER* OF MY YOUTH?

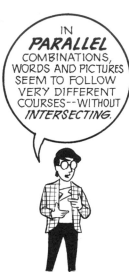

IN **PARALLEL** COMBINATIONS, WORDS AND PICTURES SEEM TO FOLLOW VERY DIFFERENT COURSES--WITHOUT *INTERSECTING*.

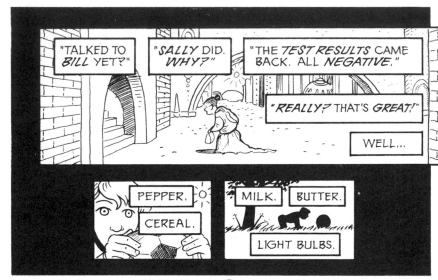

"TALKED TO *BILL* YET?"

"*SALLY* DID. *WHY?*"

"THE *TEST RESULTS* CAME BACK. ALL *NEGATIVE*."

"*REALLY?* THAT'S *GREAT!*"

WELL...

PEPPER. CEREAL.

MILK. BUTTER. LIGHT BULBS.

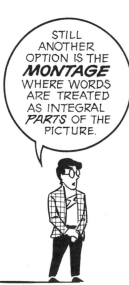

STILL ANOTHER OPTION IS THE **MONTAGE** WHERE WORDS ARE TREATED AS INTEGRAL *PARTS* OF THE PICTURE.

CASH PUBL FLOW BOTTOM LINE ANNUAL REPORT

H A P P Y!

154

PERHAPS THE MOST *COMMON* TYPE OF WORD/PICTURE COMBINATION IS THE *INTER-DEPENDENT*, WHERE WORDS AND PICTURES GO *HAND IN HAND* TO CONVEY AN IDEA THAT NEITHER COULD CONVEY *ALONE*.

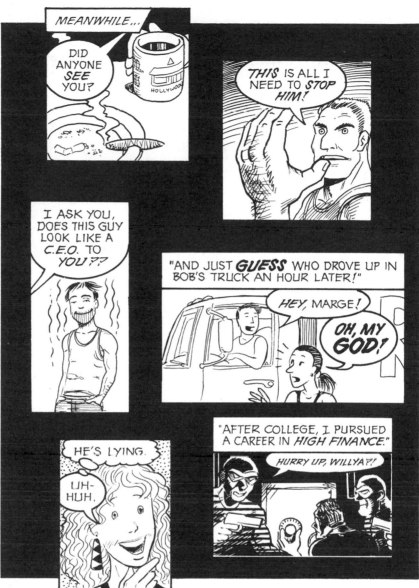

MEANWHILE...

DID ANYONE *SEE* YOU?

HOLLYWOOD

THIS IS ALL I NEED TO *STOP HIM!*

I ASK YOU, DOES THIS GUY LOOK LIKE A *C.E.O.* TO *YOU??*

"AND JUST *GUESS* WHO DROVE UP IN BOB'S TRUCK AN HOUR LATER!"

HEY, MARGE!

OH, MY GOD!

"AFTER COLLEGE, I PURSUED A CAREER IN *HIGH FINANCE*."

HURRY UP, WILLYA?!

HE'S LYING.

UH-HUH.

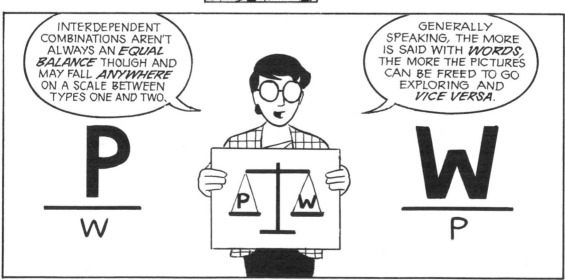

INTERDEPENDENT COMBINATIONS AREN'T ALWAYS AN *EQUAL BALANCE* THOUGH AND MAY FALL *ANYWHERE* ON A SCALE BETWEEN TYPES ONE AND TWO.

GENERALLY SPEAKING, THE MORE IS SAID WITH *WORDS*, THE MORE THE PICTURES CAN BE FREED TO GO EXPLORING AND *VICE VERSA*.

$$\frac{P}{W}$$

$$\frac{W}{P}$$

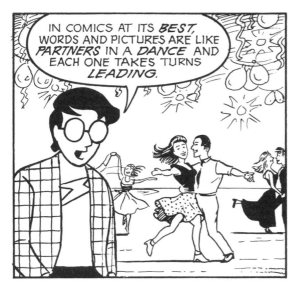

IN COMICS AT ITS *BEST,* WORDS AND PICTURES ARE LIKE *PARTNERS* IN A *DANCE* AND EACH ONE TAKES TURNS *LEADING.*

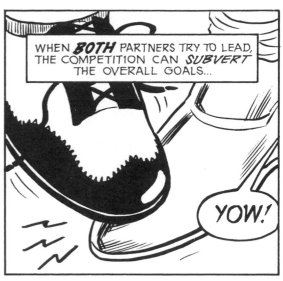

WHEN *BOTH* PARTNERS TRY TO LEAD, THE COMPETITION CAN *SUBVERT* THE OVERALL GOALS...

YOW!

...THOUGH A LITTLE *PLAYFUL COMPETITION* CAN SOMETIMES PRODUCE *ENJOYABLE RESULTS.*

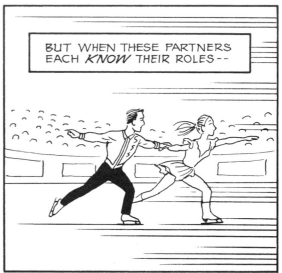

BUT WHEN THESE PARTNERS EACH *KNOW* THEIR ROLES--

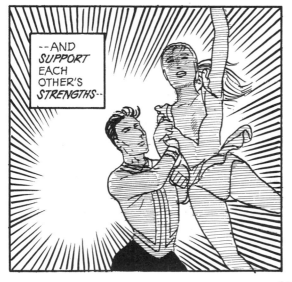

--AND *SUPPORT* EACH OTHER'S *STRENGTHS*--

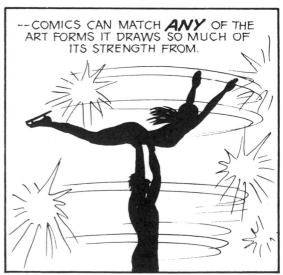

--COMICS CAN MATCH *ANY* OF THE ART FORMS IT DRAWS SO MUCH OF ITS STRENGTH FROM.

WHEN **PICTURES** CARRY THE WEIGHT OF CLARITY IN A SCENE, THEY FREE WORDS TO EXPLORE A WIDER AREA.

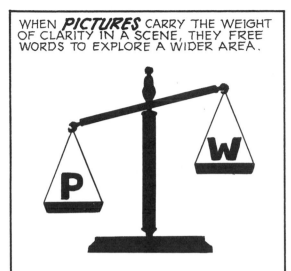

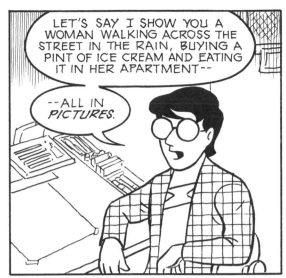

LET'S SAY I SHOW YOU A WOMAN WALKING ACROSS THE STREET IN THE RAIN, BUYING A PINT OF ICE CREAM AND EATING IT IN HER APARTMENT--

--ALL IN *PICTURES.*

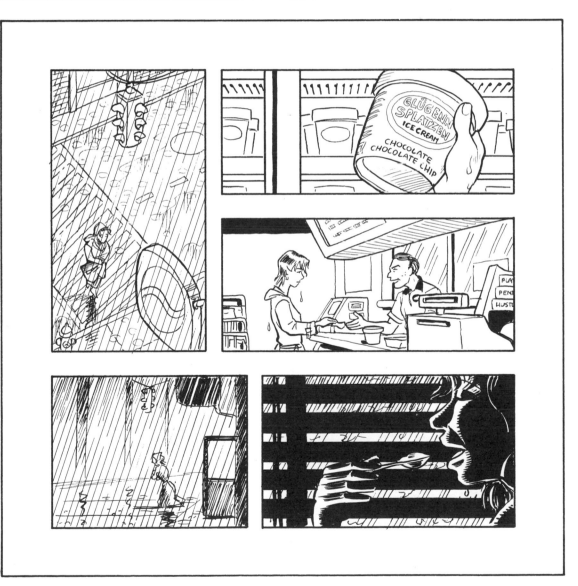

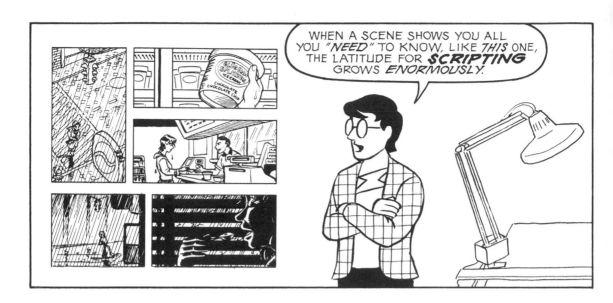

WHEN A SCENE SHOWS YOU ALL YOU *"NEED"* TO KNOW, LIKE *THIS* ONE, THE LATITUDE FOR **SCRIPTING** GROWS *ENORMOUSLY.*

I MAY BE ALONE LIKE THIS FOR A VERY LONG TIME.

IT COULD BECOME AN *INTERNAL MONOLOGUE.*

(INTERDEPENDENT)

PERHAPS SOMETHING WILDLY *INCONGRUOUS*

"MISSION CONTROL, MISSION CONTROL, DO YOU READ ME?"

(PARALLEL)

MAYBE IT'S ALL JUST A BIG *ADVERTISEMENT!*

YOU'LL *Love* THE TASTE!

(INTERDEPENDENT)

OR A CHANCE TO RUMINATE ON *BROADER TOPICS:*

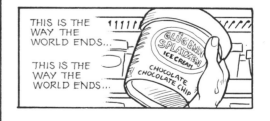

THIS IS THE WAY THE WORLD ENDS...

THIS IS THE WAY THE WORLD ENDS...

(INTERDEPENDENT)

ON THE *OTHER* HAND, IF THE **WORDS** LOCK IN THE *"MEANING"* OF A SEQUENCE, THEN THE *PICTURES* CAN REALLY TAKE OFF.

P | W

SAME SCENE NOW, BUT THIS TIME ALL IN *WORDS!*

I CROSSED THE STREET TO THE CONVENIENCE STORE. THE RAIN SOAKED INTO MY BOOTS.

I FOUND THE LAST PINT OF CHOCOLATE CHOCOLATE CHIP IN THE FREEZER.

THE CLERK TRIED TO PICK ME UP. I SAID *NO THANKS*. HE GAVE ME THIS CREEPY LOOK...

I WENT BACK TO THE APARTMENT--

--AND FINISHED IT ALL IN AN HOUR.

ALONE AT LAST.

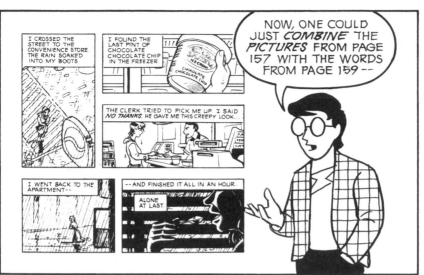

NOW, ONE COULD JUST *COMBINE* THE *PICTURES* FROM PAGE 157 WITH THE WORDS FROM PAGE 159 --

I CROSSED THE STREET TO THE CONVENIENCE STORE THE RAIN SOAKED INTO MY BOOTS

I FOUND THE LAST PINT OF CHOCOLATE CHOCOLATE CHIP IN THE FREEZER

THE CLERK TRIED TO PICK ME UP I SAID *NO THANKS*. HE GAVE ME THIS CREEPY LOOK...

I WENT BACK TO THE APARTMENT--

--AND FINISHED IT ALL IN AN HOUR.

ALONE AT LAST.

--BUT WHAT ARE SOME *OTHER* OPTIONS?

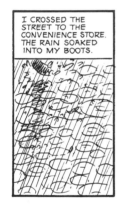

I CROSSED THE STREET TO THE CONVENIENCE STORE. THE RAIN SOAKED INTO MY BOOTS.

IF THE ARTIST WANTS TO, HE/SHE CAN NOW SHOW ONLY *FRAGMENTS* OF A SCENE.

(WORD SPECIFIC)

OR MOVE TOWARD GREATER LEVELS OF *ABSTRACTION* OR *EXPRESSION*.

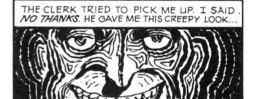

THE CLERK TRIED TO PICK ME UP. I SAID *NO THANKS*. HE GAVE ME THIS CREEPY LOOK...

(AMPLIFICATION)

PERHAPS THE ARTIST CAN GIVE US SOME IMPORTANT *EMOTIONAL* INFORMATION.

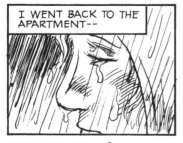

I WENT BACK TO THE APARTMENT--

(INTERDEPENDENT)

OR SHIFT AHEAD OR BACKWARDS IN TIME.

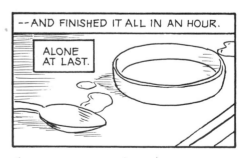

--AND FINISHED IT ALL IN AN HOUR.

ALONE AT LAST.

(WORD SPECIFIC)

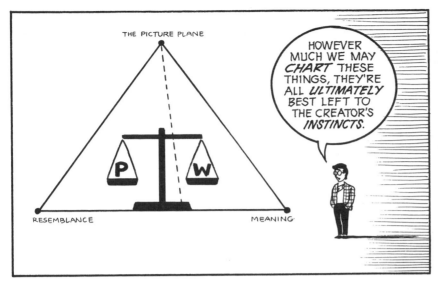

THE PICTURE PLANE

P | W

RESEMBLANCE

MEANING

HOWEVER MUCH WE MAY *CHART* THESE THINGS, THEY'RE ALL *ULTIMATELY* BEST LEFT TO THE CREATOR'S *INSTINCTS*.

THE MIXING OF WORDS AND PICTURES IS MORE *ALCHEMY* THAN SCIENCE.

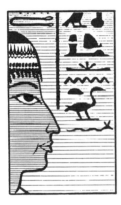

SOME OF THE SECRETS OF THOSE *FIRST* ALCHEMISTS MAY HAVE BEEN LOST IN THE ANCIENT PAST.

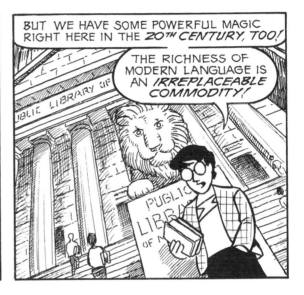

BUT WE HAVE SOME POWERFUL MAGIC RIGHT HERE IN THE *20TH CENTURY, TOO!*

THE RICHNESS OF MODERN LANGUAGE IS AN *IRREPLACEABLE COMMODITY!*

THIS IS AN *EXCITING TIME* TO BE MAKING COMICS, AND IN MANY WAYS I FEEL VERY *LUCKY* TO HAVE BEEN BORN WHEN I WAS.

STILL, I DO FEEL A CERTAIN *VAGUE LONGING* FOR THAT TIME OVER *50 CENTURIES AGO--*

-- WHEN TO TELL WAS TO *SHOW--*

-- AND TO SHOW WAS TO *TELL*.

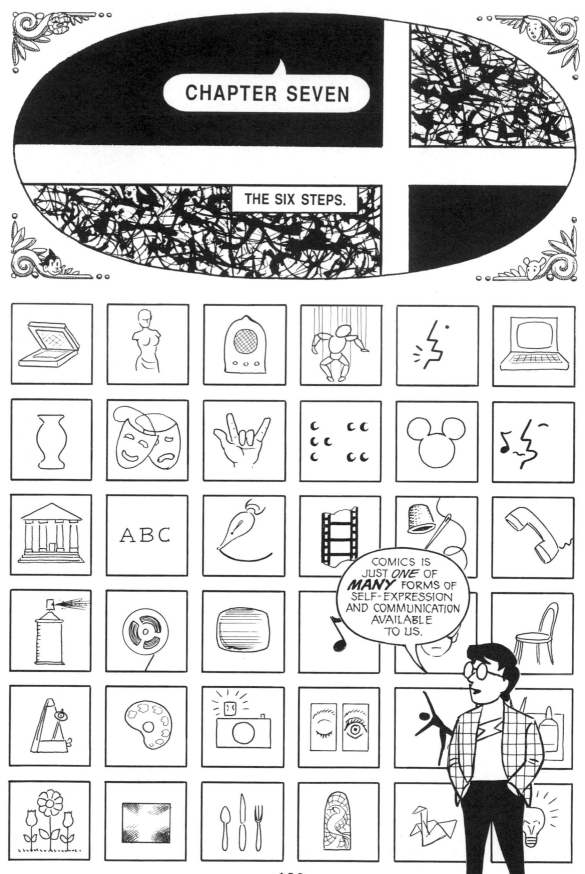

CHAPTER SEVEN

THE SIX STEPS.

COMICS IS JUST *ONE* OF *MANY* FORMS OF SELF-EXPRESSION AND COMMUNICATION AVAILABLE TO US.

ABC

SO FAR, WE'VE MOSTLY DEALT WITH THE *UNIQUE* PROPERTIES OF COMICS.

BUT THERE ARE PROPERTIES THAT COMICS SHARE WITH *ALL OTHER* ART FORMS.

THOUGH IT SEEMS INNOCUOUS ENOUGH *NOW,* THERE WAS A TIME WHEN SUCH A SIMPLE IDEA WAS *RIDICULED.*

EVEN *TODAY,* THERE ARE THOSE WHO ASK THE QUESTION, "CAN COMICS BE *ART?*"

IT IS--

--I'M SORRY--

A REALLY *STUPID* QUESTION!

BUT IF WE *MUST* ANSWER IT, THE ANSWER IS *YES.*

ESPECIALLY IF YOUR DEFINITION OF ART IS AS *BROAD* AS *MINE!*

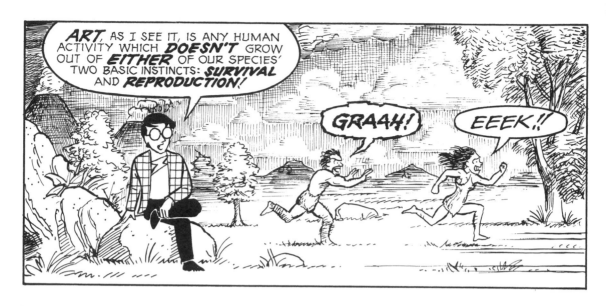

ART, AS I SEE IT, IS ANY HUMAN ACTIVITY WHICH **DOESN'T** GROW OUT OF **EITHER** OF OUR SPECIES' TWO BASIC INSTINCTS: **SURVIVAL** AND **REPRODUCTION!**

GRAAH!

EEEK!!

EXAMPLE: HERE'S A **PREHISTORIC MALE** CHASING A **PREHISTORIC FEMALE.** WITH ONLY ONE THING ON HIS MIND-- **REPRODUCTION!**

SO **STRONG** IS THIS INSTINCT THAT IT GOVERNS HIS **EVERY MOVE!** NOT ONE STEP IS WASTED IN THE **PURSUIT OF HIS GOAL!**

THE **FEMALE**--AFRAID FOR HER **SURVIVAL**-- MANAGES TO **HIDE.** NOW, **DEPRIVED** OF HIS GOAL, THE MALE STANDS **INDECISIVE.**

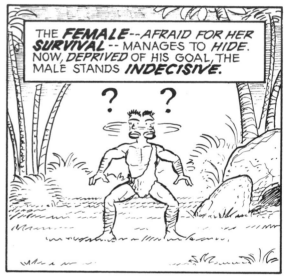

SUDDENLY--! ROAR!!!

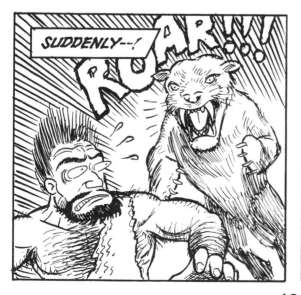

NOW ALL OF HIS THOUGHTS AND ACTIONS ARE FOCUSED ON THAT **OTHER** VITAL HUMAN INSTINCT-- **SURVIVAL!**

AGAIN HIS LEGS PROPEL HIM FORWARD WITH **MAXIMUM EFFICIENCY!**

164

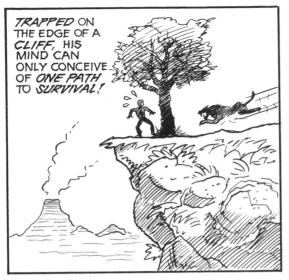

TRAPPED ON THE EDGE OF A *CLIFF,* HIS MIND CAN ONLY CONCEIVE OF *ONE PATH* TO *SURVIVAL!*

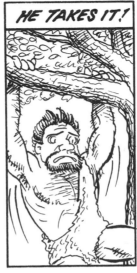

HE TAKES IT!

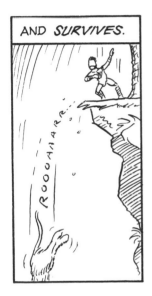

AND *SURVIVES.*

ROOOAARR

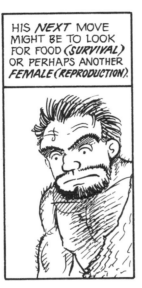

HIS *NEXT* MOVE MIGHT BE TO LOOK FOR FOOD *(SURVIVAL)* OR PERHAPS ANOTHER *FEMALE (REPRODUCTION).*

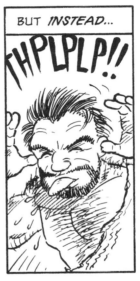

BUT *INSTEAD...*

THPLPLP!!

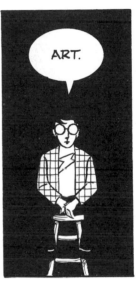

ART.

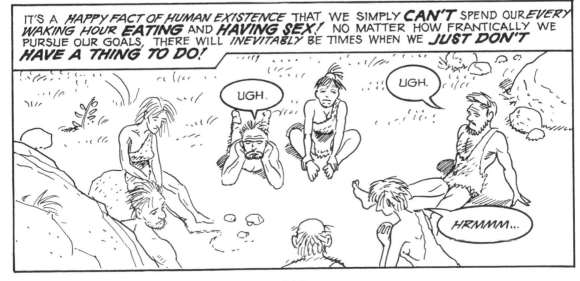

IT'S A *HAPPY FACT OF HUMAN EXISTENCE* THAT WE SIMPLY *CAN'T* SPEND OUR *EVERY WAKING HOUR EATING* AND *HAVING SEX!* NO MATTER HOW *FRANTICALLY* WE PURSUE OUR GOALS, THERE WILL *INEVITABLY* BE TIMES WHEN WE *JUST DON'T HAVE A THING TO DO!*

UGH.

UGH.

HRMMM...

165

 WHAT MAY LOOK LIKE A TRIBE OF *BORED, INACTIVE* CAVE-DWELLERS BELOW US IS, IN FACT, A *THRIVING ART COLONY!*

 SEE THAT OLD WOMAN WITH THE *STICK?* NOTICE THE *LINES* SHE'S MAKING IN THE *DIRT?*

 TODAY SHE HAS A *STOMACHACHE* AND HER LINES ARE *TIGHT* AND *ANGULAR.* YESTERDAY SHE FELT *BETTER* AND HER LINES WERE *OPEN* AND *CURVED.*

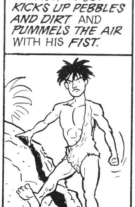 AND *OVER THERE* A MAN BEATS A *SIMPLE RHYTHM* WITH A *PAIR OF STONES.* HE DOESN'T KNOW WHY, BUT THE SOUND *PLEASES* HIM.

TAP! TAP! TAP! TAP!

TAP! TAP!

NEARBY, A BOY *KICKS UP PEBBLES AND DIRT* AND *PUMMELS THE AIR* WITH HIS *FIST.*

 TODAY HE LOST A FIGHT WITH HIS BROTHER. NOW ALL HE CAN DO IS *DANCE* AWAY HIS FRUSTRATION.

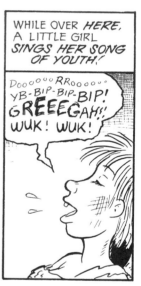 WHILE OVER *HERE,* A LITTLE GIRL *SINGS HER SONG OF YOUTH!*

Doooooo RRooooo YB-BIP-BIP-BIP! GREEEGAH!! WUK! WUK!

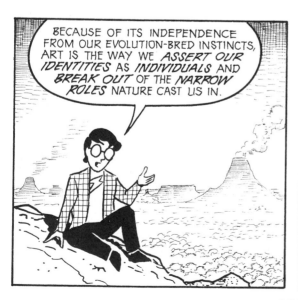 BECAUSE OF ITS INDEPENDENCE FROM OUR EVOLUTION-BRED INSTINCTS, ART IS THE WAY WE *ASSERT OUR IDENTITIES* AS *INDIVIDUALS* AND *BREAK OUT* OF THE *NARROW ROLES* NATURE CAST US IN.

 OF COURSE, THE *GENIUS* OF *"MOTHER NATURE"* IS SUCH THAT EVEN *THESE* THINGS DO HAVE THEIR USES FROM AN *EVOLUTIONARY STANDPOINT.*

 THREE, IN FACT.

166

FIRST, THEY PROVIDE EXERCISE FOR MINDS AND BODIES NOT RECEIVING *OUTSIDE STIMULUS.*

SECOND, THEY PROVIDE AN *OUTLET* FOR *EMOTIONAL IMBALANCES,* AIDING IN THE RACE'S *MENTAL* SURVIVAL.

THIRD AND PERHAPS MOST *IMPORTANTLY* TO OUR SURVIVAL AS A RACE, SUCH RANDOM ACTIVITIES OFTEN LEAD--

--TO USEFUL DISCOVERIES!

AAH!!

FUMF!

THIS FUNCTION WOULD ALSO BE PERFORMED IN *LATER* CENTURIES BY *SPORTS* AND *GAMES.*

ART AS *SELF EXPRESSION,* THE ARTIST AS *HERO;* FOR MANY, ITS *HIGHEST PURPOSE.*

ART AS *DISCOVERY,* AS THE PURSUIT OF *TRUTH,* AS *EXPLORATION;* THE SOUL OF MUCH *MODERN* ART AND THE FOUNDATIONS OF *LANGUAGE, SCIENCE* AND *PHILOSOPHY.*

A LOT HAS *CHANGED* IN HALF A MILLION YEARS, BUT SOME THINGS *NEVER* CHANGE.

OH NO! I'M GONNA BE LATE FOR THAT JOB INTERVIEW!

THE PROCESSES ARE MORE *COMPLEX* NOW, BUT THE INSTINCTS*REMAIN THE *SAME.* *SURVIVAL AND REPRODUCTION* STILL HOLD THE *UPPER HAND.*

*ALONG WITH THEIR MANY RELATED FEELINGS AND CUSTOMS.

YET IN ALMOST EVERYTHING WE DO THERE IS AT LEAST AN **ELEMENT** OF ART.

PERHAPS A LITTLE *UNNECESSARY* CHOREOGRAPHY ON THE *ASSEMBLY LINE.*

OOOH, **BEHBEE!**

OR THE *PERSONAL STYLE* OF A *BICYCLE MESSENGER.*

HONK! HONK!

OR JUST THE WAY WE *SIGN OUR NAMES!*

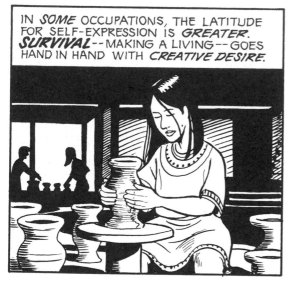

IN *SOME* OCCUPATIONS, THE LATITUDE FOR SELF-EXPRESSION IS *GREATER.* **SURVIVAL**--MAKING A LIVING--GOES HAND IN HAND WITH *CREATIVE DESIRE.*

I THINK IT'S FAIR TO SAY THAT SOME ACTIVITIES HAVE MORE ART **IN** THEM THAN OTHERS.

LIFE IS A SERIES OF *MINUTE DECISIONS,* SOME MOTIVATED BY *SURVIVAL,* SOME *NOT,* AND PROPORTIONS DO *VARY.*

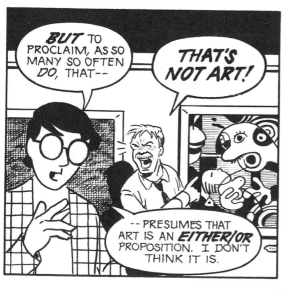

BUT TO PROCLAIM, AS SO MANY SO OFTEN *DO,* THAT--

THAT'S NOT ART!

-- PRESUMES THAT ART IS AN *EITHER/OR* PROPOSITION. I DON'T THINK IT IS.

RARE IS THE PERSON IN *ANY* OCCUPATION WHO EXPRESSES *NOTHING*...

...AND RARE IS THE *ARTIST* WHO CARES NOTHING FOR *SUCCESS,* I.E., *SURVIVAL!*

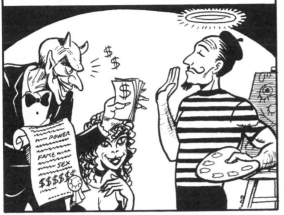

BUT THE *IDEAL* OF THE LATTER IS ALIVE IN THE HEARTS OF MANY ARTISTS WHO MAY *HOPE* FOR SUCCESS, BUT WON'T ALTER THEIR WORK TO *OBTAIN* IT.

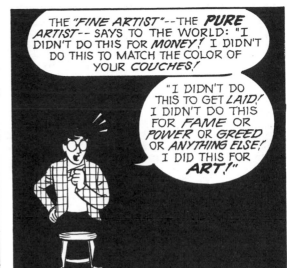

THE *"FINE ARTIST"*--THE *PURE ARTIST*-- SAYS TO THE WORLD: "I DIDN'T DO THIS FOR *MONEY!* I DIDN'T DO THIS TO MATCH THE COLOR OF YOUR *COUCHES!*

"I DIDN'T DO THIS TO GET *LAID!* I DIDN'T DO THIS FOR *FAME* OR *POWER* OR *GREED* OR *ANYTHING ELSE!* I DID THIS FOR *ART!*"

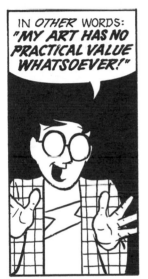

IN *OTHER* WORDS: *"MY ART HAS NO PRACTICAL VALUE WHATSOEVER!"*

"BUT IT'S *IMPORTANT!"*

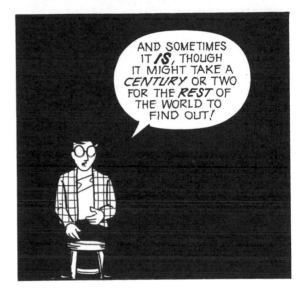

AND SOMETIMES IT *IS*, THOUGH IT MIGHT TAKE A *CENTURY* OR TWO FOR THE *REST* OF THE WORLD TO FIND OUT!

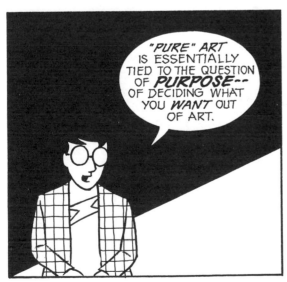

"PURE" ART IS ESSENTIALLY TIED TO THE QUESTION OF *PURPOSE--* OF DECIDING WHAT YOU *WANT* OUT OF ART.

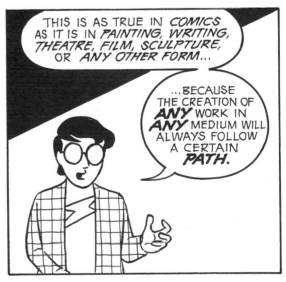

THIS IS AS TRUE IN *COMICS* AS IT IS IN *PAINTING, WRITING, THEATRE, FILM, SCULPTURE,* OR *ANY OTHER FORM*...

...BECAUSE THE CREATION OF *ANY* WORK IN *ANY* MEDIUM WILL ALWAYS FOLLOW A CERTAIN *PATH.*

169

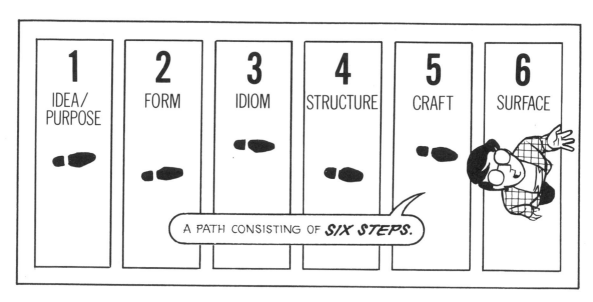

A PATH CONSISTING OF **SIX STEPS**.

1 IDEA/ PURPOSE	**FIRST:** THE *IMPULSES*, THE *IDEAS*, THE *EMOTIONS*, THE *PHILOSOPHIES*, THE *PURPOSES* OF THE WORK...THE WORK'S *"CONTENT."*

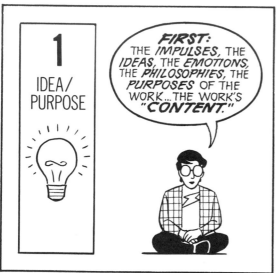

2 FORM

SECOND: THE **FORM** IT WILL TAKE...WILL IT BE A **BOOK?** A **CHALK DRAWING?** A **CHAIR?** A **SONG?** A **SCULPTURE?** A **POT HOLDER?** A **COMIC BOOK?**

3 IDIOM

THIRD: THE *"SCHOOL"* OF ART, THE VOCABULARY OF *STYLES* OR *GESTURES* OR *SUBJECT MATTER*, THE **GENRE** THAT THE WORK BELONGS TO... MAYBE A GENRE OF ITS OWN.

4 STRUCTURE

FOURTH: PUTTING IT ALL TOGETHER...WHAT TO *INCLUDE*, WHAT TO *LEAVE OUT*... HOW TO *ARRANGE*, HOW TO **COMPOSE** THE WORK.

5 CRAFT

FIFTH: CONSTRUCTING THE WORK, APPLYING *SKILLS*, *PRACTICAL KNOWLEDGE*, *INVENTION*, *PROBLEM-SOLVING*, GETTING THE *"JOB"* DONE.

6 SURFACE

SIXTH: PRODUCTION *VALUES*, *FINISHING*... THE ASPECTS MOST APPARENT ON FIRST *SUPERFICIAL EXPOSURE* TO THE WORK.

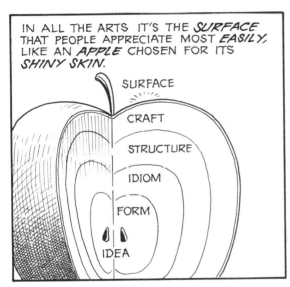

IN ALL THE ARTS IT'S THE *SURFACE* THAT PEOPLE APPRECIATE MOST *EASILY*, LIKE AN *APPLE* CHOSEN FOR ITS *SHINY SKIN*.

SURFACE
CRAFT
STRUCTURE
IDIOM
FORM
IDEA

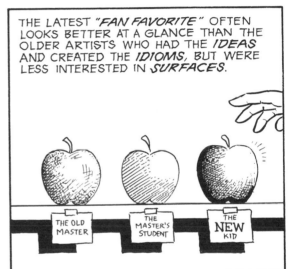

THE LATEST *"FAN FAVORITE"* OFTEN LOOKS BETTER AT A GLANCE THAN THE OLDER ARTISTS WHO HAD THE *IDEAS* AND CREATED THE *IDIOMS*, BUT WERE LESS INTERESTED IN *SURFACES*.

THE OLD MASTER

THE MASTER'S STUDENT

THE **NEW** KID

BUT OFTEN IF WE *BITE INTO* THAT SHINY NEW APPLE --

CRUNCH!

HOLLOW.

IT'S A CYCLE AS OLD AS *ART ITSELF*.

171

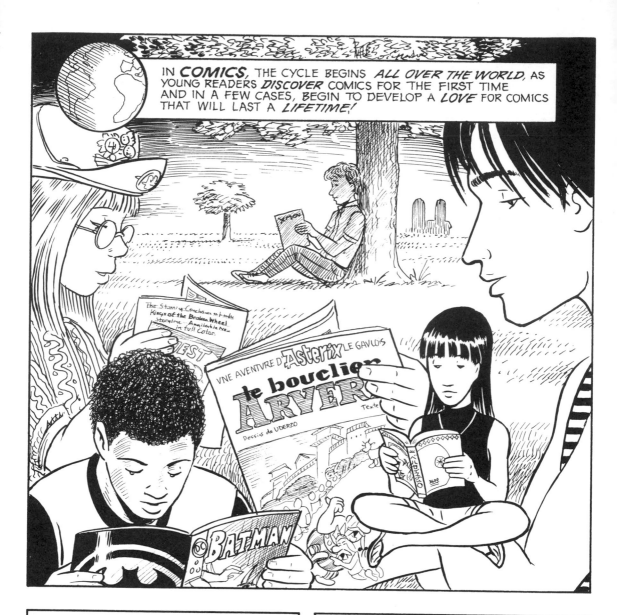

IN **COMICS**, THE CYCLE BEGINS *ALL OVER THE WORLD,* AS YOUNG READERS *DISCOVER* COMICS FOR THE FIRST TIME AND IN A FEW CASES, BEGIN TO DEVELOP A *LOVE* FOR COMICS THAT WILL LAST A *LIFETIME!*

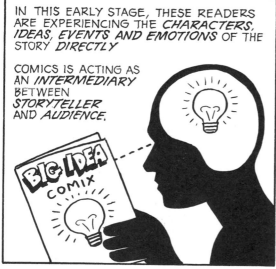

IN THIS EARLY STAGE, THESE READERS ARE EXPERIENCING THE *CHARACTERS, IDEAS, EVENTS* AND *EMOTIONS* OF THE STORY *DIRECTLY*

COMICS IS ACTING AS AN *INTERMEDIARY* BETWEEN *STORYTELLER* AND *AUDIENCE.*

BIG IDEA COMIX

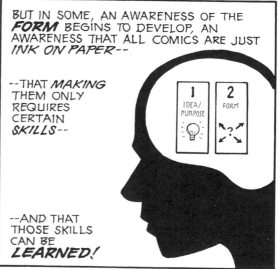

BUT IN SOME, AN AWARENESS OF THE *FORM* BEGINS TO DEVELOP, AN AWARENESS THAT ALL COMICS ARE JUST *INK ON PAPER*--

--THAT *MAKING* THEM ONLY REQUIRES CERTAIN *SKILLS*--

--AND THAT THOSE SKILLS CAN BE *LEARNED!*

1 IDEA/ PURPOSE 2 FORM

ONE OF THEM--FULL OF *BIG IDEAS*--MAKES THE *BIG DECISION.*

I'M GONNA MAKE **COMICS** WHEN I GROW UP!

HE'S OFF TO A LOGICAL START. HE HAS THE *IDEAS* AND HE'S CHOSEN *COMICS* AS HIS *FORM OF EXPRESSION.* MAYBE NOW HE'LL CONSIDER WHAT *TYPES* OF COMICS ARE RIGHT FOR HIM.

1 IDEA

2 FORM

3 IDIOM ?

BUT PROBABLY *NOT.*

MORE LIKELY HE *POSTPONES* HIS *OWN* IDEAS AND BEGINS TO STUDY THE *CRAFT* OF *OTHER* ARTISTS IN HIS ATTEMPT TO BECOME A *PROFESSIONAL.*

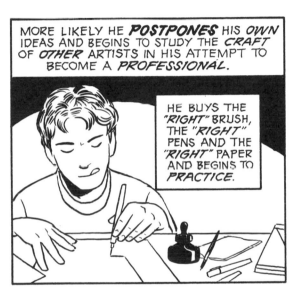

HE BUYS THE *"RIGHT"* BRUSH, THE *"RIGHT"* PENS AND THE *"RIGHT"* PAPER AND BEGINS TO *PRACTICE.*

EVENTUALLY...

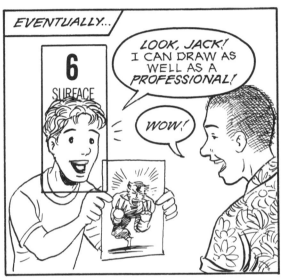

6 SURFACE

LOOK, JACK! I CAN DRAW AS WELL AS A *PROFESSIONAL!*

WOW!

BUT WHEN HE BRINGS THE WORK TO A *REAL* PROFESSIONAL AT THE LOCAL *CON:*

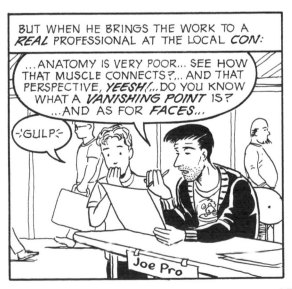

...ANATOMY IS VERY POOR... SEE HOW THAT MUSCLE CONNECTS?... AND THAT PERSPECTIVE, *YEESH!*...DO YOU KNOW WHAT A *VANISHING POINT* IS? ...AND AS FOR *FACES...*

-:GULP:-

Joe Pro

SO HE BUYS SOME BOOKS ON *ANATOMY* AND *PERSPECTIVE*, STUDIES A VARIETY OF *DRAWING TECHNIQUES* AND *PRACTICES, PRACTICES, PRACTICES* FOR *MONTHS.*

MAY

JUNE

JULY

SEPTEMBER

173

BUT SOMEHOW, IT NEVER QUITE *"CLICKS"* FOR HIM. MAYBE HE JUST DOESN'T HAVE ENOUGH *SKILL*... MAYBE HE *LOSES INTEREST*... MAYBE LIFE JUST *GETS IN THE WAY*... BUT FOR *WHATEVER REASON*--

-- HE LEAVES HIS DREAMS OF MAKING COMICS *BEHIND.*

BUT ALL OVER THE WORLD, OTHERS HAVE UNDERGONE *SIMILAR EXPERIENCES* AND *HAVEN'T GIVEN UP YET!*

ONE OF THEM IS NOW READY TO TAKE THE *NEXT STEP!* SHE'S STUDIED HER *CRAFT* ALL THE WAY THROUGH HIGH SCHOOL AND INTO *COLLEGE.*

SHE'S A *GOOD, HARDWORKING* STUDENT.

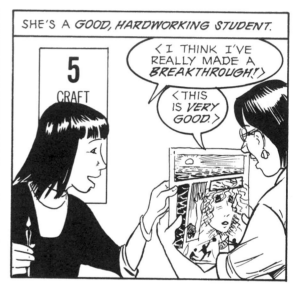

5 CRAFT

‹ I THINK I'VE REALLY MADE A *BREAKTHROUGH!* ›

‹ THIS IS *VERY GOOD.* ›

BUT WHEN SHE SHOWS HER WORK TO A *SEASONED PRO*...

‹ YOU'RE A SKILLED *SCRIPTER* AND *DRAFTSPERSON*, BUT YOUR *STORYTELLING* ISN'T GOOD ENOUGH, YOU HAVE NO SENSE OF *PACING*...THESE LAYOUTS ARE VERY *MUDDY*... YOU HAVE TO *COMPOSE* YOUR STORIES...›

‹ GULP! ›

HER SKILLS *CAN* GET HER *WORK* AT THIS POINT, BUT ONLY AS AN *ASSISTANT* TO OTHERS. UNTIL SHE UNDERSTANDS THE *STRUCTURE* OF COMICS *BENEATH* THE CRAFT, THIS IS AS FAR AS SHE CAN GO.

BUT MAYBE THIS IS **ENOUGH** FOR THIS PARTICULAR ARTIST, ENOUGH TO JUST BE PART OF THE *ART, BUSINESS,* AND *COMMUNITY* OF COMICS WITHOUT NECESSARILY *CALLING THE SHOTS.*

BUT **ELSEWHERE**, ANOTHER CREATOR HAS BEEN THROUGH THE SAME SORT OF PROCESS AND HE WANTS **MORE!**

HE SPENDS HIS *EVERY WAKING HOUR* WORKING OUT THE *DIFFICULT PRINCIPLES* OF COMICS COMPOSITION AND STORYTELLING, THE KIND THEY *DON'T TEACH IN BOOKS!**

‹ PLEASE, TRY TO GET SOME *SLEEP,* HONEY. ›

HE DISCOVERS THAT HIS *FAVORITE ARTIST* WAS ACTUALLY JUST A *WATERED-DOWN VERSION* OF AN *OLDER, LESS-POLISHED* ARTIST WHOM HE HAD ALWAYS *TAKEN FOR GRANTED.*

‹ *THIS GUY WAS GOD!* ›

HE LEARNS TO SEE **BENEATH** THE CRAFTS OF *DRAFTSMANSHIP* AND *SCRIPTING* TO SEE THE **WHOLE** PICTURE-- PACING, DRAMA, HUMOR, SUSPENSE, COMPOSITION, THEMATIC DEVELOPMENT, IRONY-- SOON THEY'RE ALL AT HIS *COMMAND!*

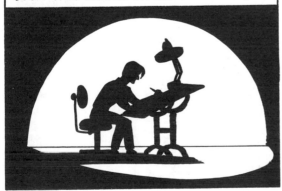

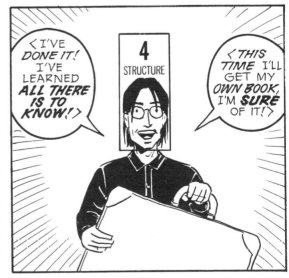

‹ I'VE DONE IT! I'VE LEARNED **ALL THERE IS TO KNOW!** ›

4
STRUCTURE

‹ *THIS TIME I'LL GET MY OWN BOOK,* I'M **SURE** OF IT! ›

* WELL, OKAY, *ONE* BOOK! EISNER'S, AGAIN.

175

AND LET'S SAY IT **WORKS!** HE *DOES* LAND HIS OWN BOOK AND SOON IS ESTABLISHED AS A CREATOR OF *GREAT SKILL.* HE UNDERSTANDS *COMICS STORYTELLING* BETTER THAN MOST.

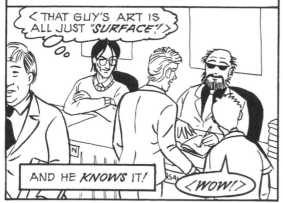

< THAT GUY'S ART IS ALL JUST *"SURFACE"!* >

AND HE *KNOWS* IT!

<WOW!>

HIS WORK ISN'T PARTICULARLY *ORIGINAL,* THE CRITICS DON'T PAY MUCH ATTENTION TO HIM, BUT HE MAKES A *DECENT LIVING* FOR *HIMSELF AND HIS FAMILY* AND THAT'S ENOUGH FOR HIM...

...ENOUGH THAT FOR WHAT HE DOES, HE'S *ONE OF THE BEST.*

BUT **ANOTHER** ARTIST HAS MADE IT THROUGH THE *SAME* SORTS OF HURDLES AND REACHED THE *SAME* LEVELS OF SUCCESS AND *STILL ISN'T SATISFIED*

SHE WONDERS IF HER SUCCESS REALLY *MEANS* ANYTHING WHEN THERE ARE *SO MANY OTHERS* DOING THE *SAME THINGS* IN THE *SAME WAYS.* SHE WANTS AN **IDENTITY.**

SHE BELIEVES THAT THERE'S SOMETHING **MORE**--SOME *PIECE OF THE PUZZLE*-- THAT SHE *STILL HASN'T FOUND.*

4

5 CRAFT

6 SURFACE

SHE BEGINS TO INVENT *NEW WAYS* OF SHOWING *"THE SAME OLD THING."* SHE DEVELOPS *INNOVATIVE NEW TECHNIQUES.* AND STARTS *DOING AWAY* WITH "THE SAME OLD THING" *ALTOGETHER!*

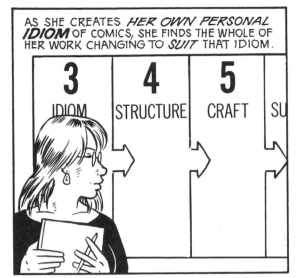

AS SHE CREATES *HER OWN PERSONAL IDIOM* OF COMICS, SHE FINDS THE WHOLE OF HER WORK CHANGING TO *SUIT* THAT IDIOM.

3 IDIOM
4 STRUCTURE
5 CRAFT
SU

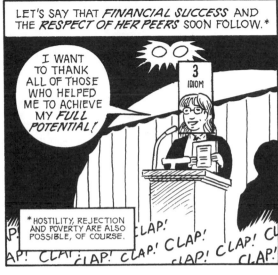

LET'S SAY THAT *FINANCIAL SUCCESS* AND THE *RESPECT OF HER PEERS* SOON FOLLOW.*

I WANT TO THANK ALL OF THOSE WHO HELPED ME TO ACHIEVE MY *FULL POTENTIAL!*

3 IDIOM

*HOSTILITY, REJECTION AND POVERTY ARE ALSO POSSIBLE, OF COURSE.

CLAP! CLAP! CLAP! CLAP! CLAP! CL

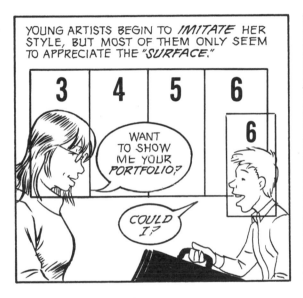

YOUNG ARTISTS BEGIN TO *IMITATE* HER STYLE, BUT MOST OF THEM ONLY SEEM TO APPRECIATE THE *"SURFACE."*

3 4 5 6

6

WANT TO SHOW ME YOUR *PORTFOLIO?*

COULD I?

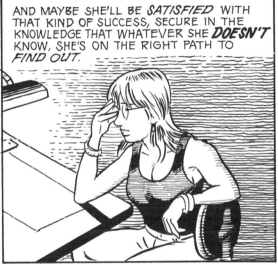

AND MAYBE SHE'LL BE *SATISFIED* WITH THAT KIND OF SUCCESS, SECURE IN THE KNOWLEDGE THAT WHATEVER SHE *DOESN'T* KNOW, SHE'S ON THE RIGHT PATH TO *FIND OUT.*

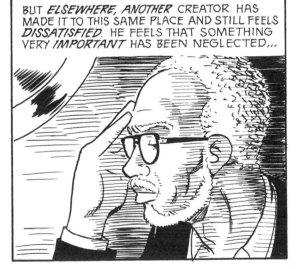

BUT *ELSEWHERE, ANOTHER* CREATOR HAS MADE IT TO THIS SAME PLACE AND STILL FEELS *DISSATISFIED.* HE FEELS THAT SOMETHING VERY *IMPORTANT* HAS BEEN NEGLECTED...

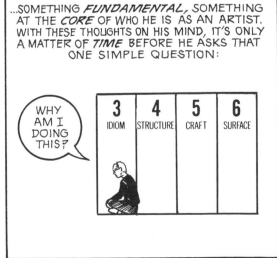

...SOMETHING *FUNDAMENTAL,* SOMETHING AT THE *CORE* OF WHO HE IS AS AN ARTIST. WITH THESE THOUGHTS ON HIS MIND, IT'S ONLY A MATTER OF *TIME* BEFORE HE ASKS THAT ONE SIMPLE QUESTION:

WHY AM I DOING THIS?

3 IDIOM
4 STRUCTURE
5 CRAFT
6 SURFACE

177

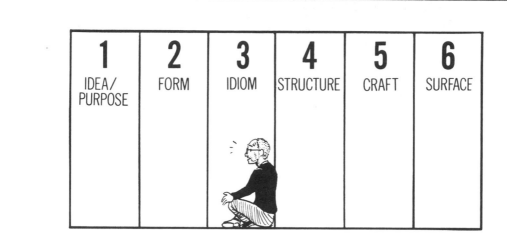

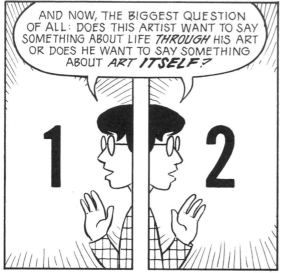

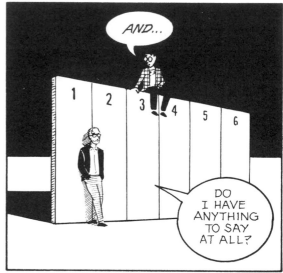

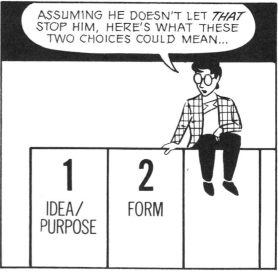

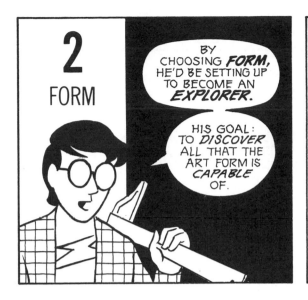

2 FORM

BY CHOOSING **FORM**, HE'D BE SETTING UP TO BECOME AN **EXPLORER**.

HIS GOAL: TO **DISCOVER** ALL THAT THE ART FORM IS **CAPABLE** OF.

AND HIS ART WOULD NOT **LACK** FOR **IDEAS** OR FOR A **PURPOSE**.

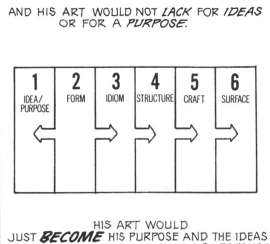

1 IDEA/ PURPOSE	2 FORM	3 IDIOM	4 STRUCTURE	5 CRAFT	6 SURFACE

HIS ART WOULD JUST **BECOME** HIS PURPOSE AND THE IDEAS WOULD ARRIVE IN TIME TO GIVE IT **SUBSTANCE**.

CREATORS WHO TAKE THIS PATH ARE OFTEN **PIONEERS AND REVOLUTIONARIES**--ARTISTS WHO WANT TO **SHAKE THINGS UP**, CHANGE THE WAY PEOPLE **THINK**, QUESTION THE **FUNDAMENTAL LAWS** THAT GOVERN THEIR CHOSEN ART.

McCAY

SPIEGELMAN

HERRIMAN

STERRETT

MOERIUS

(IN **OTHER** ART FORMS: STRAVINSKY, PICASSO, VIRGINIA WOOLF, ORSON WELLES, ETC.)

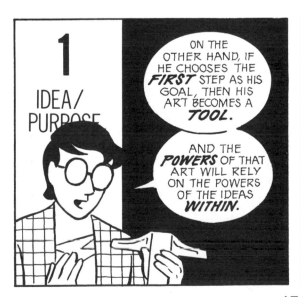

1 IDEA/ PURPOSE

ON THE OTHER HAND, IF HE CHOOSES THE **FIRST** STEP AS HIS GOAL, THEN HIS ART BECOMES A **TOOL**.

AND THE **POWERS** OF THAT ART WILL RELY ON THE POWERS OF THE IDEAS **WITHIN**.

NOW **"TELLING THE STORY"** (OR IN THE CASE OF **NON-FICTION, "DELIVERING THE MESSAGE"**) TAKES **PRIORITY** OVER **INVENTION**.

1 IDEA/ PURPOSE	2 FORM	3 IDIOM	4 STRUCTURE	5 CRAFT	6 SURFACE

BUT TELLING A STORY AS **EFFECTIVELY** AS POSSIBLE MAY **REQUIRE** SOME INVENTION. IT OFTEN **DOES**.

THIS IS THE PATH OF GREAT **STORYTELLERS**, CREATORS WHO HAVE SOMETHING TO SAY *THROUGH* COMICS AND DEVOTE ALL THEIR ENERGIES TO *CONTROLLING* THEIR MEDIUM, REFINING ITS ABILITY TO CONVEY MESSAGES *EFFECTIVELY*.

SCHULZ

BARKS

HERGÉ

EISNER

NAKAZAWA

(IN OTHER ART FORMS: CAPRA, DICKENS, WOODY GUTHRIE, EDWARD R. MURROW, ETC.)

FORTUNATELY, THIS CHOICE NEVER HAS TO BE *PERMANENT*.

IT CAN CHANGE AS OFTEN AS AN ARTIST CHANGES *PROJECTS!*

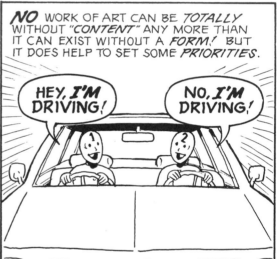
NO WORK OF ART CAN BE *TOTALLY* WITHOUT "*CONTENT*" ANY MORE THAN IT CAN EXIST WITHOUT A *FORM!* BUT IT DOES HELP TO SET SOME *PRIORITIES*.

HEY, *I'M* DRIVING!

NO, *I'M* DRIVING!

THIS IS A PROBLEM IN MANY "*ASSEMBLY LINE*" COMICS WHERE CREATIVE SPECIALIZATION HAS "*SCRIPTERS*," "*PENCILLERS*" AND "*INKERS*" ALL WORKING AT *CROSS-PURPOSES* IN THEIR ATTEMPTS TO GET *NOTICED*.

CRASH!

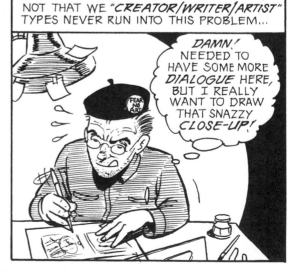
NOT THAT WE "*CREATOR/WRITER/ARTIST*" TYPES NEVER RUN INTO THIS PROBLEM...

DAMN! NEEDED TO HAVE SOME MORE *DIALOGUE* HERE, BUT I REALLY WANT TO DRAW THAT SNAZZY *CLOSE-UP!*

180

Panel 1 (top left):

THE MORE AN ARTIST DEVOTES HIM/HERSELF TO EITHER OF THESE TWO FOCAL POINTS, THE MORE DRAMATIC THE CHANGE IF HE/SHE DECIDES TO *SWITCH!*

2 FORM

...I DON'T GET AROUND MUCH ANYMORE...

THE CRACKERS AND WATER SHOULD KEEP ME GOING.

Panel 2 (top right):

ART SPIEGELMAN'S AGGRESSIVELY EXPERIMENTAL WORK OF THE *SEVENTIES* AND EARLY *EIGHTIES* LEFT NO ONE PREPARED FOR THE UNASSUMING *"REPORT"* STYLE OF HIS LANDMARK BIOGRAPHY *"MAUS."*

1 IDEA/ PURPOSE

COME FIRST UP-STAIRS FOR A LITTLE COFFEE.

NO... REALLY. I'D BETTER GET GOING RIGHT AWAY...

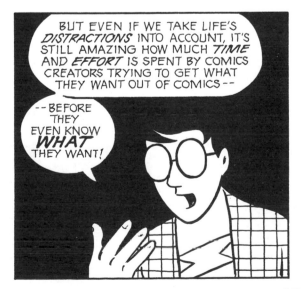

PERHAPS IF STRIPPED DOWN FAR ENOUGH, MOST ARTISTS' ULTIMATE GOALS ARE NOT THAT DIFFERENT FROM ANYONE ELSE'S. EVEN FOR THOSE WITH *HIGH IDEALS,* BASIC INSTINCTS EXERT A POWERFUL ATTRACTION.

1 ☿

1 FAME

1 $

SURVIVAL ⟷ REPRODUCTION

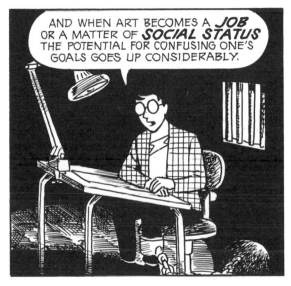

AND WHEN ART BECOMES A *JOB* OR A MATTER OF *SOCIAL STATUS* THE POTENTIAL FOR CONFUSING ONE'S GOALS GOES UP CONSIDERABLY.

Panel (bottom left):

BUT EVEN IF WE TAKE LIFE'S *DISTRACTIONS* INTO ACCOUNT, IT'S STILL AMAZING HOW MUCH *TIME* AND *EFFORT* IS SPENT BY COMICS CREATORS TRYING TO GET WHAT THEY WANT OUT OF COMICS --

-- BEFORE THEY EVEN KNOW *WHAT* THEY WANT!

OF COURSE, NOT *EVERYBODY* TAKES THE *LONG* WAY AROUND. SOME ARTISTS HAVE NO TROUBLE SETTING GOALS AND *ACHIEVING* THEM WITHOUT ANY *DETOURS...*

HERE'S A STORY I DREW ABOUT MY DOG *BUSTER!*

BUSTER WOOF!

...ESPECIALLY IF THEIR GOALS ARE *MODEST* ONES.

ART AND SCRIPT © ART SPIEGELMAN

1	2	3	4	5	6
IDEA/ PURPOSE	FORM	IDIOM	STRUCTURE	CRAFT	SURFACE

ANY ARTIST CREATING **ANY** WORK IN **ANY** MEDIUM WILL ALWAYS FOLLOW THESE *SIX STEPS* WHETHER THEY REALIZE IT OR **NOT.**

ALL WORKS BEGIN WITH A PURPOSE, HOWEVER *ARBITRARY;* ALL TAKE SOME *FORM;* ALL BELONG TO AN *IDIOM* (EVEN IF IT'S AN IDIOM OF *ONE*); ALL POSSESS A *STRUCTURE;* ALL REQUIRE SOME *CRAFT;* ALL PRESENT A *SURFACE.*

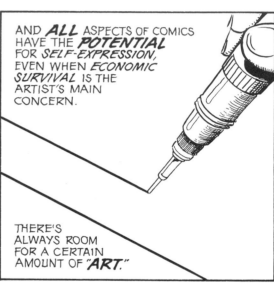

AND **ALL** ASPECTS OF COMICS HAVE THE **POTENTIAL** FOR *SELF-EXPRESSION,* EVEN WHEN *ECONOMIC SURVIVAL* IS THE ARTIST'S MAIN CONCERN.

THERE'S ALWAYS ROOM FOR A CERTAIN AMOUNT OF *"ART."*

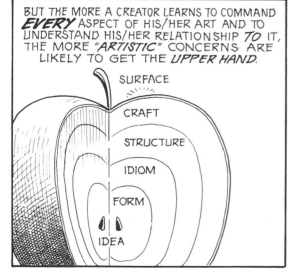

BUT THE MORE A CREATOR LEARNS TO COMMAND *EVERY* ASPECT OF HIS/HER ART AND TO UNDERSTAND HIS/HER RELATIONSHIP *TO* IT, THE MORE "ARTISTIC" CONCERNS ARE LIKELY TO GET THE *UPPER HAND.*

SURFACE

CRAFT

STRUCTURE

IDIOM

FORM

IDEA

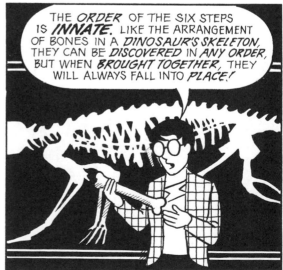

THE *ORDER* OF THE SIX STEPS IS *INNATE.* LIKE THE ARRANGEMENT OF BONES IN A *DINOSAUR'S SKELETON,* THEY CAN BE *DISCOVERED* IN *ANY ORDER,* BUT WHEN *BROUGHT TOGETHER,* THEY WILL ALWAYS FALL INTO *PLACE!*

182

IN *PRACTICE,* **ANY** ASPECT OF COMICS MAY BE THE ONE WHICH FIRST DRAWS AN ARTIST INTO ITS ORBIT.

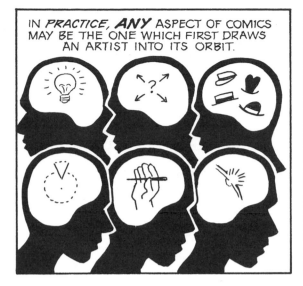

STILL, THE LEARNING PROCESS FOR MOST ARTISTS IS A *SLOW AND STEADY JOURNEY* FROM **END** TO **BEGINNING,**

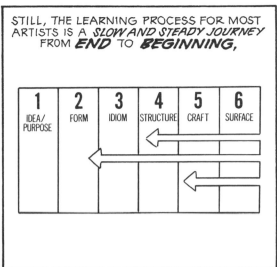

1 IDEA/ PURPOSE	2 FORM	3 IDIOM	4 STRUCTURE	5 CRAFT	6 SURFACE

FROM **SURFACE** TO **CORE.**

AND IT'S AT THE **CORE** OF ART THAT THE MOST IMPORTANT QUESTION IS FINALLY ASKED:

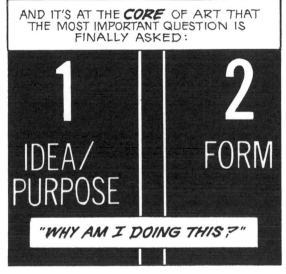

1 IDEA/ PURPOSE

2 FORM

"WHY AM I DOING THIS?"

WHEN **FORM** RULES THE WORK, IT MAY SEEM SOMEWHAT **ARTIFICIAL** AT THE CORE, LIKE A *SEEDLESS FRUIT.*

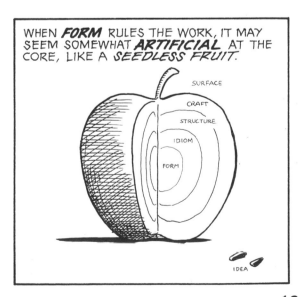

BUT SUCH WORKS DON'T TAKE THE **SHAPE** OF ART FOR GRANTED AND BY QUESTIONING OUR *FUNDAMENTAL ASSUMPTIONS--*

--CAN ANTICIPATE A *WORLD* OF *UNKNOWN EXPERIENCES*,

WHILE IF *IDEAS* RULE THE WORK AND *DETERMINE* ITS SHAPE, COMICS CAN HELP *PLANT* THOSE IDEAS *FAR AND WIDE.*

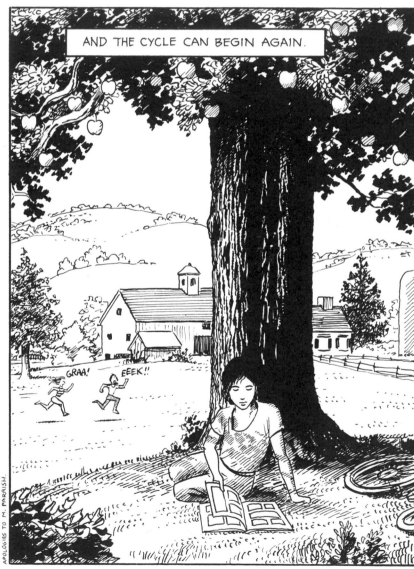

AND THE CYCLE CAN BEGIN AGAIN.

GRAA! EEEK!!

APOLOGIES TO M. PARRISH.

CHAPTER EIGHT

A WORD ABOUT COLOR.

IN CHAPTER FIVE WE DEALT WITH THE EXPRESSIONISTIC POTENTIAL OF *LINES* AS ANTICIPATED BY ARTISTS AT THE TURN OF THE CENTURY, BUT OF COURSE IT WAS *COLOR* WHICH MOST CAPTIVATED ARTISTS OF THAT ERA.

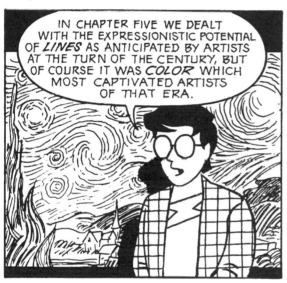

THROUGHOUT ART HISTORY, COLOR HAS BEEN A *POWERFUL,* EVEN *PREDOMINANT,* CONCERN OF FINE ARTISTS EVERYWHERE.

SOME, LIKE *GEORGES SEURAT,* DEVOTED THEIR *LIVES* TO ITS STUDY.

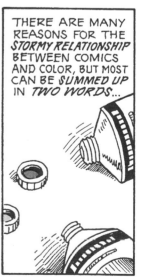

OTHERS, LIKE *KANDINSKY,* BELIEVED THAT COLORS COULD HAVE PROFOUND *PHYSICAL* AND *EMOTIONAL EFFECTS* ON PEOPLE.

THESE YELLOW WALLS MAKE ME UNCOMFORTABLE. M-M-MARY...

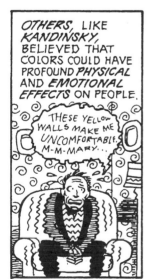

COLOR CAN BE A *FORMIDABLE ALLY* FOR ARTISTS IN ANY *VISUAL MEDIUM.*

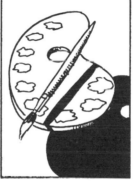

Pot o' Gold

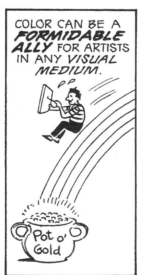

YET IN *COMICS* THE CAREER OF COLOR HAS BEEN, WELL... A BIT *"SPOTTY."*

THERE ARE MANY REASONS FOR THE *STORMY RELATIONSHIP* BETWEEN COMICS AND COLOR, BUT MOST CAN BE *SUMMED UP* IN *TWO WORDS...*

185

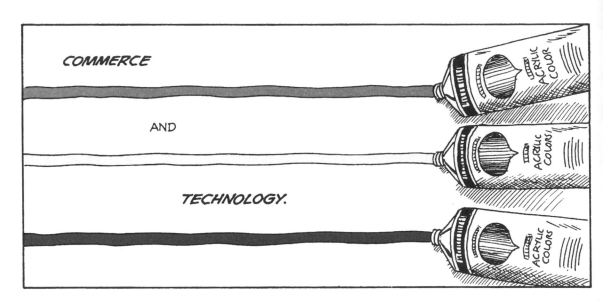

COMMERCE

AND

TECHNOLOGY.

NOW **ALL** ASPECTS OF COMICS HISTORY HAVE BEEN AFFECTED BY **COMMERCE.** MONEY HAS A TREMENDOUS EFFECT ON WHAT IS AND **ISN'T** SEEN.

BUT **COLOR** IN COMICS HAS ALWAYS BEEN UNUSUALLY **SENSITIVE** TO THE **SHIFTING TIDES OF TECHNOLOGY.**

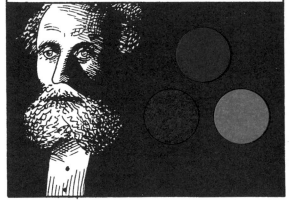

THE TECHNOLOGY OF COLOR REPRODUCTION WAS FIRST ANTICIPATED IN **1861** WHEN SCOTTISH PHYSICIST **SIR JAMES CLERK-MAXWELL** ISOLATED WHAT WE NOW CALL **THE THREE ADDITIVE PRIMARIES.**

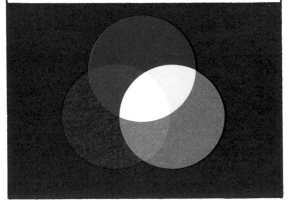

THESE COLORS -- ROUGHLY, **RED, BLUE** AND **GREEN**--WHEN PROJECTED TOGETHER ON A SCREEN IN **VARIOUS COMBINATIONS,** COULD REPRODUCE EVERY COLOR IN THE **VISIBLE SPECTRUM.**

THEY WERE CALLED **ADDITIVE** BECAUSE THEY LITERALLY **ADDED UP** TO **PURE WHITE LIGHT.**

EIGHT YEARS LATER, FRENCH PIANIST **LOUIS DUCOS DU HAURON** * DEVISED THE IDEA OF THREE **SUBTRACTIVE** PRIMARIES.

* WHOM I **DON'T** HAVE A PICTURE OF.

186

THESE COLORS -- CYAN, MAGENTA AND YELLOW* -- CAN ALSO MIX TO PRODUCE ANY HUE IN THE VISIBLE SPECTRUM, BUT RATHER THAN ADDING LIGHT, THESE THREE DO IT BY FILTERING IT OUT!

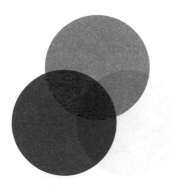

THIS SUBTRACTIVE EFFECT WAS ACHIEVED THROUGH TRANSPARENT SUBSTANCES SUCH AS CELLOPHANE, COLORED GLASS, WATER COLORS --

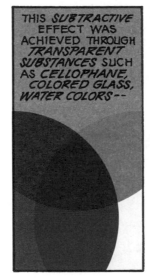

--OR PRINTER'S INK!

COLOR COMICS HIT THE NEWSPAPER INDUSTRY LIKE AN ATOMIC BOMB!

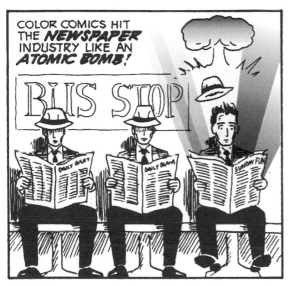

COLOR BOOSTED SALES, BUT IT ALSO BOOSTED COSTS! MEASURES WERE TAKEN TO STREAMLINE THE PROCESS AND MAKE IT MORE COST-EFFECTIVE.

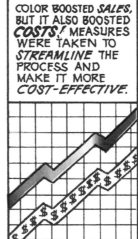

AND THE STANDARD "FOUR COLOR" PROCESS TOOK OVER.

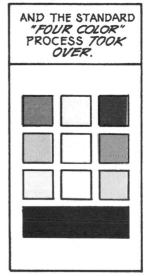

THIS PROCESS RESTRICTED THE INTENSITY OF THE THREE PRIMARIES TO 100%, 50% AND 20%, USING BLACK INK FOR THE LINE WORK.

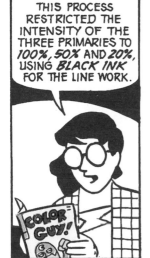

COLOR GUY!

THE LOOK OF THESE COLORS, HELD BY BOLD, SIMPLE OUTLINES, AND REPRODUCED ON CHEAP NEWSPRINT EVENTUALLY BECAME THE LOOK OF COMICS IN AMERICA.

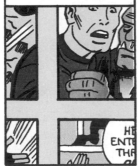

SO, WHILE THE EXPRESSIVE ART OF LINE WAS SUBJECTED TO THE SUBTRACTIVE FILTER OF COMMERCE ON ITS WAY TO COMICS, COLOR WAS SUBJECTED TO THE FILTERS OF BOTH COMMERCE AND TECHNOLOGY.

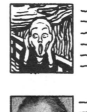

* FOR OPAQUE PIGMENTS: RED, YELLOW AND BLUE. I KNOW, IT'S TOTALLY WEIRD.

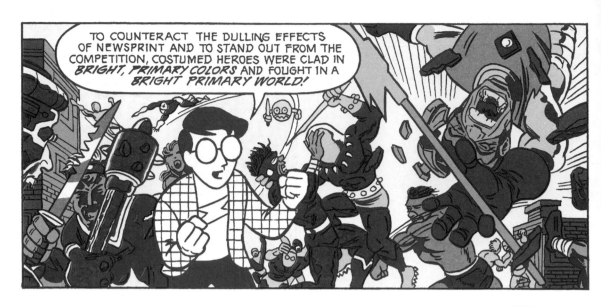

TO COUNTERACT THE DULLING EFFECTS OF NEWSPRINT AND TO STAND OUT FROM THE COMPETITION, COSTUMED HEROES WERE CLAD IN *BRIGHT, PRIMARY COLORS* AND FOUGHT IN A *BRIGHT PRIMARY WORLD!*

THE COLORS WERE PICKED FOR *STRENGTH* AND CONTRASTED STRONGLY WITH ONE ANOTHER, BUT ON MOST PAGES NO ONE COLOR *DOMINATED.*

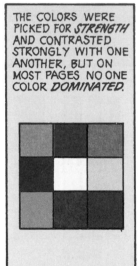

WITHOUT THE *EMOTIONAL IMPACT* OF *SINGLE-COLOR SATURATION,* THE *EXPRESSIVE POTENTIAL* OF AMERICAN COLOR COMICS --

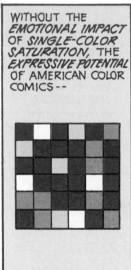

-- WAS OFTEN *CANCELLED OUT* TO AN *EMOTIONAL GREY.*

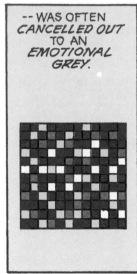

AS ALWAYS, THERE WERE SOME *EXCEPTIONS,* BUT THIS WAS THE OVERALL TREND.

HOWEVER, WHILE COMICS COLORS WERE LESS THAN *EXPRESSIONISTIC,* THEY WERE FIXED WITH A NEW *ICONIC* POWER. BECAUSE COSTUME COLORS REMAINED EXACTLY THE SAME, PANEL AFTER PANEL, THEY CAME TO *SYMBOLIZE* CHARACTERS IN THE MIND OF THE READER.

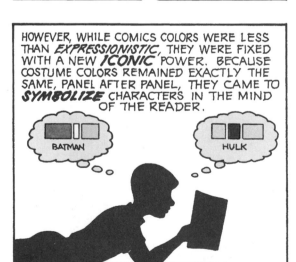

BATMAN

HULK

MANY SEE THE SUPERHERO AS A FORM OF *MODERN MYTHOLOGY.* IF SO, THIS ASPECT OF COLOR MAY PLAY A PART.

SYMBOLS ARE THE STUFF OF WHICH *GODS* ARE MADE.

ANOTHER PROPERTY OF FLAT COLORS IS THEIR TENDENCY TO EMPHASIZE THE *SHAPE* OF OBJECTS, BOTH *ANIMATE* AND *INANIMATE* --

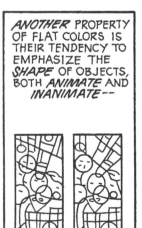

188

--AS ANY CHILD WHO HAS EVER *"COLORED-BY-NUMBERS"* KNOWS INSTINCTIVELY.

THESE COLORS *OBJECTIFY* THEIR SUBJECTS. WE BECOME MORE AWARE OF THE *PHYSICAL FORM* OF OBJECTS THAN IN *BLACK AND WHITE.*

A GAME IN MOTION BECOMES A BALL IN AIR. A FACE SHOWING EMOTION BECOMES A HEAD AND TWO HANDS.

THE WORLD TAKES ON THE CHILDHOOD REALITY OF THE *PLAYGROUND* AND RECALLS A TIME WHEN SHAPE *PRECEDED* MEANING. OBLONG SWING SETS. CYLINDRICAL JUNGLE GYMS. THE WONDER OF *THINGS!*

DOESN'T IT *FOLLOW* THEN THAT THE MASTERS OF *FLAT-COLOR* COMICS ARE, ABOVE ALL, MASTERS OF *FORM* AND *COMPOSITION?*

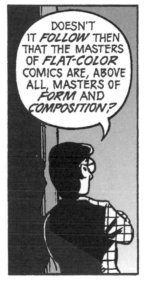

KIRBY.

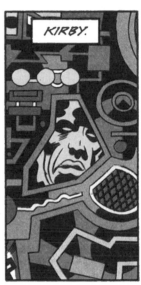

McCAY.

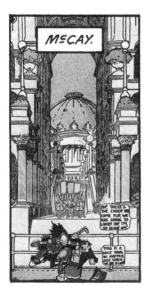

COLE.

FROM *STEVE DITKO* TO *CARL BARKS* TO *P. CRAIG RUSSELL*, THAT LOVE OF SHAPES PERSISTS IN WORLDS FAIRLY *GLOWING* WITH THE MYSTERY OF *FIRST ENCOUNTERS.*

ANY WONDER THEN THAT COMICS IN AMERICA HAS BEEN SO RELUCTANT TO *"GROW UP"?*

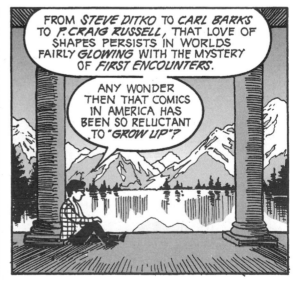

IN EUROPE HERGÉ CAPTURED THE MAGIC OF SUCH FLAT COLORS WITH *UNPRECEDENTED SUBTLETY*.

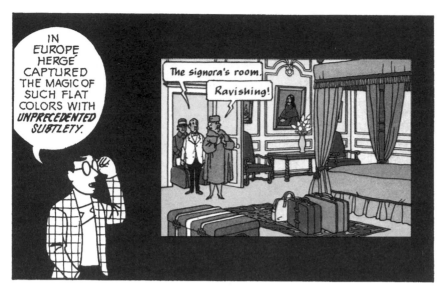

The signora's room.

Ravishing!

HERGÉ CREATED A KIND OF *DEMOCRACY OF FORM* IN WHICH NO SHAPE WAS ANY LESS IMPORTANT THAN ANY *OTHER*-- A *COMPLETELY OBJECTIVE WORLD*.

COMICS *PRINTING* WAS *SUPERIOR* IN EUROPE AND FOR HERGÉ, FLAT COLORS WERE A *PREFERENCE*, NOT A NECESSITY.

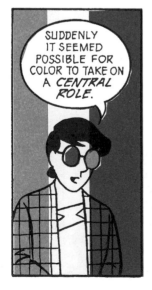

BUT OTHERS SUCH AS *CLAVELOUX, CAZA* AND *MOEBIUS* SAW IN THEIR SUPERIOR PRINTING AN OPPORTUNITY TO EXPRESS THEMSELVES THROUGH A MORE INTENSE *SUBJECTIVE* PALETTE.

SOME OF THIS WORK BEGAN REACHING AMERICA IN THE *70's,* INSPIRING MANY YOUNG ARTISTS TO LOOK *BEYOND* THEIR FOUR-COLOR WALLS.

HEAVY METAL

VODKA

SUDDENLY IT SEEMED POSSIBLE FOR COLOR TO TAKE ON A *CENTRAL ROLE*.

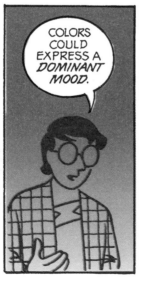

COLORS COULD EXPRESS A *DOMINANT MOOD*.

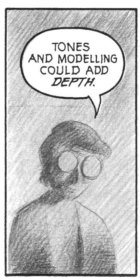

TONES AND MODELLING COULD ADD *DEPTH*.

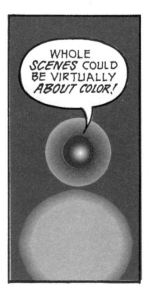

WHOLE *SCENES* COULD BE VIRTUALLY *ABOUT COLOR!*

190

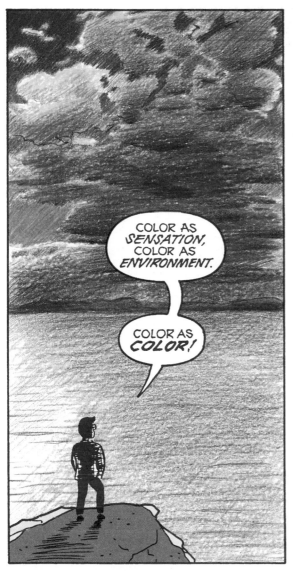

COLOR AS *SENSATION,* COLOR AS *ENVIRONMENT.*

COLOR AS *COLOR!*

SINCE THE LATE *70'S,* MORE AND MORE *"UPSCALE"* COLOR PROJECTS HAVE BEGUN APPEARING IN AMERICA.

SOME PUBLISHERS AT THE BEGINNING TRIED APPLYING THE TRADITIONAL "FOUR-COLOR" PROCESS TO BETTER PAPER WITH *GARISH RESULTS.*

TAKE *THAT!*

WHEN *MODELLING* AND MORE *SUBTLE HUES* WERE APPLIED, THOUGH, THEY SEEMED *OUT OF PLACE* ON THE OLD *SHAPE-SENSITIVE LINE DRAWINGS.*

TAKE *THAT!*

THE *SURFACE* WAS CHANGING, BUT NOT THE *CORE.* FOR ALL THEIR SUBTLE HUES, COMICS WERE STILL BEING WRITTEN IN *PRIMARY COLORS!*

THE NEW *FORM* REQUIRED THE CREATION OF NEW *IDIOMS!*

UNFORTUNATELY, COLOR IS STILL AN *EXPENSIVE OPTION* AND HAS HISTORICALLY BEEN IN THE HANDS OF LARGER, MORE CONSERVATIVE PUBLISHERS.

THIS IS BEGINNING TO CHANGE AS I WRITE THIS, BUT IT'S STILL THE *EXCEPTION,* NOT THE *RULE.* COMIC ARTISTS WANTING TO CONDUCT *BOLD NEW EXPERIMENTS* IN COMICS ART--

--STILL HAVE TO LEARN IN MOST CASES TO BE BOLD IN *BLACK AND WHITE!*

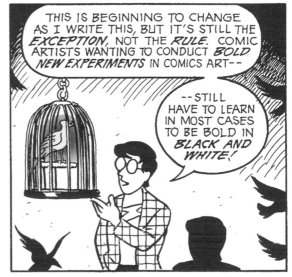

191

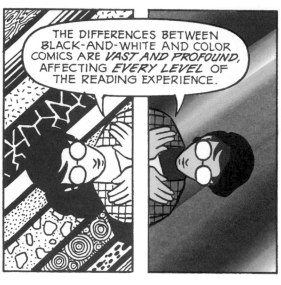

THE DIFFERENCES BETWEEN BLACK-AND-WHITE AND COLOR COMICS ARE *VAST AND PROFOUND,* AFFECTING *EVERY LEVEL* OF THE READING EXPERIENCE.

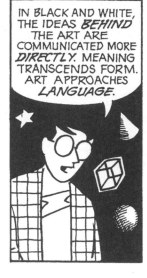

IN BLACK AND WHITE, THE IDEAS *BEHIND* THE ART ARE COMMUNICATED MORE *DIRECTLY.* MEANING TRANSCENDS FORM. ART APPROACHES *LANGUAGE.*

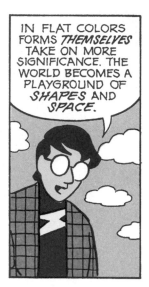

IN FLAT COLORS FORMS *THEMSELVES* TAKE ON MORE SIGNIFICANCE. THE WORLD BECOMES A PLAYGROUND OF *SHAPES* AND *SPACE.*

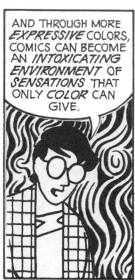

AND THROUGH MORE *EXPRESSIVE* COLORS, COMICS CAN BECOME AN *INTOXICATING ENVIRONMENT* OF *SENSATIONS* THAT ONLY *COLOR* CAN GIVE.

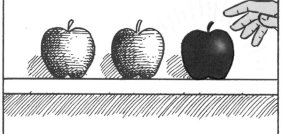

THE *SURFACE* QUALITIES OF COLOR WILL CONTINUE TO ATTRACT READERS MORE EASILY THAN BLACK AND WHITE, AND THE STORY OF COLOR WILL NO DOUBT CONTINUE TO BE INTERTWINED WITH THE FORCES OF *COMMERCE* AND *TECHNOLOGY.*

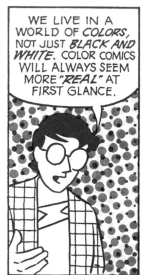

WE LIVE IN A WORLD OF *COLORS,* NOT JUST *BLACK AND WHITE.* COLOR COMICS WILL ALWAYS SEEM MORE *"REAL"* AT FIRST GLANCE.

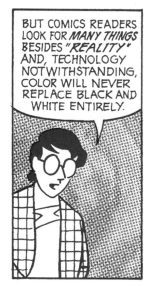

BUT COMICS READERS LOOK FOR *MANY THINGS* BESIDES *"REALITY"* AND, TECHNOLOGY NOTWITHSTANDING, COLOR WILL NEVER REPLACE BLACK AND WHITE ENTIRELY.

ONE THING'S FOR *SURE,* THOUGH. WHEN USED WELL, COLOR IN COMICS CAN--LIKE COMICS ITSELF--

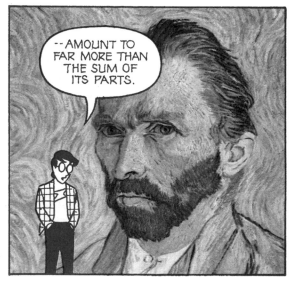

--AMOUNT TO FAR MORE THAN THE SUM OF ITS PARTS.

CHAPTER NINE

PUTTING IT ALL TOGETHER.

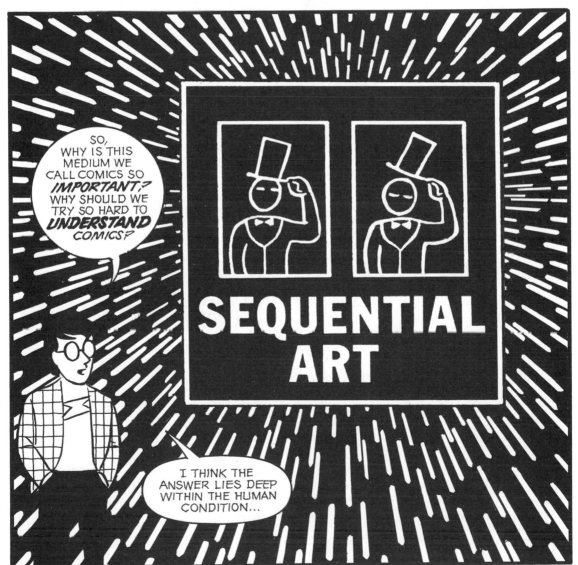

SO, WHY IS THIS MEDIUM WE CALL COMICS SO *IMPORTANT?* WHY SHOULD WE TRY SO HARD TO *UNDERSTAND* COMICS?

SEQUENTIAL ART

I THINK THE ANSWER LIES DEEP WITHIN THE HUMAN CONDITION...

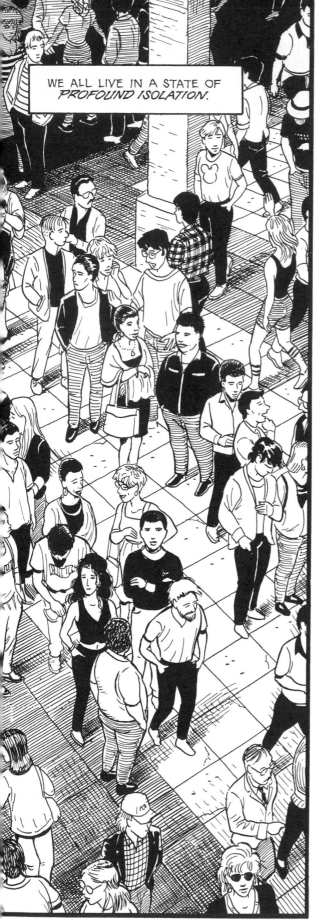

WE ALL LIVE IN A STATE OF *PROFOUND ISOLATION.*

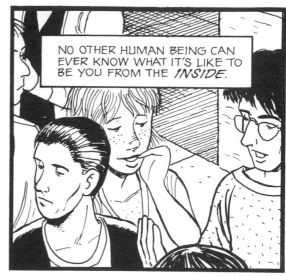

NO OTHER HUMAN BEING CAN EVER KNOW WHAT IT'S LIKE TO BE YOU FROM THE *INSIDE.*

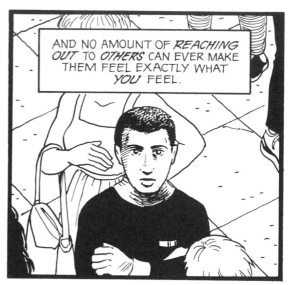

AND NO AMOUNT OF *REACHING OUT* TO *OTHERS* CAN EVER MAKE THEM FEEL EXACTLY WHAT *YOU* FEEL.

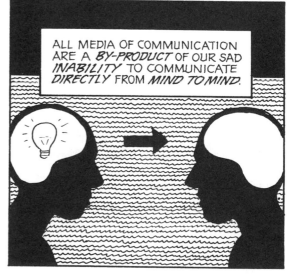

ALL MEDIA OF COMMUNICATION ARE A *BY-PRODUCT* OF OUR SAD *INABILITY* TO COMMUNICATE *DIRECTLY* FROM *MIND TO MIND.*

194

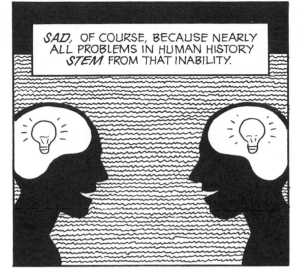

SAD, OF COURSE, BECAUSE NEARLY ALL PROBLEMS IN HUMAN HISTORY *STEM* FROM THAT INABILITY.

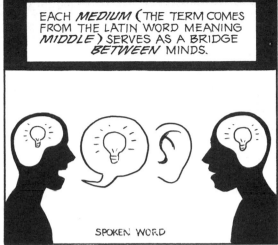

EACH *MEDIUM* (THE TERM COMES FROM THE LATIN WORD MEANING *MIDDLE*) SERVES AS A BRIDGE *BETWEEN* MINDS.

SPOKEN WORD

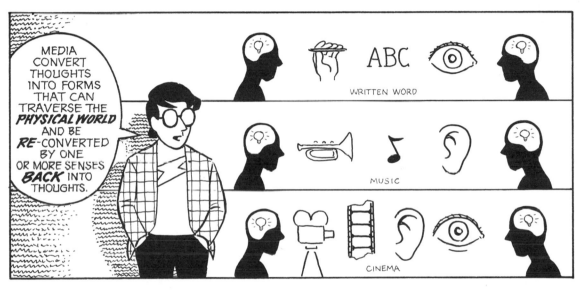

MEDIA CONVERT THOUGHTS INTO FORMS THAT CAN TRAVERSE THE *PHYSICAL WORLD* AND BE *RE*-CONVERTED BY ONE OR MORE SENSES *BACK* INTO THOUGHTS.

WRITTEN WORD

MUSIC

CINEMA

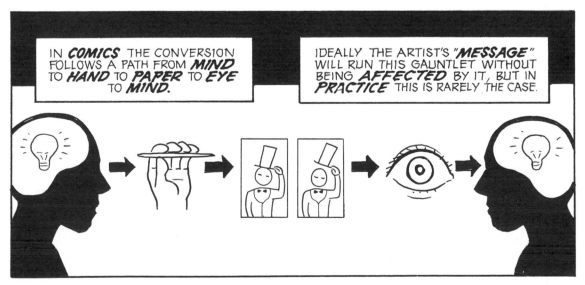

IN *COMICS* THE CONVERSION FOLLOWS A PATH FROM *MIND* TO *HAND* TO *PAPER* TO *EYE* TO *MIND.*

IDEALLY THE ARTIST'S *"MESSAGE"* WILL RUN THIS GAUNTLET WITHOUT BEING *AFFECTED* BY IT, BUT IN *PRACTICE* THIS IS RARELY THE CASE.

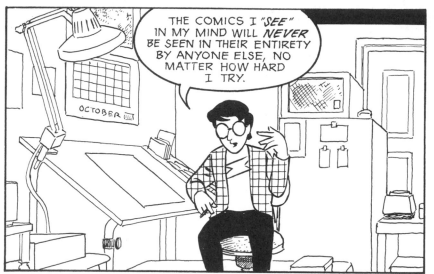

THE COMICS I "SEE" IN MY MIND WILL NEVER BE SEEN IN THEIR ENTIRETY BY ANYONE ELSE, NO MATTER HOW HARD I TRY.

ASK ANY WRITER OR FILMMAKER OR PAINTER JUST HOW MUCH OF A GIVEN PROJECT TRULY REPRESENTS WHAT HE/SHE ENVISIONED IT TO BE.

YOU'LL HEAR TWENTY PERCENT... TEN...FIVE...

FEW WILL CLAIM MORE THAN THIRTY.

THE MASTERY OF ONE'S MEDIUM IS THE DEGREE TO WHICH THAT PERCENTAGE CAN BE INCREASED, THE DEGREE TO WHICH THE ARTIST'S IDEAS SURVIVE THE JOURNEY--

--OR, FOR SOME ARTISTS, THE DEGREE TO WHICH THE INEVITABLE DETOURS ARE MADE USEFUL BY THE ARTIST.

AS I SAID IN CHAPTER SEVEN, I BELIEVE WE ALL HAVE SOMETHING TO SAY TO THE WORLD. I'M A FIRM BELIEVER IN THE INHERENT WORTH OF ALL INNER TRUTHS.

THERE'S ONLY ONE POWER THAT CAN BREAK THROUGH THE WALL WHICH SEPARATES ALL ARTISTS FROM THEIR AUDIENCE--THE POWER OF UNDERSTANDING.

UNDERSTANDING COMICS IS *SERIOUS BUSINESS.*

TODAY, COMICS IS ONE OF THE VERY FEW FORMS OF *MASS COMMUNICATION* IN WHICH *INDIVIDUAL VOICES* STILL HAVE A CHANCE TO BE *HEARD.*

THOSE OF US WHO TACKLE THE *BUSINESS* OF COMICS HAVE MANY OBSTACLES TO OVERCOME--

--BUT THEY *PALE* IN COMPARISON TO WHAT A *FILMMAKER* OR *PLAYWRIGHT* HAS TO CONTEND WITH.

COMICS WELCOMES *ANY* WRITER OR ARTIST TO STEP INTO ITS WORLD, A WORLD AS CLOSE AS *PEN* OR *PENCIL* AND *PAPER.*

KOH-I-NOOR

AND NO, THEY DON'T HAVE TO BE *THESE* TYPES OF PENS AND PENCILS.

197

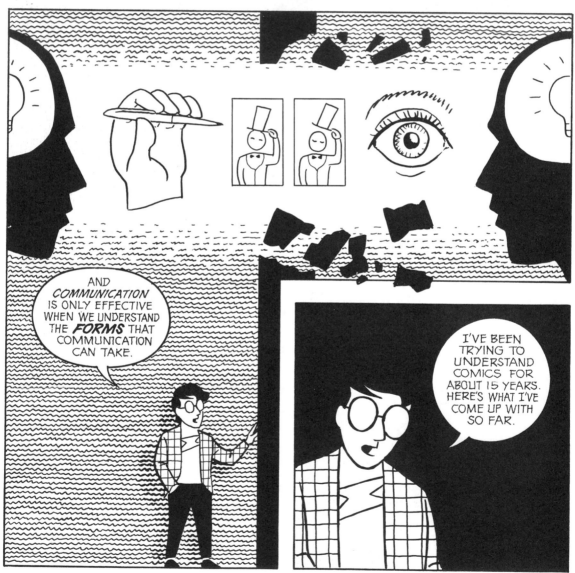

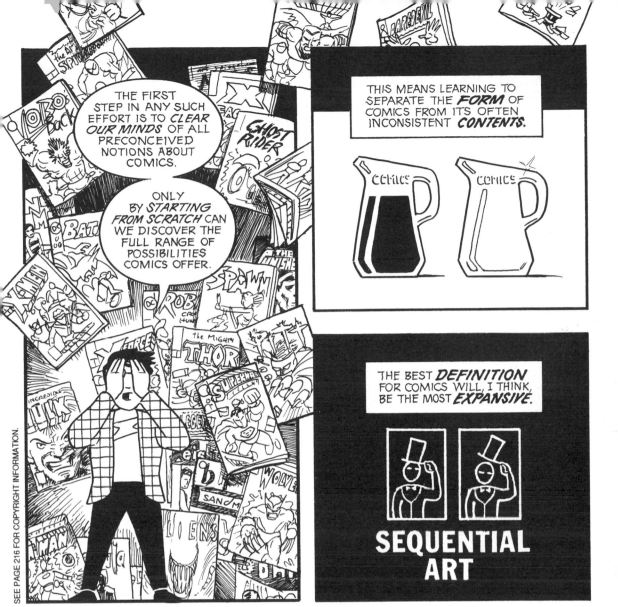

THE FIRST STEP IN ANY SUCH EFFORT IS TO *CLEAR OUR MINDS* OF ALL PRECONCEIVED NOTIONS ABOUT COMICS.

ONLY BY *STARTING FROM SCRATCH* CAN WE DISCOVER THE FULL RANGE OF POSSIBILITIES COMICS OFFER.

THIS MEANS LEARNING TO SEPARATE THE *FORM* OF COMICS FROM ITS OFTEN INCONSISTENT *CONTENTS.*

THE BEST *DEFINITION* FOR COMICS WILL, I THINK, BE THE MOST *EXPANSIVE.*

SEQUENTIAL ART

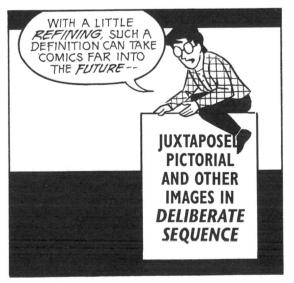

WITH A LITTLE *REFINING,* SUCH A DEFINITION CAN TAKE COMICS FAR INTO THE *FUTURE*--

JUXTAPOSED PICTORIAL AND OTHER IMAGES IN *DELIBERATE SEQUENCE*

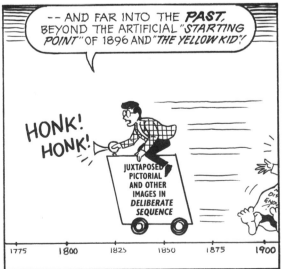

-- AND FAR INTO THE *PAST,* BEYOND THE ARTIFICIAL "*STARTING POINT*" OF 1896 AND "*THE YELLOW KID*"!

HONK! HONK!

JUXTAPOSED PICTORIAL AND OTHER IMAGES IN *DELIBERATE SEQUENCE*

1775　1800　1825　1850　1875　1900

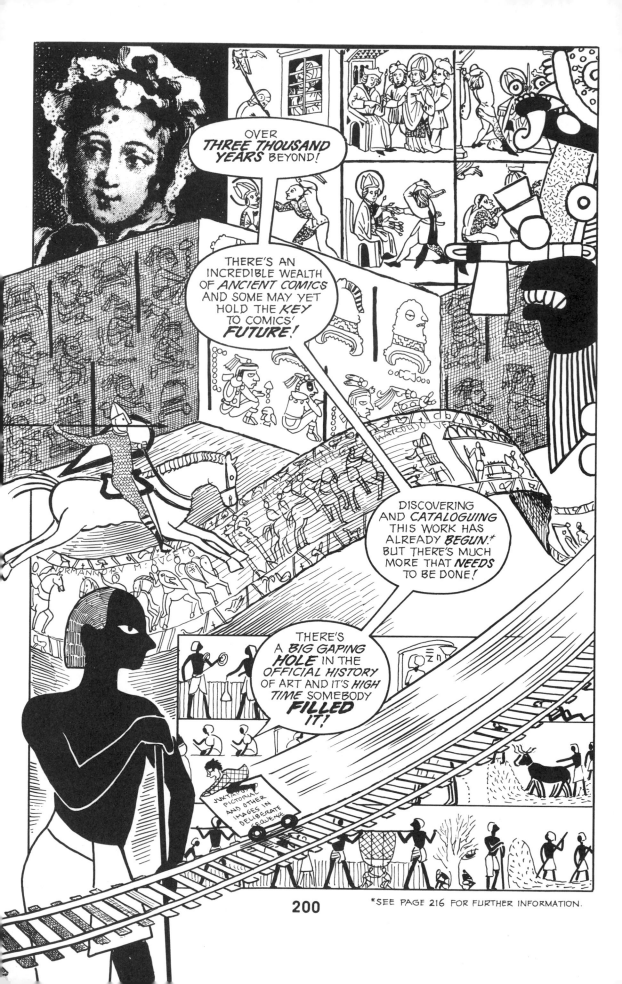

*SEE PAGE 216 FOR FURTHER INFORMATION.

THROUGH THE **WORKS** AND **WRITINGS** OF THESE NEGLECTED MASTERS, WE SEE THE **FIRST GLIMPSES** OF COMICS' **LIMITLESS POTENTIAL** AS AN ART FORM--

"...the picture-story, which critics disregard and scholars scarcely notice, has had great influence at all times, perhaps even more than written literature."

Rudolphe Topffer
1845

--AND THE ATTITUDES THAT WERE TO **OBSCURE** THAT POTENTIAL FOR **MANY YEARS TO COME!**

"...in addition, the picture-story appeals mainly to children and the lower classes..."

Rudolphe Topffer
1845

TRANSLATION BY E. WIESE.

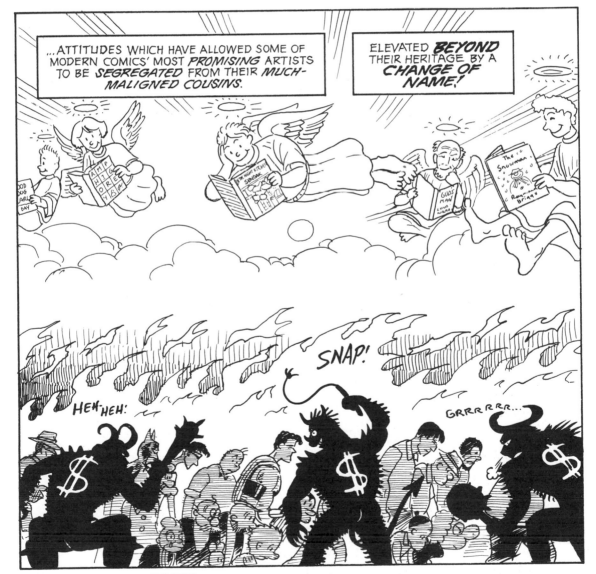

...ATTITUDES WHICH HAVE ALLOWED SOME OF MODERN COMICS' MOST **PROMISING** ARTISTS TO BE **SEGREGATED** FROM THEIR **MUCH-MALIGNED** COUSINS.

ELEVATED **BEYOND** THEIR HERITAGE BY A **CHANGE OF NAME!**

SNAP!

HEH HEH!

GRRRRRR...

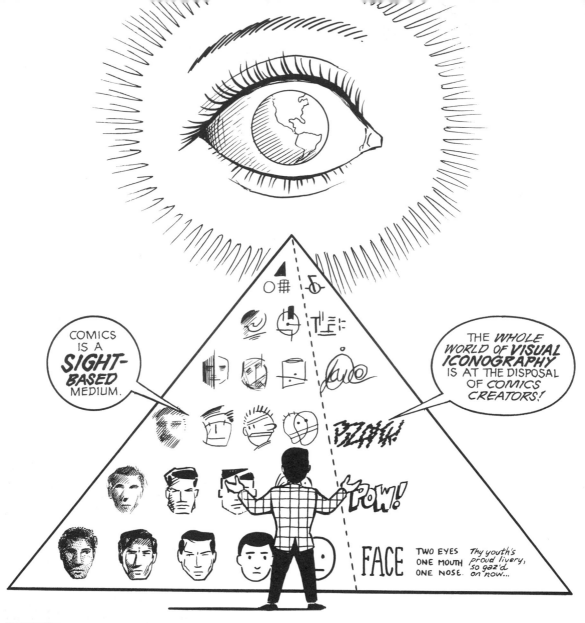

COMICS IS A **SIGHT-BASED** MEDIUM.

THE *WHOLE WORLD* OF *VISUAL ICONOGRAPHY* IS AT THE DISPOSAL OF *COMICS CREATORS!*

FACE TWO EYES ONE MOUTH ONE NOSE. *Thy youth's proud livery, so gaz'd on now...*

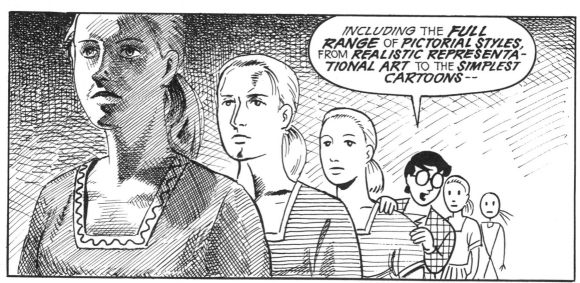

INCLUDING THE *FULL RANGE* OF *PICTORIAL STYLES,* FROM *REALISTIC REPRESENTATIONAL ART* TO THE *SIMPLEST CARTOONS* --

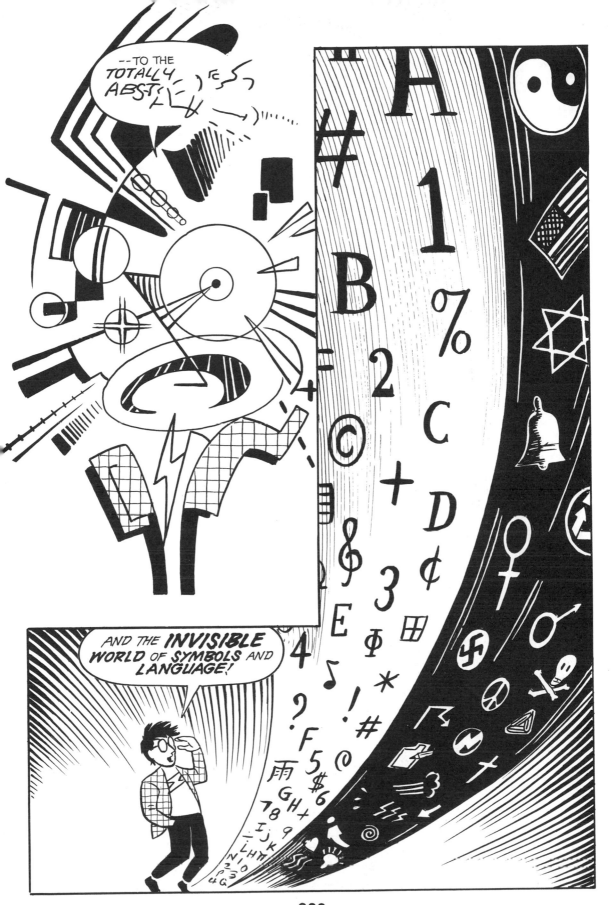

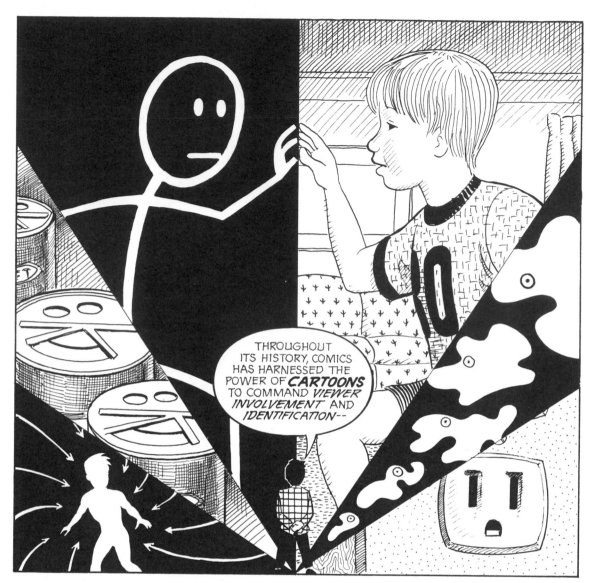

THROUGHOUT ITS HISTORY, COMICS HAS HARNESSED THE POWER OF **CARTOONS** TO COMMAND *VIEWER INVOLVEMENT* AND *IDENTIFICATION*--

-- AND *REALISM* TO CAPTURE THE *BEAUTY* AND *COMPLEXITY* OF THE *VISIBLE WORLD.*

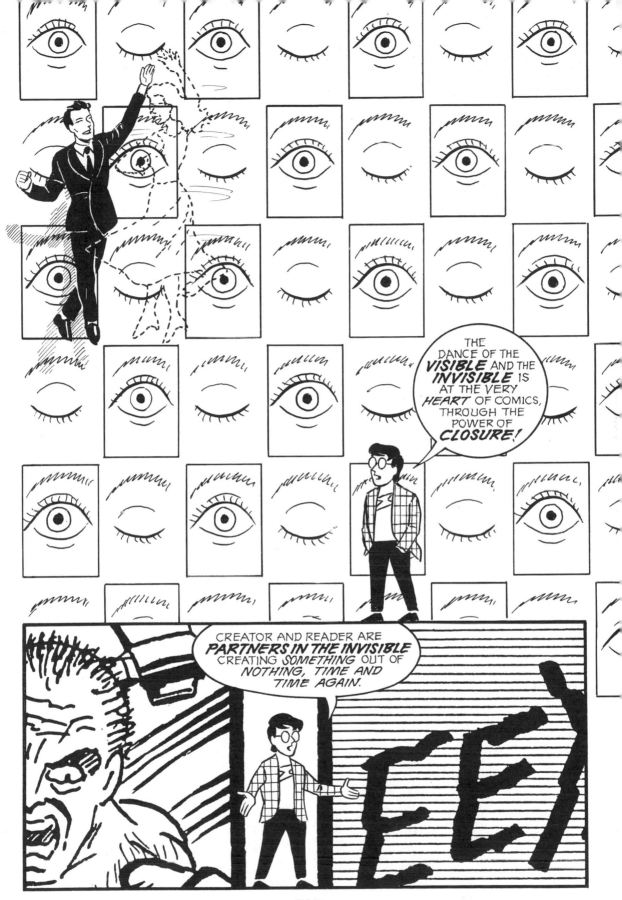

205

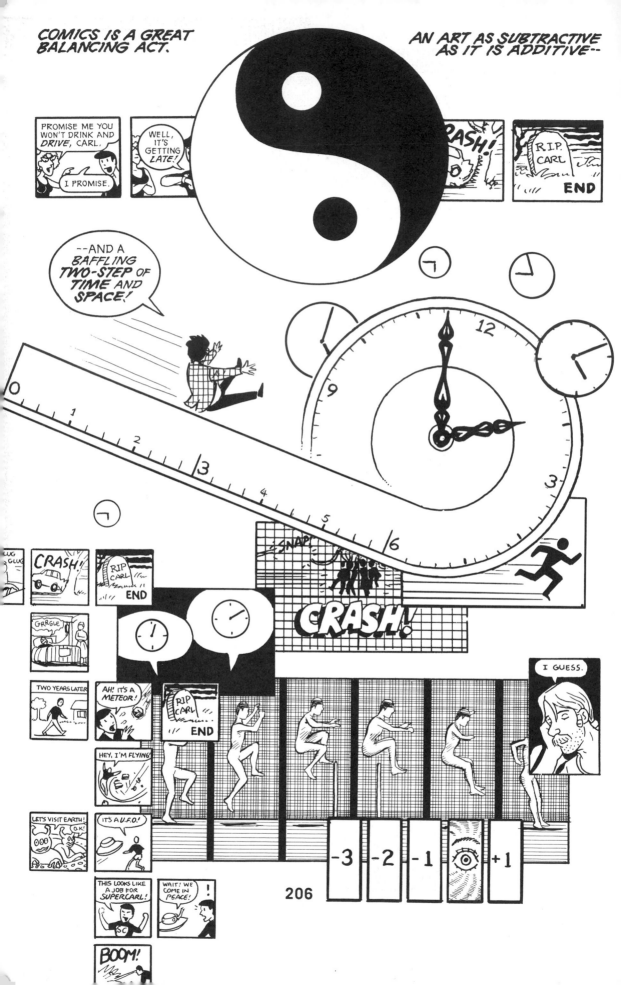

BUT NOWHERE IS THE BALANCE BETWEEN THE *VISIBLE* AND THE *INVISIBLE* MORE *CONSPICUOUS* THAN IN *PICTURES* AND *WORDS*...

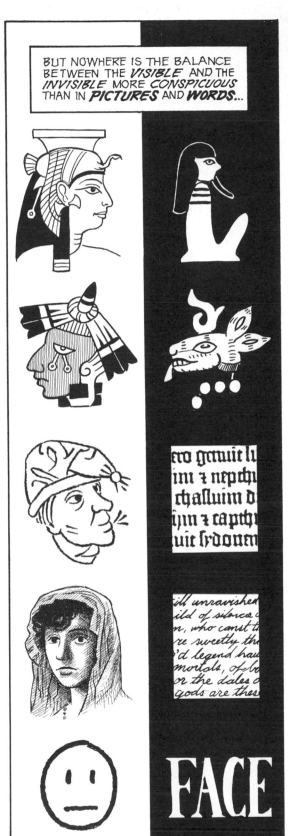

FACE

...A SPLIT FORETOLD IN THE *BIRTH OF ART ITSELF*--

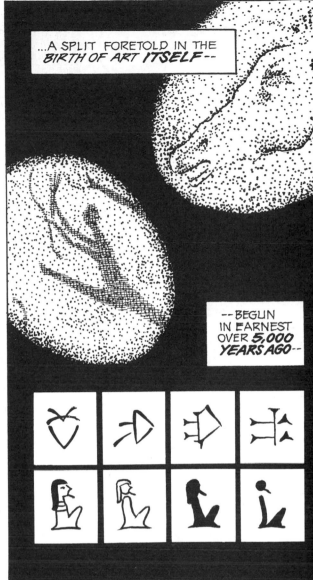

--BEGUN IN EARNEST OVER *5,000* *YEARS AGO*--

-- AND GROWN *WIDER AND WIDER* FOR *CENTURIES* UNTIL EVENTUALLY, ALL CONNECTION WAS LOST--

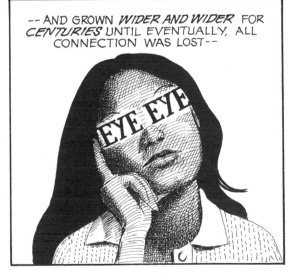

-- AND THEN *REDISCOVERED* IN THE *GREAT MADNESS* THAT WAS THE *TWENTIETH CENTURY!*

"YOU'RE OUT!!"

Ceci n'est pas une pipe

TODAY'S COMICS DO THEIR *DANCE WITH THE INVISIBLE* BETTER THAN *EVER BEFORE.*

BUT THE LANGUAGE OF COMICS CONTINUES TO *EVOLVE--*

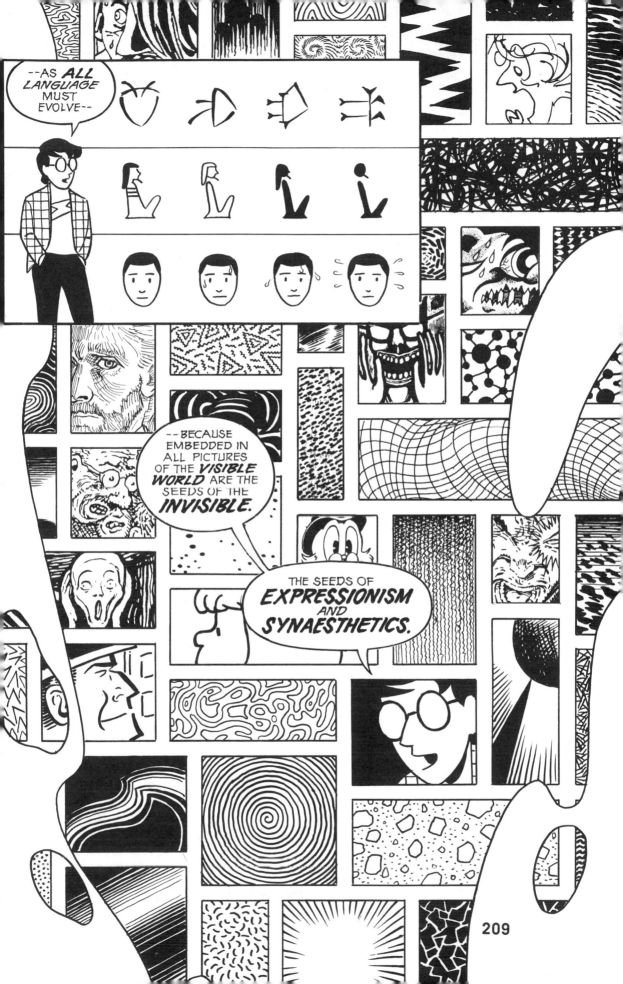

209

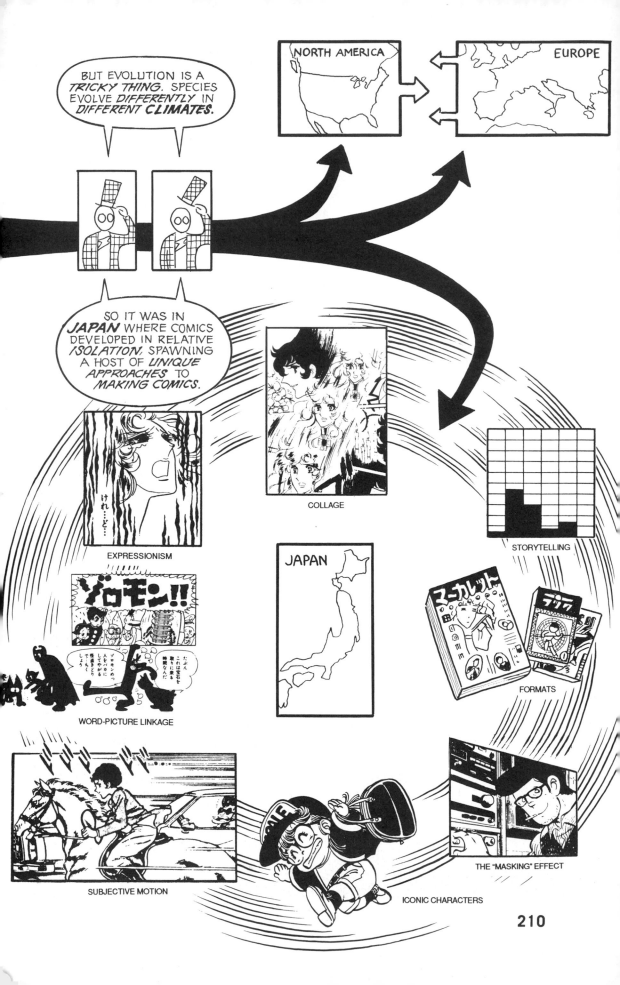

BUT EVOLUTION IS A *TRICKY THING.* SPECIES EVOLVE *DIFFERENTLY* IN *DIFFERENT CLIMATES.*

NORTH AMERICA

EUROPE

SO IT WAS IN *JAPAN* WHERE COMICS DEVELOPED IN RELATIVE *ISOLATION,* SPAWNING A HOST OF *UNIQUE APPROACHES* TO *MAKING COMICS.*

COLLAGE

STORYTELLING

EXPRESSIONISM

JAPAN

WORD-PICTURE LINKAGE

FORMATS

SUBJECTIVE MOTION

ICONIC CHARACTERS

THE "MASKING" EFFECT

AS COMICS GROWS INTO THE NEXT CENTURY, CREATORS WILL ASPIRE TO MANY HIGHER GOALS THAN APPEALING TO THE *"LOWEST COMMON DENOMINATOR."*

IGNORANCE AND *SHORT-SIGHTED BUSINESS PRACTICES* WILL NO DOUBT *OBSCURE* THE POSSIBILITIES OF COMICS FROM TIME TO TIME AS THEY ALWAYS HAVE.

BUT THE *TRUTH* ABOUT COMICS CAN'T STAY HIDDEN FROM VIEW *FOREVER* AND SOONER OR LATER--

--THE TRUTH WILL *SHINE THROUGH!*

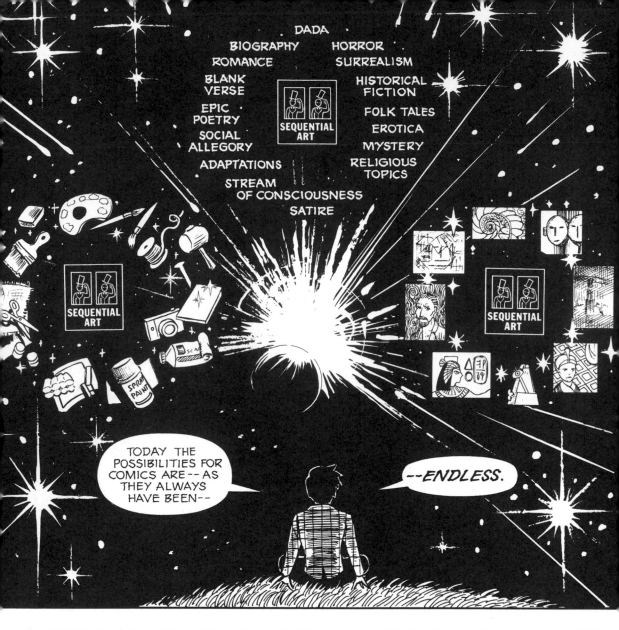

DADA
BIOGRAPHY HORROR
ROMANCE SURREALISM
BLANK
VERSE HISTORICAL
 FICTION
EPIC FOLK TALES
POETRY
SOCIAL EROTICA
ALLEGORY
 MYSTERY
ADAPTATIONS RELIGIOUS
 TOPICS
STREAM
OF CONSCIOUSNESS
SATIRE

SEQUENTIAL ART

TODAY THE POSSIBILITIES FOR COMICS ARE -- AS THEY ALWAYS HAVE BEEN --

--ENDLESS.

COMICS OFFERS *TREMENDOUS RESOURCES* TO *ALL* WRITERS AND ARTISTS: *FAITHFULNESS, CONTROL,* A CHANCE TO BE HEARD *FAR AND WIDE* WITHOUT FEAR OF *COMPROMISE...*

SEQUENTIAL ART

IT OFFERS *RANGE* AND *VERSATILITY* WITH ALL THE POTENTIAL IMAGERY OF *FILM* AND *PAINTING* PLUS THE *INTIMACY* OF THE *WRITTEN WORD.*

AND ALL THAT'S NEEDED IS THE DESIRE TO BE HEARD--

| 1 | 2 | 3 | 4 | 5 | 6 |

--THE WILL TO LEARN--

--AND THE ABILITY TO SEE.

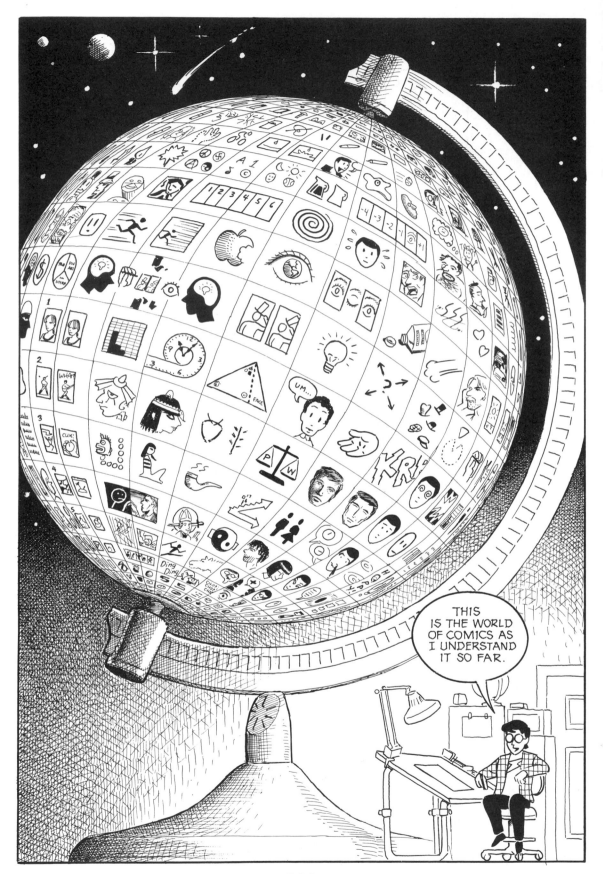

I'VE LEARNED *A LOT* ABOUT COMICS SINCE *BEGINNING* THIS PROJECT AND I KNOW I HAVE A LOT *LEFT* TO LEARN.

I HOPE YOU'LL ALL CONSIDER EXPLORING-- OR *CONTINUING* TO EXPLORE-- COMICS ON YOUR OWN!

HOWEVER YOU EXPERIENCE COMICS-- AS *READER, CREATOR* OR *BUSINESSPERSON*-- THERE ARE A *MILLION AND ONE WAYS* YOU CAN HELP COMICS TO GROW INTO THE NEXT CENTURY.

THINK ABOUT IT.

AND THANKS FOR *LISTENING*.

HMM?

OH, WOW, DID I TAKE THAT LONG? I'M SORRY. I BETTER LET YOU GO!

BACK TO THE OLD *DRAWING BOARD!*

♪

AT LEAST YOU'RE NOT *MARRIED* TO HIM. I GET THIS ALL THE TIME!

'92

Selected Bibliography.

Chip, Herschel B., editor: *Theories of Modern Art* (Berkeley: University of California Press, 1968).

Eisner, Will: *Comics and Sequential Art* (Princeton, Wi: Kitchen Sink Press, Inc., 1992).

Kunzle, David: *The Early Comic Strip* (Berkeley: University of California Press, 1973).

McLuhan, Marshall: *Understanding Media* (New York: McGraw-Hill Book Co., 1964).

Schwartz, Tony: *Media: The Second God* (New York: Anchor Books, 1983).

Wiese, E., editor, translator: *Enter: The Comics-- Rodolphe Topffer's Essay on Physiognomy and the True Story of Monsieur Crepin* (Lincoln, Ne: University of Nebraska Press, 1965).

Special note: Kunzle's book (see above) has gone virtually unnoticed by the comics community but is an enormously important work, covering nearly 400 years of forgotten European comics. Check it out!

Copyright Information.

Page 4: El Borba © Charles Burns; Mister O'Malley, Buster Brown, Miss Peach and Nemo © Field Newspaper Syndicate, Inc.; David Chelsea © himself; Cynicalman © Matt Feazell; The Dragon Lady, Little Orphan Annie, Dick Tracy and Uncle Walt © Chicago Tribune -- New York News Syndicate; E. Z. Mark, Flash Gordon, Jiggs, Hi and Popeye © King Features Syndicate, Inc; Alley Oop and Bull Dawson © NEA Service Inc.; Felix the Cat, Polly and Her Pals © Newspaper Feature Service; Li'l Abner, Charlie Brown, Gordo and Nancy © United Features Syndicate; Shazam! (Captain Marvel), Death, Superman, Wonder Woman, Batman, Plastic Man and Alfred E. Neuman © D.C. Comics; Gen © Keiji Nakazawa; Colin Upton © himself; Betty © Archie Comics; Beanish © Larry Marder; Danny © Terry Laban; The Snowman © Raymond Briggs; Adele Blanc-Sec and Tintin © Casterman; Arale © Akira Toriyama; Alec © Eddie Campbell; Groo © Sergio Aragones; Dan Clowes © himself; Cerebus the Aardvark © Dave Sim; Micky Mouse and Scrooge McDuck © Walt Disney Productions; Jack © Jerry Moriarty; Cardinal Syn © Steve Bissette; The Spirit © Will Eisner; Mike © Garry Trudeau; Heraclio © Gilbert Hernandez; Asterix and Laureline © Dargaud Editeur; Reid Fleming © Boswell; Theodore Death Head © Pascal Doury; The Torpedo © Catalan Communications; Frank © Jim Woodring; Vladek and Art © Art Spiegelman; Omaha © Reed Waller and Kate Worley; Krazy Kat © International Features Syndicate; The Thing, Wolverine and Spider-Man © Marvel Entertainment Group; Harvey Pekar © himself; Maggie © Jaime Hernandez; Astroboy © Osamu Tezuka; Cutter © WaRp Graphics; Leonardo © Mirage Licensing; R. Crumb © himself; Zippy © Bill Griffith: Arzach © Moebius: Wendel © Howard Cruse; Flaming Carrot © Bob Burden; Ricky © Kyle Baker; Ed © Chester Brown; Julie Doucet © herself; Amy © Mark Beyer; Concrete © Paul Chadwick; Pogo © Selba Kelly; Bitchy Bitch © Roberta Gregory; Piker © Mariscal; A. Mutt © McNaught Syndicate, Inc.; Mark Martin ©

himself; Carol Tyler © herself; Morty the Dag © Steve Willis.

Other Art © Sampei Shirato, Koike-Kojima, Mary Fleener, Matt Groening, Riyoko Ikeda, Joost Swarte, Harold H. Knerr, Albin Michel S. A., Dr. Seuss, O. Soglow, Jose Munoz and Krystine Kryttre.

Page 12: To the Heart of the Storm © Will Eisner.

Page 24: The Original painting "The Treachery of Images" by Rene Magritte resides at The Los Angeles County Museum of Art. Our thanks to the museum for allowing us to imitate the image.

Page 30: As on page 4, plus Kermit © Henson Associates; Bugs Bunny © Warner Brothers; Bart © 20th Century Fox; Mrs. Potts © Walt Disney Productions; Jughead © Archie Comics; Casper © Harvey Comics; Beetle Bailey © King Features.

Page 45: Savage Dragon © Erik Larsen; Tumbleweeds © King Features; Gizmo © Michael Dooney; Jenny © Ivan Velez; Nancy © United Features Syndicate, Inc.; Shadow Hawk © Jim Valentino; Bob © Terry Laban; Portia Prinz © Richard Howell; Dr. Radium © Scott Saavedra; Spawn © Todd McFarlane; Mr. Monster © Michael T. Gilbert; Cutey Bunny © Joshua Quagmire; The Maximortal © Rick Veitch; Raphael © Mirage Licensing; Panda Khan © Monica Sharp and Dave Garcia.

Page 56: As on pages 4, 50 and 51 plus: Steve © Gilbert Hernandez; Art © Mary Fleener; Checkered Demon © S. Clay Wilson; Bear © Rory Hayes; Micky Rat © R. Armstrong; Art © Kim Deitch.

Page 83: AL HELD. The Big N. (My facsimile). The original is synthetic polymer paint on canvas, 9'3/8" x 9'. Collection, The Museum of Modern Art, New York. Mrs. Armand P. Bartos Fund.

Page 126: As on pages 4, 50 and 51 plus: Reed Richards and Cable © Marvel Entertainment Group; The Teen Titans © D.C. Comics; Tantrum © Jules Feiffer; and art © Munoz and Sampayo, Jooste Swarte, Art Spiegelman and Will Eisner.

Page 133: The Rose of Versailles © Riyoko Ikeda; other art © H. Sato and (?).

Page 199: Daredevil, Ghost Rider, The Punisher, X-Factor, The Amazing Spider-Man, Thor, X-Force, Wolverine, X-Men, Hulk and Iron Man © and tm Marvel Entertainment Group; Superman, Batman, Robin, Sandman and Lobo © and tm D.C. Comics; Aliens © and tm 20th Century Fox; Dark Horse Presents © Dark Horse Comics; Spawn © and tm Todd McFarlane; The Pitt © Dale Keown; Youngblood © and tm Rob Liefeld.

Page 201: As on pages 4, 50 and 51.

Page 208: Batman returns tm Warner Bros.; Linus © U. F. S., inc.; Action Comics © and tm D.C. Comics. The Yellow Kid © Scripps-Howard Newspapers

Originals for Sale / Letters of Comment.

For information on original art, write to: Scott McCloud, Box 798, Amherst, MA 01004.

Letters of comment are appreciated (if seldom answered due to overwhelming commitments), but I would especially appreciate a *public* discussion of these issues in comics' trade journals, art magazines, computer nets and any other forum. This book is meant to stimulate debate, not settle it.

I've had my say.
Now, it's *your* turn.